SIGNS OF CHANGE

SOCIAL MOVEMENT CULTURES 1960s TO NOW

AK PRESS & EXIT ART | 2010

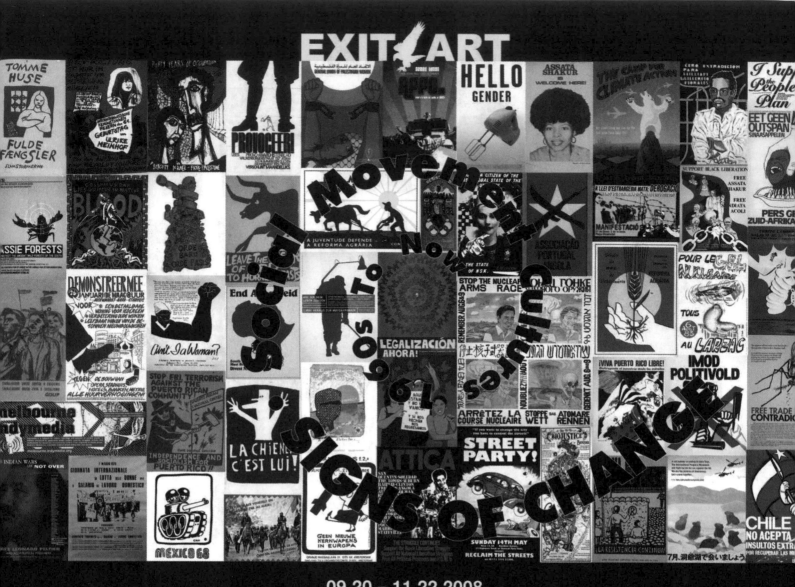

EXIT ART

HELLO GENDER

Social Movement Cultures 1960s to Now SIGNS OF CHANGE

09.20 – 11.22.2008

Published 2010 by AK Press/Exit Art
Copyright © 2010 AK Press/Exit Art
Individual copyright retained by the respective contributors.

AK Press
674-A 23rd Street
Oakland, CA 94612
www.akpress.org
www.akuk.com

Exit Art
475 Tenth Avenue
New York, NY 10018
212-966-7745
www.exitart.org

ISBN: 9781849350273
LCCN: 2010925764

Cover and internal design by Josh MacPhee/Justseeds.org

For information regarding images on the cover, see items 27, 68, 144, 182, 237, 277, 278, 345

Printed and bound in Canada.

SIGNS OF CHANGE

This catalogue is published in conjunction with *Signs of Change: Social Movement Cultures 1960s to Now*, an exhibition produced by Exit Art, New York. *Signs of Change* was the inaugural project of the Curatorial Incubator Program. The program expands Exit Art's commitment to young and emerging curators, artists, and scholars in contemporary art, by devoting material, financial, and human resources to developing curatorial talent. Working with Exit Art directors and staff, fellows curate large-scale exhibitions, learn fundraising, develop outreach and educational programs, and produce a catalogue. Access to Exit Art's acclaimed archives facilitates these curatorial fellows' abilities to contextualize their projects within international and historical frameworks.

Editors/Curators and Curatorial Incubator Fellows: Dara Greenwald and Josh MacPhee
Curatorial Incubator Director and Executive Editor: Mary Anne Staniszewski
Project Managers: Herb Tam and Lauren Rosati
Exit Art Installation and Poster Design: Papo Colo
Executive Director/Co-founder: Jeanette Ingberman, Artistic Director/Co-founder: Papo Colo

ABOUT EXIT ART

Exit Art is a twenty-eight-year-old cultural center in New York City that offers an independent vision of contemporary culture. Founded by Directors Jeanette Ingberman and Papo Colo, Exit Art has grown from a pioneering alternative art space into a model for a twenty-first century artistic center committed to supporting artists whose quality of work reflects the transformations of our culture. Exit Art is prepared to react immediately to important issues that affect our lives. By engaging with cultural differences and aesthetic, social, political, and environmental issues, Exit Art produces experimental, historical, and unique presentations and prototype exhibitions. A center for multiple disciplines, Exit Art is internationally recognized for its unmatched spirit of inventiveness and consistent ability to anticipate the newest trends in the culture. With a substantial reputation for curatorial innovation and depth of programming in diverse media, Exit Art is always changing.

VENUES

September 20–December 6, 2008
Exit Art, New York, New York

January 23–March 8, 2009
Miller Gallery, Carnegie Mellon University, Pittsburgh, Pennsylvania

April 5–June 5, 2009
The Arts Center of the Capital Region, Troy, New York
Co-Sponsored by Rensselaer's iEAR Presents! and Humanities@Rensselaer

February 4–March 19, 2010
The Philip Feldman Gallery and Project Space, Pacific Northwest College of Art, Portland, Oregon

1. Papo Colo, **Poster design for *Signs of Change***, Exit Art, New York, NY, September 20–December 6, 2008.
2. Fireworks Graphics Collective, **Build A Wall of Resistance**, offset lithograph poster, 1982, USA.
3. MPLA (artist unknown), **Solidariedade dos Povos de Angola, Guiné e Cabo Verde** [Solidarity between the Peoples of Angola and Guinea-Bissau and Cape Verde], offset lithograph poster, 1976, Angola.

EXIT ART STAFF
Associate Director: Audrey Christensen, Associate Director: Seth Cohen, Associate Curator: Herb Tam, Assistant Curator: Lauren Rosati, Grants Manager: Cora Fisher, Graphics: Alfred Maskeroni, IT Person: Eric Tsai

Former staff who worked on the show:
Managing Director: Janine Al-Janabi and Grants Manager: Molly Reed

EXIT ART BOARD
Charles Kremer, Chairman; Alberta Arthurs, President; Ida Applebroog, Papo Colo, Deborah Colton, Marilynn Donini, Fairfax Dorn, Mark L. Epstein, Frayda Feldman, Ronald Feldman, Peter Frey, Stuart Ginsberg, Jeanette Ingberman, Jenette Kahn, Eileen S. Kaminsky, Jerry Kearns, John Koegel, Richard J. Massey, Leslie Moran, Amy Newman, Yigal Ozeri, Mary Anne Staniszewski

THANKS
Charles, Kate, Lorna, Suzanne, Zach and everyone at AK Press, our families, Anabella and Fantasmas de Heredia, Finn Thybo Andersen, Allan Antliff, Archiv Papier Tiger, Aviv, Kazembe Balagun, Craig Baldwin, Bani, Brett Bloom, Blue Mountain Center, Bluestockings Bookstore, Skip Blumberg, Amadee Braxton, Lindsay Caplan, Kevin Caplicki, Chris Carlsson, Chris at 56A Infoshop, Estelle Carol, Tom Civil, Margaret Cox, Lincoln Cushing, Paloma Diaz, Deirdre at Ungdomshuset, Marco Deseriis, Kirsten Dufour, Stephen Duncombe, Alec Dunn, Silvia Federici, Anna Feigenbaum, Jim Fetterly, Jim Fleming, Emily Forman, Michelle Foy and Fernando Marti, Aaron Gach, Michael Gallagher, William Gambetta, Benj Gerdes, Grrrt, Alex Halkin, DeeDee Halleck, Barbara Hammer, Jodi Hanel, Kyle Harris, Kathy High, Chris Hill, Brian Holmes, students, staff, and faculty of the Department of the Arts at Rensselaer, illcommonz, Irina, Sarah Jarmon, John Jordan, Justseeds Artists' Cooperative, Jonathan Kahana, Ramsey Kanaan, Malav Kanuga, Sandy Kaltenborn, George Katsiaficas, Narita Keisuke, Nadia Khastagir, Janet Koenig, Sabu Kohso, Tami Lawson, Cale Layton, Britta Lillesøe, Mark Looney, Lower East Side Print Shop, Juan Pablo Macías, Martin Mantxo, Claude Marks, Mack McFarland, Lauren Melodia, Ben Meyers, Miguel at Indymedia Brazil, Branda Miller, Doug Minkler, KJ Mohr, Claude Moller, Jan Novak, Craig O'Hara, 123 Community Space, Dina Passman, Mary Patten, Paolo Pedercini, Canek Pena-Vargas, Erin Pischke, Gordon Quinn, Melissa Rachleff Burtt, Paul Rapp, Mark Reed, Rio, Olivia Robinson, Favianna Rodriguez, Heather Rogers, Sasha Roseneil, Michael Rossman (RIP), Timo Russo, Malena Ruth, Sarah Ryhanen, Surajit Sarkar, Paige Sarlin, Judy Seidman, Stevphen Shukaitis, Greg Sholette, Tim Simons, 16beaver group, Theresa Smith, Jacqui Soohen, Sphinx, Chris Stain, Meg Starr, Astria Suparak, Nato Thompson, Miriam Tola, Eric Triantafillou, Daniel Tucker, Kathryn Tufano, Jose Vasquez, Nils Vest, Butcher Walsh, Carol Wells and all at CSPG, Jamie Wilkinson, Deborah Willis and Asian/Pacific/American Institute and Tisch Department of Photography & Imaging at NYU, all who submitted writing to the exhibition, the translators, Interns: Gabriel Cohen, Merrily Grashin, Nicole Whalen, BreAnne Dale, Jessica Hong, Scott Schultheis, Elsa Konig, Lilly Alexander, Nina Barnett, Saskia Coulson, Alexandra Ingalls, Kelsey Witt, and all who have participated in the production of social movement cultures!

LENDERS
All Of Us Or None (AOUON) Archive; American Friends' Service Committee; Archivo Arnulfo Aquino; Athénée Français Cultural Center; Autonomedia; Beehive Design Collective; Benton Gallery at University of Connecticut; Big Noise Films; Fabrizio Billi/Archivio Storico della Nuova Sinistra "Marco Pezzi;" Boston Women's Video Collective; Boyd; Bread & Puppet Theater; Breakdown Press; Bristle Magazine; Bullfrog Films; Kevin Caplicki; Center for the Study of Political Graphics (CSPG); Chiapas Media Project; CIRA (Japan); Christiania's Cultural Association; Corrugated Films; Tony Credland/ Cactus Network; Cultureshop.org; Lincoln Cushing; Chicago Women's Liberation Union Herstory Project; Tano D'Amico; Mariarosa Dalla Costa; Deep Dish TV; Jesse Drew; El Fantasma de Heredia; Tracy Fitz; Freedom Archives; William Gambetta/Centro Studi Movimenti; David Goodman; Greenpepper Project and Candida TV; HKS 13; Ilka Hartmann; Chris Hill and Bob Devine; Hoover Institution Archives; R. Howze; Roger Hutchinson; Ilaria La Fata/Centro Studi Movimenti; illcommonz; International Institute for Social History (IISH); image-shift berlin; Indymedia Brazil; Inkworks; Institute for Applied Autonomy; Interference Archive; Iraq Veterans Against the War; Irregular Rhythm Asylum; It's All Lies; Magdalena Jitrik; John Jordan; Kartemquin Film Collective; Judi Kelemen; Last Gasp; John Law; Jessica Lawless; Lesbian Herstory Educational Foundation, Inc.; The Linen Hall Library; Raphael Lyon; Matt Meyer; Marcom Projects; Middle East Division of Harvard's Weiner Library; Neue Slowenische Kunst (NSK); Katie Orlinsky; Political Art Documentation/Distribution (PAD/D) Archives at the Museum of Modern Art; Panopticon Gallery of Photography; Paper Tiger Television; Mary Patten; Darko Pokorn; Jill Posener; Endi Poskovic; Radio Zapatista; Oliver Ressler and Zanny Begg; Bill Rolston; Rachael Romero; Sasha Roseneil; Roz Payne Archives; Leonel Sagahón; Rafel Seguí i Serres; Joel Sheesley; Greg Sholette; South African History Archive; Stanford University; David Tartakover; Third World Newsreel; Eric Triantafillou; Undercurrents; Nils Vest; Video Data Bank; Videofreex Partnership; Yustoni Volunteero/Taring Padi Collective; Stacey Wakefield; Sue Williamson; Women's Library; Women Make Movies; and others. We sincerely apologize if we have neglected to include anyone on this list.

EXHIBITION SUPPORT
Signs of Change was supported by a major grant from the Andy Warhol Foundation for the Visual Arts. Additional support was provided by the Museum program at the New York State Council on the Arts, a State agency, and the Starry Night Fund at The Tides Foundation. Public programs were supported by the New York City Department of Cultural Affairs. Material support for the screen printing studio was provided by the Lower East Side Printshop, New York. General exhibition support was provided by Bloomberg LP; Carnegie Corporation; Jerome Foundation; Pollock-Krasner Foundation; Exit Art's Board of Directors and our members. We gratefully acknowledge public funding from New York City Council Speaker Christine C. Quinn and New York State Senator Thomas K. Duane.

Sponsoring partners of Signs of Change were The Center for the Study of Political Graphics (CSPG) in Los Angeles and the International Institute of Social History (IISH) in Amsterdam.

State of the Arts
NYSCA

TABLE OF CONTENTS

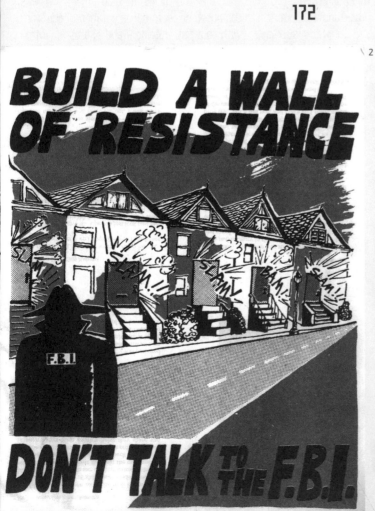

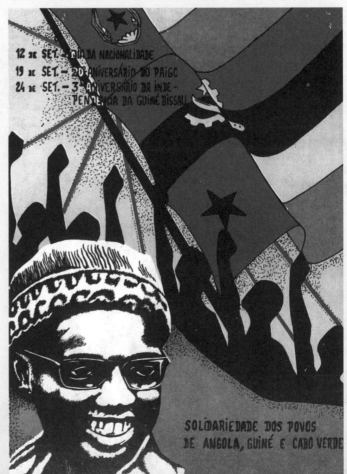

GOOD TIMING

Jeanette Ingberman

It couldn't have been more timely. The *Signs of Change* exhibition at Exit Art opened in the fall of the 2008 Presidential election in which the winning candidate, Barack Obama, united the country with the word "change."

Signs of Change continues Exit Art's long tradition of producing exhibitions of ephemera, graphic design, and social and political documents set within the context of contemporary art. From the founding of Exit Art, we have critically examined the role of the art institution, the definition of an exhibition, and the idea of presenting social ephemera as art and what it means to view this kind of material in a cultural space. The unique installations of these exhibitions by Papo Colo guide the public through a maze of information and allow the viewer time and space to absorb the works.

As a cultural center, Exit Art has always felt a responsibility to respond to cultural and artistic trends and movements. We can do so immediately, and react in the form of an exhibition, a dialogue, or a publication. But as a cultural space, we are also deeply concerned with global political, environmental, and social issues and feel a responsibility to investigate and explore these questions.

Signs of Change is aligned with that mission and is, in a sense, a successor to a number of Exit Art shows that presented sociopolitical and cultural ephemera. In particular, *Signs of Change* can be seen as an update and reinterpretation of *Counterculture: Alternative Information from the Underground Press* (1996), which was a comprehensive historical exhibition that examined the role of alternative media in fostering social, cultural, and political change in United States from 1965 to the then-present. Its materials ranged from mimeographed letters from the Weathermen to the birth of college newspapers published to protest the Vietnam War. *Public Notice: Art and Activist Posters 1951–1997* (1997) featured innovative posters designed for art exhibitions and political causes from the postwar years to the then-present. Considering the poster form as a strategy to communicate information, *Public Notice* highlighted the intersection of graphic design, the fine arts, and political activism.

Signs of Change was also not the first exhibition at Exit Art to chronicle graphic design from a particular period. *The Design Show* (1993) was a comprehensive presentation of exhibition invitations produced by museums, galleries, and alternative spaces in the US from 1940 to 1992. Intended to be an investigation of the design of exhibition invitations and their significance as cultural and art historical artifacts, the show raised questions such as: how did the history of exhibition invitations expand our graphic vocabulary? The works in the exhibition displayed a remarkable diversity of materials, such as paper, cloth, metal, rubber, and plastic and also took diverse innovative forms: napkins, matchbooks, bandanas, buttons, and slides. *The LP Show* (2001) featured over 2,500 innovative album covers that were culled from over fifty collections. This exhibition traced the history of graphic design for LPs from their inception in the 1940s to contemporary examples that endure as the medium has given way to the digital age of the compact disc.

That Exit Art has been involved with presenting social ephemera as art since its beginning is literally true, in that this was addressed in our very first exhibition in 1982, *Illegal America*. This historical show featured artists, who in the process of making their work, came into conflict with the law and challenged issues of legality and censorship. International in scope, it included work produced from 1930 to 1982 by artists from the United States, Europe, and Japan. Another way to describe the show is that *Illegal America* looked at artists breaking the law in order to do their work. The exhibition consisted of Xerox documents, court records, newspaper articles, trial transcripts, artists' statements, and a lot of things to read. The show was composed of photo-documentation of the work with an artist statement and extensive written documentation of each incident, many of which continued as legal cases. The installation was very unique, with works on different eye levels, unframed, and pinned to the wall. The public would stay for hours and read everything—something we were told would never happen.

Why do we do these kinds of shows?

They are critical evidence of grassroots activities, communities, and cultures. Many of these printed materials have a very short life span and limited public. They are put up for a particular reason at a specific location and time, and then they are gone, sometimes forever, except in documentation. Organizing these kind of exhibitions gives new life to these materials, restores some of the importance that they once held, and allows a much larger public access to view, study, and remember these inspiring artworks and their social movements.

4. **Entrance of *Signs of Change* installation**, Exit Art, New York, NY, 2008.
5. Chicago Women's Graphics Collective, **Boycott Lettuce**, screen print, 1977, USA.
6. **Election Night, November 4, 2008**, Signs of Change, Exit Art, New York, NY, 2008.

YES WE CAN!

Lauren Rosati

"Sí, se puede!" ("Yes, it can be done!")
—César Chávez, 1972

"Yes, we can!"
—Barack Obama, 2008

In 1972, César Chávez, the co-founder of the United Farm Workers (UFW), devised a slogan to unite California farm workers and motivate them to unionize for better wages and working conditions, and for other rights and protections. "Sí, se puede!" ("Yes, it can be done!") became the stirring cry at Chávez's speeches, during strikes, and in grape fields across California.[1] Due to the efforts of Chávez and the UFW, California passed the groundbreaking 1975 California Agricultural Labor Relations Act to protect the right of farm workers to unionize.

More than thirty-five years later, on January 27, 2008, Barack Obama made some remarks after he won the South Carolina Democratic primary. He challenged Americans to stand against the Republican hold on Washington and vote for change:

> The cynics who believed that what began in the snows of Iowa was just an illusion were told a different story by the good people of South Carolina... We are hungry for change and we are ready to believe again... And where we are met with cynicism and doubt and fear and those who tell us that we can't, we will respond with that timeless creed that sums up the spirit of the American people in three simple words—yes, we can![2]

Invoking an English translation of Chávez's rallying cry, Obama's "Yes, we can!" was a deliberate move to connect a historical moment of change with the hope of change for the future. Obama's adoption of the UFW slogan, heard across the nation for many months leading up to the presidential election, was a potent reminder that by contextualizing a historical reference, the energy and motivations of such a movement can be harnessed and repurposed for the present.

This is precisely what *Signs of Change* seeks to do: to make connections between historical and contemporary leftist social movements; to show a geographic, artistic, and ideological continuity; and to explore activism as concerned with global socio-political and environmental issues. *Signs of Change* emphasizes the fact that the spirit of activism did not die with the conclusion of the Vietnam War or the dismantling of South African Apartheid, but is alive and well; that the motivation to bring about social and political change is not limited to specific issues and actions, but based on a global culture of activism which spans continents; and that without a way to disseminate or broadcast information from within social movements, the impact of the message or the action would be lost.

Signs of Change illustrates that "Libertad," "Freiheit," and "Freedom" have the same meaning. It shows that Basque radicals, fighting their own war for independence from Spain, were in solidarity with the liberation movement in El Salvador; that students on both coasts of the United States were protesting the Vietnam War; and that feminist movements for women's rights and empowerment have thrived for the past forty years from Iowa to France to Iran to Germany. It makes clear that "Sí, se puede!" was a rousing rallying cry in 1972 and in 2008.

But perhaps more importantly, *Signs of Change* presents not just a recent history of social movements, but a collective history—*our* collective history—of individuals united to better the world in which we live.

Endnotes
1 See "Statement from Arturo S. Rodriguez, President, United Farm Workers of America, AFL-CIO," United Farm Workers, March 31, 1998, http://www.ufw.org/_board.php?mode=view&b_code=news_press&b_no=185&page=16&field=&key=&n=53 (June 6, 2009).
2 "Transcript: Barack Obama's South Carolina Primary Speech," *The New York Times*, January 26, 2008, http://www.nytimes.com/2008/01/26/us/politics/26text-obama.html?pagewanted=print (June 6, 2009).

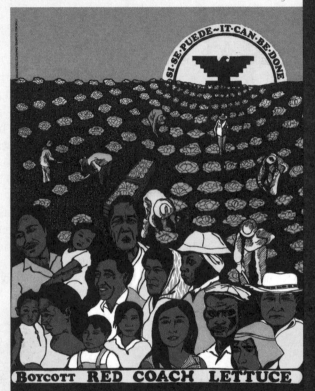

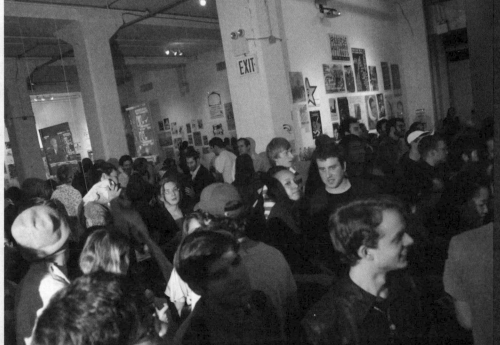

THE TIMES THEY ARE A-CHANGIN'

Mary Anne Staniszewski

The times are always changing, but sometimes change is faster, greater, we see it more. Now may be such a time.

Signs of Change: Social Movement Cultures 1960s to Now offers a chance to see what artists and activists have produced to help ignite progressive political and social transformation.

The show and catalogue are manifestos conjuring the possibilities of activist creativity. They are testaments to aesthetic efforts that are too often overlooked by mainstream art worlds. And if they truly succeed, *Signs of Change* will be an inspiration to those who hope and work for peace and justice in all their forms.

Exit Art was established to challenge "social, political, sexual, or aesthetic norms," expand the spectrum of whose artwork could be shown, and raise difficult questions of race, ethnicity, gender, and equality. For its twenty-fifth anniversary, founders Jeanette Ingberman and Papo Colo wanted to look to the future rather than celebrate the past. In keeping with Exit Art's mission to be a laboratory for cultural experimentation, we devised a "curatorial incubator" to give young curators opportunities to present exhibitions and programs.

Since the late 1990s, I had been seeing activists and artists thinking and working in exciting, new, and imaginative ways. I thought that Dara Greenwald and Josh MacPhee exemplified this spirit and could capture these changes and their histories in exhibition form. So we invited Josh and Dara to do a history of activist art, as an initiative of Exit Art's Curatorial Incubator program, and they focused the exhibition on "social movement cultures" (figs. 11, 14). The show continues the kind of engaged political programming that distinguishes Exit Art and offers an update to the 1996 *Counterculture: Alternative Information from the Underground Press to the Internet*, which included more than 2,000 newspapers, magazines, zines, posters, and websites that were brought together to examine the role of independent media in fostering social, cultural, and political change in the United States from 1965 to the present (figs. 8–9).[1] The *Signs of Change* installation, conceptualized by Colo with the installation of works overseen by MacPhee and Greenwald, was reminiscent of the design Colo produced for the *Counterculture* show. Both exhibitions had works high on the wall to evoke the way these posters and ephemera

would be seen in their original public settings, and both installations included tables on which materials were displayed.[2]

Although *Signs of Change* spans nearly fifty years, from the mythic 1960s to today, it was the changes I had witnessed during the past ten years that were the initial catalyst for the show. Activists are transforming the successes and failures of those who came before them: mixing traditional and new technologies, igniting almost instantaneous networks, linking heterogeneous causes, expanding the reach of human rights, and engendering new forms, such as smart mobs, sustainability projects, and tactical media. It seemed critical to capture not only this present, but also its past. These magnificent outpourings needed a chance to be appreciated, learned from, and remembered. This was all the more pressing given the fact that mainstream art worlds are often little more than über markets.

Dara and Josh structured the exhibition according to seven atypical themes: Struggles for the Land, Agitate! Educate! Organize!, All Forward to People's Power, Freedom and Independence Now, Let It All Hang Out, Reclaiming the Commons, and Globalization

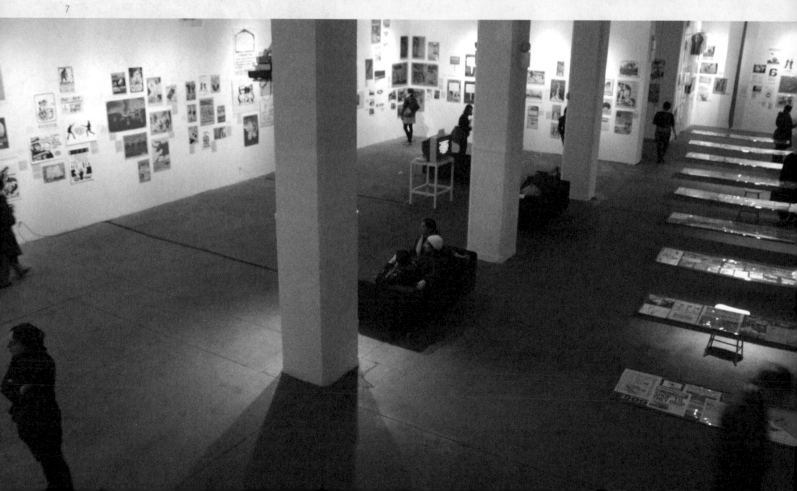

from Below. The social movements included in these thematic sections possess variations of certain important characteristics: imaginative creative strategies, integrated aesthetic production, progressive social agendas, alignment with leftist politics, collective and democratic working methods, and resourceful and/or cutting edge use of technologies. A large percentage of these movements also share an independence from traditional political parties and from working for reform within governmental structures of nation states.

Signs of Change features movements that are representative of an approach to social change that has been developing for decades, but now has become a more widespread phenomenon. In the late 1960s and early 1970s, activists' perspectives were, in general, "inter" "national," but today these views are significantly different in that they are "global." This change is clearly evident when comparing peace movements. In 1968, one of the prime goals of activists was to end the war in Vietnam. The world was then divided into the two Cold War spheres of the United States and the Soviet Union. Within the past decade, the predominance of this type of conventional modern warfare of state versus state has diminished and been altered. The Vietnam War was itself evidence of a failure—and a catalyst for the transformation—of that worldview. The vast majority of conflicts are now fought within states rather than between them.[3] For most of the decade, the principal war that peace activists have been trying to stop is the one on "Terror."[4] Named after an ever-present human emotion, the enemy is invisible, disseminated, and could be everywhere. The emergence of non-state actors taking on empires is just one illustration of similar types of transformations that have taken place in all areas of life.

In the late 1980s and early 1990s, this global process was enhanced with the cession of the Cold War. The dismantling of the Berlin Wall was a concrete symbol of all kinds of walls, borders, and boundaries that were being eroded and destroyed. What was an already weakened hierarchical, binary universe of the late sixties and early seventies had given way to a more dispersed, fluid, multivalent one. By the nineties, what was conventionally black or white, male or female, gay or straight, first world and third world was becoming multicultural, gendered, with a

spectrum of sexualities, and possessing degrees of development. The Internet became a grand metaphor for new realities that seemed to be everywhere and ever-changing. By the 2000s, borders of bodies, states, disciplines, genders, species, races, media, and all kinds of spheres of everyday life had become porous, integrated, networked, and in flux.

These reconfigurations wrought an increase in the strength, visibility, and populations of autonomous cells, non-governmental organizations, transnational entities, independent medias, and alternative networks. This became clearly visible in the web of direct action groups that converged in 1999 to protest the transnational World Trade Organization, which had been founded four years earlier. The character of this new global landscape is what makes the aesthetic and creative work of activists ever more present and powerful. Eloquently manifesting the "healthy" and just dimensions of these energies, strategies, and cartographies, these vibrant social movements have integrated creativity with politics and are representative of new types of organizations—and organisms— that are born of the necessities of our time.

* * *

Although *Signs of Change* includes the work of extremely diverse social movements, the selections can be seen as a constellation of glitteringly varied creations, issues, and groups that illuminate the following perspectives:

Aesthetics and creativity are not an add-on to political and social movements, but are integral forces within them. These works and actions are not merely illustrations of political activity, but *are* political activity.

The show entries represent not only revolutionary impulses, protests, and dissent, but also

the regeneration and integration of revitalizing and just alternatives into our everyday lives.

The curatorial intention is to make the *Signs of Change* geographically global. But this is very much a beginning, and there are no doubt huge gaps, missing nodes, and absent voices. The incompleteness of this picture is part of the mandate of the show to make visible and support progressive activists globally, particularly those in the more remote regions with less resources, and, most importantly, who are not as yet known to some of us. We hope our omissions will be addressed as part of the reactions to the show and will continue the process started by *Signs of Change*. But the overall agenda is to render a sense of the unstoppable production of politically-driven collective creativity that exists almost everywhere.

Creative adaptations of technologies and inventive strategies of all kinds are viewed as so original and appropriate that they possess the mark of art. These innovations and transformations are imaginative productions in their own right, engendered to fit the site, the cause, the moment, the limitations.

Rather than staging an exhibition of atomized individuals, groups, and events, *Signs of Change* was created from a sustainable worldview that envisions the linking of one cause to another and any person to all of us.

A non-hierarchical structure permeates the show, ranging from the value placed on all types of creative work to the make-up of the collectives. This approach eschews work produced under the auspices of a state or charismatic leader.

Signs of Change is a portrait of the left, but one of the late twentieth and early twenty-first century, where an individual's autonomy is

7. Installation view of *Signs of Change*, Exit Art, New York, NY, September 20–December 6, 2008.
8. Installation view of *Counterculture: Alternative Information from the Underground Press to the Internet*, Exit Art, New York, NY, February 24–April 20, 1996.

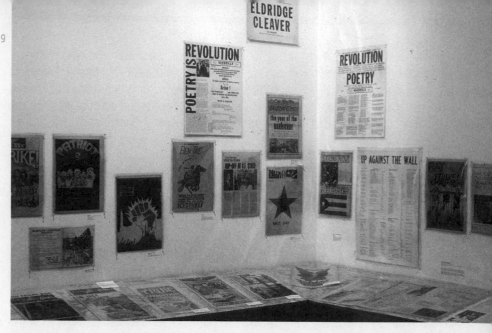

retained within ever-changing collectives that cluster and connect to engender networks.

The exhibition also maps a shift in vision for many of the left. Rather than looking toward centralized authorities and political parties, these activists mix an independence and sensitivity to local concerns and individual rights with global priorities. The groups whose activities and creations comprise the show are either aligned with or have some features that are representative of this perspective. George Katsiaficas has written extensively on this phenomenon and what are known as "autonomous social movements." His essay in this catalogue captures the character of these groups and the spirit of this change. It can also be read as a manifesto for those sudden popular upheavals and grassroots protests that transform repressive orders of the day, what Katsiaficas calls the "eros effect."

* * *

We hope the exhibition and its programs and catalogue are not only experiences viewed and observed, but are catalysts for future actions. To drive this message home, we incorporated as part of the show screen-printing workshops where visitors can learn to make graphics, posters, and even t-shirts.[5]

All works featured in *Signs of Change* are the passionate handiwork of activists. On display are not only artworks and activism, but also by-products of hope that the world can be a better place.

The past decade has been marked by a global war, a broad-based recognition of global warming, the spread of corporate globalization, and a backlash against advances in civil and human rights. Given the political climate in the

United States during the eclipse of the Bush regime, New York City in 2008 was the time and place to bring forth such efforts created in the name of peace, justice, egalitarianism, and healing for this planet and its people.

Endnotes

1 *Counterculture: Alternative Information from the Underground Press to the Internet* (February 24–April 20, 1996) was curated by Brian Wallis and Exit Art's former curator Melissa Rachleff Burtt, and Papo Colo designed the installation and poster.
2 In *Counterculture*, the materials were displayed on tables and shelves. In *Signs of Change*, tables were hung from the ceiling with wire, a design invention used in previous Exit Art shows. The shows differed in that films and videos were shown at screenings for *Counterculture*, whereas video monitors and projections presented films and video within the exhibition at *Signs of Change*, and there were screenings as well. In *Counterculture*, there was the relatively innovative, at that time, inclusion of a computer in the installation to access websites.
3 This change in traditional manifestations of war was featured in the 2001 Noble Peace Prize "Presentation Speech," given by chair of the Norwegian Nobel Committee, Gunnar Berge, Oslo, December 10, 2001, see Nobel.org, http://nobelprize.org/nobel_prizes/peace/laureates/2001/presentation-speech.html (July 7, 2008). See also Ekaterina Stepanova, "Trends in Armed Conflicts," *The Stockholm International Peace Research Institute*

(SIPRI) Yearbook 2008, Bates Gill et al., Stockholm International Peace Research Institute, summary available at: http://www.sipri.org/yearbook/2008/02 (September 30, 2009) and Dan Smith et al., *The State of War and Peace Atlas*, (Oslo: International Peace Research Institute), 1997, 1.
4 In March 2009, the Obama Administration began using the term "Overseas Contingency Operation" (OCO) instead of "Global War on Terror" (GWT), see for example, Scott Wilson and Al Kamen, "'Global War On Terror' Is Given New Name: Bush's Phrase Is Out Pentagon Says," *The Washington Post*, March 25, 2009, http://www.washingtonpost.com/wpdyn/content/article/2009/03/24/AR2009032402818.html (October 10, 2009) and United States of America Department of Defense, "National Defense Budget Estimates for FY 2010," United States of America Department of Defense, 2009, 6, http://www.defenselink.mil/comptroller/defbudget/fy2010/Green_Book_Final.pdf (October 10, 2009).
5 *Signs of Change* has traveled and will be traveling to venues other than Exit Art. At the original Exit Art exhibition there was a print workshop set up.

9. Installation view of *Counterculture: Alternative Information from the Underground Press to the Internet*, Exit Art.
10. Installation view of *Signs of Change*, Exit Art.
11. Dave "Buffalo" Greene, *Free Richard Mohawk/Paul Skyhorse*, offset lithograph poster, 1975, USA.
 Richard Mohawk and Paul Skyhorse were AIM leaders framed for a murder in 1974, and later acquitted.

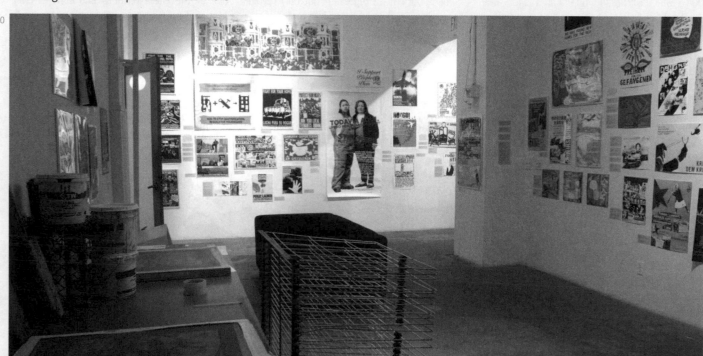

SOCIAL MOVEMENT CULTURES: AN INTRODUCTION

Dara Greenwald and Josh MacPhee

What you hold in your hands is a visual history of social movements from the 1960s to the late 2000s. The posters, flyers, photographs, and other ephemera in these pages were created by participants in the movements represented, often at the height of struggles and mass mobilizations. We've collected this material, first in an exhibition, and now as a book, in order to create a large-scale overview—the beginnings of a map—which illustrates how people have organized across the globe for liberation and equality. Each of these movements is one of thousands of points on this map. Even though there is not sufficient space here for an in-depth analysis of any one grouping, we felt it was more important to err on the side of breadth. We have visited many archives and collections, and with each visit, this project grew. We wanted to take these materials out of the drawers, closets, and basements and bring them back into the light. *Signs of Change* spotlights just some of the evidence of the decades of struggle, effort, and creative expression produced by movements organized to build a new and better world.

We are indebted to the committed people who have built the important collections at the Center for the Study of Political Graphics and the International Institute of Social History, where we began our research. We also depended on a vast network of individuals who have kept a few posters rolled up under their bed, or could tell us who had a copy of a protest video. The materials were borrowed from over eighty lenders. Many of the videos included in the exhibition hadn't been shown since the time of their production (see page 158 for a list of film and video that screened in *Signs of Change*). Our research was not just about movements and the culture they produce, but also about what happens to the works when a movement demobilizes. Who picks up the placards after the protest? Who stores them and catalogs them? Who makes them public again for research and understanding?

Signs of Change is intended to do many things: make visible histories of social movements, teach us about collective cultural production, challenge us to think more deeply about communicative activity in the public sphere, ask us what the role of aesthetics can be in the context of social struggles, and reveal innovative grassroots visions for new societies. There were over one thousand pieces in the *Signs of Change* exhibition, and there are over four hundred images in this book. They are from different movements spanning close to fifty years and across the globe, but presenting them together allows us to see the resonances and dissonances among struggles. We can catch a glimpse of some of the commonalities across the national, ethnic, and linguistic borders that many of the movements attempted to break down. Several key ideas related to the histories and objects represented here emerged as we organized this project: the importance of the historical and social context of each piece and movement, social movement as autonomous activity, the generation of alternative social formations, prefigurative politics, using and inventing new technologies, and the development of new conceptions of the artist.

HISTORICAL AND SOCIAL CONTEXT

All art develops within a social and historical context, but the work we are examining was created consciously as a means to participate in a struggle to change that context. The more we unearthed and studied these materials, the more important it became to distinguish between popular conceptions of *political art* and what we are calling *social movement culture*. Generally, the work collected in *Signs of Change* does not merely have political content, nor was it originally created for a gallery, or by an individual artist reflecting on their world. Rather, it was born from a context in which large numbers of people mobilized to achieve transformative goals. The individuals who comprise these struggles generate culture from a need to express, represent, and propose alternative ways of existing, both within the movements and to society at large.

Understanding the social and historical context of art and media production is important to comprehending both the works themselves and their relationship to the world in

which we live now. Some of the images and graphics in this book may look familiar because artists and advertisers have used them over the years (the bold silk-screened graphics of the 1968 student and worker revolt in France have been particularly popular, see pages 40–41). Rarely in those contexts is there an acknowledgment of the images' origins or an explanation of the movements that produced them. While researching, we have been shocked by how little we actually know about the struggles from which many iconic images emerged. At the same time, we discovered so many struggles we knew nothing about. The artifacts collected here are evidence of the existence of movements and deserve attention. Although we both were familiar with the American Indian Movement (AIM), posters produced by AIM and its supporters introduced us to many Native political prisoners we had previously never heard of (fig. 11). In this way, *Signs of Change* contextualizes familiar images and at the same time reveals little-known or under-represented histories.

With this in mind, we hope this book will act as a pedagogical tool. Hundreds of students have toured the exhibition. The posters

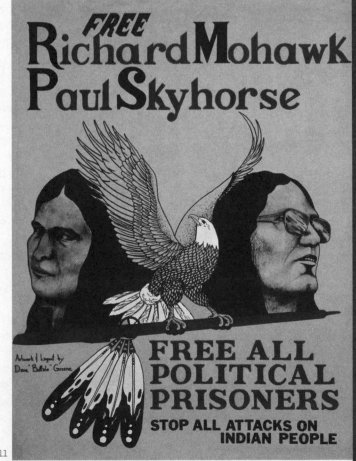

11

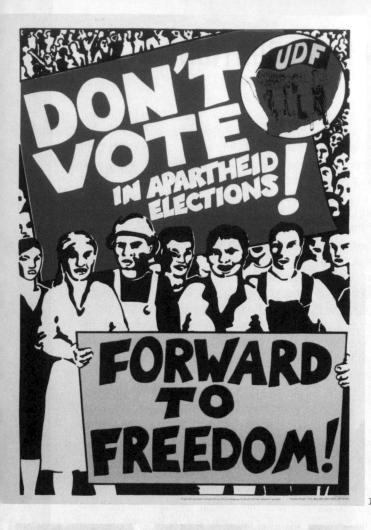

and videos introduced many viewers to certain histories and political ideas for the first time. For example, we were surprised by how few of the high school or undergraduate college students had been taught about apartheid in South Africa (see pages 88–91). We hope that students of all ages and educators of all types will use this book as a starting point for understanding social movements and their aesthetic histories.

AUTONOMOUS ACTIVITY

This book focuses almost exclusively on "autonomous social movements." These are movements that emerge from the 1960s onward that define themselves as separate from traditional modes of political organizing, such as social democratic electoral politics, authoritarian communist and socialist parties, or top-down and bureaucratic union structures. None of the work here was produced by governments, but instead was created by grassroots and bottom-up social organizations, collectives, and individuals. Although we were producing the exhibition during the US presidential election season of 2008, we decided not to include material related to voting and electoral politics. Voting is only one way to politically participate in a society; we wanted to show thousands of other ways that people have engaged since the 1960s.

Many of the movements and cultural expressions explored in *Signs of Change* have an overarching critique of several aspects of society; this complex critique is "radical" in the sense of attempting to get to the root of oppression and our current system of gross inequality. These movements do not simply want to replace one ineffective ruler with another, or one version of capitalism with a less virulent one, but to change the entire system, to build a completely different world and completely different way of life.

ALTERNATIVE SOCIAL FORMATIONS

The cultures that movements produce are created through a complex interplay amongst available resources, forms of expression and organization, and aesthetic decisions. In contrast to culture produced, preserved, and celebrated in the mainstream art world, many of the

posters, graphics, and videos we found were produced through collective processes with little concern for authorship. In addition, movement art production is often a synthesis of process and product, where the form of production must manifest the anti-authoritarian and anti-capitalist values of the movements; this is sometimes referred to as prefigurative politics. Feminist media collectives are good examples of enacting or prefiguring political values. The Chicago Women's Graphics Collective's process of poster production involved input from all members. This process is documented in the video the members produced entitled *It Can Be Done* (1973). This approach can be seen as a means to a means as well as a means to an end; the creative process of production contributes to the development of new social relationships among those involved, all the while potentially creating new cultural forms.

The culture of movements is not solely posters, media, or graphics. Its resonance can be found in the social formations movements create, such as public protests, demonstrations, encampments, affinity groups, collectives, and solidarities. At shorter-term demonstrations and longer-term encampments (tent villages set up at contestational sites, such as military bases, airports, or borders), concerns with many aspects of life, including food preparation, housing, group decision making, and visual production are influenced by egalitarian movement values. This can be seen particularly well in the peace encampments of the women's movement, such as the Greenham Common and Seneca Women's Peace Encampment (see page 127), that influenced the Climate and No Borders Camps (see pages 138–139, 156–157) of today.

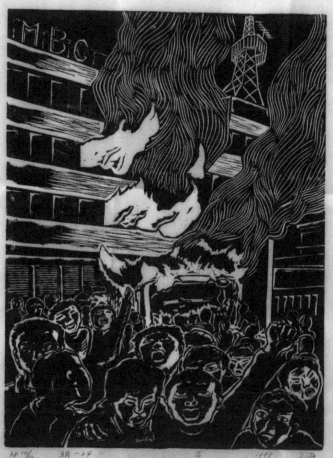

12. United Democratic Front (artist unknown), **Forward to Freedom**, offset lithograph poster, 1984, South Africa.
Originally designed and printed in South Africa, this poster was reprinted in the United States as a solidarity gesture with the anti-apartheid movement. In the 1980s, many South African posters were reprinted in the US and Europe to raise awareness and money for the movement.
13. Hong Sung Dam, **Gwangju Uprising**, wood block print, c. 1983–1989, South Korea.
14. Still from **Women's Lib Demonstration I** (1970, 05:00 minutes, Videofreex), USA.

UTOPIAN PROPOSALS

In order for groups of people to consciously change the world, part of their struggle must be envisioning and experimenting with what this new and changed world will look like. By imagining and practicing what could be, social movements often develop ideas and innovations about society that transform the status quo. Movement experiments and proposals, which at the time of their inception might seem absurd to outside observers, are often later adopted, in part or whole, and eventually are thought of as common sense. Early environmental activists who pushed for transforming our relationship to the earth's resources are now seeing many of their ideas widely practiced, including the growth of organic food production, recycling, and eliminating toxins in the environment. The women's liberation movement fundamentally transformed the status quo understanding of women's roles in society. Participants in the movement proposed, prefigured, and enacted different gender relations and roles, and now many related aspects of society have changed.

Unfortunately the more anti-capitalist aspects of these ideas are often lost in their shift from margin to center. In the mid-1960s in Amsterdam, Provo developed a series of proposals for better urban planning and existence, including the White Bicycle Plan (see pages 94–95), which proposed that thousands of free and unlocked white bikes be left around the city for everyone to share.[1] Today this strategy for convenient and accessible urban transportation has been adopted in a variety of municipalities by for-profit companies that rent fleets of tourist bicycles, which can only be released from their parking spaces by credit card. After Provo

dissolved in 1967, the Kabouters (literally translated as the Gnomes, or Gnome Party) formed; one of the initiatives they developed and put forward was a Green City Plan. They proposed to sink the roads and mandate gardens be created on top of all cars so that pedestrians walking city streets would only see green space passing them by.[2] The idea of the green city is now a mainstream concept, even if some of the more creative, anti-capitalist, and visionary ideas of earlier social movements that influenced today's green urban planning have been ignored.

COMMUNICATION AND TECHNOLOGY

All social struggles have had important relationships to the media of their day, from the newspapers of the radical labor movements at the turn of the twentieth century to today's use of the internet and mobile technologies. Mass communication technologies are important to movements for many reasons, including internal dialogue, getting movement messages out to wider audiences, and for alternative expressions. Social movement relationships to communication technologies and distribution systems can be parasitic, antagonistic, and/or productive, and most often are a combination of these strategies.

In the early 1960s, the Civil Rights Movement in the United States harnessed the power of the relatively new medium of television. Organizations like the Southern Christian Leadership Council (SCLC) and the Student Non-Violent Coordinating Committee (SNCC) made use of media spectacles by consciously organizing non-violent civil disobedience actions in locations with a media presence.[3] The mass distribution of images on

television and in print media of brutal confrontations by police acting out racist state and personal agendas helped the movement gain empathy and support throughout the world. These activists inserted themselves into, and took advantage of, the existing communication structures. As movements in the late 1960s attempted to build on the success of the Civil Rights Movement, they developed an increasing consciousness and critique of the uni-directionality of mainstream media. Movements could *become* the news story, but they could never *write* the news story. The decentralization of media, and the desire to learn the tools of media production, became a movement demand. Controlling a struggle's image and message became increasingly important and the relationship to media shifted to one of production, with movement actors making their own media and experimenting with their own distribution systems (fig. 14).

Other media strategies have included occupations of TV and radio stations by workers, students, and other groups in order to control the means of production and distribution of the story of a movement. During the Gwangju popular uprising in South Korea in 1980, participants occupied and attempted to use the government-controlled television station, but once they realized they couldn't figure out how to broadcast, the relationship quickly shifted from being parasitic to being antagonistic, and they burnt the station to the ground (fig. 13).[4] During the Oaxaca teachers' strike in 2006, participants in the movement occupied the local TV station and successfully broadcast from it. In addition, they also occupied radio stations and set up their own. This story is documented in

the movie *Un Poquito de Tanta Verdad/A Little Bit of So Much Truth* (fig. 16) which screened in *Signs of Change*.

Embodying a different form of media intervention, the French network Stop Pub organized groups of people to actively resist the increasing encroachment of corporate advertisements into daily life. In one such action in 2003, they armed multiple teams of activists with spraypaint, markers, stickers, rollers, and house paint, which they used to destroy hundreds of the advertisements in the Paris subway system in one night (see page 135).[5]

During the counter-globalization movement in the late 1990s, activists developed Indymedia (fig. 15), a public web interface where anyone could publish public reports. Using what they call a "democratic open-publishing system," Indymedia set off an explosion of citizen journalists and commentators, who often were reporting on the ground from inside the movements.[6] This predates the ubiquity of "Web 2.0" and what we now call "user-generated content." Even prior to this, in 1994, when the internet had only just begun to see widespread use, a group of indigenous campesinos and revolutionaries in rural Chiapas, Mexico, calling themselves the Zapatistas, began using the Internet to raise international awareness and solidarity with their movement. Some refer to the Zapatistas as the first post-modern social movement, where rural peasants use high tech communications systems for the instantaneous and global distribution of their ideas. The Zapatistas are an example of how movement actors are often quick to adopt new technologies and use them in ways that were perhaps not intended.

NEW SUBJECTS/NEW ARTISTS

Participation in the social movements we are examining produces new subjects, people who are capable of enacting history rather than simply having history happen to them. Part of becoming an agent of change develops from the sharing of skills among movement participants, which, in the case of art and media skills, gives expression to voices that may not have been public before. Out of both desire and necessity, people who previously did not consider themselves media or art producers emerge from struggles as artists, designers, and video makers—as well as organizers, communications specialists, public speakers, caretakers, carpenters, group facilitators, electricians, and dozens of other new identities. This process challenges the common notion of the individual artistic genius and creates more flexible definitions of who is or can be an artist.

Signs of Change is flush with examples of these new movement artists, from the women's liberation movement to the anti-apartheid struggle to the resistance to the Pinochet dictatorship in Chile. The Cape Town Community Arts Project and many similar popular silkscreen workshops in South Africa taught people with little or no art experience to produce effective posters for their unions, student groups, and women's organizations. Media and video access programs, which teach anyone who wants to learn how to make their own media, have sprung up in many movements, from Women's Liberation in the 1970s to the Zapatistas in the 1990s. In Chile during the dictatorship in the 1970s and 1980s, women with no formal art training began making *arpilleras* (see pages 82–83). *Arpilleras* are small hand-sewn pictorial pieces of fabric on which women represented the brutality of the Pinochet regime. Countering the repression of public expression in Chile during these years, a network supported by the left-wing Catholic Church set up craft workshops and then distributed these *arpilleras* internationally.[7] The movements we are looking at transform what it means to be an artist, as well as what participation in civil society can be.

ARCHIVES: OUR COLLECTIVE HISTORY
BELONGS IN THE COMMONS

What happens or should happen to all of the cultural material produced by social movements? There is no question that the majority of the material is created for specific uses, including education, communication, political expression, and/or creating visual spectacles at protests, rallies, and marches. Most of it is destroyed, but some of it ends up in the personal collections of participants and makers, other pieces are kept by

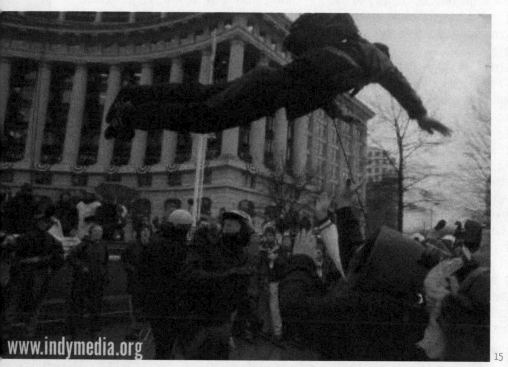

www.indymedia.org

15

16

people who want a reminder of history or are interested in aesthetics and design. Much of what is saved eventually ends up in archives, ranging from large personal collections, such as Michael Rossman's All of Us or None Archive in Berkeley, California, to institutions that developed directly out of specific social movements, such as the Lesbian Herstory Archive in Brooklyn, to giant art institutions and university libraries' special collections.[8]

Although often made anonymously or by groups working collectively, and created to be used openly, publicly, and for free, much of this work ends up being controlled by institutions, which have the resources to store it, but not the means or the will to make it truly public. The problem of storage and preservation creates complex issues in relation to copyright and ownership. Additionally, many institutions are not sympathetic either politically or aesthetically to the social movement material they own. One archive we visited at a major art museum contained a Post-It note in one of the drawers holding social movement posters, which said, "Not cool enough to catalog." Institutions like this one may have larger budgets than independent spaces, but the work remains uncataloged, sitting stagnant in flat files, because no one knows it's there.

Meanwhile, there are places like the Center for the Study of Political Graphics (CSPG) in Los Angeles, which exclusively focuses on the collecting and preserving of political posters and survives with minimal institutional funding. Not affiliated with any major educational or art institutions, CSPG has been able to collect over sixty thousand posters, the largest collection of post-war political posters in the US. With limited resources, they have done an impressive amount of work, cataloging fifteen thousand of these posters and preparing a searchable database they hope to make public.

We firmly believe the images and information collected in this book belong in the commons, where we can all share, value, and attempt to use them to understand our past. With the advancements in web technologies and digital data storage, we are at a point where we can envision a massive free and public archive, a wiki of social movement culture. But that is another project!

CONCLUSION

Moments of social upheaval generate large-scale aesthetic and creative outpourings. In location after location, intense eruptions of art production can be seen. In a short six weeks in France in 1968 during the student and worker revolt, the walls of Paris and other cities were covered with hundreds of thousands of slogans and posters. One group alone, the Atelier Populaire at Beaux-Arts, produced over 350 different poster designs and printed up to two thousand copies of each poster.[9] In Portugal during the brief three years of the Revolution of the Carnations, thousands of walls were painted with murals expressing the political beliefs and desires of the people making them (see pages 84–85). When portable video was first available in the late 1960s and early 1970s, video collectives formed and began documenting their actions and the events around them, producing thousands of tapes. In recent years, with wider access to the tools of digital media making, the amount of media and art produced by movement actors is overwhelming.

There is an incredible diversity and richness in the cultural material produced by social movements. We found very little overlap among the archives and personal collections we visited, and many of these contained thousands of items. Choosing an extremely small sampling of this material might have made for a very tight and easy to digest exhibit and catalog, but we feel that the sheer volume of work produced is as important as any one particular piece. We hope to have documented not just individuals creating things, but networks of people in connection to each other, merging their collective ideas and skills toward something exciting and new. In many ways Signs of Change is itself a conceptual project, attempting to convey the dizzying array of what movements produce.

That said, we are not suggesting that all of these materials are equally effective or even capable of succeeding at accomplishing the changes their creators aspired to. Although some important changes have occurred due to the work of these movements, injustice remains, including the grossly unequal distribution of wealth. As people engaged with questions of culture and social change, we want to know what the successes and failures of this type of work have been, so that this history can inform the work we do now. We turned a spotlight on social movement culture, and now we can collectively begin a more in-depth analysis. We hope this next step will be taken by many. Each piece included here, as well as each movement, deserves more attention: politically, historically, and aesthetically—let us continue the journey together.

Endnotes
1 Richard Kempton, Provo: Amsterdam's Anarchist Revolt (Brooklyn: Autonomedia, 2007), 71.
2 Ibid, 132–135
3 Steven Kasher, The Civil Rights Movement: A Photographic History, 1954–1968 (New York: Abbeville Press, 2006), http://www.stevenkasher.com/html/exhibinfo.asp?exnum=297 (October 4, 2009).
4 Todd Tevares, "Kwangju Against the State 1980," Paper delivered at Renewing the Anarchist Tradition Conference (Montpelier, VT), November 9, 2008.
5 Lothar Blissant, Do-It-Yourself Geopolitics: Cartographies of Art in the World, http://www.journalofaestheticsandprotest.org/webonly/Holmes.htm (May 20, 2009).
6 Indymedia, "About Indymedia," http://www.indymedia.org/en/static/about.shtml (May 25, 2009).
7 Jacqueline Adams, "Art in Social Movements: Shantytown Women's Protest in Pinochet's Chile," Sociological Forum, Vol 17, No 1 (March 2002): 29.
8 We visited Michael Rossman (1939–2008) at his collection and borrowed several pieces from it for the exhibit. Sadly, he passed away before the show opened.
9 Rebecca DeRoo, The Museum Establishment and Contemporary Art: the Politics of Artistic Display in France After 1968 (New York: Cambridge University Press, 2006): 48.

15. Indymedia (artist unknown), **Indymedia**, sticker, 2000, USA.
16. Promotional image from the video **Un Poquito de Tanta Verdad/A Little Bit of So Much Truth** (2007, 93:00 minutes, produced by Corrugated Films in collaboration with Mal de Ojo), Mexico and USA, photograph by Pablo Specas Castells.
17. Lincoln Cushing, **Michael Rossman (RIP, 1940–2008) sharing his All of Us or None Poster Archive**, photographic documentation, 2002, USA.

READING SIGNS OF CHANGE

George Katsiaficas

In the last half of the twentieth century, political movements exploded in a million different directions, offering at first glance what might seem like a bewildering array of actions. From peace to black power, gay activism to student and worker strikes, and feminism to liberation from car culture, activists themselves chose new terrains for resisting established forms of power. As they changed their lives to focus attention on previously unacknowledged issues, they created poignant images to facilitate their struggles.

"The people make history," little more than an empty rhetorical device in the mouths of politicians and pundits, comes alive in the art of *Signs of Change*. A wide variety of forms of representation, media used, and political foci is evident. The inner tension among these differences, far from being reflective of the global movement's weakness, shows its diversity, its vibrant inner dialectic of development, differentiation, and progression. Without the free expression of divergent viewpoints, no movement can claim to reflect a truly popular impetus.

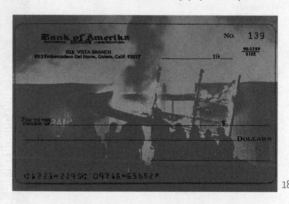

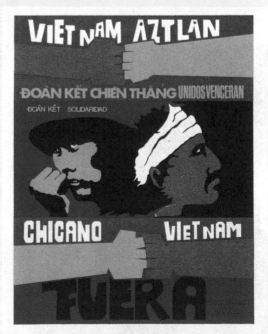

Are there universal dimensions to what appear to be contradictory and sometimes even conflictual issues and tactics? Is there a unifying grammar of liberation that clusters these many aspects of struggle within an overriding logic? Or has the "postmodern turn" doomed insurgency to fragmentation, isolation, and an inability to challenge the system as a whole?

By creatively assembling fragments of the movement's history, *Signs of Change* gives us the means to comprehend the movement's universal meaning and its logical structure. The cultural artifacts in this collection may seem juxtaposed across unbridgeable divides of continents and time, but they nonetheless share qualities forged by people as they fight for lives worth living. In each struggle represented here, direct-democratic forms of decision-making and militant popular resistance are intimately woven together. People's self-organization is contained within a grammar of autonomy, decommodification, and solidarity (which I call the "eros effect").[1]

The "eros effect" refers to moments of suddenly popular social upheavals that dramatically transform established social orders. When people identify with insurgent movements and massively rise up, the basic assumptions of a society—patriotic nationalism and the authority of the government, hierarchy, the division of labor, and specialization—vanish overnight. During moments of the eros effect, popular movements not only imagine a new way of life and a different social reality, but millions of people live according to transformed norms, values, and beliefs. The conscious spontaneity of self-directed actions of hundreds of thousands of people—sometimes millions—who come together in beloved communities of struggle is a new tool in the struggle for freedom.

In the twenty-first century, human beings continually demonstrate a capacity to govern themselves without the "help" of politicians and leaders. Indeed, ordinary people today consistently show a far greater intelligence than economic elites or political leaders. In the 1960s, social movements provide astonishing evidence of the creation of participatory forms of popular power that contest the established system in favor of more freedom. In May 1968 in France, the entire country convulsed in near-revolution as organs of self-government sprang up everywhere from the grassroots. Two years later in the United States, four million students and half-a-million faculty declared a nationwide strike in May 1970 in response to the killings at Kent State and Jackson State Universities, the invasion of Cambodia, and the repression of the Black Panther Party. Once again, no central organization brought together this strike—the largest in US history. Despite the absence of centralized organization (or should I say because of it?), people were able to formulate unified national demands around *political* issues (not simply problems like tuition increases or demands for higher wages) and to question the structure of the militaristic system that compelled universities to be part of weapons research and development. Although the movement fell short of its long-term goals, it provoked numerous political reforms and thoroughly transformed civil society.

In almost every country in the world, insurgent social movements intimately related to each other emerged in 1968. From Japan to Senegal, as in dozens of other countries, militant students were at the cutting edge, often detonating massive social explosions. In Mexico, hundreds were killed protesting the coming Olympics.[2] When the Czechoslovakian experiment of "socialism with a human face" was brought to an early end by half-a-million invading Soviets, people in Prague took down street signs and buildings identification markers. It took the Russian Army a week to find the post office.[3] In France, the May 1968 general strike of ten million workers was sparked by student protests. When the Communist-dominated trade unions negotiated a settlement calling for higher wages with the government, thousands of workers threw bottles and lunches at their union leaders, and booed them off the stage. Around the country, workers rejected the Communists' settlement. They wanted new kinds of lives—self-management and an end to drudgery, not better pay for enduring stultifying assembly lines and offices for the majority of their lives. Opposing capitalism and Soviet-style Communism because neither kind of society was free, these movements became known as "New Left" to distinguish them from their Communist—or "Old Left"—predecessors (or, as some insisted, nemesis).

The eros effect that erupted in 1968 transformed millions of people. The US

18

women's liberation movement gained momentum throughout the 1960s, with 1968 being the year of protests at the Atlantic City Miss America competition. Women's consciousness-raising groups had been forming among networks of friends throughout these years, and by 1970, there were over two hundred such groups in New York City alone.[4] Feminism rapidly became an international movement and continues to transform people's everyday lives.

The US New Left reached its high point in a remarkable five-month upsurge from May to September 1970. The movement produced the political strike of millions on campuses, the National Organization for Women's call for a general strike of women (and the design of the modern symbol for feminism), the eruption of Vietnam veterans, the first Gay Pride week, and the Chicano Moratorium. As the entire society was disquieted, Puerto Ricans, Native Americans, and a rainbow of constituencies flocked to Philadelphia in answer to the Black Panther Party's call to write a new constitution for the US. More than ten thousand people attended this Revolutionary People's Constitutional Convention and agreed that it made sense to replace the nation's standing army and police forces with popular militias and community groups and to redistribute the world's wealth.[5]

While that particular phase of our movement's buildup was torn apart by government repression and internal divisions, today, more than at any point in the 1960s, activists continue the quest to empower new forms of governance that work to enhance all forms of life, including that of planet Earth. Larzac, France, where some of the world's finest Roquefort cheese is produced, became one focal point for ecological sensibility. While farmer José Bove's attack on McDonald's in 1999 resonated around the world, the sheep from Larzac spoke most eloquently in the 1970s when they were brought to Paris for a protest against the government's plan to use some of the region's deep canyons for nuclear tests. The sheep grazed peacefully along the banks of the Seine except for one small detail: they refused to drink both the river water and Parisian tap water—a scandal of no small proportions. Water was eventually trucked in from Larzac amidst popular sentiment that the sheep showed more common sense than France's political elite.

The global wave of movements in the later half of the twentieth century is united by forms of direct democracy present in all of them—from Rosa Parks and the struggle to desegregate buses in Montgomery; to the student movements in dozens of countries; to the international counterculture embracing Christiania's communards in Copenhagen, San Francisco's Diggers, Amsterdam's Provos and Kabouters, and Berkeley's partisans of People's Park; to the Black Panther Party's Revolutionary People's Constitutional Convention; to the 1980 Gwangju uprising in South Korea; and to the Seattle protests against the World Trade Organization (WTO) in 1999. In all of the above struggles, networks for direct action based upon strict principles of participatory democracy were organized.

The erotic energies unleashed by these movements tie people together in intimate ways with more force than years of sharing jobs, taking the same classes, or living in the same apartment buildings are often able to do. Impulses to return to the land, to live in communities based on love and respect for one another, and to observe basic notions of peace and justice cannot be controlled by any elite. "Smart mobs" (crowds whose members communicate with each other) in today's protests formulate direct actions, as people increasingly use their own intelligence and personal technologies, like text messaging, to decide when and where to act, and at which targets to aim. In Seattle in 1999, some people advocated strictly constructed pacifism and condemned property destruction, while others attacked symbols of corporate power like McDonald's and Niketown in actions they felt decolonized corporate control of public space.

The art in *Signs of Change* was produced when activists chose to initiate changes in arenas they regarded as significant and problematic. The connective threads running through grassroots movements weave together innumerable strands of what might seem like very different struggles. In the 1970s, the most spectacular of dozens of autonomous groups that constituted Italian Autonomia were the Metropolitan Indians, who adopted the paint and attire of Native Americans. Like US Yippies or Dutch Provos before them, these working-class youth committed to liberation from daily drudgery and boredom, proudly embraced the aura of the "other" because they considered themselves marginalized outsiders. Like Black Panthers, they defended themselves with guns, and they never lost their sense of humor. Their 1977 manifesto included:

* Free marijuana, hash, LSD, and peyote for anybody who wanted to use them.
* Destruction of zoos and the rights of all animals in the zoos to return to their native lands and habitats.
* Destruction of the Altar of the Fatherland, a memorial sacred to fascists in Rome.
* Destruction of all youth jails.
* All empty buildings to be used as sites to establish alternatives to the family.
* Historical and moral revaluation of the dinosaur Archaeopteryx, unfairly constructed as an ogre.

At the Black Panther Party's Revolutionary People's Constitutional Convention in 1970, the same drugs beloved by Italy's Indians had been named "life drugs," as opposed to death drugs, like cocaine, speed, and heroin. In Denmark twenty years later, Christiania's communards erected signs prohibiting these

18. Metamorphosis, **Bank of America**, offset lithograph poster, 1970, USA.

In February 1970, students at the University of California Santa Barbara, angered by the Vietnam War, the firing of a professor, and police brutality, rioted and burned down a Bank of America after police wrongfully arrested a student.

19. Malaquías Montoya, **Vietnam Aztlan, Chicano Vietnam**, offset lithograph poster, 1972, USA.

20. Artist unknown, **Poster from the August 8th Uprising**, hand painted poster, 1988, Burma.

21. Christiania (artist unknown), **Hvad Sejrede? [What Victory?]**, offset lithograph poster, c. 1980s, Denmark.

20

HVAD SEJREDE?

same death drugs from their community, while simultaneously permitting the open sale of marijuana and hash. The Panthers, Metropolitan Indians, and Christiania were all dealing with a massive flood of heroin coming in part from US involvement in Southeast Asia, a problem that tied the communities together across continents. No formal means of communication united these three communities of struggle; rather, the eros effect of intuition and love made the same conclusion flow naturally from people's hearts.

The Metropolitan Indians stormed a jazz festival in Umbria, and then offered their critique: it "serves up a spectacle just like the ritualized demos and rallies serve up politics as spectacle. In both cases, we're reduced from a public to spectators."[6] Groups of young Italians began to do the same thing in movie theaters. Entering in groups of forty or more people, they would simply refuse to pay or pay what they felt was reasonable. These were not "spoiled children of the rich," as film director Bernardo Bertolucci referred to militant students of 1968 before he caricatured them in his film, *The Dreamers*. The Metropolitan Indians carried irony and paradox to their political limits, even in circumstances that would have been taken seriously by most people. By putting play and joy at the center of political projects that are traditionally conducted in a deadly serious manner, they did to Italian cities what Dada had done to the European art world at the beginning of the twentieth century. Dada's anti-art scandalized the world of galleries and parodied the seriousness of

artists, and the counterculture's anti-politics broke with traditional conceptions of political conduct and revealed a wide gulf between themselves and previous generations.

Continuing in the New Left tradition of directly changing everyday life, the autonomous movement (or Autonomen) in Germany, was galvanized in the crucible of militant struggles against nuclear power in the 1970s, the broad-based peace movement, German feminism, and squatters in hundreds of occupied buildings. Unlike other groups from the period, this movement has sustained itself over several generations of activists. Allied with farmers and ecologists (as in the Larzac struggle), the Autonomen successfully played a big role in stopping the German nuclear power industry's attempt to produce bomb-grade uranium. As they developed through militant actions, the Autonomen became a force resisting the corporate system *as a whole*. In 1988, more than a decade before the Seattle protests against the WTO, tens of thousands of people in Berlin confronted a global gathering of the most powerful wizards of high finance to demand global economic justice, and they compelled the world's bankers to adjourn hastily a day earlier than planned.[7]

Unlike Social Democracy, anarchism, and Leninism, which are the main currents of the twentieth-century left, autonomous social movements are relatively unencumbered by ideology. The absence of any central organization dictating actions helps keep theory and practice in continual interplay. As one small group acts, another is inspired to rise up, and

they, in turn, galvanize yet others. This chain reaction of social insurgency, a process I understand as essential to the eros effect, leads to the emergence of social movements capable of transforming civil society.

A brutal resurgence of German racism appeared after the fall of the Berlin Wall. As racist attacks on immigrant African and Vietnamese workers in the eastern part of the country intensified, the autonomist movement redirected its energies to confront neo-Nazi groups. Autonomen formed at least four different anti-fascist publications that provided quality exposés of the New Right, and closed down Nazi demonstrations permitted by the police. These anti-fascist groups, or Antifa as they became known, were able to mobilize hundreds of people to stop racist pogroms in Hoyerswerde and Rostock. While the police stood by when racist mobs attacked immigrants, the Antifa fighters arrived to save the innocents. Only then did police finally act—but they arrested the anti-fascists, not the racists.[8]

Autonomous activists seek to live according to a new set of norms and values within which everyday life and all of civil society can be transformed. They want to transform isolated individuals into members of collectives within which egalitarian relationships can be created. These relationships are intended to subvert the traditional parent-child, husband-wife patterns that characterize patriarchal lifestyles. In place of the hierarchies of traditional political relationships (order-givers/order-takers, leaders/followers, media stars/media consumers), they strive for political interactions in which these roles are subverted. At their high point in the 1980s, their collective forms negated atomization; their activism transformed the passivity of consumerist spectacle—thereby negating the reification and standardization of mass society; their self-determination contrasts sharply with the all too prevalent alienation produced by hierarchies of power.

In the struggle to create new human beings fit for freedom, political movements play paramount roles. Although many believe that participatory democracy is the province of only brief periods of time, what you see in *Signs of Change* is proof to the contrary. These creations of liberated collectives emanate from forms of participatory democracy at multiple points in time and geography. Humanity's history encompasses thousands of years, and there have always been societies that lived communally and enjoyed our planet's resources and wealth. Today politicians have made militarized nation-states their provinces

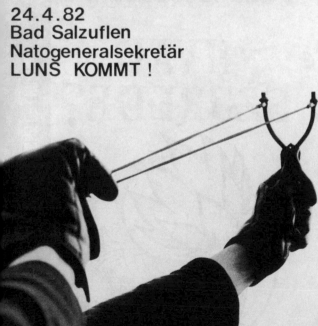

24.4.82
Bad Salzuflen
Natogeneralsekretär
LUNS KOMMT !

KRIEG
DEM KRIEG

of power, and billionaires have appropriated as their private property the collective legacy of generations of workers whose sweat, blood, and tears produced our cities, canals, irrigable lands, seed stocks, and all our wealth.

Humanity's creative energies and our un-ending need for freedom, graphically arrayed in these works of protest art, constitute the planet's most powerful natural resource. Billions of dollars of advertising seeks to chan-nel our life-forces into consumerism. Constant messages of fear discipline us to accept wars as necessary (or sometimes "humanitarian"). By way of contrast, the calls to action in *Signs of Change* seek to put equality, autonomy, and love at the center, not hate and fear; they re-mind us that human beings remain capable of changing the political and economic struc-tures that condemn billions to a living hell at the periphery of the world system, and mil-lions more to lives of drudgery at the core of the capitalist system.

Like the art you see in this exhibition, po-litical movements have gone far beyond the era of individual ownership and authorship. What we are witnessing is nothing short of human beings emerging as subjects of collec-tive liberation. In the cultivation of agriculture, no one person can claim corn's bountiful har-vest as their invention; similarly no one artist claims this show as their private inspiration or production. Does this mean the individual is lost in the shuffle of collective creation? If one means the single person as ego, then per-haps the answer is affirmative. But if, on the other hand, we mean the individual as proud creator of an imaginary world that inspires us to move beyond the wretched conditions of the present, then clearly we are talking about the free compositions of liberated individuals (rather than the tight formalism of egocentric "bourgeois" individuals). In contrast to nearly all other exhibitions in recent memory, the near-absence of individual signatures in these works of art is part of the process of rescuing art from commodification and of resituating the life-force in its proper place at the center of our own communal productions.

Does this mean art's capacity to imagine a better life, to expand the domain of our senses and imagination, needs to be constrained to politics? To do so fails to understand creativ-ity's own subversive power, and art's capacity to dream another reality. Art's great promise is by no means contained in the mold of politics, yet without art's graceful enunciation of our innermost desires and needs, politics is woe-fully impoverished and suffocatingly rational.

Forms of direct de-mocracy and collective action developed by the New Left continue to define movement aspi-rations and structures. This is precisely why the New Left was a world-historical movement. In Gwangju, South Korea in 1980, people refused to accept a new military dictator and stayed in the streets for democra-cy. When the army bru-tally attacked the city, outraged citizens beat back a vicious military assault and held their liberated city for a week, using general assem-blies and direct democ-racy to run their com-mune. Within a dozen years, a chain reaction of uprisings swept East Asia—the Philippines in 1986, Korea and Taiwan in 1987, Burma in 1988, Tibet and China in 1989, Nepal and Bangladesh in 1990, and Thailand in 1992. Unlike the upris-ings in East Europe in this same period, the eros effect in East Asia was not precipitated by leaders at the highest levels of government seeking to shift power blocs, but by the accu-mulation of experience and desire for freedom in the hearts and minds of millions of people.

Almost without ex-ception, revolutionary social movements in the twentieth century prior to the New Left sought simply to conquer national political power—either to take it over through elec-tions or overthrow it through violence. The goal of autonomous movements is to tran-scend nation-states, not capture them. The great refusal articulated in the Greek poster's OXI ("NO") speaks to such intuition. Even when inarticulate, our intuition, like our love and solidarity, defies the Old Left's stodgy

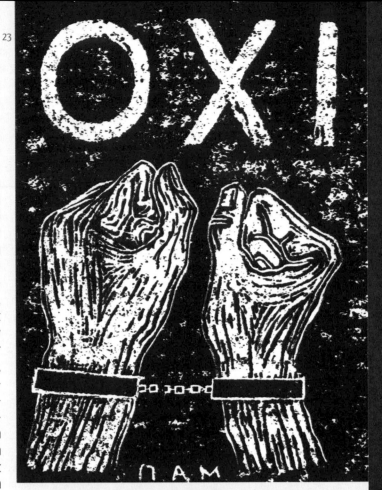

22. Artist unknown, **Krieg Dem Krieg [War Against War]**, offset lithograph poster, 1982, Germany.

A poster for an anti-NATO action. The slingshot became common in the autonomous movement in the 1980s, used by Autonomen in battles at Startbahn West, nuclear power plants, and attempted squat evictions.

23. Artist unknown, **OXI [NO]**, relief print, 1969, Greece.

In 1967, a US-supported, right-wing military government took control of Greece. Many groups, both in exile and in Greece, organized to oppose this Junta.

24. Still from **The Land Belongs to Those Who Work It/La tierra es de quien la trabaja** (2005, 15:00 minutes, Chiapas Media Project, in Spanish and Tzeltal with English subtitles), Mexico.

rationality while simultaneously challenging the existing powers-that-be.

In the twenty-first century, as society's velocity of change accelerates, so too must our movement's capacity to adapt to changing circumstances. In the absence of the capability to innovate tactics and targets, revolutions atrophy, or even turn into their opposite (as happened in both the US and the USSR). Alongside participatory currents, the history of social movements is also the history of popular insurgencies being placated, accommodated, and sold out by parties and organizations of all kinds—whether they are French or Italian Communists, Czech or Bangladeshi democrats, or Korean or US trade unions. Ritualized protests organized by top-down groups with leaders whose faces do not change no longer suffice to bring the "masses" into the streets. Apparently, entrenched elites, like Leninist-style parties, are no longer needed to transcend the reformism of spontaneously formed movements, since these movements are themselves capable of developing a universal critique and autonomous capacities for self-government.

Betrayals within the movement (or "psychic Thermidors" as Herbert Marcuse named this phenomenon) internally sap the strength that we so badly need to defend ourselves from right-wing physical assaults (to say nothing of the incessant corporate consumer onslaught). In Chile, democratically-elected President Salvador Allende was killed in a 1973 *coup d'etat* orchestrated by US officials that brought fascist dictator Augusto Pinochet to power for seventeen years. In Nicaragua, the Sandinistas came to power in 1979, only to face the reduction of their lands to absolute poverty by a US war against them.

Even great victories won, like the breakthrough of Vietnam's national liberation struggle, become subverted by the limitations of isolated political autonomy in a sea of global capitalism. The global anti-apartheid struggle brought Nelson Mandela out of decades of imprisonment on Robbin Island and into the highest seat of power in the South Africa, but the African National Congress was still compelled to implement neoliberal economic policies that continue to plague the poor. Similarly, East Asian uprisings against dictatorships, even when they included significant forces against capitalism, enabled the International Monetary Fund (IMF) and World Bank to broaden their markets. In democratic South Korea, the Philippines, and elsewhere, newly-elected administrations implemented

neoliberal programs that permitted foreign investors to penetrate previously closed markets and to discipline workforces of millions of people in order to extract greater profits.

Compared to dictatorships, democratic governments, like countercultural spaces, *also* contain greater freedoms and new opportunities for subaltern groups—women, workers, minorities, gays, and youth. Clearly, the victories in achieving democracy in Korea, ending apartheid in South Africa, mitigating US racism and sexism, and promoting expanded rights for subaltern people can't be taken as end goals, but as the staging grounds for better lives as well as for future struggles.

Attacks on the poor constitute an essential component of the capitalist system. The residents of the International Hotel, a San Francisco haven for Filipino seniors on limited incomes, were evicted after a long struggle against gentrification. The US prison-industrial complex has expanded to the point where now more than two million people—most of them poor or people of color—languish in prisons and jails. And yet, despite all the horror and injustice, resistance blossoms again and again. In the 1980s when the AIDS epidemic began taking lives and there was no governmental response, those affected formed ACT UP to bring attention and resources to the problem.

The 1999 protests in Seattle broke new ground when Teamsters and Turtles, workers and ecologists, Lesbian Avengers and Zapatista partisans all converged for unified action. The world-wide synchronicity of protests that day involved actions in dozens of other cities around the world. Precursors to Seattle exist in victorious confrontations of attempted imposition of the corporate behemoth's domination in Caracas (1987), Berlin

(1988), and Seoul (1997). After Seattle, as the giants of industry and high finance took aim on millions more workers and their consumer counterparts, people in places such as Cochabamba, Bolivia (2000) and Arequipa, Peru (2002) fought back against attempted privatization of communal natural resources and won significant victories.

While political leadership based upon authoritarian models of organization have withered among freedom-loving movements, the power of example remains instructive and potent—especially when its promulgators are among the poorest inhabitants of a world capable of providing plenty for all. Nation states and corporations' quest for global domination and the destruction of indigenous cultures and local autonomy finds its most articulate negation in the Zapatista movement for dignity for the peoples of Chiapas, Mexico. What began as an insurrection on the same day that the North American Free Trade Agreement (NAFTA) went into effect has turned into a world-wide focal point for grassroots actions against neoliberal capitalism's systematic injustices—its perpetuation of billionaires' wealth alongside hundreds of millions of starving human beings. Zapatista *encuentros* (international gatherings of activists) in the jungle were instrumental in preparing the ground of the now mythologized protests against the WTO in Seattle. In Europe, they helped inspire the actions of Reclaim the Streets, Carnival Against Capitalism, and EuroMayday.

Around the world, grassroots movements against corporate capitalism have emerged, confronting elite summits and making demands to cancel the national debt of the world's poorest countries. Made famous by celebrities like Bono, the struggle against world starvation and human misery will, unfortunately, one

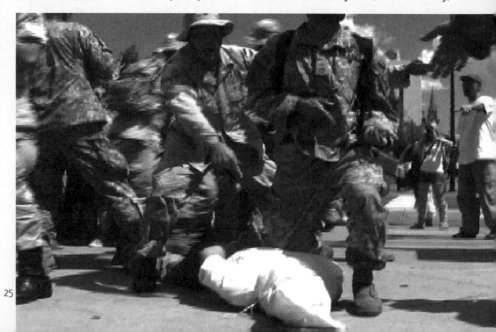

day need to remind Bono that his brotherhood with World Bank presidents Wolfensohn and Wolfowitz failed to end hunger. In the future, when we observe continuing human misery and ecological devastation, humanity's wisdom will be enriched by the insight that it is the system that is the problem. Bono is attempting to work with a failed system, and it is the system itself that must go.

The twentieth century will be remembered for its horrific wars and mass starvation amid great prosperity. As this exhibit illustrates for us, it will also be known as a time when human beings sought to overturn the self-serving decisions of politicians and corporate executives and when we moved directly to meet our own needs. With the ghost bikes showing up across the US (bikes painted white, chained to street signs at crash sites, in memoriam to those injured or killed), we see precisely a human response to unsustainable urban planning. The wisdom of city bureaucrats, corporate CEOs, and politicians in Washington, DC have seldom brought us anything but more highways, more cars, and more deadly fumes. Those who brave the urban landscape by riding bicycles risk death while Hummers and SUVs are celebrated consumer goods. In a society where forgetfulness is the watchword of conformity, where grabbing all the gusto today means forgetting yesterday, these ghost bikes serve as a reminder of the lives and life-force lost to the logic of corporate culture.

Alternative models for social organization are evident throughout *Signs of Change*. In December 2001, the people of Argentina provided us with an example of how we can change the world. Refusing to submit to IMF/World Bank impoverishment, they mobilized to sweep out collaborationist politicians. Workers took over factories, hotels, and offices and ran them more productively than capitalists were able to do. Argentina's people showed the world their spontaneous refusal to allow their labor and wealth to enrich those who were strangling their livelihood. In Oaxaca, Mexico in 2006, a teachers' strike, demanding such outrageous items as shoes for their pupils, drew the entire city into its epicenter, and with other organized grassroots elements formed Popular Assembly of the Peoples of Oaxaca (APPO). The mobilized citizens fought a courageous battle for control of their city; as the struggle matured, they declared APPO the de facto governing authority. A popular, participatory council became the city's government for months. Despite what has become a bitter struggle marked by physical attacks and

eviction by thousands of police, APPO continues to organize.

The movement artifacts in *Signs of Change* would have been impossible to conceive and create without the safe haven of refuge offered by ateliers, garages, and living room tables. While they may seem marginalized and insignificant, these spaces can be incredibly significant facilitators of our capacity to envision our lives in terms that are not geared solely to subsistence. In such free spaces, people can experience, however temporarily, a break from the sometimes overwhelmingly incessant imposition of capitalist logic.

Free spaces are essential to people's movements building momentum. In parts of the world where people have these spaces, their everyday lives are profoundly different than the ones lived in the hierarchical, competitive, and patriotic spaces of the dominant culture. I think that it's in those areas that the movement can begin to fight the status quo. There, people can experiment with new social forms and create visionary new programs while organizing against wars and other atrocities. Because of this, we can't understand them just as "countercultural spaces" in the way that term gets used by the mainstream or by sociologists. At their best, they are spaces for the cultivation of the desire to live more fulfilling lives. Because experiences of direct democracy and unfettered creativity flow from our infinite need for freedom, they tend to ripple outward and have influence far beyond the immediate contexts from which they arise. Governments recognize the threat posed by these spaces. That explains why Christiania suffers continual threats from police invasions, and why Ungdomshuset, a Copenhagen youth movement center that existed for decades, was violently evicted on March 1, 2007.

We know from the history of the left how the system uses a dual strategy of repression and recuperation against social movements. It encroaches upon the free spaces we create and uses them to make profit. As the greatest natural resources on the planet, creativity and the human need for freedom are tremendously seductive to capital. Soon after the Black Panthers popularized the slogan, "Right On!" Parker Brothers brought out an advertisement singing "Write on brothers, write on!" to sell their pens, and president Richard Nixon uttered, "All Power to the People!" in a 1972 radio address.[9] So long as the world system retains its institutions of power, our free spaces and ideas will continually be appropriated by the capitalist logic of hierarchy,

competition, and commodification—the main form of capitalism's transformation of life into dead labor, into objects that can be bought and sold. Even Dada, the great movement against art's commodification, had its remnants auctioned off in 1968.

Signs of Change has assembled action-art that is not simply about our past—it concerns our future. Far from being muffled, cries for change are daily amplified. Largely invisible on CNN and media except for occasional sound bites, million of activists around the world work incessantly for peace and justice. Without central organization, some thirty million people in dozens of countries took to the streets on February 15, 2003 to protest the second US war on Iraq, even though it had not yet started. With the construction of a transnational civil society unanchored in any state or political party, a new world becomes visible. While now seemingly marginalized, the global movement today involves more activists than at any other point in our species' historical evolution. As we become increasingly aware of our own power and strategic capacities, our future impact can become more focused and synchronized. As the multitude of humanity animates our own dynamic, the tendency we can project into the future is for the activation of a global eros effect, in which synchronous actions erupt and unify people across the world.

Endnotes
1 Autonomous movements are independent of political parties and self-organize themselves along non-hierarchical lines. For discussion of these concepts and the movements that brought them to life, see my book, *The Subversion of Politics: European Autonomous Social Movements and the Decolonization of Everyday Life* (Oakland: AK Press, 2006). I first uncovered the "eros effect" from an empirical study of the world-wide revolt of 1968, which I published as *The Imagination of the New Left: A Global Analysis of 1968* (Boston: South End Press, 1987). Further materials can be found at www.eroseffect.com (June 6, 2009).
2 A reliable estimate put the number of people killed at 325. See *Massacre in Mexico* by Elena Poniatowska, Octavio Paz, and Helen R. Lane (Columbia: University of Missouri Press, 1991).
3 Interview with Emile Kacirek, Prague, February 1980.
4 See Robin Morgan, *Sisterhood is Powerful* (New York: Random House, 1970), xxv.
5 The documents from the workshops at the Panthers' convention are contained in *Liberation, Imagination and the Black Panther Party*, edited by Kathleen Cleaver and George Katsiaficas (New York: Routledge, 2001).
6 *Indianer und P38* (Munich: Trikont, 1978), 18.
7 These protests at the meetings of the World Bank and International Monetary Fund became examples for activists the world over.
8 See *The Subversion of Politics*, 160.
9 Richard Nixon, "356: Radio Address on the Philosophy of Government," October 21, 1972, *The American Presidency Project*, http://www.presidency.ucsb.edu/ws/index.php?pid=3637 (June 6, 2009).

25. Still from *Iraq Veterans Against the War: Operation First Casualty* (2008, 5 minutes, Elizabeth Press for Democracy Now!), USA.

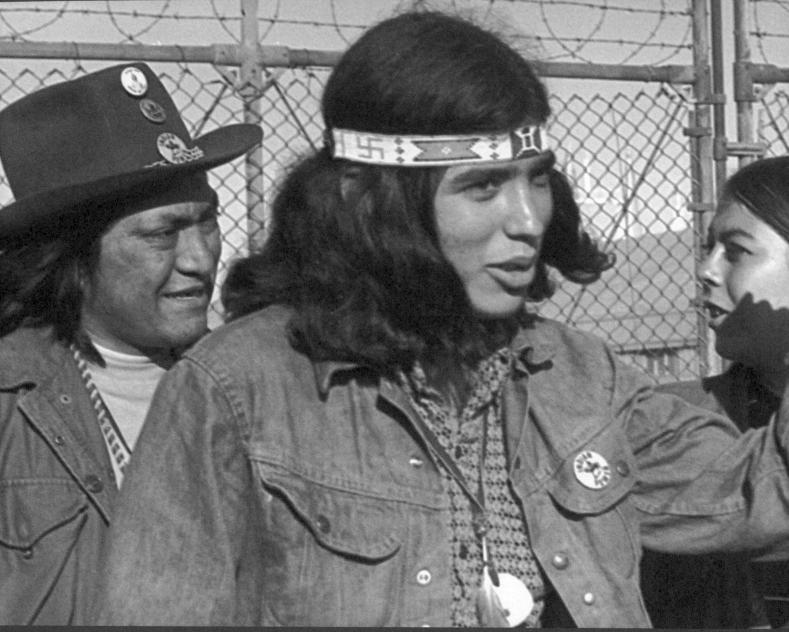

We must begin by acknowledging the land we walk on. Since the 1960s, colonized peoples the world over have renewed their struggle for control of their ancestral lands. In the United States, Native Americans organized under many banners, including Indians of All Tribes and the American Indian Movement. Catholics in Northern Ireland, who trace their lineage to native Celtic ancestry, strengthened the fight against British rule. In 1987, Palestinian youth ignited the first Intifada (an Arabic word for "rebellion") that caught the world, and even many Palestinians, by surprise. In British Columbia, Indigenous peoples and allies struggled to prevent the occupation and destruction of their lands due to the 2010 Winter Olympics in Vancouver.

26. Ilka Hartman, **Indian occupiers moments after the removal from Alcatraz Island on June 11, 1971**, photographic documentation, 1971, USA.

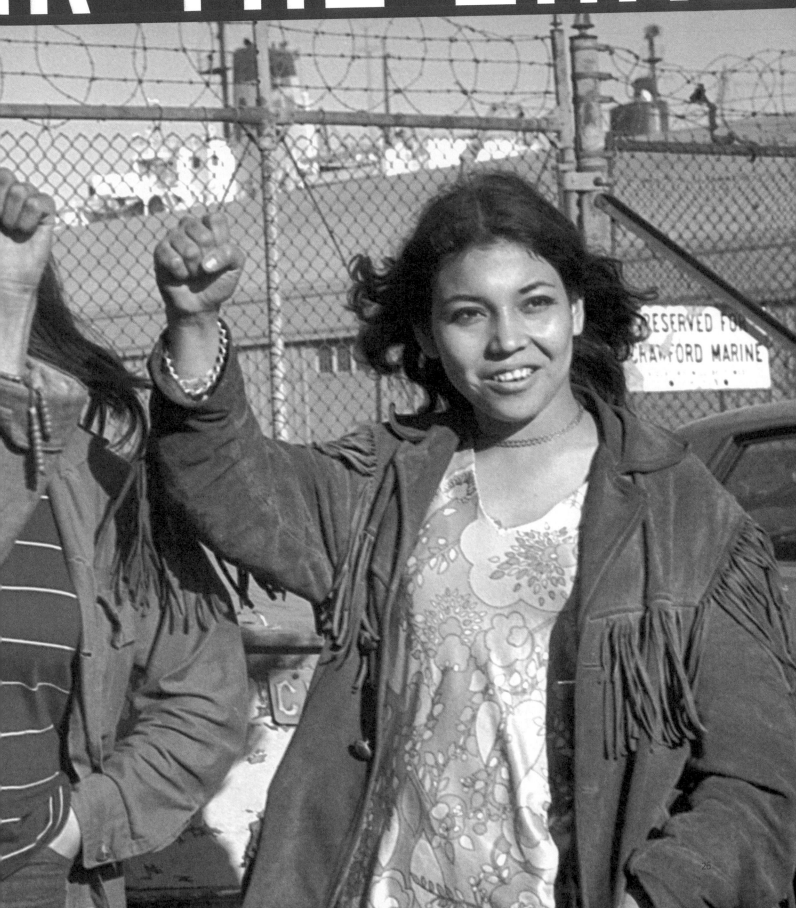

TO KEEP ALCATRAZ RED
KEEP ALCATRAZ FED!

"WHAT THE GOVERNMENT IS DOING AT THIS TIME IS PLAYING POLITICS WITH THE ALCATRAZ ISSUE AS THEY DO WITH MANY ISSUES THAT CONCERN HUMAN LIVES...BUT WE WILL NOT BE INTIMIDATED..."

After 500 years of experience, the Indians on Alcatraz are not fooled by the government's latest fork-tongued offer of a "National Park". They have taken a heroic stand in their struggle for self-determination. Last November Alcatraz became liberated Indian territory. Those who settled there proposed that the government deed thim the island so that they could build an Indian Cultural and Spiritual Center on it. The American government, totally ignoring the Indians' proposal, responded with its typical PIGgish brutality. Last week, the water and electrical supply to Alcatraz was cut off. Now attempts are being made to set up a blockade around Alcatraz so that our brothers and sisters there will be forced to leave or starve.

SUPPLIES NEEDED:

The Native Americans on Alcatraz are badly in need of the following supplies: CANNED FOODS, especially milk and fruit juices, as well as flour, rice, beans, and cereals; FRESH WATER, TOOLS; WARM CLOTHING, FIRST AID EQUIPMENT, and MONEY

The Indians have chosen Alcatraz as the front on which they will wage their struggle against the economic, political, and cultural IMPERIALISM of AmeriKa. It is up to us to show our solidarity with their struggle by keeping that front supplied.

SUPPLY LINE

Friday morning a supply line (like the Ho Chi Minh Trail) from Berkeley to Alcatraz will be set up. Supplies can be stockpiled daily through Thursday between 12 and 6 at PEOPLE'S ARCHITECTURE, 1940 B Bonita Street. To help with the supply line, call 849-2577 between 12 and 6.

IF YOU DIG ALCATRAZ, DO IT!

ALL POWER TO THE PEOPLE!

OCCUPATION OF ALCATRAZ [1964–1971, USA/Native Land]

In the nineteenth and early twentieth centuries, Alcatraz Island had been the site of a federal prison, where Native American prisoners were often held. The first attempted occupation of the island took place in 1964, when five Sioux demanded the use of the island for a cultural center and an Indian university; it lasted four hours. In November of 1969, a group from many different tribes, uniting under the name "Indians of All Tribes," occupied the island for eighteen months, until July 1971. The occupation of Alcatraz Island was an important event in the contemporary struggles of Native North Americans. Claiming the island by "right of discovery," Indians of All Tribes carried out the occupation to draw attention to the mistreatment of indigenous people's by the US government, which included the failure of the US to live up to the treaties it had signed with Native tribes. Their demands included developing Native American educational, historical, and spiritual centers on the island. The occupation was spectacularly visible in local and international media, with Indians of All Tribes marking the island as "Indian Territory" with signs and graffiti, and with a radio program about the occupation, *Radio Free Alcatraz*, narrated by John Trudell and broadcast in San Francisco, Los Angeles, and New York.

28

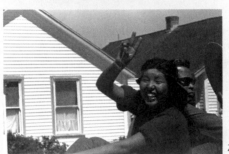

29

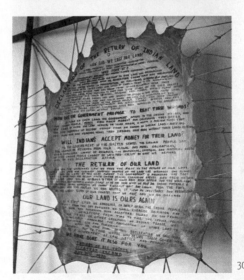

30

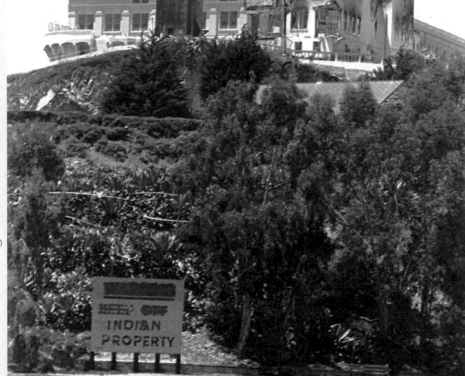

31

27. Artist unknown, **Keep Alcatraz Fed!**, offset lithograph poster, c. 1970, USA.

28. Ilka Hartman, **Alcatraz occupier on his way to Alcatraz, March 1971**, photographic documentation, 1971, USA.

29. Ilka Hartman, **Exuberant Occupier and Gino**, photographic documentation, c. 1970, USA.

30. Ilka Hartman, **The Proclamation**, photographic documentation, c. 1970, USA.

31. Ilka Hartman, **Newly arriving Indian Occupiers were greeted by this sign when they were approaching the island, May 30, 1970**, photographic documentation, 1970, USA.

AMERICAN INDIAN MOVEMENT

[1968–present, USA/Native Land]

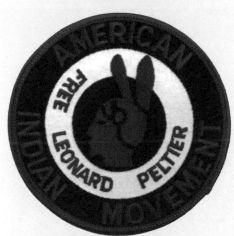

The American Indian Movement (AIM) has been one of the most visible of the organizations fighting for Native sovereignty in the US. AIM is most well known for a string of occupations, which were used to reach a mass audience with their message by calling attention to their cause through media coverage. On Thanksgiving Day 1970, members of AIM occupied a replica of the Mayflower at Plymouth, Massachusetts, and in 1972 they occupied the DC headquarters of the Bureau of Indian Affairs, after completing a cross-country protest caravan called the Trail of Broken Treaties.

In 1973, they sparked a militant confrontation with the federal government, taking over the town of Wounded Knee, South Dakota, for seventy-one days. Wounded Knee was both a site of historic importance, being the location of the 1890 US military massacre of hundreds of Oglala Lakota, and the contemporary site of an extremely corrupt Native leadership, which AIM opposed. Over 200 AIM members entered the town to discuss the situation and the US government quickly cordoned off the town in an attempt to arrest them. AIM organized to protect themselves and the citizens of Wounded Knee and traded gunfire with the police. Armed with machine guns and automatic weapons, US federal marshals, FBI agents, and the National Guard descended on the town in armed personnel carriers and helicopters. Two AIM members were killed during the occupation.

THE *Spirit* of the past will rise to claim the FUTURE

WOUNDED KNEE.

IN THE MOON WHEN THE DEER SHED THEIR HORNS (DEC. 28, 1890)

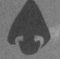

MARCH 1973...

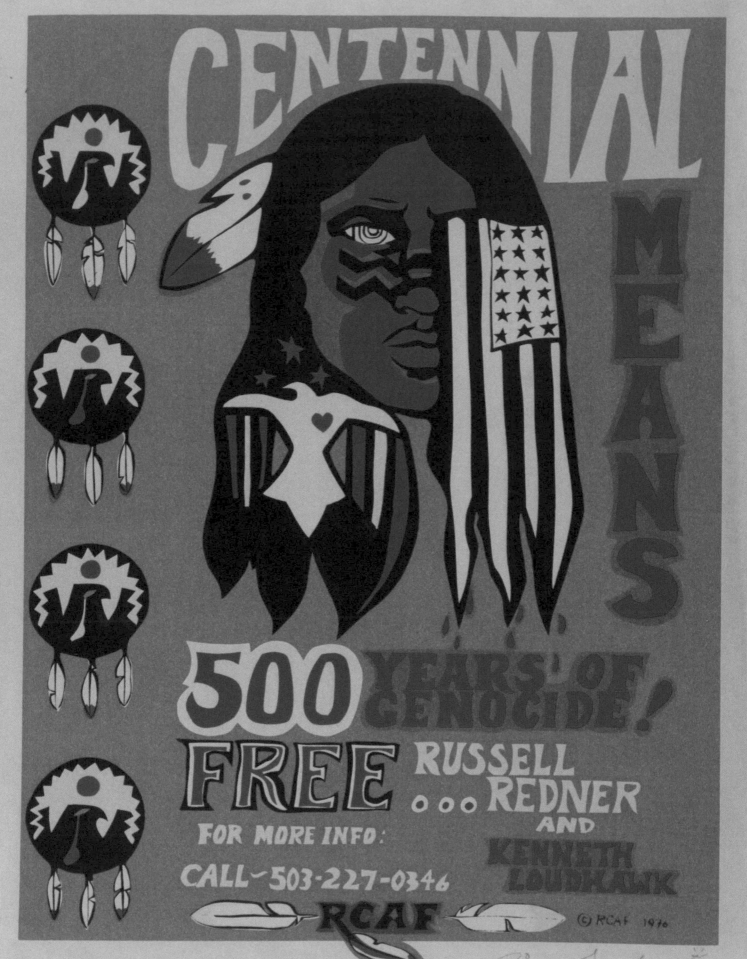

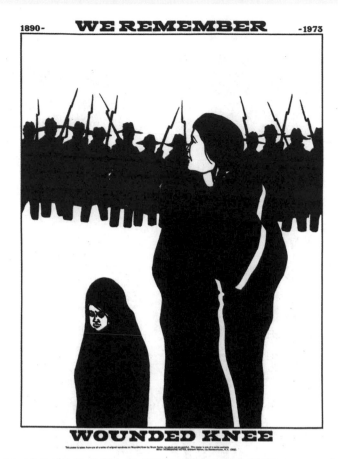

1890- **WE REMEMBER** -1973

WOUNDED KNEE

36

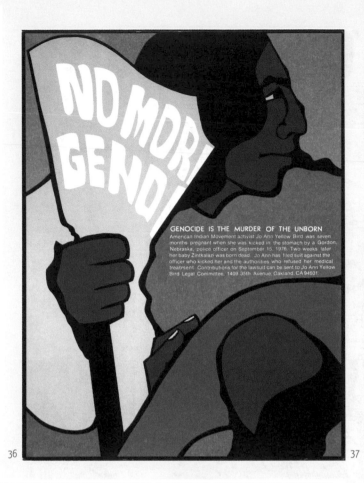

GENOCIDE IS THE MURDER OF THE UNBORN
American Indian Movement activist Jo Ann Yellow Bird was seven months pregnant when she was kicked in the stomach by a Gordon, Nebraska, police officer on September 15, 1976. Two weeks later her baby Zintkalazi was born dead. Jo Ann has filed suit against the officer who kicked her and the authorities who refused her medical treatment. Contributions for the lawsuit can be sent to Jo Ann Yellow Bird Legal Committee, 1409 35th Avenue, Oakland, CA 94601

37

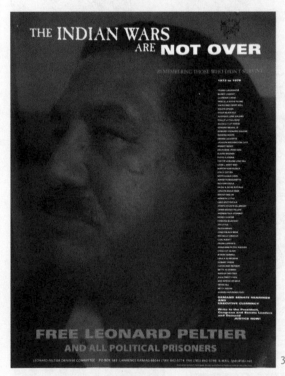

THE INDIAN WARS ARE **NOT OVER**

FREE LEONARD PELTIER
AND ALL POLITICAL PRISONERS

38

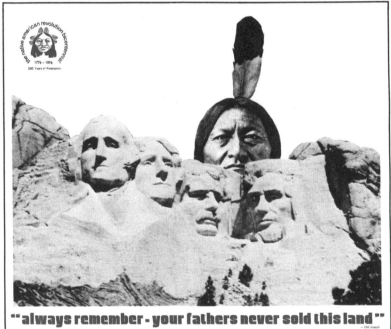

"always remember - your fathers never sold this land"

39

32. AIM (artist unknown), **Various Patches**, embroidered patches, c. 1980s–2000s, USA.

33. AIM (artist: Steve Blake), **7th Annual Indian Treaty Conference**, offset lithograph poster, 1981, USA.

34. AIM (artist unknown), **Wounded Knee**, screen print, 1973, USA.

35. Royal Chicano Air Force (artist: Ricardo Favela), **Centennial Means 500 Years of Genocide**, screen print, 1976, USA.

The Royal Chicano Air Force was a Sacramento-based artist collective founded in 1969 to promote the then-young Chicano Movement in California. They are most known for their screen-printed posters, but they also painted murals, held performances, taught youth workshops, and even hosted a free breakfast program in the vein of those created by the Black Panther Party.

Russell Redner founded the Northern California Chapter of the American Indian Movement and was involved in the 1973 siege at Wounded Knee. This poster is referencing charges he and Kenneth Loudhawk faced after being arrested in relation to a 1975 shoot out at the Pine Ridge Reservation.

36. Akwesasne Notes (artist: Bruce Carter), **Wounded Knee**, offset lithograph poster, 1973, USA.

37. Jo Ann Yellow Bird Legal Committee (artist: Malaquías Montoya), **No More Genocide**, offset lithograph poster, 1980, USA.

38. Leonard Peltier Defense Committee (artists: Luis V. Rodriguez & Guillermo Prado), **The Indian Wars Are Not Over**, offset lithograph poster, 1998, USA.

Leonard Peltier is an AIM activist who is currently imprisoned for two consecutive life sentences for alleged murder. In 1975, Peltier and other AIM activists were living at the Pine Ridge Reservation in South Dakota at the behest of residents who claimed they were being terrorized by the FBI and the Bureau of Indian Affairs. He was involved in a shootout in which an AIM member and two FBI agents were killed. While Peltier was convicted of the murders, two other AIM members involved were acquitted of their charges at a separate trial.

39. Akwesasne Notes (artist unknown), **Shrine of Hypocrisy**, offset lithograph poster, 1976, USA.

THE 'OKA CRISIS'

DURING THE SUMMER OF 1990, A 77-DAY ARMED STANDOFF OCCURRED IN THE MOHAWK TERRITORIES OF KAHNAWAKE AND KANEHSATAKE/OKA, NEAR MONTREAL.

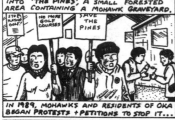

MOHAWK TERRITORIES — QUEBEC — KANEHSATAKE — MONTREAL — OTTAWA — ONT. — KAHNAWAKE — AKWESASNE — USA

MOHAWK WARRIORS CONFRONTED OVER 2,000 QUEBEC POLICE AND 4,500 CANADIAN SOLDIERS...

IN KANEHSATAKE, THE TOWN OF OKA HAD PLANNED TO EXPAND A GOLF COURSE INTO 'THE PINES', A SMALL FORESTED AREA CONTAINING A MOHAWK GRAVEYARD.

STOP PLAYING GOLF! — NO MORE GOLF COURSES — SAVE THE PINES

IN 1989, MOHAWKS AND RESIDENTS OF OKA BEGAN PROTESTS + PETITIONS TO STOP IT...

IN THE SPRING OF 1990, MOHAWKS SET UP A CAMP IN THE PINES AND BLOCKED A SMALL, DIRT ROAD...

ON JULY 11, 1990, OVER 100 HEAVILY-ARMED QUEBEC POLICE ATTACKED THE MOHAWK BLOCKADE, SHOOTING TEAR-GAS + AUTOMATIC WEAPONS. MOHAWK WARRIORS RETURNED FIRE; IN A BRIEF FIRE-FIGHT, ONE POLICE MAN WAS SHOT + KILLED...

MOHAWK TERRITORY — NO TRESPASSING

THE POLICE FLED, ABANDONING MANY VEHICLES. THESE WERE USED TO BUILD NEW BARRICADES...

GET BACK! BACK UP!

AT NEARBY KAHNAWAKE, WARRIORS SIEZED THE MERCIER BRIDGE, A VITAL COMMUTER LINK TO MONTREAL...

HUNDREDS OF POLICE ARRIVED + SEALED OFF THE AREA; ADVISORS + EQUIPMENT FROM THE MILITARY WERE ALSO SENT...

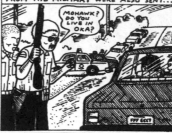

MOHAWK? DO YOU LIVE IN OKA?

IN KANEHSATAKE, WARRIORS FORTIFIED THEIR POSITIONS; REINFORCEMENTS AND SUPPLIES WERE SMUGGLED IN...

AT KAHNAWAKE (POP. 7,000), ENTRANCES WERE BARRICADED. FOOD, MEDICAL AID, AND COMMUNICATIONS WERE ORGANIZED.

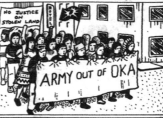

VOLUNTEER SCHEDULE — FOOD BANK — SEE YOU AT THE MEETING!

AS THE SIEGE WENT ON, WHITE MOBS FROM NEARBY TOWNS BEGAN TO RIOT. THEY DEMANDED POLICE RE-OPEN THE BRIDGE.

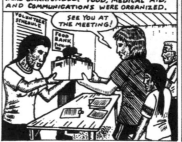

ON AUGUST 20, THE CANADIAN ARMED FORCES TOOK OVER FROM POLICE AT BOTH KAHNAWAKE + KANEHSATAKE.

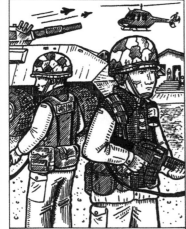

4,500 TROOPS WOULD BE DEPLOYED, WITH LEOPARD TANKS, APC'S, HELICOPTERS, FIGHTER JETS, ARTILLERY, AND NAVAL VESSELS IN THE ST. LAWRENCE RIVER.

IN KAHNAWAKE, SOME MOHAWKS WANTED OUT. ON AUG. 28, AFTER BEING DELAYED BY POLICE, A CONVOY WAS ATTACKED BY WHITE MOBS; THE POLICE DID NOTHING...

AT KANEHSATAKE, WARRIORS RETREATED AS THE ARMY ADVANCED, ENDING UP IN A TREATMENT CENTER BY SEPTEMBER...

ON SEPTEMBER 18, SOLDIERS RAIDED TEKAKWITHA ISLAND (OFF OF KAHNAWAKE). THEY SHOT TEAR GAS + LIVE AMMO. AS MOHAWKS RESISTED...

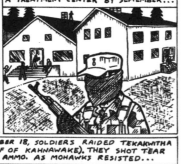

THE SOLDIERS WERE LATER EVACUATED BY HELICOPTERS...

ACROSS THE COUNTRY, NATIVE PEOPLE SHOWED THEIR SOLIDARITY WITH THE MOHAWKS THRU PROTESTS, OCCUPATIONS, ROAD + RAIL BLOCKADES, + SABOTAGE...

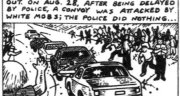

NO JUSTICE ON STOLEN LAND — ARMY OUT OF OKA

IN BC + ALBERTA, RAILWAY BRIDGES WERE DESTROYED BY FIRE...

IN ONTARIO, 5 HYDRO-ELECTRIC TOWERS WERE CUT DOWN BY SABOTEURS...

CANADA FACED AN INDIGENOUS UPRISING IF IT USED FORCE TO END THE SIEGE.

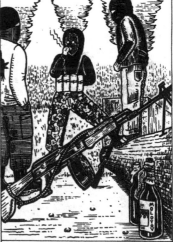

OKA SERVED TO REVITALIZE THE WARRIOR SPIRIT OF INDIGENOUS PEOPLES AND OUR WILL TO RESIST...

ALTHO' THE GOVERNMENT AND MEDIA PORTRAYED THE WARRIORS AS CRIMINALS + TERRORISTS, MANY SAW THEM AS HEROES DEFENDING THEIR PEOPLE...

ON SEPT. 26, THE LAST HOLD-OUTS AT KANEHSATAKE BURNED THEIR WEAPONS AND WALKED OUT...

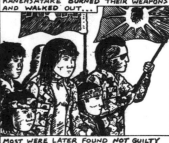

MOST WERE LATER FOUND NOT GUILTY OF WEAPONS + RIOT CHARGES. THE OKA GOLF COURSE WAS NEVER EXPANDED...

-THE END-

FIRST NATIONS OF CANADA RESIST

[1812–present, Canada/Indigenous Land]

As in other parts of the Americas, the First Peoples of Canada have resisted colonization for hundreds of years. Militant struggles over land have taken place in recent decades, including the 1990 Oka Crisis, in which violent conflicts erupted over sacred Mohawk land being turned into a golf course. Shawn Brant, a participant in the occupation at Oka, is a Mohawk activist from Tyendinga who has been imprisoned multiple times by the Canadian government. Brant took part in the 2006 reclamation by the Mohawk community of a gravel quarry operating on their traditional territory without consent. The railroad tracks on the poster below represent the 2007 blockades of the Canadian National Railway lines running through Mohawk land, which Brant was involved in organizing.

A movement also emerged against the 2010 Winter Olympics, led in-part by Coast Salish communities. The construction of Olympic sites often radically restructure the natural and built environment and displace populations living in these areas. (It is estimated that 1.5 million suffered forced evictions due to the 2008 Beijing Olympics.) The 2010 Olympics in Vancouver are no exception. Olympic construction displaced Indigenous peoples, as well as other communities, while creating huge profits for developers. Native 2010 Resistance, Native Youth Movement, Warrior Publications, Sutikalh camp, Downtown Eastside Indigenous Elders Council, Skwekwekʼwelt Protection Centre, and the Native Warrior Society called on people to publicize these indigenous, environmental, and human rights issues and to converge in Vancouver to shut down the games. No 2010 Olympics represented one moment in an ongoing Indigenous struggle against resort development and for recognition of rights to land.

41

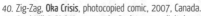

40. Zig-Zag, **Oka Crisis**, photocopied comic, 2007, Canada.
41. Gord Hill & Riel Manywounds, **Resist 2010**, digital poster, 2008, Canada.
42. Zig-Zag, **Convergence February 2010**, offset lithograph poster, 2008, Canada.
43. Punchclock Collective (artist: Stefan Pilipa), **Economic Disruption for Land & Survival**, screen print, 2008, Canada.

43

INDEPENDENCE FOR NORTHERN IRELAND

[1920–present, Northern Ireland]

Many Catholics and left political activists in Northern Ireland have been struggling for independence from the United Kingdom (or re-unification with Ireland) since the partition of Ireland by the British in 1920. Many Protestants, descendants of British colonial rule, were significantly more wealthy than the indigenous population and aligned themselves with the British government. The much larger Catholic community lived in impoverished and oppressive conditions. In the late 1960s, the struggle of the Catholic community took on new forms: a civil rights movement modeled on the one in the United States and the revival of the Irish Republican Army in the form of the Provisional IRA (an armed wing of the movement that had popular support). Culture has been integral to the struggle, including song, dance, the re-emergence of the Gaelic language, and the development of a large and popular mural movement.

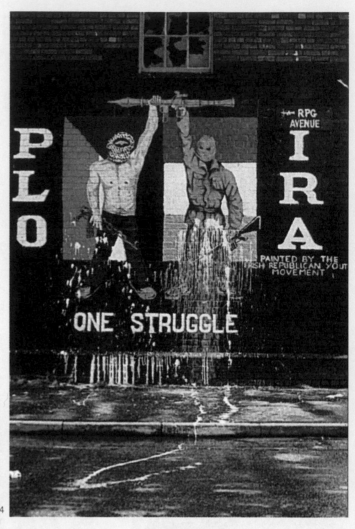

44

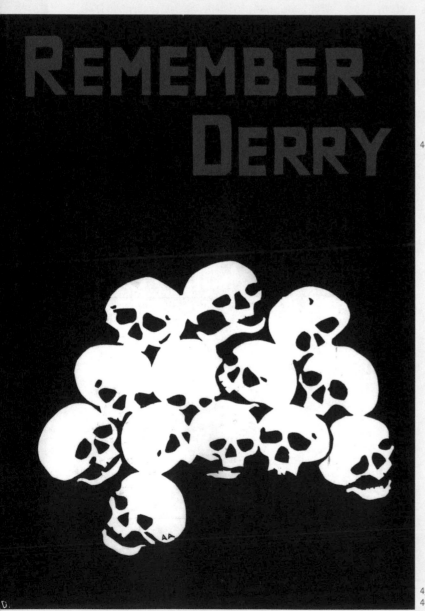

45
46

44. Bill Rolston, **Beechmount Ave., Belfast**, photographic documentation, 1982, N. Ireland.

45. People's Democracy (artist: Sean O'Toole), **Remember Derry**, screen print, 1974, N. Ireland.

"Remember Derry" is a reference to Bloody Sunday, January 30, 1972, when 13 unarmed civil rights marchers were shot and killed by British Paratroopers. The use of the name Derry is also a political statement, dropping London from the city's official name: Londonderry.

People's Democracy (PD) was a non-sectarian political organization that fought for civil rights for Northern Ireland's Catholic minority. The PD formed out of multiple leftist student organizations and included both Catholics and Protestants, as well as Marxists, anarchists, and Irish Republicans.

46. People's Democracy (artist: John McGuffin), **Smash Stormont**, screen print, 1969, N. Ireland.

Stormont was the home of the Unionist Northern Ireland government until 1972. Stormont Castle was also the home of the MI5, the British secret police.

47. Bill Rolston, **Westland St., Derry**, photographic documentation, 1986, N. Ireland.

48. Bill Rolston, **Bancroft Park, Newry, County Down**, photographic documentation, 1994, N. Ireland.

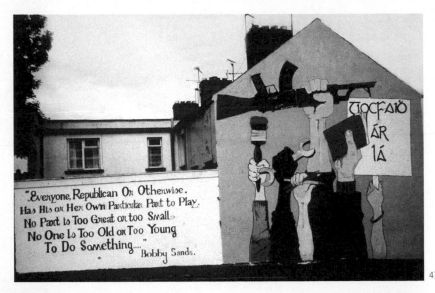

47

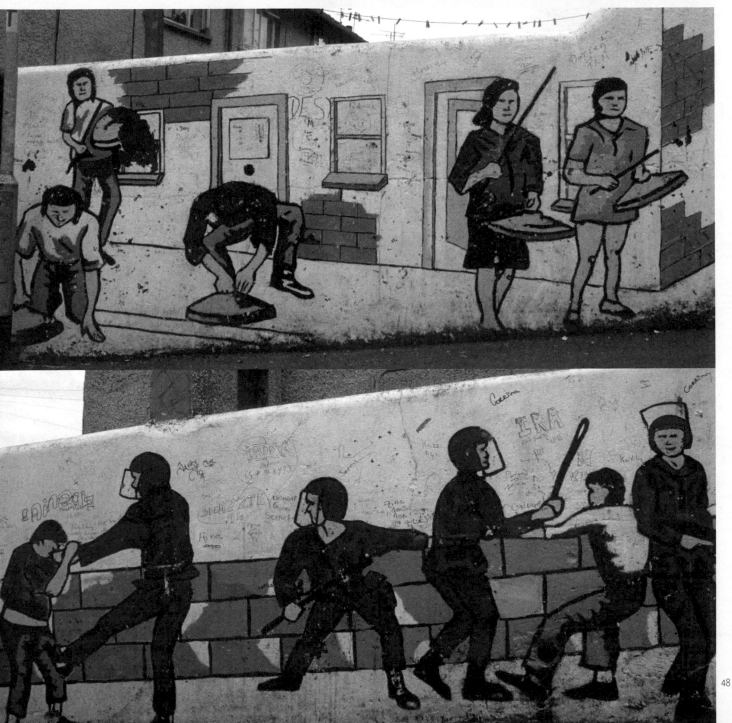

48

PALESTINIAN INTIFADA [1987–present, Palestine]

The First Intifada was a grassroots Palestinian uprising against Israeli occupation that began in the Jabalia refugee camp in 1987 and quickly spread throughout the rest of the Gaza Strip and the Occupied Territories. The Intifada was largely organized by local community councils and initially took the Palestine Liberation Organization and other traditional political leadership by surprise. Beginning with demonstrations by youth, who threw rocks at Israeli tanks, the Intifada grew to include mass civil disobedience, the boycott of Israeli products, graffiti, and general strikes. Lasting until 1993, the uprising gained popular support around the globe, largely because of media coverage which broadcast the contrast between Palestinian resources and tactics and those of the immensely more powerful Israeli Defense Forces, who, according to human rights groups, killed over 1,200 Palestinians during those six years. A Second Intifada, known as Al-Aqsa, ran from 2000 until a truce was reached in 2006.

FORTY YEARS OF OCCUPATION

BOYCOTT ISRAEL - FREE PALESTINE

49

50

THE INTIFADA 89 الانتفاضة

53

المرأة الفلسطينية

GENERAL UNION OF P

54

49. Punchclock Collective (artist: Nideal el-Khairy), **Forty Years of Occupation**, screen print, 2007, Canada/Jordan.

50. Association of Artists for Freedom of Expression (artist: Taleb Duwak), **Down with the Occupation**, offset lithograph poster, 1987, Israel.

51. Malaquías Montoya, **A Free Palestine**, offset lithograph poster, 1983, USA.

52. Palestinian Liberation Organization (artist unknown), **Land Day–March 30**, offset lithograph poster, c. 1990s, Palestine.

A play on the US magazine *LIFE*, this poster depicts Palestinian life being one of struggle. Land Day is an annual protest on March 30th in opposition to Israeli occupation of Palestinian land.

53. Palestinian Liberation Organization (artist unknown), **Intifada**, offset lithograph poster, 1989, Palestine.

54. GUPW (artist: Mark Rudin), **General Union of Palestinian Women**, offset lithograph poster, 1980, Palestine.

55. David Tartakover, **Bring the Settlers Home**, offset lithograph poster, 2000, Israel.

In addition to creating the logo for the Peace Now movement, Israeli designer David Tartakover has been producing posters against the Israeli occupation of the Palestinian Territories for over thirty years.

51

52

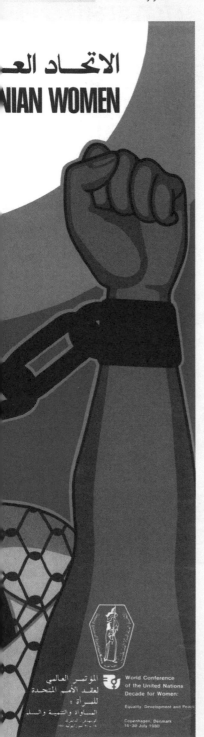

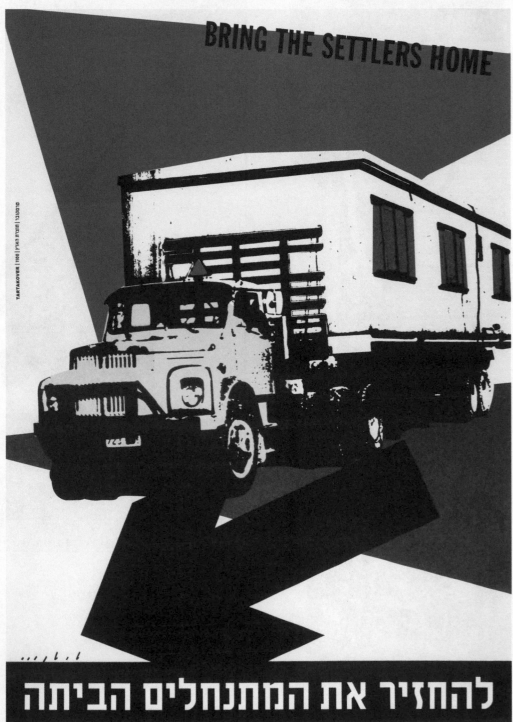

BRING THE SETTLERS HOME

להחזיר את המתנחלים הביתה

55

200 YEARS OF
SLAVERY AND SLAUGHTER IS NO REASON FOR A PARTY

BOYCOTT THE BICENTENNIAL!
FREEDOM NOW FOR BLACK AUSTRALIA

56

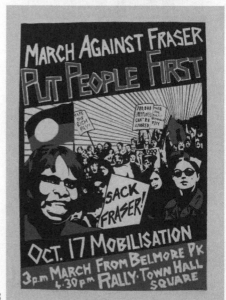

57

58

AUSTRALIAN INDIGENOUS STRUGGLES
[1788-present, Australia]

Australia's Indigenous communities have been fighting for autonomy and land sovereignty for hundreds of years. In the 1960s, inspired by the Civil Rights Movement in the US, they staged freedom rides, which helped publicize the struggle in the national and international press and helped to end official segregation. Land and sovereignty struggles continue to this day.

In March 2006, Indigenous rights groups organized an event to coincide with the Commonwealth Games in Melbourne—the Stolenwealth Games. Using creative tactics and visual spectacles, they demanded an end to Indigenous genocide, sovereignty over the land, and called for treaties to be made and honored.

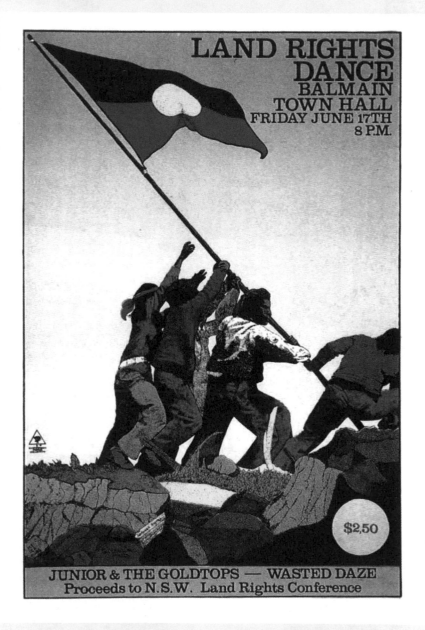

59

56. Artist unknown, **Boycott the Bicentennial**, screen print, 1988, Australia.
57. Artist unknown, **Land Rights Teach-In**, screen print, c. 1980s, Australia.
58. Artist unknown, **March Against Fraser, Put People First**, screen print, c. late 1970s, Australia.
59. Earthworks Poster Collective (artist: Chips Mackinolty), **Land Rights Dance**, screen print, 1977, Australia.
60. Breakdown Press (artist: Tom Civil), **Stolenwealth Poster Series**, printed publication, 2006, Australia.

61. Black GST (Genocide, Sovereignty, Treaty) (photographer: Tom Civil), **Stolenwealth Games actions**, photographic documentation, 2006, Australia.

In 2006, Black GST planned a demonstration confronting the Commonwealth Games in Melbourne. Organizers hoped to focus the media on the struggles of Indigenous Australians during the Games. They employed multiple creative spectacles, including 7' tall mobile letters for spelling out STOLENWEALTH GAMES in various locations.

60

61

37 ★ SIGNS OF CHANGE ★ STRUGGLE FOR THE LAND

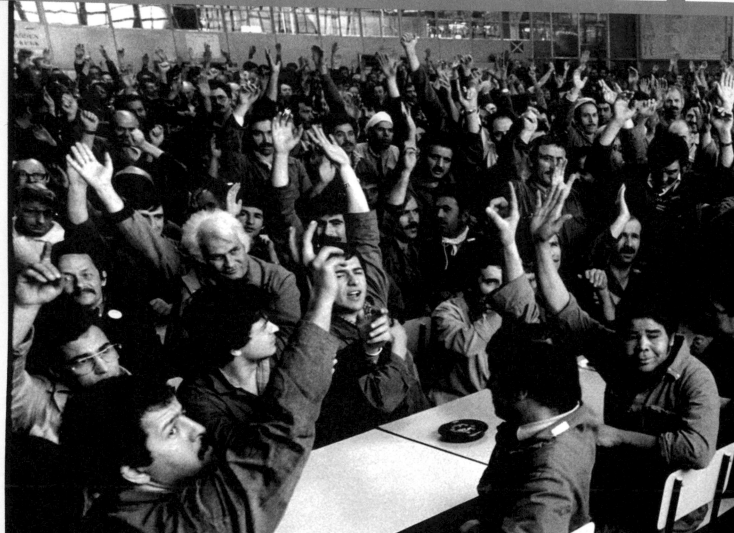

Issues of labor have been at the center of social movements since the advent of capitalism. In the 1960s and 1970s, the definition of labor began to take on new and more inclusive forms as workers, students, women, and teachers organized and often banded together to oppose their exploitation. During these years, workers in many countries revolted against authoritarian and politically-conservative bosses, unions, and political parties, taking to the streets, going on wildcat strikes, and occupying their workplaces. Students recognized their power and mobilized for peace, democracy, economic reforms, progressive curricula, and university reorganization. In 1974, workers and soldiers successfully rose up against Portugal's fascist government, occupying both army barracks and factories. In Oaxaca, Mexico in 2006, a teachers' strike led to a massive people's movement and the formation of the Popular Assembly of the Peoples of Oaxaca (APPO), which temporarily wrested power from the corrupt state government.

62. Michel Pellanders, **De Be Zetting Wordt Goedgekenrd [The Occupation is Approved]**, photographic documentation, 1981, the Netherlands.
 In 1981, Ford automobile workers in Amsterdam occupied their factory to protest layoffs and the threat of the plant being shut down. This action kept the plant open for a short period of time, but eventually the courts allowed Ford to close it.

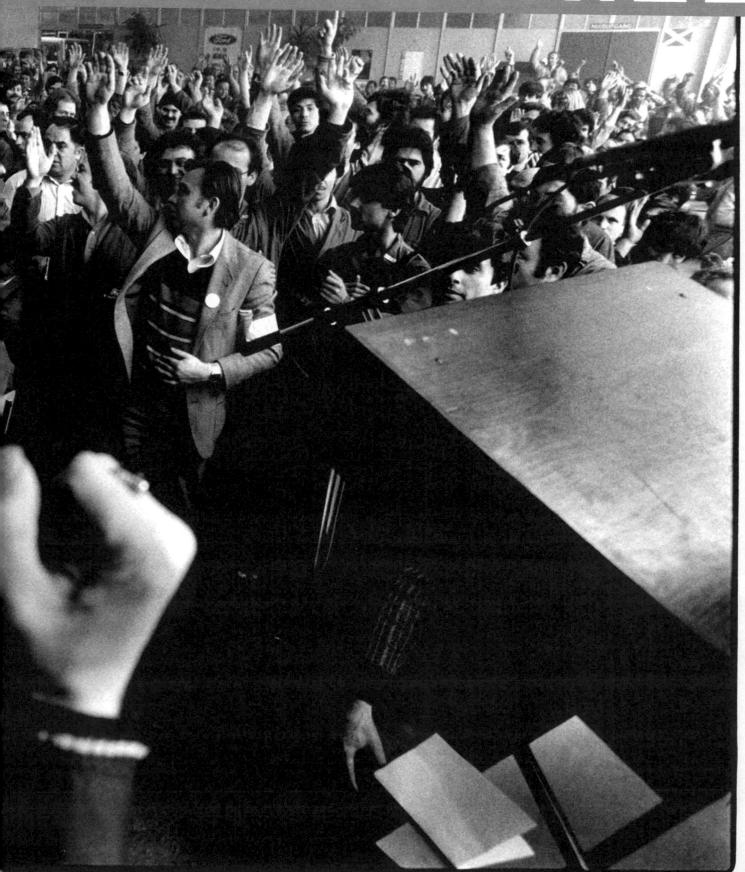

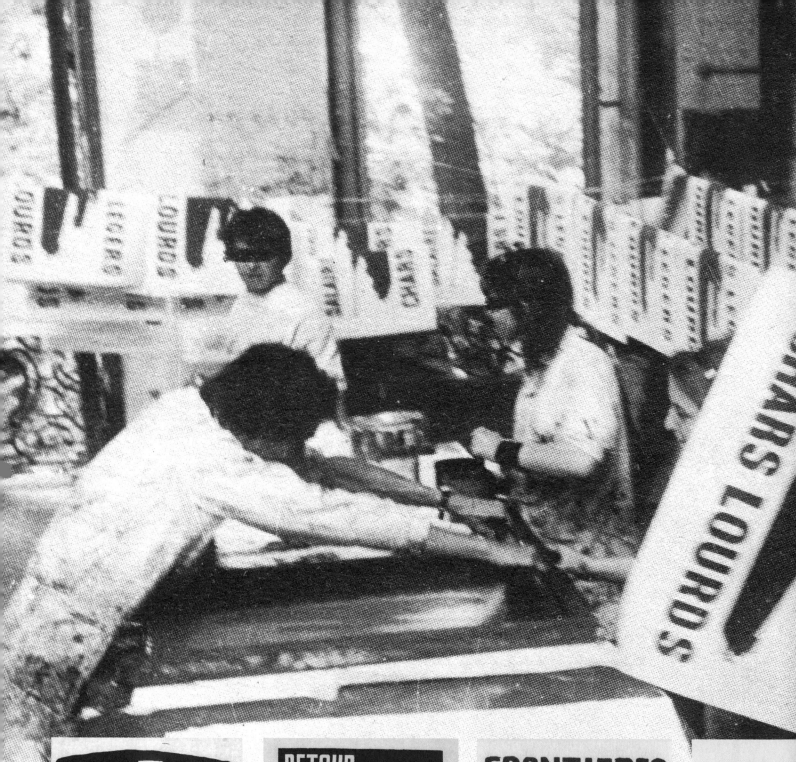

LA CHIENLIT
C'EST LUI!

RETOUR
A LA NORMALE...

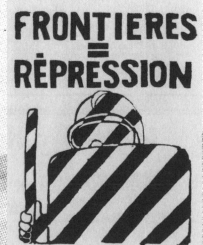

FRONTIERES
=
RÉPRESSION

L'IN
VIE
A DOM

FRENCH MAYDAYS
[1968, France]

In May of 1968, Paris, and eventually all of France, was rocked by what is considered its largest protest movement since the Paris Commune (1871). Hundreds of thousands of students and workers flooded into the streets, calling a general strike that paralyzed France. By mid-May, ten million French workers (two-thirds of the French work force) were on strike, often against the wishes of their union leadership. Students occupied their universities, including the art schools, which were converted into workshops to produce posters for the movement. Graffiti, collaboratively screenprinted posters, and street theater played integral roles in the struggle. The first Atelier Populaire began when artists and students occupied the École des Beaux-Arts, Paris' most prestigious art school, and set up an ad hoc poster factory. Other Ateliers were set up at five other Parisian schools and in at least five other French cities. The workshop at Beaux-Arts alone produced somewhere between 350 and 500 poster designs and hand silkscreened 120,000 to 150,000 total posters in May and June of 1968. Although artists dominated the workshops, at Beaux-Arts large-scale general assemblies were held every day, where artists, students, union representatives, and even a few workers would debate slogans and graphics for the posters.

63. Photographer unknown, **Atelier Populaire at work**, photographic documentation, 1968, France.

64. Atelier Populaire, **La Chienlit C'est Lui! [The Chaos is You!/ de Gaulle Shits His Bed!]**, screen print, 1968, France.

The image on this poster would have been immediately recognizable to people on the street as General Charles de Gaulle, then president of France.

65. Atelier Populaire, **Retour a la Normale...[Back to Normal...]**, screen print, 1968, France.

Although a number of their posters contain puns and witty turns of phrase, the Atelier members took themselves very seriously. A sign above the entrance stated: "To work at the Atelier Populaire is to give concrete support to the great movement of the workers on strike who are occupying their factories in defiance of the Gaullist Government which works against the people. By placing all his skills at the service of the worker's struggle, each member of this workshop is also working for himself, in that he is coming in contact through his practical work with the educative power of the people."

66. Atelier Populaire, **Frontieres=Repression [Borders=Repression]**, screen print, 1968, France.

67. Atelier Populaire, **L'intox Vient a Domicile [Brainwashing Delivered Direct to Your Home]**, screen print, 1968, France.

68. Atelier Populaire, **Ceder un Peu C'est Capituler Beaucoup [To Give a Little Is to Capitulate a Lot]**, screen print, 1968, France.

69. Atelier Populaire, **Debut D'une Lutte Prolongee [The Beginning of a Long Struggle]**, screen print, 1968, France.

The artists at work at the Atelier desired a new world, one in which their art would have meaning beyond commodification and the logic of the market. An Atelier statement reads: "Bourgeois culture separates and isolates artists from other workers by according them a privileged status. Privilege encloses the artist in an invisible prison. We have decided to transform what we are in society."

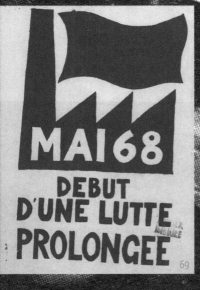

CEDER un PEU C'EST CAPITULER BEAUCOUP

MAI 68 DEBUT D'UNE LUTTE PROLONGEE

MEXICAN STUDENT MOVEMENT
[1968, Mexico]

Throughout 1968, students protested in Mexico City, occupying campuses and creating a National Strike Committee (CNH). The movement was primarily a response to police intervention on campuses, and the suppression of non-violent demonstrations. During the struggle, students organized into Propaganda Brigades, creating banners and posters, distributing literature, and shooting film. The Propaganda Brigades also held what they called "lightning meetings," where they would occupy a street, block traffic, and enact skits to illustrate the movement's demands.

The students were organizing around a number of social issues while focusing attention on government repression, as well as on the Olympics, which were to be held in Mexico that year. The struggle culminated in the Tlatelolco Massacre on October 2nd, when the police and military shot and killed over two hundred student protesters and their supporters, just ten days before the opening of the Olympics. The actual death toll is still unknown. The Mexican government never released a body count and for decades suppressed information about the massacre.

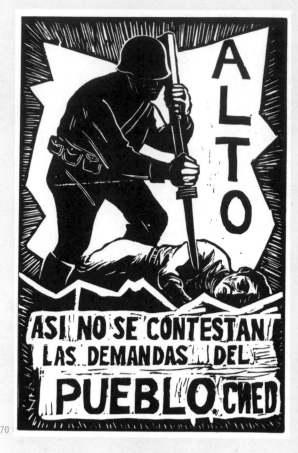

70. Confederación Nacional de Estudiantes Democraticos [National Confederation of Democratic Students] (artist unknown), **Alto, Asi No Se Contestan las Demandas Del Pueblo [Stop, This Does Not Answer the Demands of the People]**, relief print, 1968, Mexico.

71. Comité Nacional de Huelga [Student Strike Committee] (artist: Adolfo Mexiac & Antonieta Castillo), **La Policia y el Ejercito Matan a tus Mejores Hijos [The Police and Army Kill Your Finest Sons]**, relief print, 1968, Mexico.

Unlike the police/pig caricature popularized by the Black Panther Party in the United States, Mexican police and military were almost exclusively caricatured as apes because of the brutality they used against the student movement.

72. Photographer unknown, **Mexican student propaganda brigades**, photographic documentation, 1968, Mexico.

70

71

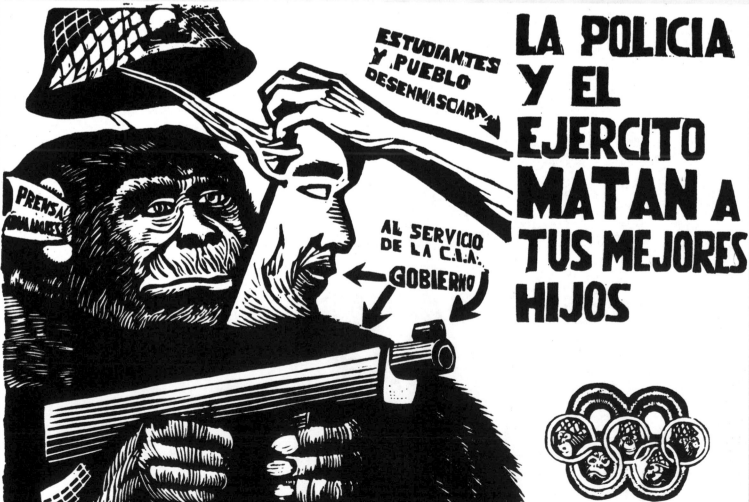

72

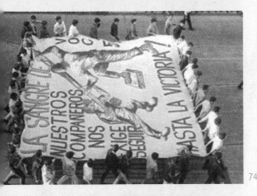

73

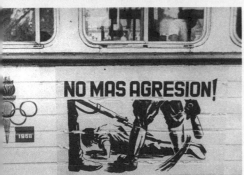

74

NO MAS AGRESION!

75

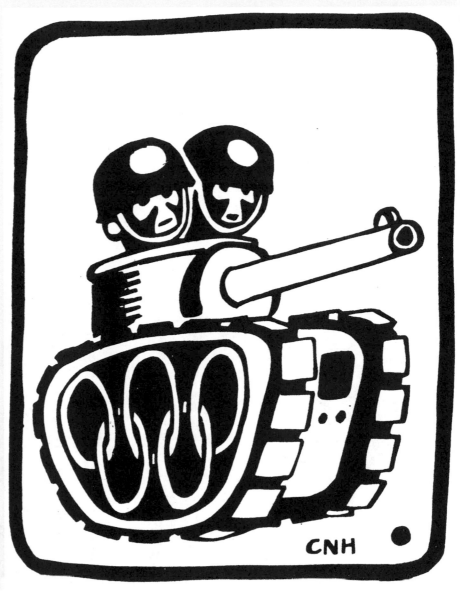

CNH

MEXICO 68

76

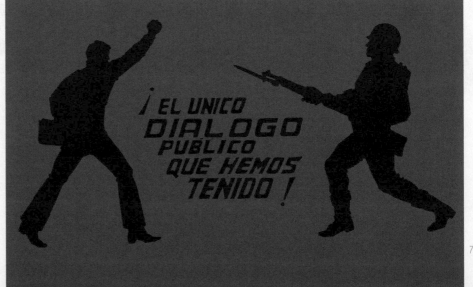

¡ EL UNICO DIALOGO PUBLICO QUE HEMOS TENIDO !

77

73. Óscar Menéndez, **Mexican student print shop**, photographic documentation, 1968, Mexico.

74. Photographer unknown, **La Sangre de Nuestros Companeros** [The Blood of Our Comrades We Must Follow. UNTIL VICTORY!], photographic documentation, 1968, Mexico.

Gigantic banners like the one seen in this photo have a legacy in Mexico, as they were produced in the 1940s and 1950s by political art groups like the Taller de Grafica Popular.

75. Héctor García, **¡No Mas Agresion!** [No More Aggression!], photographic documentation, 1968, Mexico.

76. Comité Nacional de Huelga (artist unknown), **Mexico 68**, relief print, 1968, Mexico.

77. Comité Nacional de Huelga (artist unknown), **¡El unico dialogo publico que hemos tenido!** [The only public dialogue we have had!], relief print, 1968, Mexico.

UNITED FARM WORKERS [1962–present, USA]

The United Farm Workers (UFW) was official-ly founded in 1965. It evolved from smaller unions founded by César Chávez, Philip Vera Cruz, Dolores Huerta, and Larry Itliong, which had been organizing since 1962 and were alternatives to the dominant AFL-CIO (American Federation of Labor and Congress of Industrial Organizations). As a significant portion of California and Southwest farm workers were Mexicans and Chicanos, the UFW became a voice for both farm work-ers being organized and the growing Chicano rights movement. The UFW engaged in many successful and well-publicized strikes from the 1960s to 1980s, and were well known for their successful promotion of the con-sumer boycott and their adherence to the principles of non-violence championed by Dr. Martin Luther King, Jr. and much of the Civil Rights Movement (see page 64).

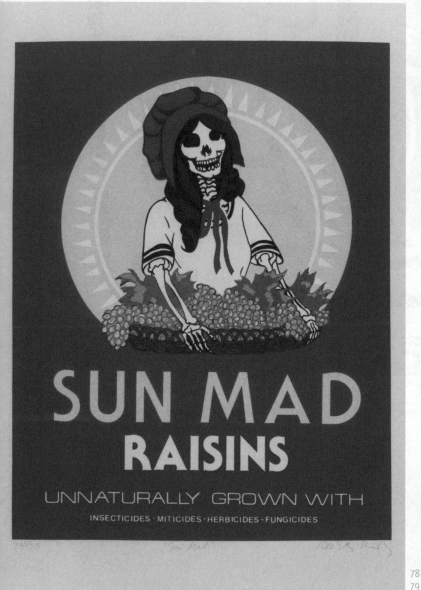

SUN MAD RAISINS

UNNATURALLY GROWN WITH

INSECTICIDES · MITICIDES · HERBICIDES · FUNGICIDES

SUPPORT THE FARMWORKES BOYCOTT SAFEWAY SI SE PUEDE!

78
79

78. Ester Hernández, **Sun Mad Raisins**, screen print, 1982, USA.
 The United Farm Workers developed a strong critique of the chemicals used on crops, both because of the danger they posed to farm workers and their potential harm to the environment.
79. United Farm Workers (artist unknown), **Support the Farmworkers–Boycott Safeway**, letterpress poster, c. 1960s, USA.

80. United Farm Workers Organizing Committee (artist un-known), **Huelga en Salinas [Strike in Salinas]**, offset lithograph poster, c. 1970s, USA.

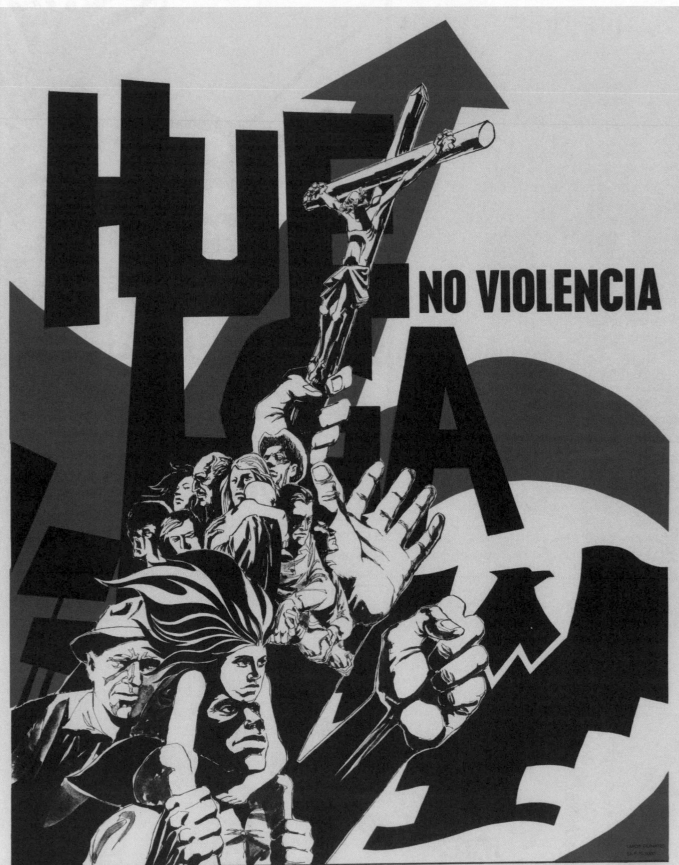

AUTONOMIA

[1960s–1980s, Italy]

Beginning in the early 1960s, workers and students in Italy began reinventing their tactics and vision for political, economic, and social change. Dubbed "Hot Autumn," Italy was rocked in the fall of 1969 by massive strikes of both workers and students. The workers broke from oppressive trade union bureaucracies, staging wildcat strikes (strikes organized by rank-and-file workers against the wishes of the union leadership), organizing democratically, and opposing union officials' attempts to negotiate settlements with industry. The students demanded that the over-burdened educational system be enhanced and modernized, with no tuition hikes—they, like students across the globe, organized in assemblies built on the principles of direct democracy.

Simultaneously, a sector of the revolutionary labor movement developed an unorthodox Marxist theory called *Operaismo* (Workerism) that places the workers, not unions or Communist parties, as the central catalysts for revolution to dismantle capitalism. In the 1970s, Operaismo mixed with Situationist, anarchist, and counter-cultural elements to become the diverse social movement known as Autonomia. In 1977, when it was most powerful, Autonomia claimed over a hundred thousand adherents, including students, blue- and white-collar workers, and feminists, and shook the foundations of Italian society. The cultural wing of the movements, known as the Metropolitan Indians, were the most anarchic, daubing their faces in "Indian" warpaint, publicly mocking the Communist Party, and taking part in "proletarian shopping"—mass shoplifting actions where dozens of youth would simultaneously steal clothing from stores or force their way into movie theaters. Autonomia deeply influenced the German Autonomen (see page 102), Dutch Kraakers (see pages 98–101), and the creation of anti-authoritarian social centers across the globe.

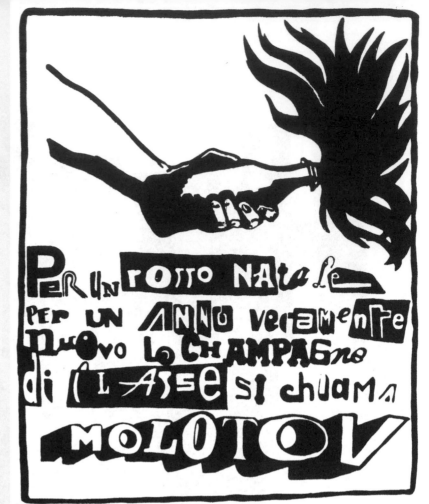

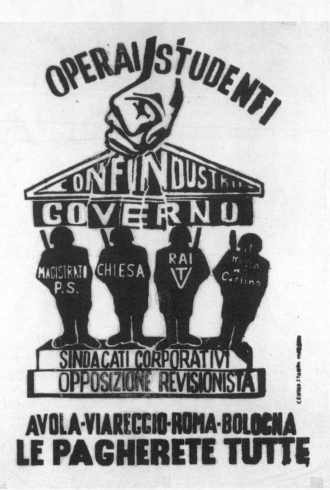

OPERAI STUDENTI
CONFINDUSTRIA
GOVERNO
MAGISTRATO P.S. — CHIESA — RAI TV — ...
SINDACATI CORPORATIVI
OPPOSIZIONE REVISIONISTA
AVOLA·VIAREGGIO·ROMA·BOLOGNA
LE PAGHERETE TUTTE

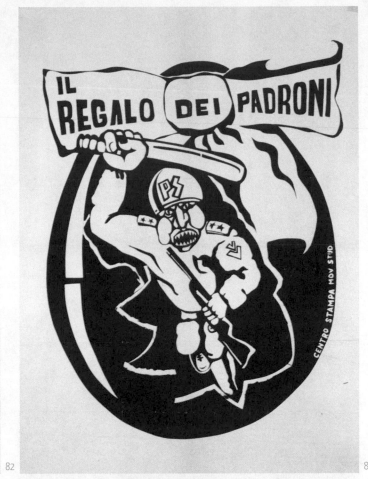

IL REGALO DEI PADRONI

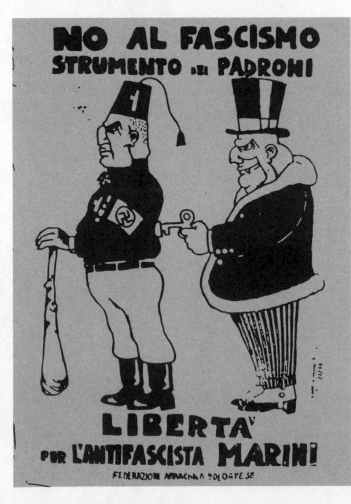

NO AL FASCISMO
STRUMENTO DEI PADRONI
LIBERTA'
PER L'ANTIFASCISTA MARINI
FEDERAZIONE ANARCHICA BOLOGNESE

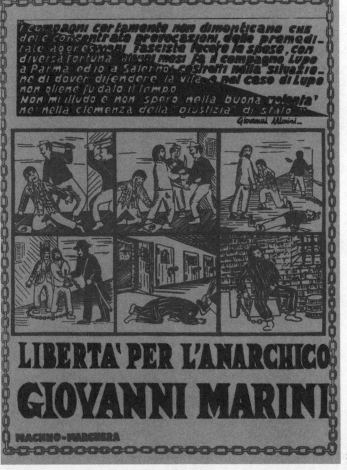

LIBERTA' PER L'ANARCHICO
GIOVANNI MARINI

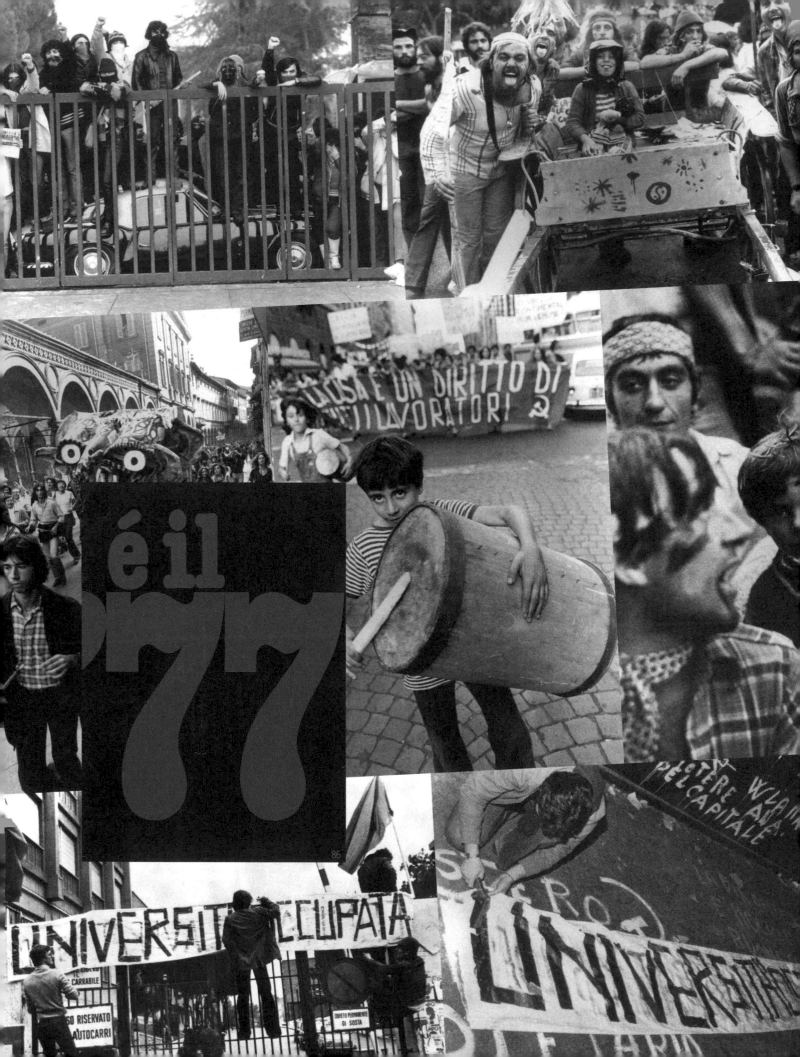

é il '77

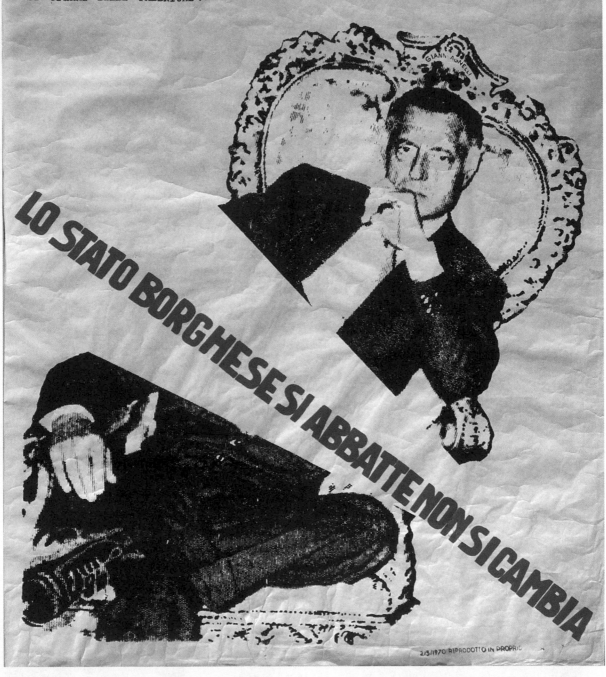

CHE COSA VUOL DIRE IL BLOCCO DEGLI AFFITTI, QUANDO CI SONO OPERAI AMMASSATI IN POCHE STANZE, BARACCATI AI MARGINI DELLE CONCEN= TRAZIONI INDUSTRIALI, QUANDO ASSISTIAMO ALLO SPOPOLAMENTO DELLE CAMPAGNE E ALL'AMMASSAMENTO NELLE CITTA', QUANDO CONTINUA A SOPRAVVIVERE LA RENDITA FONDIARIA ?

COSA RISOLVE LA RIFORMA DEGLI ENTI PREVIDEN= ZIALI, QUANDO I PADRONI NON RICONOSCONO NEPPURE LE MALATTIE PROFESSIONALI IN FABBRICA, QUANDO LA SILICOSI, LA NOCIVITA', I RITMI DI LAVORO DISTRUGGONO FISICAMENTE E PSICHICAMENTE GLI OPERAI DELLE FABBRICHE ?

QUESTE E ALTRE RICHIESTE PARZIALI NON PORTANO CHE SCARSI VANTAGGI ALLE MASSE POPOLARI. NON SONO CHE DELLE CONCESSIONI ALLE QUALI POSSONO ARRIVARE I GRUPPI MONOPOLISTICI, ALLO SCOPO DI ATTENUARE LO SCONTRO DI CLASSE.

ILLUDERSI DI ARRIVARE AD UN CAMBIAMENTO REALE DELLA SOCIETA' SENZA UNO SCONTRO CON I MONOPOLI E CON LO STATO CHE LI RAPPRESENTA, SIGNIFICA STARE AL GIOCO DEI PADRONI.

IL CANCRO DELLA NOSTRA SOCIETA' E' QUELLO DI ESSERE ORGANIZZATA AI FINI DEL PROFITTO.

LO STATO BORGHESE SI ABBATTE NON SI CAMBIA

81. Artists unknown, **various pages from Autonomia publications**, printed publications, c. 1970s, Italy.

Similar to the zines of today, self-publishing flourished within Autonomia, with hundreds of different magazines being printed, filled with political analysis, graphics, collage, and comics.

82. Centro stampa movimento studentesco [Student Movement Printing Center] (artist unknown), **Operai–Studenti [Workers–Students]**, screenprint poster, 1969, Italy.

Translation: Workers—Students/Against the Government, Corporate Trade Unions/Revisionist Opposition/Avola—Viareggio —Roma—Bologna/You'll Pay for Each of Them

83. Centro stampa movimento studentesco [Student Movement Printing Center] (artist unknown), **Il Regalo dei Padroni [The**

Boss' Gift], screen print, 1969, Italy.

84. Federazione Anarchica Bolognese (artist unknown), **No Al Facismo [Say No to Fascism]**, screen print, 1969, Italy.

Translation: Say No to Fascism/A Tool of the Bosses/Freedom for the Anti-Facist Marini

85. Machno-Marghera, **Liberta per l'anarchico Giovanni Marini [Freedom for the Anarchist Giovanni Marini]**, screen print, 1974, Italy.

Giovanni Marini was an anarchist who was imprisoned after killing a neo-fascist who attacked him during a riot in Bologna.

86. Tano D'Amico and Collettivo Resa dei Conti, **é il '77**, printed publication of photographs, 1977, Italy.

In 1977, at the height of the Autonomia, the Collettivo Resa dei Conti published this collection of Tano D'Amico's photographs

of the different aspects of the movement, including the Metropolitan Indians, the feminist movement, university occupations, and community-organized utilities strikes. Since the 1960s, D'Amico has been the unofficial photographer of Italian social movements, covering hundreds of protests and actions over the past forty years.

87. Artist unknown, **Lo stato borghese si abbatte non si cambia [The bourgeois state has to be knocked down, not changed]**, screen print, 1970, Italy.

The man shown in the poster is Gianni Agnelli, the principal stockholder in and president of Fiat (as well as the son of Fiat founder Giovanni Agnelli). He was seen as an enemy of the left throughout the '60s and '70s for his use of strike-breaking.

AUTONOMIA FEMMINISTA

[1970s–1980s, Italy]

In the mid-1970s, women of the Italian Autonomia movement developed a strong feminist direction. Many groups formed, including Lotta Femminista (Feminist Struggle) and the Comitatos per il Salario al Lavora Domestico (Committees for Wages for Housework). Focusing on both the production of feminist theory and direct action, they critiqued Marxism for not including domestic labor as part of its analysis of capitalist social relations. The Italian feminist movement built on the ideas of Italian Workerism and used a mix of Marxist theory and their own experiences to create a new conception of the role of women under capitalism. Viewing the work women did at home as the foundational labor that allowed men to go to work in the factories, they argued that capitalists depended on this labor being "free," or unwaged, in order to maintain their profits. If women demanded wages for housework, they believed they could force a restructuring of relationships between capital and worker. Although often rejected by the male-dominated left, during the height of the 1970s Italian social movements, their analysis was central to community-wide rent and utilities strikes led by women. These ideas also spread internationally to other women's movements.

88. Comitato Veneto per il Salario al Lavora Domestico (artist unknown), **Troppo Lavoro Gratis! [Too Much Work For Free!]**, offset lithograph poster, 1974, Italy.

Translation: *Too Much Work for Free!/Wages for Housework/March 8, 1974 International Women's Day*

89. See Red Women's Workshop, **Capitalism Also Depends on Domestic Labor**, screen print, c. 1976–78, UK.

90. Le Operaie della Casa, **Le Operaie della Casa [The Home Worker]**, printed publication, 1976, Italy.

91. Gruppo Musicale del Comitato per il Salario al Lavoro Domestico di Padova, **Amore e Potere [Love and Power]**, music LP, 1977, Italy.

92. Gruppo Musicale del Comitato per il Salario al Lavoro Domestico di Padova, **Canti di Donna in Lotta [Songs of Women in Struggle]**, music LP, 1976, Italy.

93. Various publications collectives, **Publications from the Italian feminist movement**, printed publications, 1970s, Italy.

94. Photographer unknown, **Feminist protest in Padova**, photographic documentation, c. 1970s, Italy.

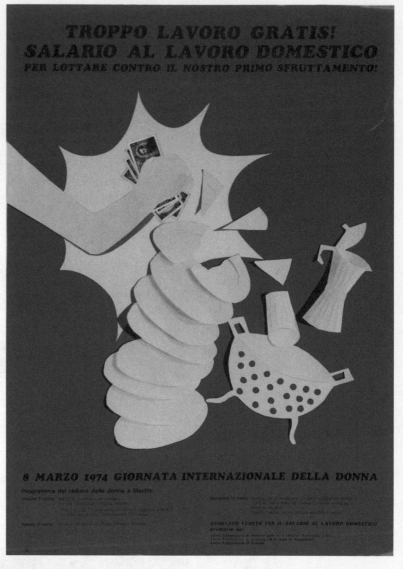

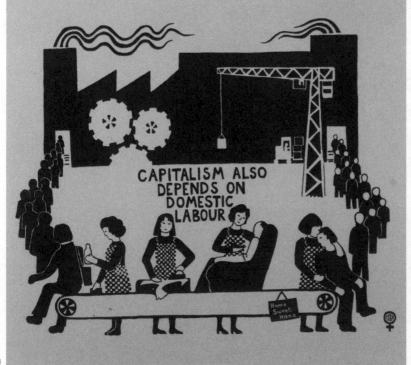

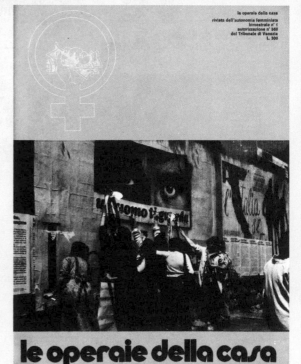

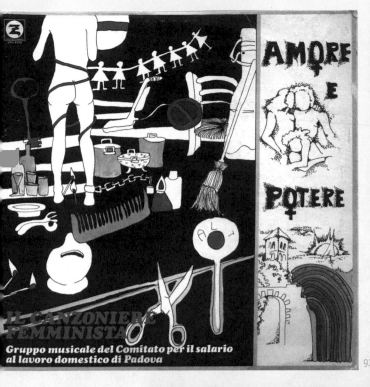

IL CANZONIERE FEMMINISTA

AMORE E POTERE

Gruppo musicale del Comitato per il salario al lavoro domestico di Padova

91

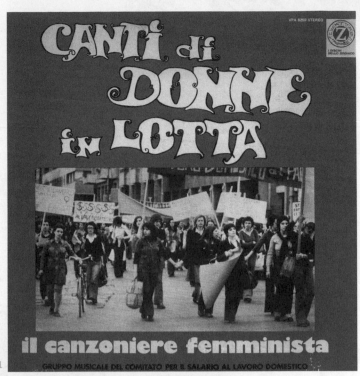

VPA 8259 STEREO

CANTI di DONNE in LOTTA

il canzoniere femminista

GRUPPO MUSICALE DEL COMITATO PER IL SALARIO AL LAVORO DOMESTICO

92

COME TO A CONFERENCE ON
WAGES FOR HOUSEWORK & WELFARE

Open To All Women - Saturday, April 24, 10am–6pm
To Discuss How To Organize To

RESIST the welfare cuts and
DEMAND wages from the
government for
all women for
all the house-
work we do.

le operaie della casa

marsilio editori

potere
femminile
e sovversione
sociale
mariarosa
dalla costa
con «il posto della donna»
di selma james

i interventi

salario al lavoro domestico
strategia internazionale femminista

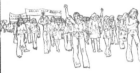

le operaie della casa
a cura del collettivo internazionale femminista

marsilio editori

salario contro
il lavoro domestico
di silvia federici

- lo chiamano amore, noi lo chiamiamo lavoro non pagato
- la chiamano frigidità, noi la chiamiamo assenteismo ogni volta che restiamo incinte contro la nostra volontà è un incidente sul lavoro
- l'omosessualità e l'eterosessualità sono entrambe condizioni di lavoro ... ma l'omosessualità è il controllo degli operai sulla produzione, non la fine del lavoro
- più denaro, niente sarà più efficace per distruggere le virtù di un sorriso
- nevrosi, suicidi, desessualizzazione: malattie professionali delle casalinghe

a cura del Collettivo Femminista Napoletano per il Salario al Lavoro domestico

93

94

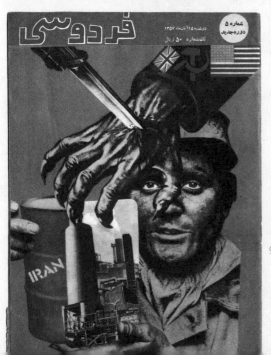

IRANIAN REVOLUTION [1978–1979, Iran]

Throughout the 1960s and 1970s, workers, students, and other groups in Iran struggled against the US-backed Shah. Presented in the West as a democratic reformer, the Shah's rule was closer to a totalitarian dictatorship, with the Iranian secret police raiding homes and kidnapping anyone suspected of opposing the government. In January 1978, major protests and strikes against the Shah began, and in January 1979 he fled the country. In April 1979, a referendum was approved that converted Iran to a theocratic Islamic republic. But, from 1978 to the middle of 1979, the Iranian Revolution contained many different political strains, including those from the left tradition. Workers occupied their factories and oil refineries, and formed worker's councils to run them. Students took over the universities and women played important roles in the organization of protests and other revolutionary activities.

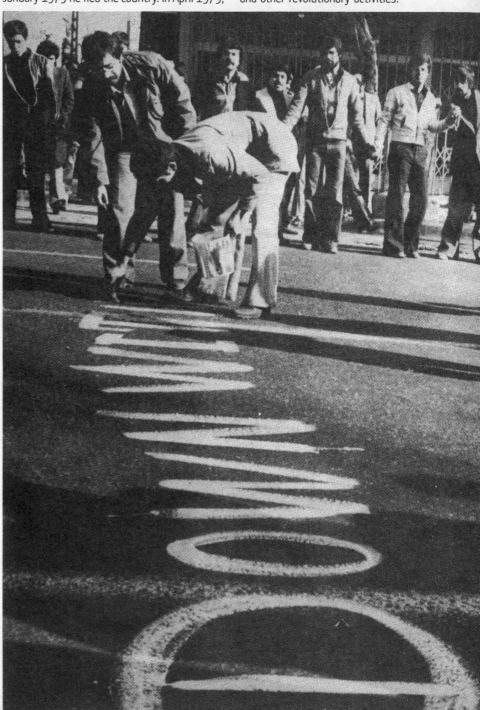

95. Artists unknown, **Magazines from the Iranian Revolution**, printed publications, 1978–1980, Iran.
These magazines were found by an Iranian-American returning to Tehran after twenty years in exile. They were discovered in the attic of the family home, and are part of a larger collection that has since been thrown away. Taking these magazines out of the

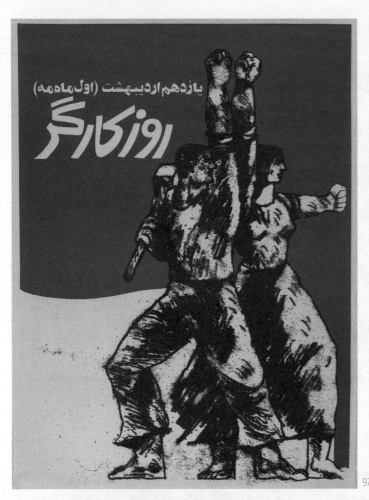

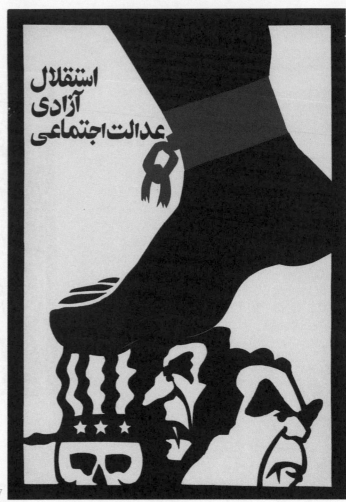

97

98

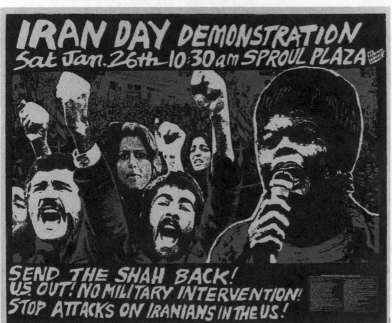

99

IRAN DAY DEMONSTRATION
Sat Jan. 26th 10:30am SPROUL PLAZA

SEND THE SHAH BACK!
U.S. OUT! NO MILITARY INTERVENTION!
STOP ATTACKS ON IRANIANS IN THE US!

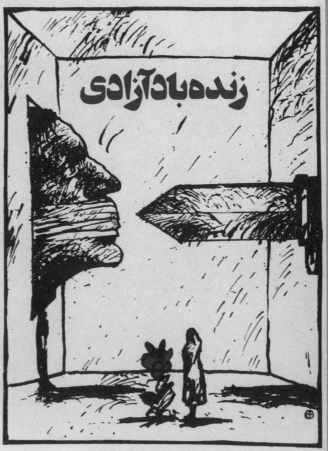

100

country was very risky, and this is why there are not more in this particular collection. Most people shredded or burned these sorts of documents in the years following the revolution, and their existence today is a testimony to the complexity of the political context and movements of the time. In an attempt to cleanse or eradicate political democracy or diversity, the Islamic regime has relentlessly pursued destroying archives and traces of the origins of the revolution.

96. Photographer unknown, **Down with the Shah,** photograph from printed publication, 1979, Iran.

97. Nickzad Nodjoumi, **11 Ordibehesht [May 1]—Worker's Day,** offset lithograph poster, c. 1976, Iran.

98. Nickzad Nodjoumi, **Independence—Freedom—Social Justice,** offset lithograph poster, c. 1976, Iran.

99. San Francisco Poster Brigade (artist: Rachael Romero), **Iran Day Demonstration,** offset lithograph poster, 1980, USA.

100. Nickzad Nodjoumi, **Long Live Freedom,** offset lithograph poster, c. 1976, Iran.

GWANGJU UPRISING [1980, South Korea]

In May 1980, students in Gwangju revolted against the military dictatorship and marched in protest. In response, the South Korean military attacked the students, beating, bayoneting, and raping them. Shocked by the brutality, a massive number of Gwangju's citizens also took to the streets, fighting the military and occupying the city. On May 20, 200,000 of Gwangju's 700,000 citizens marched through the city and set up general assemblies, building a popular commune. The uprising lasted six days before being overwhelmed by the military. During the uprising, the population produced its own media, including newspapers and a new form of popular print making, which included cutting block prints out of rubber desk mats taken from occupied office buildings.

101–105. Hong Sung Dam, **Gwangju Uprising**, wood block prints, c. 1983–1989, South Korea.
101. Translation: The People of Gwangju Oppose the Government and the Military
105. Translation: Freedom for Gwangju/Fight to Overthrow the Government

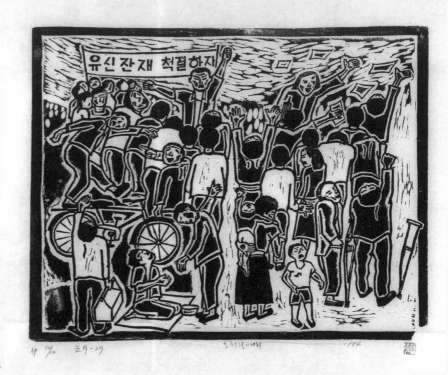

101

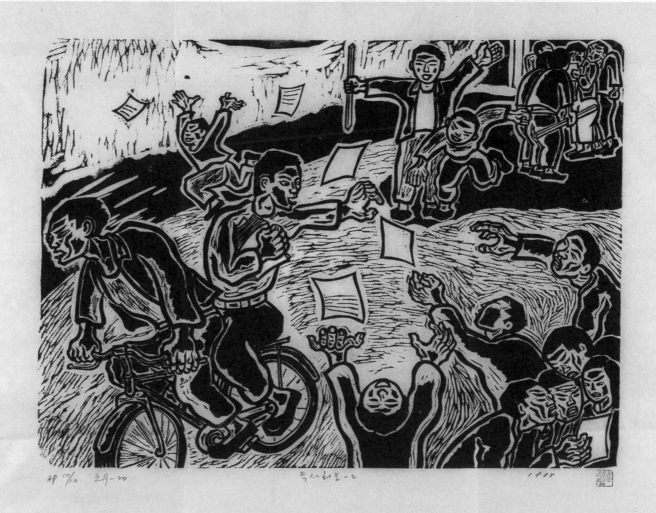

102

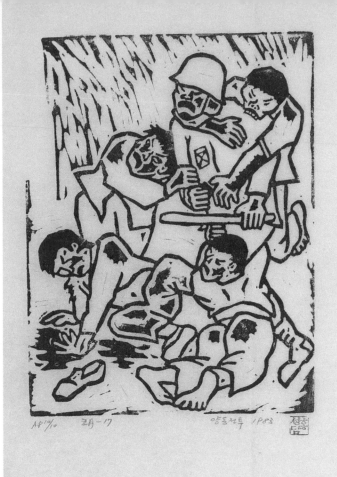

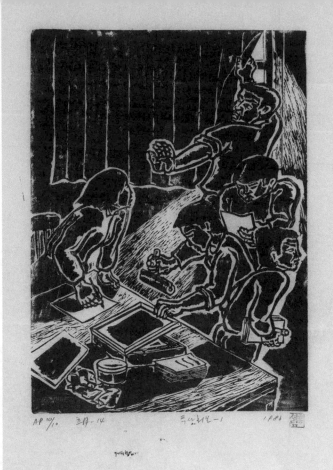

103

104

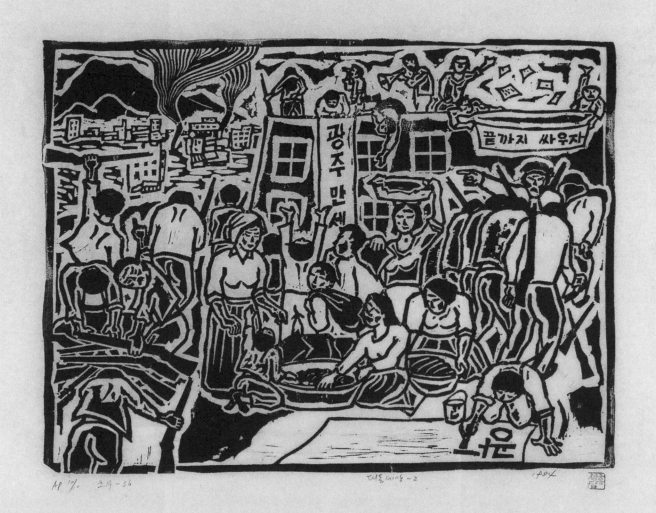

105

OAXACA TEACHERS STRIKE AND UPRISING [2006–2007, Mexico]

In May of 2006, teachers in the Mexican state of Oaxaca went on strike for much needed resources for their students and themselves. (The average teacher made approximately $120 US dollars a week, out of which they had to buy all school supplies. Schools in rural areas are, in many cases, huts where children used rocks and logs for seats.) The teachers occupied public squares and buildings in the state capital, Oaxaca City. When their demands were not met, and the government tried to evict them, 70,000 teachers along with 350 other organizations formed a political body called the Popular Assembly of the Peoples of Oaxaca (APPO). The APPO created multiple radio stations in order to communicate to other Oaxacans, and took over the state-run television station. In the fall of 2006, support for the strike swelled, demonstrations had some 800,000 participants, and all called for the resignation of corrupt governor Ulises Ruiz. At the end of October, paramilitary forces shot at protestors and killed three people, including two locals and one US journalist. The next day federally-backed riot police came in. Throughout it all, murals, graffiti, printmaking, video, and radio played important roles in the movement.

106

107

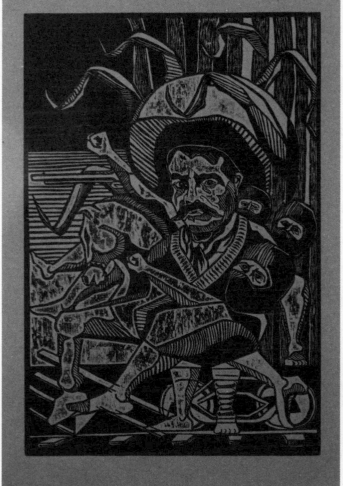

108

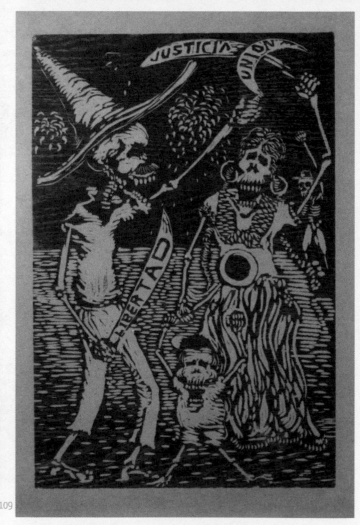

109

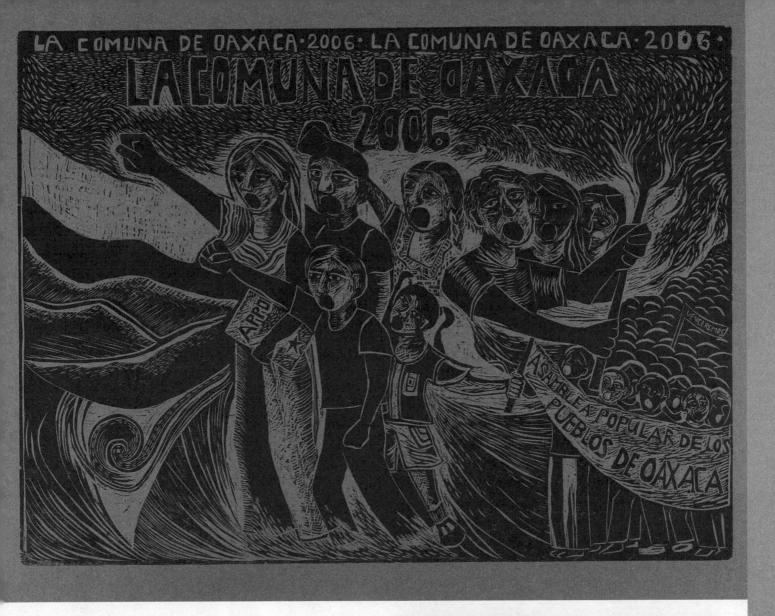

106. Katie Orlinsky, **Oaxaca**, photographic documentation, 2007, Mexico.

Performative street demonstrations were an important part of the struggle.

107. Katie Orlinsky, **Graffiti**, photographic documentation, 2006, Mexico.

Graffiti, and in particular stencil art, swept through Oaxaca City as part of the struggle. Strikers and their supporters used the walls as a canvas to broadcast information and opinions that weren't being distributed by mainstream channels.

108. ASARO, **Untitled**, relief print, 2006, Mexico.

In response to a call by the Oaxaca Peoples Assembly (APPO) for artists to organize, the Oaxacan Assembly of Revolutionary Artists (ASARO) was formed in October 2006. ASARO is made up of artists working in a variety of media, but is most well known for its stencils and relief prints, which are both wheat pasted on the streets of Oaxaca and sold in public markets. The role of ASARO in Oaxaca has been controversial. Some members are also part of the

Popular Revolutionary Front (FPR), a more traditional communist party grouping which has tried to split APPO in order to take part in elections.

In their mission statement, ASARO calls for: "The pursuit and development of a New and Free art, committed to our people who live in resistance, oppressed and alienated by the individualistic culture, decadent in every sense, that has been imposed upon them. We also call for the creation of spaces where our children and youth can develop their artistic creativity."

109. ASARO, **Justicia, Unidad, Libertad [Justice, Unity, Liberty]**, relief print, 2006, Mexico.

110. ASARO, **La Comuna de Oaxaca 2006 [The Oaxaca Commune 2006]**, relief print, 2006, Mexico.

111. Katie Orlinsky, **ASARO distributing their prints on the street**, photographic documentation, 2007, Mexico.

112. Katie Orlinsky, **Graffiti Writers**, photographic documentation, 2006, Mexico (following page spread).

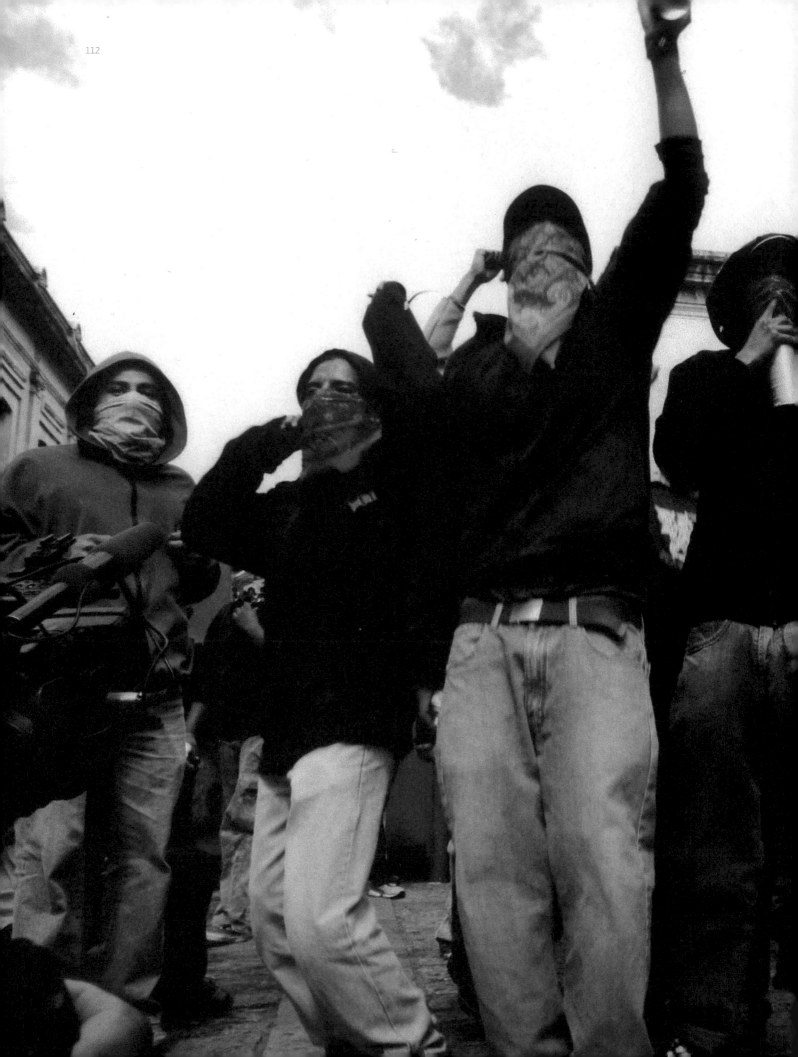

ORGANIZING THE PRECARIAT

[2001–present, International]

Economic precarity is a concept commonly used in Europe (and starting to gain currency elsewhere) to describe the lack of security or predictability in contemporary labor conditions. Precariousness, or precarity, describes a life where workers have no social safety net. This loss of job security and lack of benefits encompasses multiple types of contemporary labor situations, including "flexible" workers in creative industries, temporary workers, day laborers, immigrants working "illegally," and service sector employees. The conversion of so many types of workers and the traditional proletariat into a "precariat" has sparked these groups to organize in new and innovative ways. Starting in Italy in 2001 and then gaining momentum elsewhere, EuroMayDay is an updated version of the international day of worker solidarity—May 1. Convening each year in multiple European cities, EuroMayDay focuses on the rights of anyone who labors under precarious conditions. Since many artists, designers, and writers are freelance or precarious workers, these groups, and their creative work, are integral to EuroMayDay propaganda and performance.

113. EuroMayDay Berlin (artist: image-shift berlin), **1. Mai: Heraus Zur Mayday Parade [May 1st: Out to the MayDay Parade]**, set of 3 offset lithograph posters (2 shown), 2007, Germany.

Translation: Take back your life/Solidarity instead of precarity/Super-friendly, super-creative, super-flexible, super-busy, super-cheap . . . but WTF? Is it enough?/May 1st: Out to the MayDay Parade

114. EuroMayDay Berlin (artist: image-shift berlin), **MayDay 08**, set of 7 offset lithograph posters (3 shown), 2008, Germany.

Translation: ISTRESS/Career, Ego and Solidarity/1st of May 2 o'clock/Boxhagener place/Friedrichshain/Berlin. All out on Mayday! Come with us to the MayDay Parade 2008: demonstrate, dance, move—for the precariat in the making, the lust of solidarity, a city for all and the organized "istrike"... against the market inside our heads. We are part of Our Corp., our Stock Exchange is the street, sometimes also the kitchen table. The battery is loaded, the iPod broken. Who Cares? In this sense—Be MayDay.

115. Miles de Viviendes, **Tarot de Barcelona**, offset printed set of cards with box, 2007, Spain.

The Tarot of the Present-to-Come, a poetic tool for reading the precariousness of the future.

116. EuroMayDay Italy, **EuroMayDay Parade 08**, offset lithograph poster, 2008, Italy.

117. EuroMayDay Italy, **EuroMayDay Parade 006**, offset lithograph poster, 2006, Italy.

118. EuroMayDay Italy, **EuroMayDay Parade 04**, offset lithograph poster, 2004, Italy/Spain.

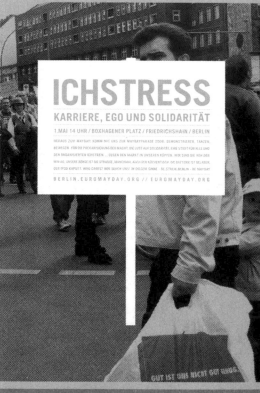

La Precariedad

El Trabajo

La Hipoteca

Tarot
(del Present-Per-Venir)
de Barcelona

La Grieta

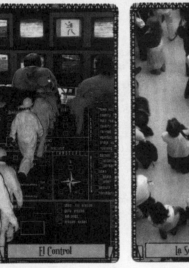

El Control

La Soledad

euro Mayday Parade 1° maggio 2008

MILANO P.TA TICINESE ORE 15

euro **MAYDAY**

NO BORDERS NO PRECARITY

...day.org

Let's conspire&fight for the Other Europe

...ne per i/le migranti. Chiusura di tutti i cpt! Reddito per tutti/e. ...lavoro e oltre il lavoro: case, salute ed istruzione, pubbliche gratuite ...er l'accesso libero e condiviso ai saperi – Contro la precarizzazione e il ...fini: autorganizzazione e transnazionalizzazione delle lotte!

Join a parade near YOU!

Barcelona Berlin Copenhagen Hamburg Helsinki L'Aquila Léon Liège London Maribor Milano Napoli Palermo Paris Sevilla Torino Tornio Wien

lunedì 1° maggio

euro **Mayday** Parade 006

Milano P.ta Ticinese ore 15

NON à la précarité

www.euromayday.org

Party, action&protest for social equality in Europe

The first of May of queer temps, immigrant part-timers, student stagiaires, nomadic free-lancers, pregnant flex-workers

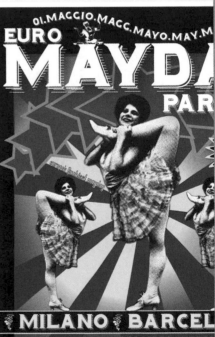

01.MAGGIO.MAGG.MAYO.MAY.M

EURO **MAYDA**

PAR

MILANO BARCEL

ACTIONS · PIQUETE · PRECAIRES · INTERN PARTIMERS · CICLOPRECARI · HUELGAS · HACKTIV MUZIK · PERMATEMPS · STRIKES · PRECO PACE · WWW.EUROMAYDAY.O

PRECARI COGNIT PER DIRITTI SOCIALI EU

FORWARD TO P

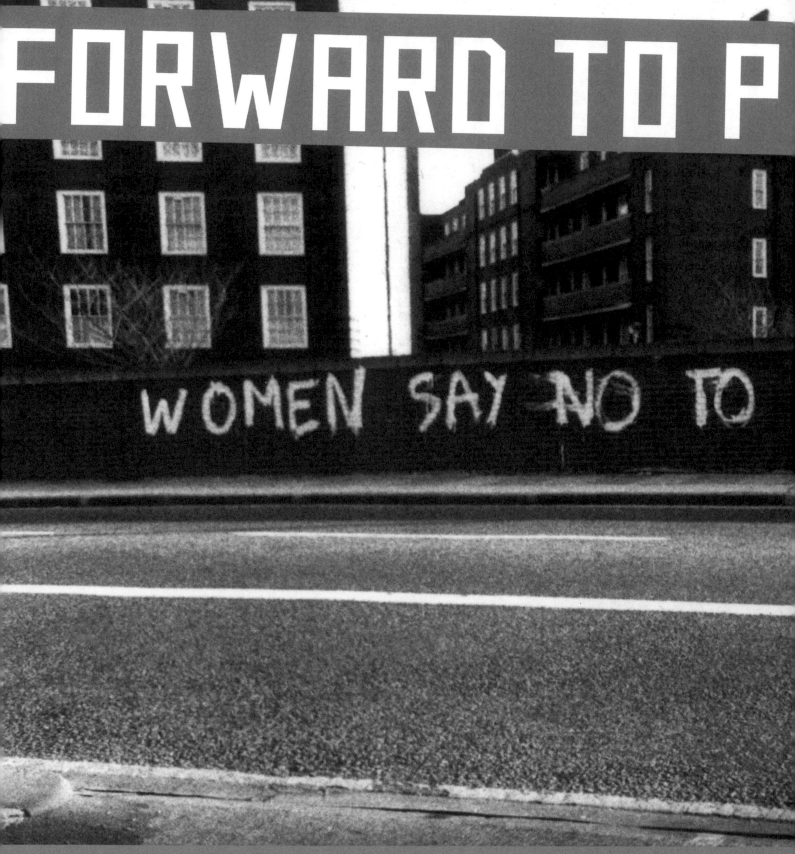

WOMEN SAY NO TO

Movements organized and led by women, people of color, and oppressed groups of many kinds have radically changed society and transformed understandings of how power operates in the world. The post-war Civil Rights Movement in the United States and women's and queer liberation internationally are just a few of the countless examples of people fighting for equality for all. Many of these movements found voice in the culture they produced, which took the form of posters, protest placards, newspapers, buttons, and music.

*119. Jill Posener, **Women Say No to Male Violence**, photographic documentation of graffiti, 1980, UK.*

THE CIVIL RIGHTS MOVEMENT [1955–1968, USA]

The Civil Rights Movement in the US in the early 1960s was an important moment in African American struggles and influenced protest internationally. By combining powerful civil disobedience techniques, like Ghandhian sit-ins, effective grassroots organizing, boycotts, mass marches, and successfully using news coverage in television and other media to their advantage, the movement helped spark an entire generation committed to resistance and change. Because of the savvy use of mainstream media, the ideas and images of the movement were broadcast across the globe, inspiring activism world-wide.

Mass-based organizing was achieved through the work of multiple organizations, including the Student Non-Violent Coordinating Committee (SNCC), Congress On Racial Equality (CORE), and the Southern Christian Leadership Conference (SCLC). Culture was an important part of the movement, as exhibited by the songbook and record created by CORE. The Civil Rights Movement worked on multiple fronts, including, but not limited to, education, transportation, community control, and labor organizing—which the iconic I AM A MAN placards from the 1968 sanitation strike in Memphis demonstrate.

120

120. Student Non-Violent Coordinating Committee (artist unknown), **SNCC**, button, c. 1966, USA.
121. Student Non-Violent Coordinating Committee (artist unknown), **Is He Protecting You?**, offset lithograph poster, 1966, USA.
122. Congress On Racial Equality/CORE (artist unknown), **Sit-In Songs**, lyric booklet from music LP, 1966, USA.
123. Ernest Withers, **I Am a Man**, photographic documentation, 1968, USA.

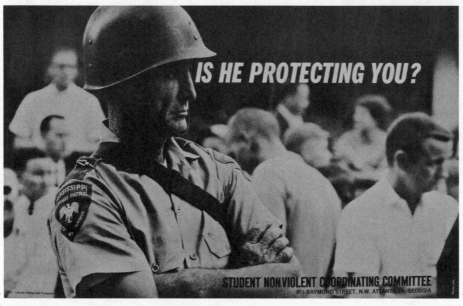

121

122

123

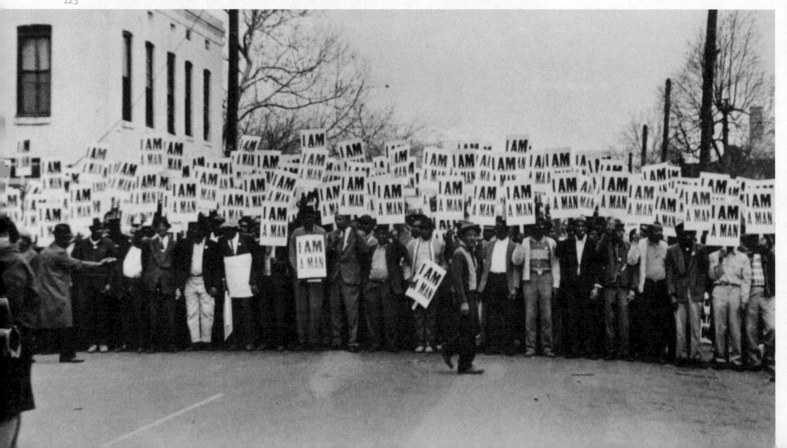

THE BLACK PANTHERS [1966–1980s, USA]

Following the assassination of Malcolm X, many black people in the US Civil Rights Movement became more strident, calling for Black Power. The most visible representation of this shift was the Black Panther Party, initially called the Black Panther Party for Self Defense. Militant, and in many instances armed, the Black Panther Party was created to protect, liberate, nurture, and educate African Americans. The Party was extremely adept at furthering its struggle through creative self-representation and cultural production, as well as providing for the needs of its communities through Free Breakfast for Children programs, free medical clinics, and a variety of other social programs. In their newspapers, posters, and pamphlets, the Black Panthers spread their ideas through writing and graphics.

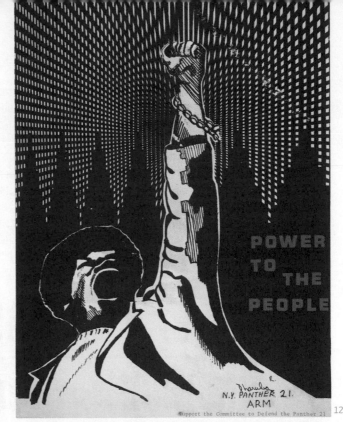

POWER TO THE PEOPLE

N.Y. PANTHER 21. ARM

Support the Committee to Defend the Panther 21 125

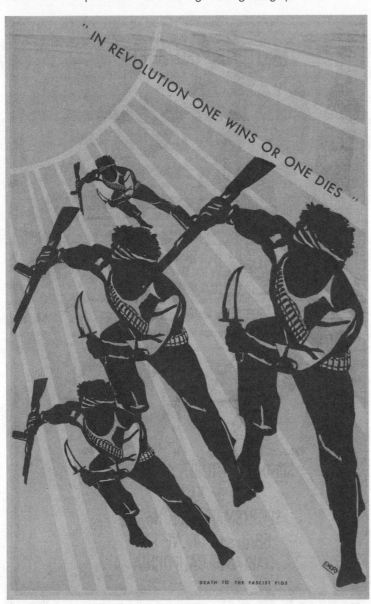

" IN REVOLUTION ONE WINS OR ONE DIES "

DEATH TO THE FASCIST PIGS

124

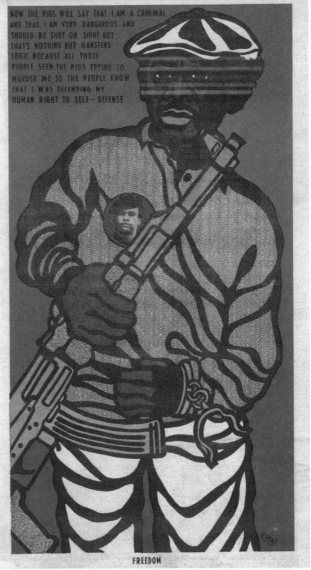

NOW THE PIGS WILL SAY THAT I AM A CRIMINAL AND THAT I AM VERY DANGEROUS AND SHOULD BE SHOT ON SIGHT BUT THAT'S NOTHING BUT GANSTERS LOGIC BECAUSE ALL THOSE PEOPLE SEEN THE PIGS TRYING TO MURDER ME SO THE PEOPLE KNOW THAT I WAS DEFENDING MY HUMAN RIGHT TO SELF — DEFENSE

FREEDOM 126

124. Black Panther Party (artist: Emory Douglas), **Death to the Fascist Pigs**, offset lithograph poster printed in *The Black Panther* newspaper, 1966, USA.

125. The Committee to Defend the Panther 21 (artist: R. Dhoruba), **Power to the People**, offset lithograph poster, 1970, USA.
 This poster was produced to support the campaign to free the Panther 21, the New York City Black Panther leadership who were facing charges of conspiracy to blow up the New York Botanical Gardens. In May 1971, after the longest political trial in New York history, all twenty-one Panthers were acquitted after just forty-five minutes of jury deliberation.

126. Black Panther Party (artist: Emory Douglas), **Freedom**, offset lithograph poster printed in *The Black Panther* newspaper, 1968, USA.

BLACK LIBERATION ARMY [1960s–1980s, USA]

During and after the US government's repression of the Black Panther Party—with such initiatives as the FBI's counterintelligence programs (COINTELPRO), created to neutralize political dissidents—a number of factions of the Black liberation movement went underground, creating militarized cells within what has loosely been dubbed the Black Liberation Army (BLA). This guerrilla army carried out bank robberies to fund community organizing; attacked police stations and other sites judged genocidal to people of color; and attempted to build the infrastructure to successfully wage a war of independence from the US in order to secure Black people's self-determination. The activities of the BLA were most widely publicized through the escape from prison of one of its members, Assata Shakur. In the late 1970s, Assata Shakur became a symbol of Black resistance, and was extremely popular in the African American community, many putting up "Assata Shakur Is Welcome Here" signs in their windows when she was on the run after her escape.

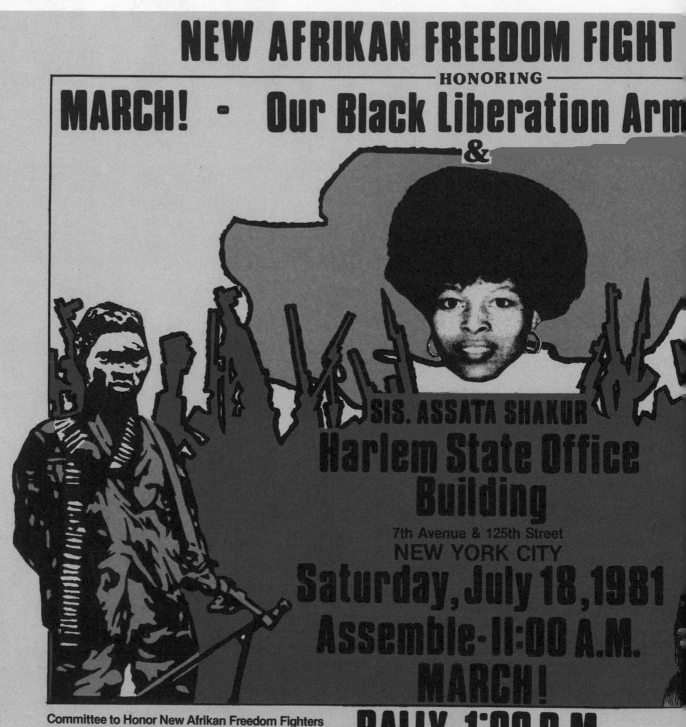

NEW AFRIKAN FREEDOM FIGHT

— HONORING —

MARCH! - Our Black Liberation Arm
&

SIS. ASSATA SHAKUR
Harlem State Office Building
7th Avenue & 125th Street
NEW YORK CITY
Saturday, July 18, 1981
Assemble-11:00 A.M.
MARCH!
RALLY-1:00 P.M.
(Back At Assembly Point)

Committee to Honor New Afrikan Freedom Fighters
P.O. Box #1184 Manhattanville Station New York, NY 10027 (212) 864-6944

127. Committee to Honor New Afrikan Freedom Fighters (artist unknown), **New Afrikan Freedom Fighter Day**, screen print, 1981, USA.

128. Madame Binh Graphics Collective (lead artist: Mary Patten), **Support Black Liberation, Free Assata Shakur**, screen print, c. 1980s, USA.

The Madame Binh Graphics Collective (MBGC) (1975–1985) was a poster and print making collective comprised primarily of women. They were the propaganda arm of the May 19th Movement, a splinter group of the Weather Underground, and named after Nguyen Thi Binh, the North Vietnamese lead negotiator at the Paris Peace Talks. MBGC created many posters in support of the Black Liberation Movement, Puerto Rican Independence, and the liberation struggles in Palestine and Zimbabwe.

129. Republic of New Afrika (artist: Madame Binh Graphics Collective), **Assata Shakur is Welcome Here**, offset lithograph poster, 1979, USA.

130. African People's Party (artist unknown), **Black Revolution**, printed publication, 1980, USA.

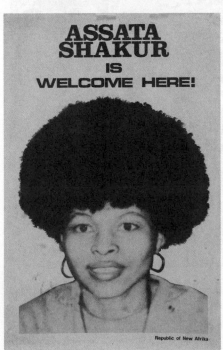

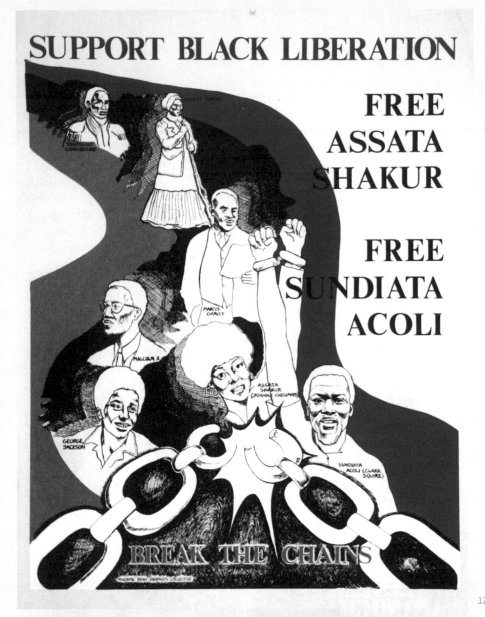

128

129

130

THE ATTICA UPRISING AND PRISONER STRUGGLES [1970s-1980s, USA]

In 1971, prompted in part by the shooting death of imprisoned Black Panther George Jackson by guards at California's San Quentin Prison, some 1,300 prisoners of Attica Prison in Attica, NY, rioted and took over the prison to protest the inhumane conditions at the facility. The prisoners demanded improved living conditions, removal of the warden, access to educational and vocational programs, and amnesty to those participating in the revolt. On the fifth day, National Guard, prison guards, and police attacked the prison, killing twenty nine prisoners and ten prison employees. After

the takeover, guards tortured the prisoners. The riot also focused media attention on US prison conditions and made these issues part of large public dialogues. (New York State continues to pay reparations to prisoners and their families for the abuse suffered.)

Attica was only the most visible example of the vast unrest in the US prison system. The 1970s saw both an explosion of prison populations and of resistance, with prisoners across the country not only rioting for better conditions, but organizing classes and publications inside prison walls in association with those outside.

132

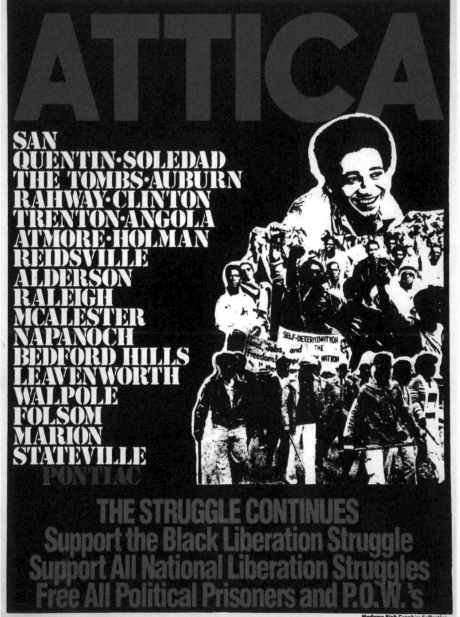

131

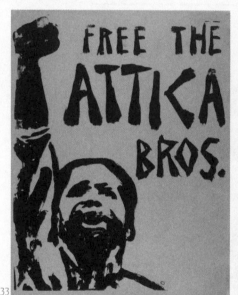

133

134

131. Madame Binh Graphics Collective (lead artist: Laura Whitehorn), **Attica**, screen print, 1978–1979, USA.
132. Anarchist Black Dragon, **Anarchist Black Dragon #8**, printed publication, 1981, USA.

The *Anarchist Black Dragon* was a revolutionary prison publication, created by prisoners in the Washington State

Penitentiary in order to resist oppressive prison conditions as well as struggle for social change outside the prison walls.
133. Artist unknown, **Free the Attica Bros.**, screen print, 1971, USA.
134. United Prisoners Union (artist unknown), **United Prisoners Union**, screen print, 1973, USA.

THE YOUNG LORDS [1960s–1980s, USA]

Founded in Chicago in 1968, the Young Lords was an organization that called for the self-determination of the Puerto Rican people. Soon after, a chapter was created in New York City and others were started in a dozen additional cities. The Young Lords took on many issues important to Puerto Rican people, including Puerto Rican independence, a socialist economic system, women's equality, and community-controlled health care and housing. Their activities included the occupations of buildings for housing; food, health care, and education programs; and the development of a strong propaganda apparatus, producing multiple newspapers as well as flyers and posters to support their political demands for the Puerto Rican community.

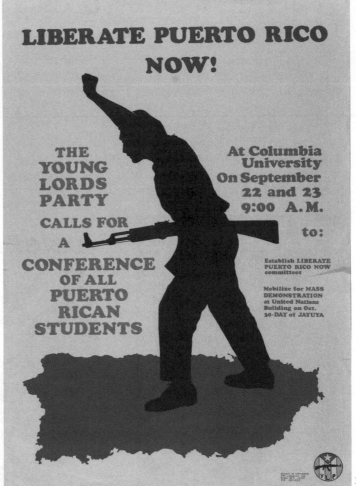

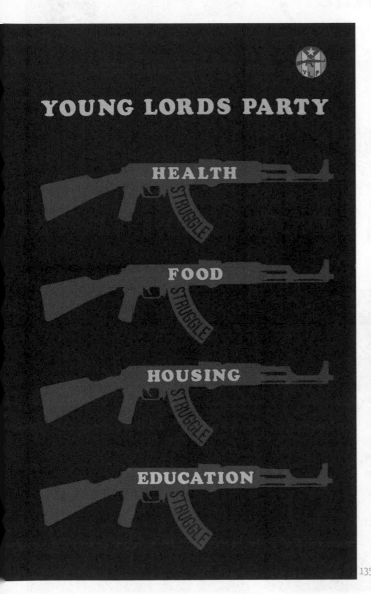

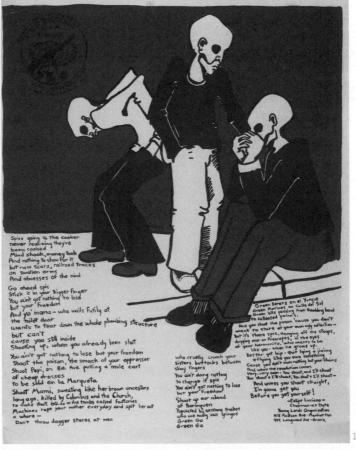

135. Young Lords Party (artist unknown), **Young Lords Party: Health, Food, Housing, Education,** offset lithograph poster, 1971, USA.
136. Young Lords Party (artist unknown), **Liberate Puerto Rico Now!,** offset lithograph poster, 1971, USA.
137. Young Lords Party (artist: Denise Oliver), **Young Lords Organization,** screen print, c. 1970s, USA.

WOMEN'S LIBERATION MOVEMENT [1960s–present, International]

As workers, students, and racial groups mobilized for political power and autonomy, women began to question whether the movements they were participating in were addressing their rights as women. Building on women's long struggle for equality, in the 1960s an international movement rose up to fight for economic equality, reproductive rights, and an end to violence against women. This new women's liberation movement initially attacked beauty pageants and other public symbols of patriarchy, while at the same time creating women's unions, newspapers, and print shops. In the 1970s, women developed an analysis of their central role in society and the economy, demanding wages for housework and leadership roles in organizing their communities. In the 1980s, women in the UK set up a permanent encampment around the Greenham Common military base. Their direct actions against the proliferation of nuclear weapons also made links between gender oppression, environmental degradation, and the threat of nuclear war (see page 127). Today, INCITE! Women of Color Against Violence initiates grassroots organizing, dialogue, and direct action campaigns against all violence to make visible connections between domestic violence and state perpetuated violence such as war, police violence, and abuses of colonialism.

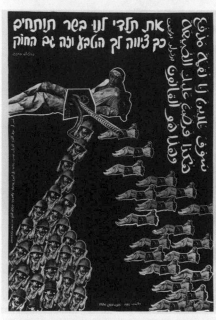
138

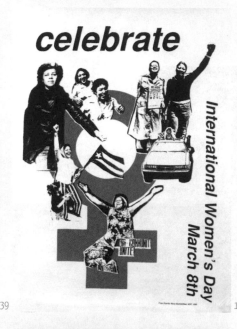
139

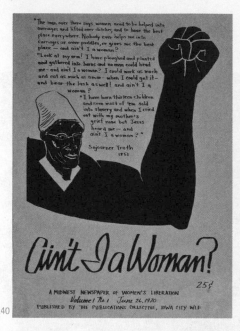
140

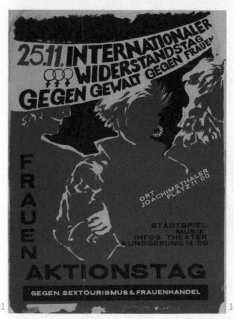
141

142

143

138. Artist unknown, **You Should Bear Cannon Fodder**, offset lithograph poster, c. 1990s, Israel.

139. Free Puerto Rico Committee (artist unknown), **Celebrate International Women's Day**, screen print, 1990, USA.

140. Iowa City Women's Liberation Front (artist unknown), **Ain't I A Woman**, offset lithograph poster, 1970, USA.

141. Artist unknown, **Frauen Aktionstag [Women's Action]**, offset lithograph poster, c. 1980s, Germany.

Translation: International Resistance to Violence Against Women/Smash Sex Tourism & the Sale of Women.

142. Artist unknown, **No real mass movement can exist without the participation of women**, offset lithograph poster, 1979, Iran.

143. INCITE! (artist: Favianna Rodriguez), **We Resist Colonization!**, offset lithograph poster, 2004, USA.

144. See Red Women's Workshop, **Protest**, screen print, 1976, UK.

The See Red Women's Workshop was one of many women's print shops that developed out of the women's liberation movement and the need for women to have their own means to distribute and promote ideas. Started in 1976, See Red was a cooperative that originally produced silkscreen posters (this is one of their earliest), and eventually acquired the equipment to mass-produce offset printed posters.

145. SisterSerpents, **Fuck a Fetus**, offset lithograph poster, 1989, USA.

SisterSerpents was a feminist art collective formed in 1989 that plastered the streets of Chicago with their DIY style artworks, posters, and stickers. Known for an unapologetically

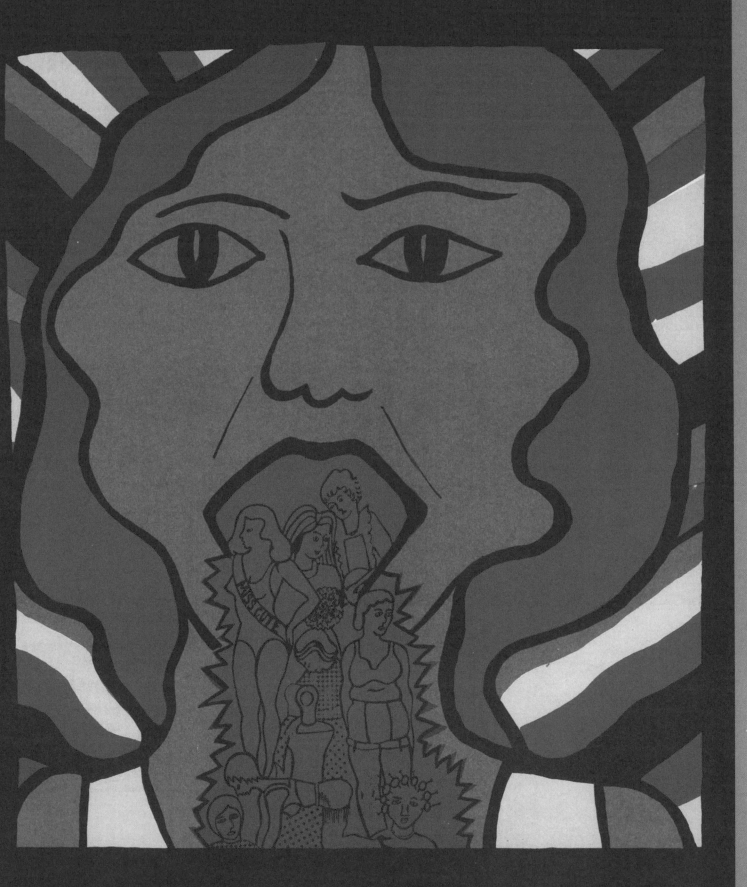

PROTEST

144

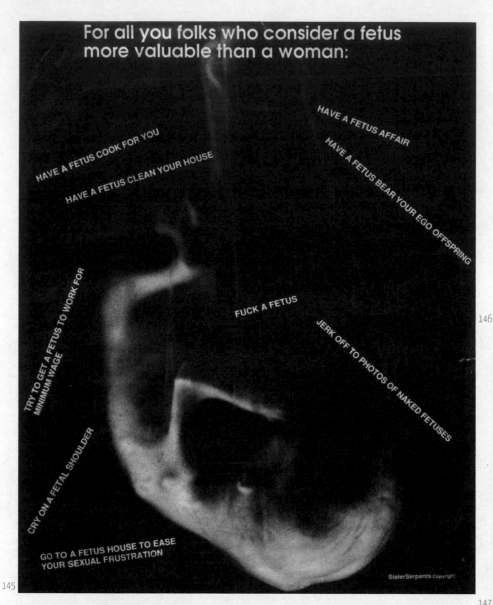

For all you folks who consider a fetus more valuable than a woman:

HAVE A FETUS COOK FOR YOU
HAVE A FETUS CLEAN YOUR HOUSE
HAVE A FETUS AFFAIR
HAVE A FETUS BEAR YOUR EGO OFFSPRING
TRY TO GET A FETUS TO WORK FOR MINIMUM WAGE
FUCK A FETUS
JERK OFF TO PHOTOS OF NAKED FETUSES
CRY ON A FETAL SHOULDER
GO TO A FETUS HOUSE TO EASE YOUR SEXUAL FRUSTRATION

SisterSerpents Copyright

145

146

More Than a Choice
WOMEN TALK ABOUT ABORTION

147

We Celebrate Women's Struggles
We Celebrate People's Victories.

THE MOUNTAIN IS ONLY SO HIGH...
OUR CAPACITY IS WITHOUT LIMIT.
THE STARS MOVE; OUR WILL IS UNSHAKABLE!

INSCRIPTION ON THE WALLS OF A CELL: CON SON WOMEN'S PRISON, SOUTH VIET NAM
(Liberated April 30 1975)

149

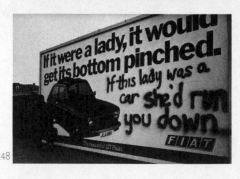

148

"pissed-off" stance, the collective intentionally and illegally placed their work in public spaces to provoke conversations about physical and sexual violence against women, sexist advertising and media, the prevalence of eating disorders among young women, the eroding of abortion rights, and Operation Rescue, a right-wing campaign to end abortion.

146. Chicago Women's Graphics Collective, **Women Declare War on Rape**, screen print, 1970, USA.

147. Abortion Action Coalition (artist unknown), **More Than A Choice**, printed publication, 1978, USA.

148. Jill Posener, **If this Lady was a Car**, photographic documentation, 1979, UK.

149. Inkworks Press (artist: Susan Shapiro), **We Celebrate Women's Struggles**, offset lithograph poster, 1975, USA.

WOMEN'S PRINTSHOPS [1960s–1980s, International]

Many print workshops and collectives for women formed out of the women's liberation movement in the 1970s and into the 1980s, including those represented on this page: Creative Women's Collective (New York), See Red Women's Workshop (London), The Chicago Women's Graphics Collective (Chicago), Everywoman Press (Melbourne), and Madame Binh Graphics Collective (New York). These groups gave women the means to disseminate their ideas by teaching them how to produce prints, flyers, posters, and publications, most often collectively. Groups used both silkscreen and offset printing techniques. The printed materials not only reflected women's issues, but often were produced in consultation and solidarity with other movements.

150. Everywoman Press (artist unknown), **Everywoman Press**, screen print, 1976, Australia.
151. Creative Women's Collective (artists: Bernadette Evangelist, Bea Kreloff, Kathy Hopfer, Jacqueline Skiles), **International Women's Day 1977**, screen print, 1977, USA.
152. See Red Women's Workshop, **Catalog poster**, offset lithograph poster, c. 1970s, UK.
153. Madame Binh Graphics Collective, **Silkscreen Class for Women**, photocopied flyer, 1981, USA.
154. Chicago Women's Graphics Collective, **Catalog**, printed publication, 1979, USA.

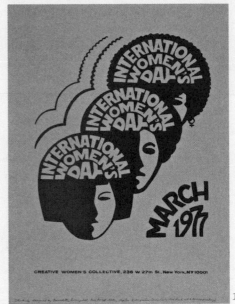

151

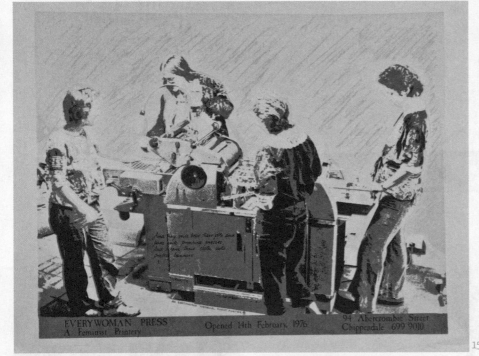

150

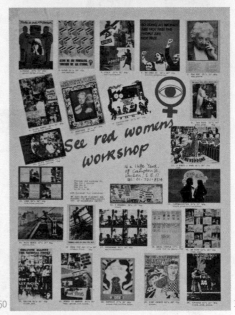

152

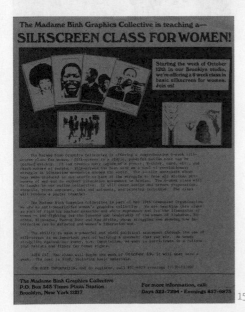

153

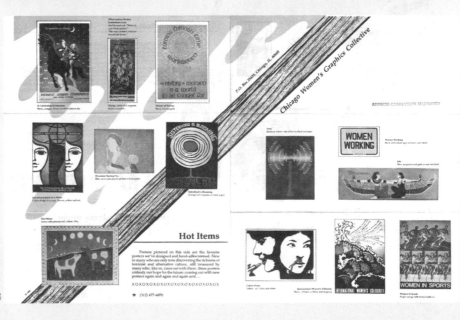

154

QUEER LIBERATION MOVEMENT

[1969–present, International]

Although people had been organizing for more than a hundred years for gay, transgender, and lesbian rights and visibility, the Gay Liberation Movement became highly visible and more powerful after the 1969 Stonewall Riot in New York City. This important event in gay, lesbian, bisexual, transgender, and two-spirit history, was followed by the formation of many direct action groups, including the Gay Liberation Front (New York, founded 1969), the Lavender Menace (New York, founded 1970), Lesbian Feminist Liberation (New York, founded 1973), and the Front Homosexuel d'Action Revolutionnaire/FHAR (Paris, founded 1971), to name a few. These groups promoted their mix of queer identity and revolutionary politics with direct action, posters, underground publications, and theatrical street actions, demanding a total rethinking of gender, family, and other dominant social structures. In conjunction with the new social movements of the time, they called for "Gay Power" and sexual liberation, rather than simply gay rights. The term "queer" was later adopted to be inclusive of the multiplicity of sexual and gender expressions and identities. More recent groups that have followed in the tradition of radical organizing and analysis include Queer Nation (New York, founded 1990), Gay Shame (US, founded 1998), Queercore (US/UK, 1980s), and Bash Back! (US, founded 2007).

156

157

Girls Against Gender Assignment

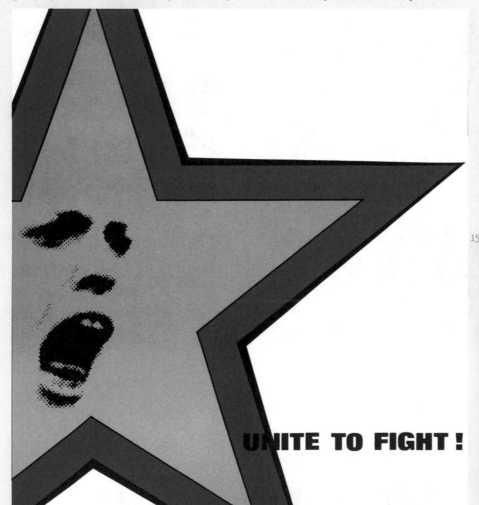

UNITE TO FIGHT !

JUNE 28/ DAY OF SOLIDARITY WITH GAY STRUGGLES

155

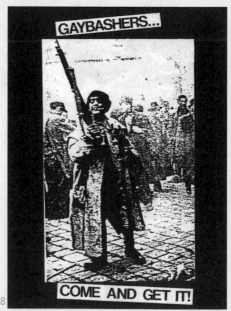

158

155. Inkworks Press (artist: Inkworks/Su Negrin), **Unite to Fight!**, offset lithograph poster, 1976, USA.
156. jt bunnell and irit reinheimer, *Girls Will Be Boys Will Be Girls Coloring Book*, printed publication, 2002, USA.
157. jt bunnell and irit reinheimer, **GAGA**, page from coloring book, 2002, USA.
158. "John," **Gaybashers…Come and Get It!**, photocopied flyer, c. 1980s, UK.

159. Gay Liberation Front (artist unknown), **Gay Liberation Front: Right On!**, offset lithograph poster, 1973, UK.
160. Come! Unity Press (artist unknown), **Demonstrate**, offset lithograph poster, 1973, USA.
 Poster for a demonstration at the American Museum of Natural History, New York on Sunday, August 26, 1973. This poster was for the demonstration that is documented in the video entitled *Purple Dinosaur Action* by L.O.V.E.

161. Times Change Press (artists: Su Negrin/Peter Hujar/Suzanne Bevier), **Gay Liberation**, offset lithograph poster, 1970, USA.
162. Lesbian and Gay Campaign Against Fascism & Racism (artist unknown), **Queer Nation Berlin**, offset lithograph poster, 1992, Germany.
Translation: Queer Nation Berlin calls for/invites you to an information and discussion event on approaches and perspectives of a lesbian-gay, antifascist analysis and resistance.

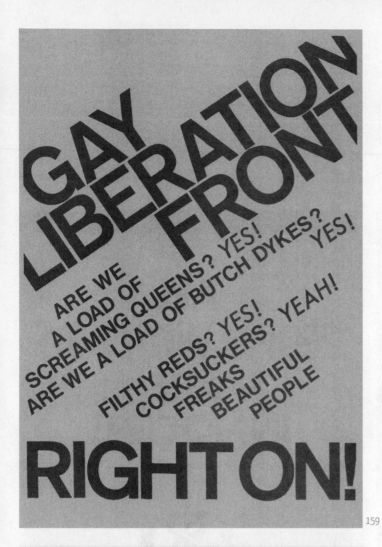

159

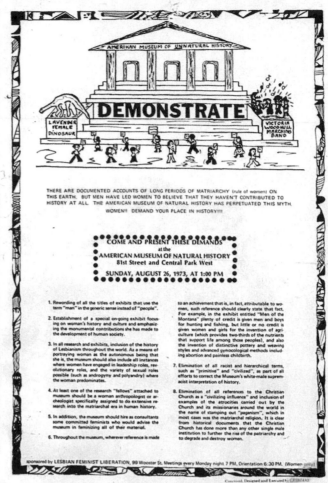

THERE ARE DOCUMENTED ACCOUNTS OF LONG PERIODS OF MATRIARCHY (rule of women) ON THIS EARTH. BUT MEN HAVE LED WOMEN TO BELIEVE THAT THEY HAVEN'T CONTRIBUTED TO HISTORY AT ALL. THE AMERICAN MUSEUM OF NATURAL HISTORY HAS PERPETUATED THIS MYTH.

WOMEN!! DEMAND YOUR PLACE IN HISTORY!!!

COME AND PRESENT THESE DEMANDS at the AMERICAN MUSEUM OF NATURAL HISTORY 81st Street and Central Park West

SUNDAY, AUGUST 26, 1973, AT 1:00 PM

160

GAY LIBERATION

161

QUEER NATION BERLIN

ruft auf/ lädt ein

zu einer informations- und diskussionsveranstaltung über ansätze und perspektiven einer lesbischen-schwulen antifaschistischen analyse und gegenwehr

4 Okt. 1992
19 uhr

SO 36
oranienstraße 190
1000 Berlin 36

es sprechen u.a. vertreterinnen der lesbian and gay campaign against fascism and racism (gb)

162

ACT UP AND AIDS ORGANIZING [1987–present, International]

In the 1980s, marginalized communities affected by a new and misunderstood disease began organizing for their rights. Their work made the disease visible and reframed it not as just a health crisis, but as a political issue. Organizing for health care, scientific research, and an end to discrimination, among other demands, the movement became international and is still visible today. An influential US group in this movement was ACT UP (AIDS Coalition to Unleash Power). ACT UP is a direct action group formed in response to the AIDS crisis. Its many victories include successfully using media, culture, and creativity to

make spectacular public actions and to get the word out about government inaction and media stereotypes concerning people with AIDS. Although the US movement is no longer as active as it was in the beginning, a number of ACT UP chapters continue to organize. Groups around the world—including the Treatment Action Campaign in South Africa, who are influenced by direct action, trade unionism, and anti-apartheid struggles—continue the fight for the rights of people with HIV/AIDS.

This Political Scandal Must Be Investigated!

54% of people with AIDS in NYC are Black or Hispanic... AIDS is the No. 1 killer of women between the ages of 24 and 29 in NYC...

By 1991, more people will have died of AIDS than in the *entire* Vietnam War... What is Reagan's *real* policy on AIDS!

Genocide of all Non-whites, Non-males, and Non-heterosexuals?...

SILENCE = DEATH

163

ALL PEOPLE WITH AIDS ARE INNOCENT

SPRING AIDS ACTION '88: Nine days of nationwide AIDS related actions & protests.

Gran Fury

164

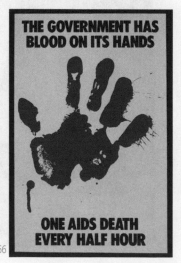

165 166

163. ACT UP (artist: SILENCE=DEATH Project), **AIDSGATE**, offset lithograph poster, 1987, USA.
164. ACT UP (artist: Gran Fury), **All People with AIDS are Innocent**, offset lithograph poster, 1988, USA.

Gran Fury was a collective of artists and designers who operated as the unofficial propaganda wing of ACT UP. They formed in 1988 and operated until 1994, when seminal member Mark Simpson died. They produced a significant amount of the AIDS graphics used throughout the 1980s and 1990s, and were extremely successful at using simple images and text to make a powerful impact on an audience.
165. ACT UP (artist unknown), **AIDS Cure Now**, button, c. 1990, USA.
166. ACT UP (artist: Gran Fury), **The Government Has Blood On Its Hands**, sticker, 1988, USA.
167. SILENCE=DEATH Project, **Silence=Death**, offset lithograph poster, 1987, USA.

The Silence=Death graphic has become an international symbol for the AIDS crisis. It inverts the upside down pink triangle, the symbol that the Nazis forced homosexuals to wear in World War II concentration camps.

SILENCE=DEATH

Why is Reagan silent about AIDS? What is really going on at the Center for Disease Control, the Federal Drug Administration, and the Vatican?

Gays and lesbians are not expendable...Use your power...Vote...Boycott...Defend yourselves...Turn anger, fear, grief into action.

1987 AIDS Coalition To Unleash Power

During the past several decades, powerful grassroots movements for peace and democracy have risen up against repressive militarized states. From Chile to China, and across the globe, people have rebelled against totalitarian regimes. Although struggling in situations where unions, public organizations, and even speech were often violently repressed, these movements still found ways to get their messages out. In Czechoslovakia in 1968, after the Soviet invasion, people flooded into the streets and wrote graffiti on Soviet tanks, and in South Africa in the 1980s, community groups screenprinted posters under threat of firebombing and imprisonment.

168. David Goodman, **Democracy Wall**, photographic documentation, 1978–1979, China.

CZECH RESISTANCE TO SOVIET INVASION
[1968, Czechoslovakia]

In the spring of 1968, there was a thawing of Soviet and centralized control over Czechoslovakian society. Media, arts, and youth culture flourished during Prague Spring. But this lasted only for a short time. In August, fearing the influence of Czech freedom on the rest of the Eastern Bloc, the Soviet Union sent in tanks to take over the country. Both the blossoming of freedom and the resistance to the occupation created an outpouring of theater, art, posters, and graffiti. Handmade and printed posters covered walls, windows, and monuments in Prague and other Czechoslovakian cities.

169. Artist unknown, **Socialismus Ano, Okupace Ne!!!** [Socialism Yes, Occupation No!!!], hand drawn poster, 1968, Czechoslovakia.
170. Artist unknown, **Untitled**, hand drawn poster, 1968, Czechoslovakia.
171. Artist unknown, **1945–1968**, relief print, 1968, Czechoslovakia.

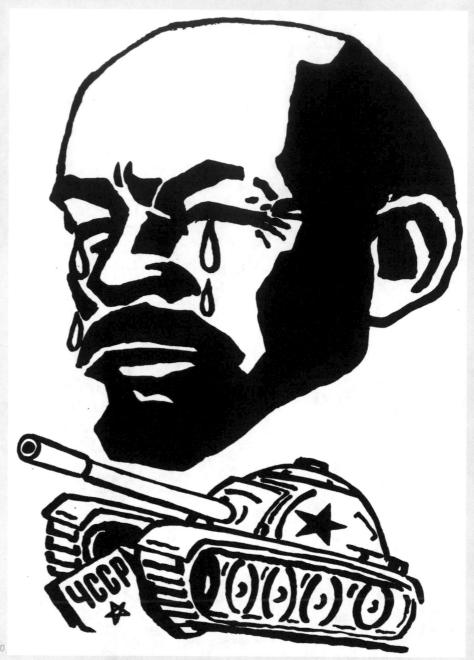

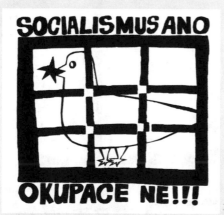

169
170

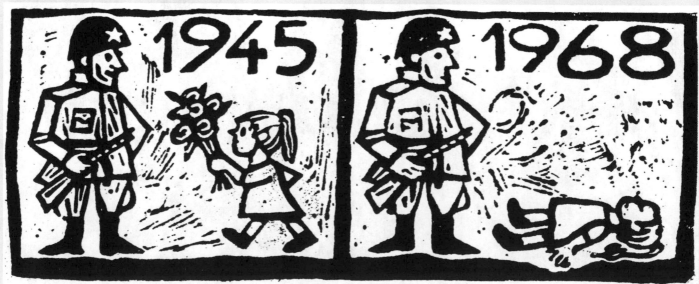

171

THE DEMOCRACY WALL

[1978–1979, China]

In 1978, a brick wall near the center of Beijing became the focus for democratic dissent in China. Activist poets and artists began expressing their ideas on the wall in the form of handwritten posters. A democracy wall movement spread to other cities—Shanghai, Guangzhou, and Wuhan. The Beijing Wall survived through 1979, but when activists became too critical of the Communist Party leadership, it was shut down in December of that year. The most well-known poster put on the wall was entitled "The Fifth Modernization" and was a signed by Wei Jingsheng. Indirectly criticizing the Chinese Communist Party's "Four Modernizations" campaign, it called for more democracy and individual liberties, and stated that only then would the other modernizations truly matter.

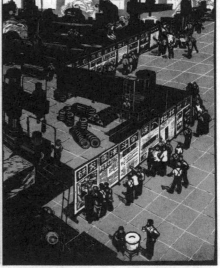

PROGRAMMA:
- **diaserie met indrukken van de reis**
- **inleiding over de demokratie in China**
- **aansluitend diskussie, onderwerpen: o.a.**
- **arbeiderskontrole**
- **vrijheid van meningsuiting**
- **rol partij**
- **positie kerk**

demokratie in china
verslag van een reis door China, zomer '78

PLAATS:	DATUM:
TIJD:	TOEGANG:

organisatie: Vriendschapsvereniging Nederland-China

173

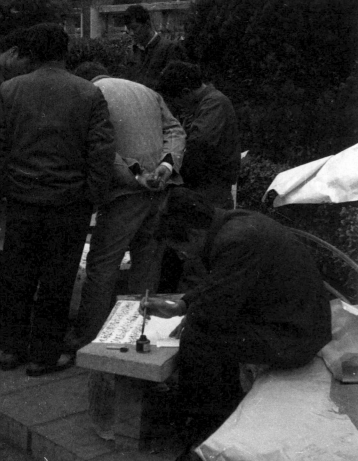

172. David Goodman, **Democracy Wall**, photographic documentation, 1978–1979, China.
173. Artist unknown, **Demokratie in China [Democracy in China]**, screen print, 1978, the Netherlands.

"Democracy" in Dutch would usually be written "democratie;" however, from the 1960s well into the 1980s, much of the left used alternate spellings, which were intended to imply more grassroots and direct democracy, in this example "demokratie." This is a solidarity poster with the Chinese movement.

Translation: Democracy in China/A report travels through China, summer of '78 (place, date, time, admission)/Organization: Dutch-Chinese Friendship League/Program: Overhead Projections with impressions of the journey. Introduction on democracy in China followed by discussion on several topics, such as: Workers' self control, Freedom of opinion, The role of the Party, Position of the church

CHILEAN RESISTANCE TO PINOCHET [1973–1988, Chile]

On September 11, 1973, US-backed General Augusto Pinochet led a military coup against Chile's democratically-elected government. Tens of thousands of people who opposed the coup were "disappeared" or publicly executed in Santiago's national football stadium (including the well-known musician Victor Jara). Since the situation was so violently repressive, resistant cultural forms were often masked in order to be produced.

174. Unidad Popular (artist unknown), **Chile No Acepta Insultos Extranjeros por Recuperar las Minas de Cobre [Chile Does Not Accept Insulting Foreign Control of the Copper Mines]**, offset lithograph poster, c. early 1970s, Chile.
175. Socialist Student Union of Finland (artist unknown), **Chile Septiembre 1973–Septiembre 1974**, offset lithograph poster, 1976, Finland.
176. Artist unknown, **Solidarität Mit Chile [Solidarity with Chile]**, offset lithograph poster, 1973, Germany.
Translation: 100,000 Matchboxes
177. Chile Resistance Committee (artist: Ricardo Levins Morales), **Chile: ¡La Resistencia Continua!**, offset lithograph poster, c.

1980s, USA.
178. Artist unknown, **Libertad [Freedom]**, hand quilted *arpillera*, c. 1980s, Chile.

Many Chilean women expressed their opposition to Pinochet through *arpilleras*—three-dimensional appliquéd textiles. These were often created in workshops supported by leftist Catholic churches. The *arpilleras* helped get the word out to an international community about the torture and violence in Chile.

179. Artist unknown, **No Muerte [No Death]**, hand-quilted *arpillera*, c. 1980s, Chile.
180. Artist unknown, **Por La Libre Expresíon [For Freedom of Speech]**, hand-quilted *arpillera*, c. 1980s, Chile.

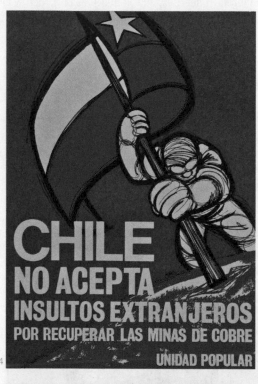

174

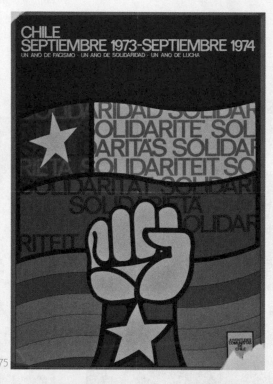

175

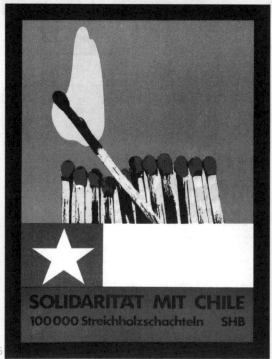

176

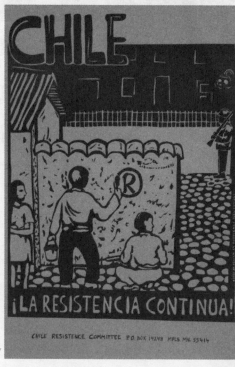

177

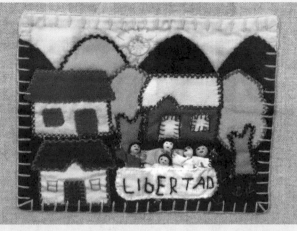

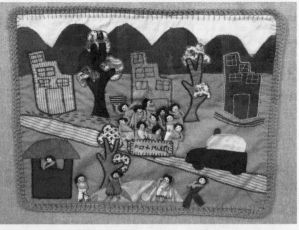

178

179

180

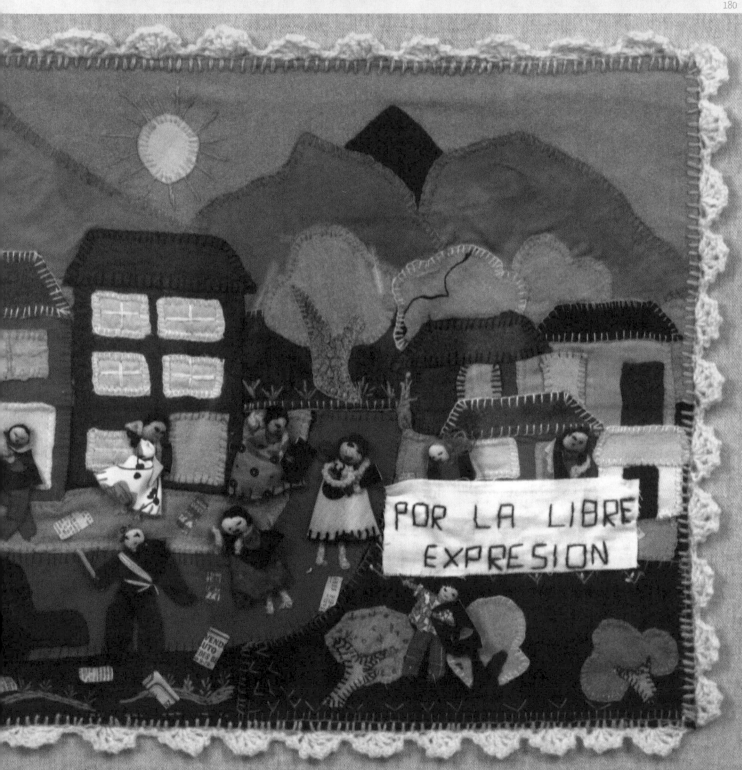

REVOLUTION OF THE CARNATIONS [1974–1977, Portugal]

In 1974, left-leaning military leaders rose up and overthrew Portugal's fascist dictator Antonio Salazar in an almost bloodless coup. The name "Revolution of the Carnations" comes from Portuguese citizens handing out red carnations to soldiers who revolted against the government. In the wake of the coup, a people's revolution spread across Portugal, with workers occupying their factories and farmers taking over the land they worked. A large percentage of Portuguese society was politically supportive of the coup, with communist, socialist, anarchist, workers', women's, and youth groups emerging after the dictatorship. There was an explosion of propaganda in the years following the revolution, with uncensored newspapers, occupied radio stations, and a proliferation of political posters, stickers, and murals.

181. Artists and photographers unknown, **a collection of revolutionary Portuguese murals**, photographic documentation of public murals, 1974–1977, Portugal.

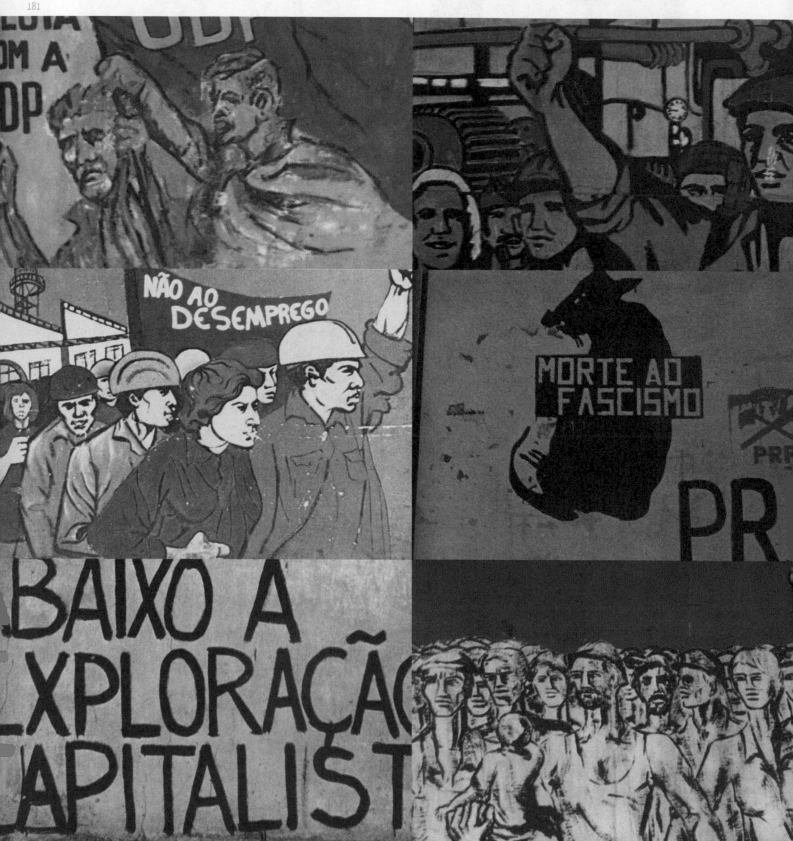

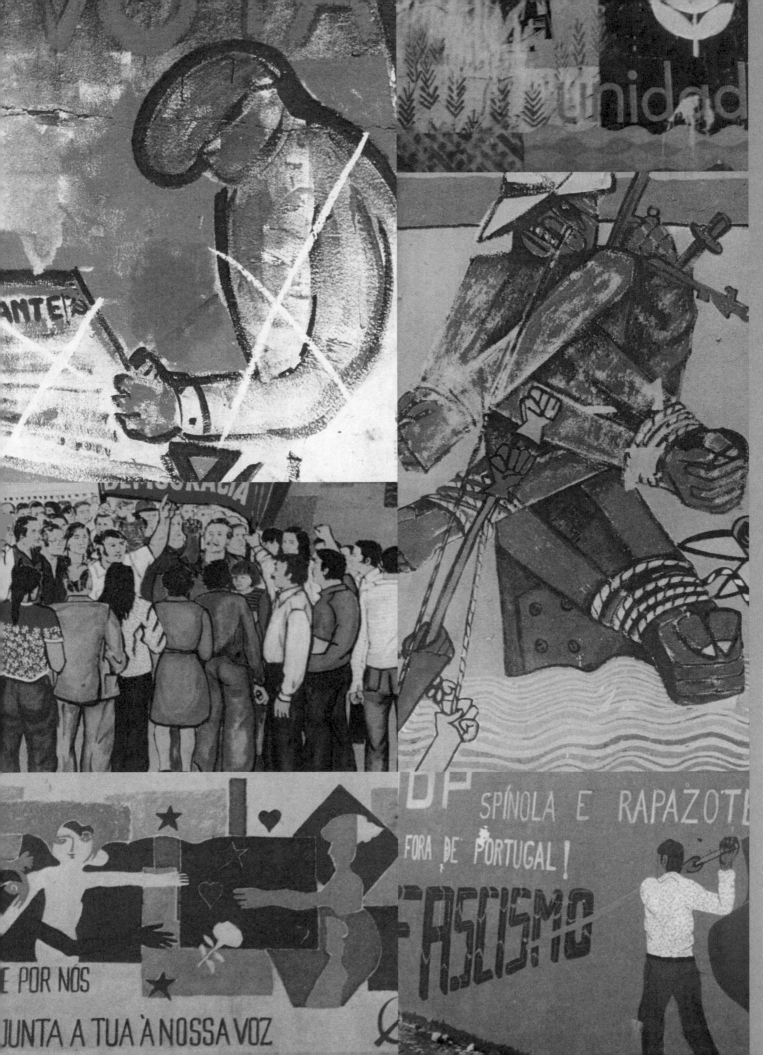

NICARAGUAN REVOLUTION [1960s–1979, Nicaragua]

In July 1979, the people of Nicaragua carried out a successful revolution that ousted US-backed dictator Anastasia Somoza. The revolution, largely led by the Frente Sandinista de Liberación Nacional (FSLN), known as the Sandinistas, was preceded by decades of political organizing and guerrilla military activity, and more than one hundred years of resistance to US intervention in the country. Using the name and image of Augusto Sandino, an early twentieth-century Nicaraguan revolutionary, the Sandinistas organized a mass-based popular movement composed of students, farmers, the working class, and the unemployed.

An integral part of the revolt, at least since the mid-1960s, was the *pinta*, what the Nicaraguans call a graffiti'd political slogan. Graffiti and street stenciling, often with the image or name of Sandino, was a widely popular activity central to the struggle.

182. Joel Sheesley, **Sandino Stencils**, photographic documentation , 1970s–1980s, Nicaragua.

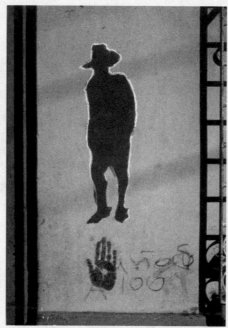

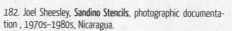

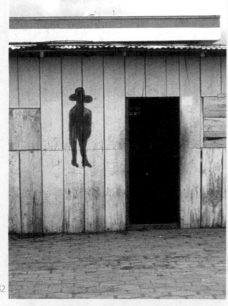

PUERTO RICAN INDEPENDENCE MOVEMENT [c.1800s–present, Puerto Rico & USA]

In the 1970s, there was a resurgence of political action for Puerto Rican independence from the United States, both on the island and on the mainland. In the US, Puerto Ricans organized as part of the Young Lords, but were also connected to a number of independence and socialist organizations in Puerto Rico. These organizations developed propaganda wings, including screenprint workshops. In New York City and Chicago, white solidarity organizations also helped create posters and flyers. To this day, Puerto Rico remains a territory of the United States, with its chief of state being the US president. However, the people of Puerto Rico have no voting rights in the US congressional or presidential elections.

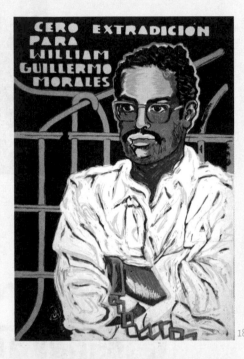

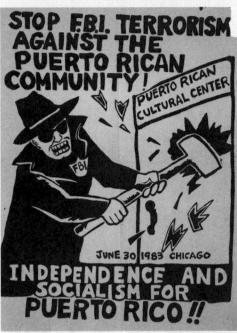

183. Mary Patten (from a painting by Elizam Escobar), **Cero Extradición Para William Guillermo Morales**, screen print, 1983, USA.

William Guillermo Morales was a member of the armed Puerto Rican organization, Armed Forces of National Liberation (FALN). In the 1970s and 1980s the FALN carried out a number of bombings and attacks in the United States as part of their struggle for Puerto Rican Independence. In 1978, Morales lost both hands and an eye when a bomb he was making exploded. He was arrested, but escaped from a hospital in 1979 by climbing out of a three-story window on a rope made from bandages. He was arrested in Mexico in 1983, the year this poster was made, and faced extradition to the US. He was never extradited, however, and after five years in prison he fled to Cuba. He is still wanted by the FBI.

184. Mary Patten, **Stop F.B.I. Terrorism against the Puerto Rican Community**, screen print, 1985, USA.

185. Madame Binh Graphics Collective (lead artist: Margo Pelletier), **Independencia y Socialismo para Puerto Rico**, screen print, 1979, USA.

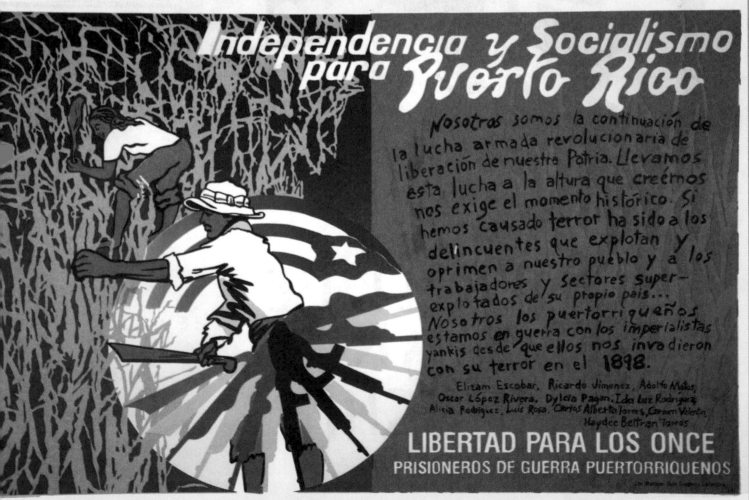

ANTI-APARTHEID MOVEMENT [1948–1993, South Africa]

Apartheid was a system of legalized racial segregation and inequality enforced by the Afrikaner (white settler) government of South Africa between 1948 and 1993. Under apartheid, South Africans were categorized initially as one of three racial classifications, Native (Black), White, and Colored, and in 1959 a fourth was added, Asian. Each racialized grouping had different rights, access to different job opportunities, and was forced to live in different areas. Blacks were stripped of South African citizenship, categorized according to tribal groups, and required to live on reservations called "bantustans."

The anti-apartheid movement, led by the African National Congress, was criminalized in 1960, and then went underground until the mid-1970s, when students and workers took to the streets in protest. In the early 1980s, the struggle grew in visibility and scale, with huge mobilizations of people in union, community, women's, student, and youth organizations. As repressive conditions increased, activists developed a variety of strategies for disseminating information, including the establishment of screenprint workshops and the production of street stenciling, graffiti, and political t-shirts. Cultural work in solidarity with the anti-apartheid struggle was also produced internationally.

186. Sue Williamson, **Anti-Apartheid Stencils**, photographic documentation, c. 1980s, South Africa.
187. Screen Training Project (artist: Jonny Campbell), **There Shall Be Peace and Friendship**, screen print, 1985, South Africa.

In the early 1980s, silkscreen workshops were set up in many South African cities in order to produce and distribute posters for the growing anti-apartheid movement. Two of the biggest were the Screen Training Project (STP) in Johannesburg and Community Arts Project (CAP) in Cape Town. Both projects were intended to be training programs so that activists from around the country would gain the skills to set up their own production facilities locally. Some of this training occurred, but the movement grew so fast and there was such a large demand for posters that both workshops got caught up in direct production. Like the Paris 1968 posters, these were being created on the spur of the moment, in response to immediate needs and events. But unlike the Atelier Populaire, few if any of

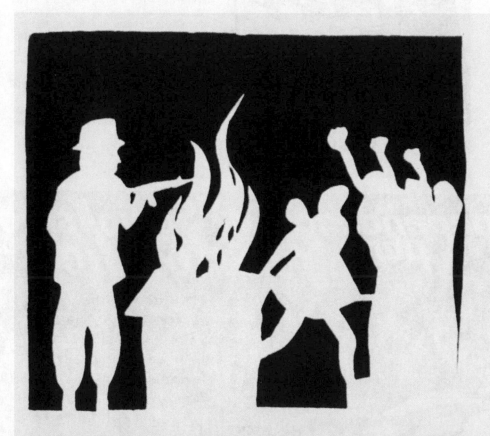

THERE SHALL BE PEACE AND FRIENDSHIP

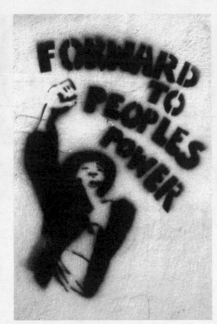

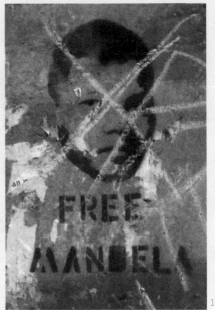

HUÂÙDI YOUTH ORGANISATION

PUDUMONG

NO TO HUNGER
NO TO HIGH RENTS
NO TO PUDUMONG!

the members of these projects had formal art training, so the designs were often extremely raw and poorly printed. A number of their designers borrowed heavily from, if not outright copied, Paris 1968 and early-twentieth-century Soviet and German political posters. Even if formally untrained, South African activists were aware of the history of left posters and propaganda. Just six months after opening, the Screen Training Project had their space broken into and their equipment destroyed. A year later, the police confiscated a large number of their posters, and then STP workers were arrested and detained. STP went underground to continue producing posters.

188. Artist unknown, **Asinamali Unite**, screen print, 1985, South Africa.

189. The Lesedi Silkscreen Workshop (artist unknown), **Huhudi Youth Organisation—No to Pudumong!**, screen print, 1985, South Africa.

The Lesedi Silkscreen Workshop was started by the Huhudi Youth Organization in 1985. Around this time, small workshops often faced harsh repression. According to one member: "The people of Huhudi started printing posters at the Lesedi workshop in 1985. The reaction of the state was swift. The workshop was petrol-bombed, some activists were detained, others fled the country. The States of Emergency imposed after 1985 eventually forced Lesedi to close."

190. Boycot Outspan Aktie (artist unknown), **Eet Geen Outspan Sinaasappelen—Pers Geen Zuid Afrikaan Uit!** [Don't Squeeze Outspan Oranges—Don't Squeeze a South African!], offset lithograph poster, 1973, the Netherlands.

Although produced in 1973, this poster was prohibited by the Dutch Advertising Code Committee and wasn't distributed until 1980. Versions of this poster were also produced in other languages in other countries.

191. Congress of South African Trade Unions/COSATU (artist: Garden Media Camp/CAP), **May Day is Ours**, offset lithograph poster, 1989, South Africa.

192. Medu Art Ensemble (artist: J. Seidman), **The People Shall Govern!**, screen print, 1982, South Africa.

In 1978, just across the border from South Africa in Gabarone, a group of exiled South Africans formed the Medu Art Ensemble. Medu designed anti-apartheid posters with the intention of sending them into South Africa, giving voice to the struggle. Medu also wanted the South African movement to develop the screen printing of political posters as a mass communications tool, since silkscreening takes little capital or set up, and could be easily taught to activists. In July 1982, Medu organized the Culture and Resistance Festival in Botswana and began training activists to silkscreen. Right after the festival, the government banned Medu's posters, forcing them to be smuggled into the country. In 1985, South African army units crossed the border and murdered multiple Medu members; those remaining were forced underground, effectively destroying the group.

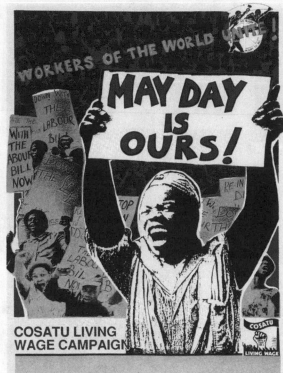

191

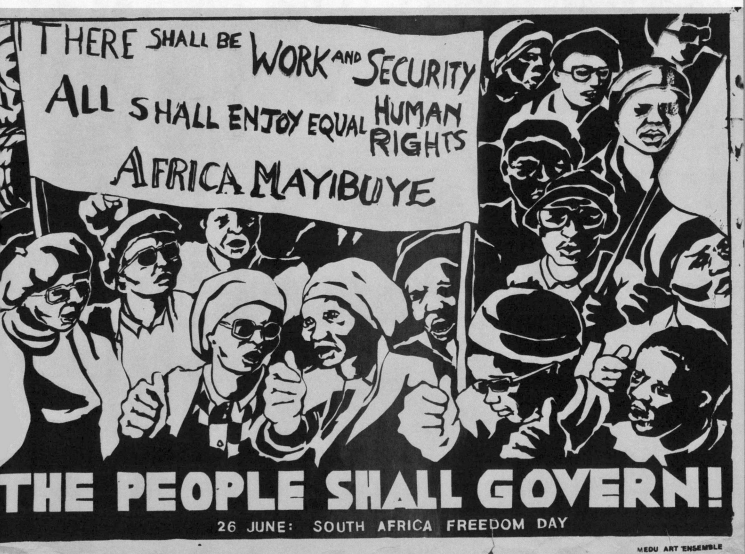

192

LET IT ALL

193

HANG OUT

Youth all over the world became increasingly restless in the 1960s and 1970s, and developed new countercultures that integrated political critiques into their daily lives. Groups such as Provo, the Diggers, Black Mask, Yippies, and Solvognen did not intend to withdraw from mainstream society, but wanted to radically transform it. They did this by living in communes, squatting in empty buildings, setting up free soup kitchens, growing their own food, experimenting in alternative economies, challenging patriarchal norms, opposing the Vietnam War, and demanding that life be more fulfilling and fun. These movements strengthened in the 1970s, particularly in Europe, where groups emerged that worked against undemocratic urban development and nuclear proliferation, and to protect the environment. More recently, massive punk-inspired countercultures, many of which are egalitarian and support anti-authoritarian politics, have sprung up in Asia and Latin America.

193. Solvognen (photographer: Nils Vest), **The Santa Claus Army**, photographic documentation, 1974, Denmark.

PROVO [1965–1967, the Netherlands]

Provo was a group of Dutch anarchists that turned Amsterdam on its head with an explosive mixture of art and politics. They combined pranks and performance "happenings" (that targeted everything from tobacco to the Dutch royalty) with well-organized "White Plans" for transforming the city into a more socially and ecologically sustainable and culturally fun place. Provo immediately became popular with young people around the world, and deeply influenced the late 1960s youth revolt.

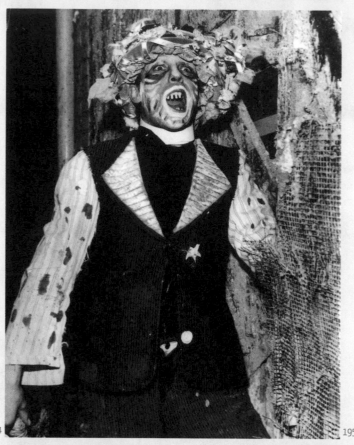

10 maart
dag van de
anarchie

194
195

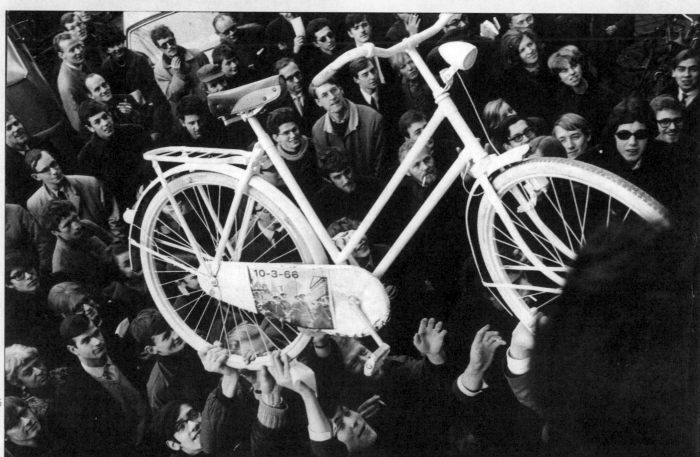

196

194. Cor Jaring, **Robert Jasper Grootveld**, photographic documentation, 1965, the Netherlands.

Grootveld was one of the founders of the Provo and regularly held "happenings" in the streets of Amsterdam in the early 1960s.

195. Provo, **10 Maart: Dag Van de Anarchie [March 10th: Day of Anarchy]**, screen print, 1966, the Netherlands.

196. Cor Jaring, **White Bicycle**, photographic documentation, 1966, the Netherlands.

Provo hoists a White Bicycle on March 19, 1966 at a photography exhibition on police brutality in Amsterdam, which in turn provoked another attack by the police. The bike is a representation of the Provo White Bicycle Plan:

Amsterdamers! The asphalt terror of the motorized bourgeoisie has lasted long enough. Human sacrifices are made daily to this latest idol of the idiots: car power. Choking carbon monoxide is its incense; its image contaminates thousands of canals and streets.

PROVO'S BICYCLE PLAN will liberate us from the car monster. PROVO introduces the WHITE BICYCLE, a piece of PUBLIC PROPERTY.

The first white bicycle will be presented to this Press and public on Wednesday July 28 at 3pm near the statue of the Lieverdje, the addicted consumer, on the Spui. The white bicycle is never locked. The white bicycle is the first free communal transport. The white bicycle is a provocation against capitalist private property, for the white bicycle is anarchistic.

The white bicycle can be used by anyone who needs it and then must be left for someone else. There will be more and more white bicycles until everyone can use white transport and the car peril is past. The white bicycle is a symbol of simplicity and cleanliness in contrast to the vanity and foulness of the authoritarian car. In other words:

A BIKE IS SOMETHING, BUT ALMOST NOTHING!
(translation courtesy of Autonomedia)

197. Provo, **Het Witte Huizen Plan [The White House Plan]**, mimeographed flyer, 1966, the Netherlands.

Translation: THERE IS A HOUSE IN HOLLAND/And nobody lives there. It stands in the Dam Square in the heart of Amsterdam. The Palace on the Dam is the symbol of the housing shortage. In Amsterdam there are thousands of empty houses around canals and in the Jordan, the city's bastion of freedom./Your house is your pleasure temple. You have a right to your own house, a fair share of the community's housing. No house in the Magic Center can be allowed to be demolished if it is still being occupied. New Amsterdam! The Provo White House Plan workshop puts forward a grand revolutionary solution to the housing problem—The White House. Anyone can enter the White House and choose his apartment. New Babylon!

THE WHITE HOUSE PLAN
The White House Plan workshop has taken the following steps:
1. declaring the Palace on the Dam the Town Hall, the collective Klaas temple of the Magic Center;
2. publishing every week a list of addresses of empty houses for distribution on Saturday mornings at 10 in the Dam Square;
3. painting the doors and doorposts of empty houses white to indicate that anyone can use them;
4. founding an employment agency to mobilize young people in the summer months to combat the housing shortage;
5. The White House Plan will form part of the New Amsterdam Plan.

SAVE A BUILDING—OCCUPY A BUILDING JUST FOR FUN
(translation courtesy of Autonomedia)

198. Cor Jaring, **Provos with their mimeo machine**, photographic documentation, 1966, the Netherlands.

IN HOLLAND STAAT UN HUIS

EN IN DAT HUIS
WOONT NIEMAND
HET STAAT OP DE DAM
IN HET HART VAN AMSTERDAM
HET PALEIS OP DE DAM IS
HET IMAGE VAN DE WONINGNOOD
IN AMSTERDAM STAAN DUIZENDEN HUIZEN LEEG LANGS
DE GRACHTENGORDEL EN IN DE JORDAAN, HET
AMSTERDAMSE BOLWERK VAN DE VRYHEID

UW HUIS IS UW GNOTTEMPEL. U HEEFT RECHT OP UN EIGEN HUIS EN UN RECHTVAARDIGE VERDELING VAN HET KOLLEKTIEF WONINGBEZIT. GEEN HUIS IN HET MACIES CENTRUM MAG WORDEN AFGEBROKEN ZOLANG ER NOG MENSEN IN WONEN NEW AMSTERDAM

PROVO'S WERKGROEP WITTE HUIZENPLAN LANSEERT UN LIEVEREVOLUSIONAIRE OPLOSSING VAN HET WONINGPROBLEEM. HET WITTE HUIS IN HET WITTE HUIS KAN IEDEREEN BINNENGAAN EN ZYN WOONRUIMTE UITZOEKEN NEW BABYLON

HET WITTE HUIZEN PLAN

DE WERKGROEP WITTE HUIZENPLAN NAM DE VOLGENDE INITIATIEVEN:
① HET UITROEPEN VAN HET PALEIS OP DE DAM TOT STADHUIS VAN AMSTERDAM DE KOLLEKTIEVE KLAASTEMPEL VAN HET MACIES CENTRUM
② DE WEKELYKSE UITGAVE VAN UN LYST MET ADRESSEN VAN LEEGSTAANDE HUIZEN DIE 'SZATERDAGS OM 10 UUR OP DE DAM VERSPREID WORDT
③ HET WITSCHILDEREN VAN DE DEUR EN DEURPOST VAN LEEGSTAANDE WONINGEN TEN TEKEN DAT IEDEREEN ERIN WONEN KAN
④ DE OPRICHTING VAN UN ARBEIDSBUREAU OM DE JONGEREN IN DE ZOMERMAANDEN TE MOBILISEREN TEGEN DE WONINGNOOD
⑤ HET WITTE HUIZENPLAN ZAL DEEL UITMAKEN VAN HET PLAN NIEW AMSTERDAM

REDTUNPANDJEBEZETUNPANDJE-GNOTWILHET

197

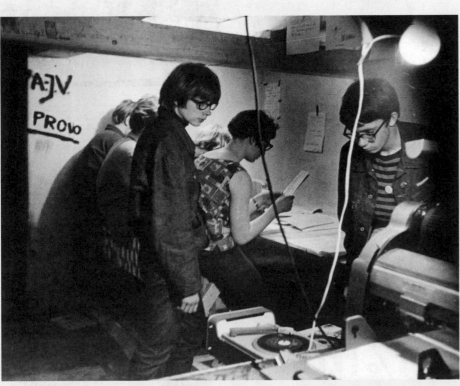

198

POLITICAL COUNTERCULTURE

[1966–1970s, International]

The following are just some of the groups and activities begun in the 1960s that combined cultural production, radical politics, community organizing, and experimental lifestyles:

Black Mask and Up Against the Wall Motherfucker were New York City anarchist collectives organized to integrate art into revolutionary action. They organized a large number of political street theater actions, including shutting down the Museum of Modern Art, renaming Wall Street "War Street," and cutting the fences at the Woodstock Music Festival to turn it into a free event.

The Bread and Puppet Theater (often known simply as Bread & Puppet) is a theater troupe which focuses on progressive political and social issues. Founded in 1963 in New York City and now located in Vermont, the troupe combines dance, sculpture, masks, and large-scale puppets. The name Bread & Puppet comes from the theater's practice of sharing its own homemade bread with the audience and its belief that art should be as basic to life as bread. Bread & Puppet theatrics have been dramatic and colorful additions to political demonstrations for decades. In addition to agitational theater and street protest, Bread & Puppet members are advocates of "Cheap Art." They make and distribute inexpensive posters and prints at their performances, which allows audience members to walk away with a piece of propaganda that may then be seen by even more people.

The San Francisco Diggers were a collective of activists and improv actors that developed

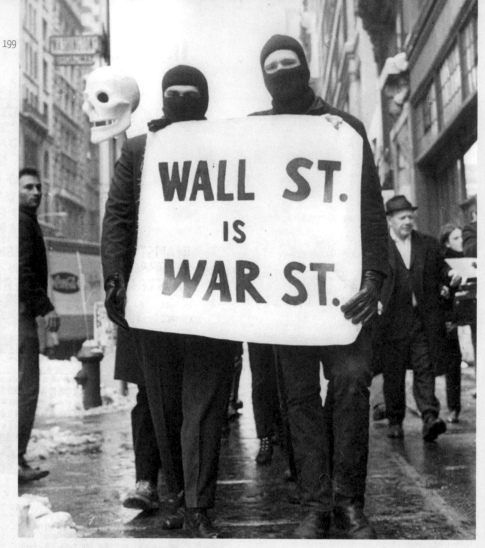

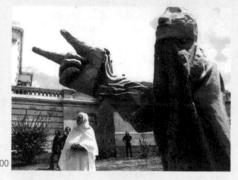

1% FREE

joint the revolution

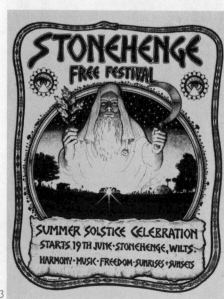

STONEHENGE FREE FESTIVAL

SUMMER SOLSTICE CELEBRATION
STARTS 19TH JUNE · STONEHENGE, WILTS.
HARMONY · MUSIC · FREEDOM · SUNRISES · SUNSETS

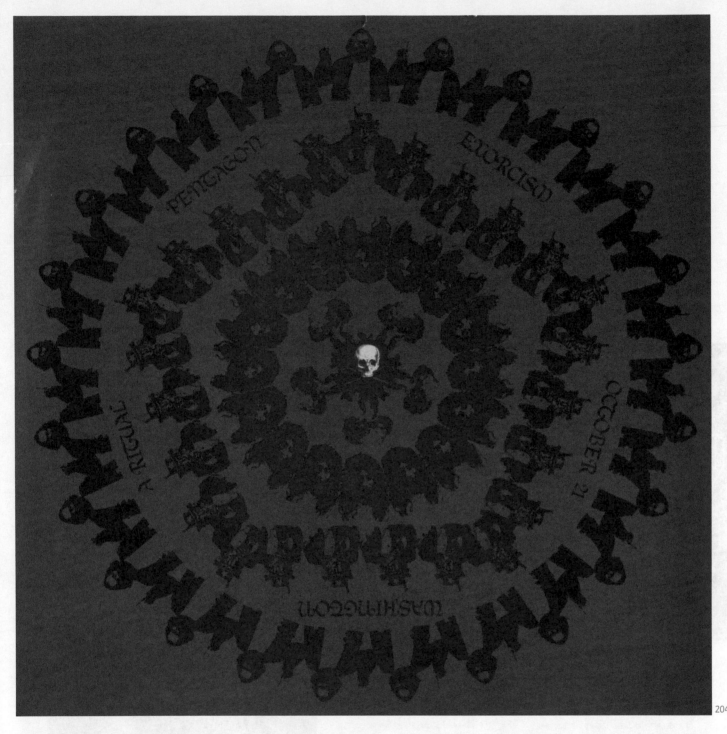

204

a militant form of community organization and action that included: stealing food from stores and restaurants and serving it for free, setting up free stores (where goods were distributed), holding free concerts, and creating large spectacular happenings. They strongly believed in building alternative structures to fulfill the needs of those under-represented and under-served by mainstream society.

Free Festivals were a network of festivals in the UK in the 1970s. These large-scale social experiments in free expression and practices of collective anarchy were repressed by the government as a threat to public order. The spirit of these festivals inspired both the rave scene and the road protest movement.

The poster for the 1967 Ritual Pentagon Exorcism in Washington refers to an action called by the Youth International Party, known as the Yippies (whose members included Abbie Hoffman and Jerry Rubin). The action proposed was to encircle the Pentagon building in order to levitate it (through chants led by Allen Ginsberg and songs by the band the Fugs) and exorcise the evil spirits of the war machine.

199. Black Mask (photographer unknown), **Wall St. Is War St.**, photographic documentation, 1967, USA.

200. Bread & Puppet (photographer: Jim Crawford), **Bread & Puppet Actions**, photographic documentation, 1971, USA.

201. The San Francisco Diggers (artist unknown), **1% Free**, offset lithograph poster, 1967, USA.

This poster, originally 3' wide by 6' tall, was pasted on walls across San Francisco in 1967. The image depicts two Chinese assassins patiently waiting beneath a sign with the I Ching character for "revolution" on it. "1% Free" was a slogan the Diggers used, part of their maxim that "everything is free because it is already yours."

202. Black Front Trippy Anarchist Group, *Liberation News #2*, printed publication, 1973, Israel.

203. Roger Hutchinson, **Stonehenge Free Festival**, offset lithograph poster, 1977, UK.

204. Artist unknown, **A Ritual Pentagon Exorcism Washington**, offset lithograph poster, 1967, USA.

POLITICAL SQUATTING MOVEMENT [1960s–present, International]

As an extension of the counterculture developing in the 1960s in Europe and North America, groups of activists decided that space was important for constructing movements and communities, and they began occupying abandoned buildings. A strong movement developed based on taking over these buildings, or "squatting." By using collective direct action to fulfill one of life's necessities—putting a roof over one's head—squatters were able to spend more of their time on activism and movement building.

In addition to providing housing, squats are also used as meeting spaces, cafés, bookstores, libraries, clothing swaps, pirate radio stations, and computer labs. Squatters regularly paint the sides of their buildings with large-scale, colorful murals, which both mark the building as being outside the traditional rules of property ownership and stake a claim for controlling space in the city. As real estate values have increased across Europe and N. America, there has been increasing state repression against squatters. In cities such as Amsterdam, Berlin, Copenhagen, New York, and Rome, there have been city initiatives to legalize longtime squats, in part to control and defuse the larger squatting movement.

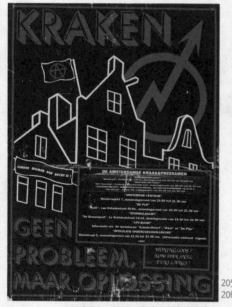

205
206

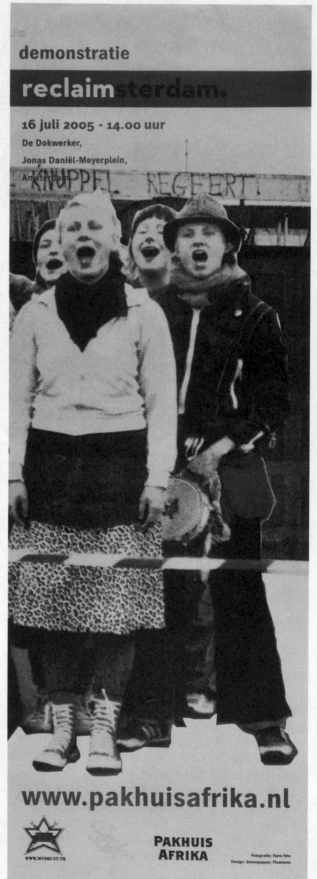

205. Artist unknown, **Kraken: Geen Probleem Maar Oplossing [Squatting: Not a Problem, but a Solution]**, offset lithograph poster, c. 1980s, the Netherlands.
206. George Mendez, Robert Cooney, and Tom Otterness, **Gas Gratis [Free Gas]**, screen print, 1977, USA.
207. Greenpepper/Flexmens, **Reclaimsterdam**, offset lithograph poster, 2005, the Netherlands.

This demonstration followed the eviction of the Afrika squat. The squat is pictured in the background. The graffiti on the wall reads "the baton reigns."
208. Photographer unknown, **KuKuck Squat**, photographic documentation, 1981, Germany.
209. Artist unknown, **Vågn Op**, offset lithograph poster, c. 1980s, Denmark.
210. Ratgeb, **Mietertage [Tenant's Days]**, screen print, 1980, Germany.

Translation: Tenant's Days Against Raised Rent in New and Old Bulidings./White Circle and Chart Rent (The White Circle is a landlord's organization.)
211. Produktionskollektiv Kreuzberg, **Berlin hat fur jeden eine Kugel [Berlin has balls for everyone]**, offset lithograph poster, 1974, Germany.

This poster was produced to protest the 1974 World Cup Finals held in Berlin. It makes connections between the World Cup, police repression, and urban development.
212. Aktiegroep Nieuwmarkt (artists: De Vrije Zeefdrukker and Iris), **de een zijn brood is de ander zn woningnood! [the bread of one is the housing shortage of another!]**, screen print, 1973, the Netherlands.

The last sentence of a poem by Henk van Randwijk makes up the main text. It reads: "A people that bow to tyrants will loose more than safety; their light will die." The poem was originally written in response to the Second World War.
213. Aktiegroep Nieuwmarkt (artist unknown), **Demonstreermee**, screen print, 1972, the Netherlands.

Translation: Wednesday evening the 26th of January at De Waag, Nieuwmarkt, march toward City Hall/For: Affordable housing for all, improvement of older areas, making the concrete, new housing project more livable./Against: The building of the Opera, City Hall, hotels, banks, subway and against the raising of any rent!/De Nieuwmarkt, it's now or never. Since the local elections are finished, pressure on the 260 people living on the trajectory of the east-line of the subway is rising. During the holidays, when the parliament, municipal council, and a lot of Amsterdam citizens are away, Lammers wants to evict with the consent of his minister./People of Amsterdam: the subway and city renewal are a threat to all of us. When they come to evict, you come and help!/Amsterdam helps de Nieuwmarkt.
214. Artist unknown, **Uprise Hafenstrasse**, screen print, 1984, Germany.

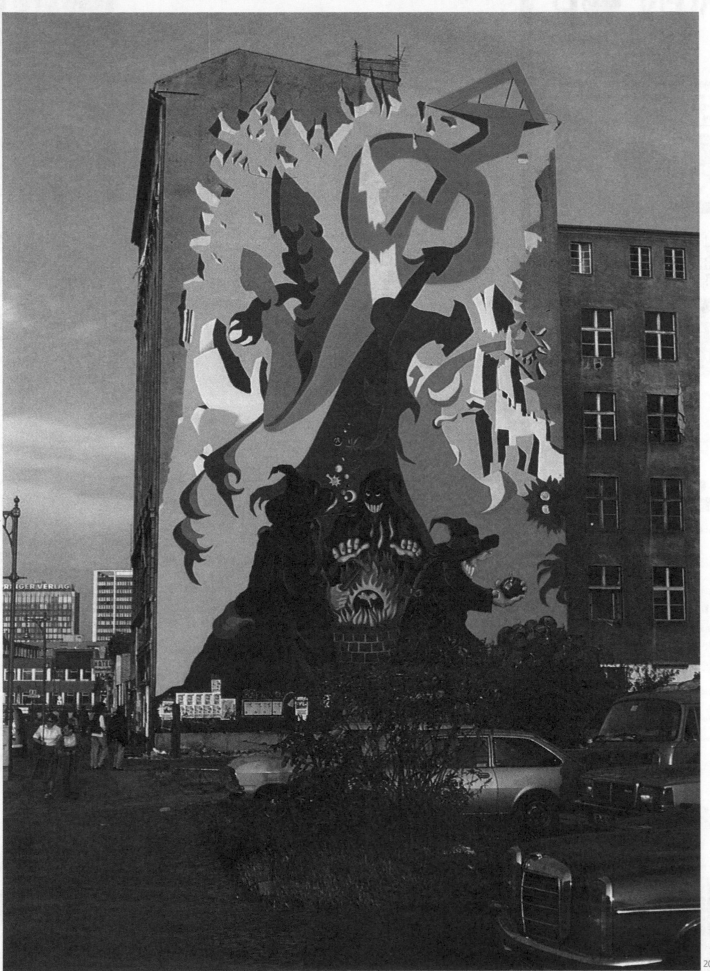

Hafenstrasse is a street in Hamburg which has been the site of intense squatting struggles since people began occupying houses on it in 1981. Between 1981 and 1992, when it became a legal housing cooperative run by the residents, Haffenstrasse held mass meetings of up to 5,000 people, was regularly painted with multi-story murals, and ran a pirate radio station.

Translation: Uprise, Hafenstrasse (Habour Street)/Discussion and Action on: Resistance, Oppression, Social Poverty, Facism-Antifacism, Internationalism/Concert, Party, Demonstration/December 31st against Prisons

215. Poster Workshop (artist unknown), **Empty Houses**, screen print, 1968, UK.

Inspired by the collaborative poster production in France in May 1968, screen print collectives began sprouting across Europe. In the UK, a number of collectives were born, with many producing posters about the squatting movement. This poster represents the grey corrugated metal sheets used to block the entrances to abandoned buildings.

216. Kalenderpanden (artist unknown), **Keerpunt Kalenderpanden! [Turning point Kalenderpanden]**, offset lithograph poster, 2000, the Netherlands.

Kalenderpanden was a large squatted warehouse complex on Amsterdam's Entrepotdok. In the 1990s, it was a center for Amsterdam's political counterculture, and was the site for concerts, performances, an information shop, free meals, and a "free" store. Residents were evicted in October 2000 and the warehouse was converted into luxury condominiums.

Translation: 29th of January 2000, Westermarkt Amsterdam/The municipality chooses the big bucks, and not for the first time! They want to make 47 luxury apartments for millionaires in the Kalenderpanden. But we have chosen a long time ago: extraordinarily cheap concerts, movies, info, free radio, and much more. Don't let their greedy claws come near!

217. Operation Move In (artist unknown), **Operation Move In**, screen print, 1970, USA.

218. Kalenderpanden (artist unknown), **Boer den Hartog Hooft**, offset lithograph poster, c. 1999, the Netherlands.

Translation: Boer Hartog Hooft Real Estate Brokers sell houses with people in them. More and more, the city center becomes the exclusive domain of the rich and richer. In this downward spiral of real estate speculation and rising prises, "normal" renters and people with lower income are forced out of the city center. The result: forced removals and an increasingly boring and one-dimensional city without room for those who are not interested by or interested in the free market. Boer Hartog Hooft is a forerunner in this trend and currently plans to build luxury apartments in the Kalenderpanden together with the BAM Building Company at the Entrepotdok in Amsterdam from Fl. 550.000 upwards. Unfortunately for them, the houses have been squatted, and the inhabitants are intent on breaking the spiral of rising prices and greed. Our demands: the creation of permanent affordable living and working spaces in the Kalenderpanden.

219. Artist unknown, **Permanent Universal Rent Strike**, photocopied flyer, 1992, UK.

220. Artist unknown, **Desirable Residences for Free**, offset lithograph poster, 1978, UK.

221. Artist unknown, **Squatter Bart Says**, photocopied flyer, c. 1990s, USA.

222. Artist unknown, **The Case for Squatters**, screen print, 1975, UK.

223. Mysquat.tk (artist unknown), **Day X-3**, offset lithograph poster, 2005, the Netherlands.

This poster was produced to oppose the May 2005 wave of evictions in Amsterdam.

224. Rob Stolk, **Slopers [Demolition Team]**, screen print, 1968, the Netherlands.

Translation: Each space that someone chooses to live in is livable. Therefore, do not demolish houses while there are too few; but rather demolish buildings that make our society unlivable: banks, stockbrokers, insurance offices, military barracks and so forth. Or you can build new houses.

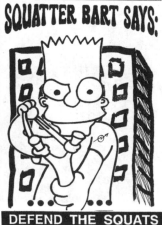

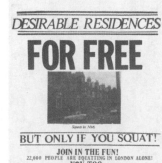

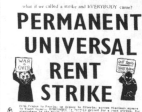

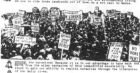

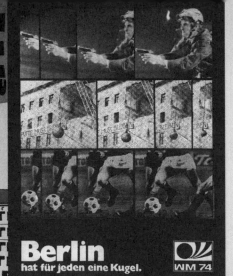
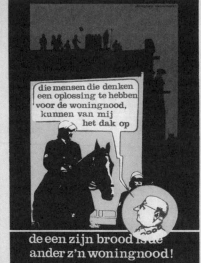
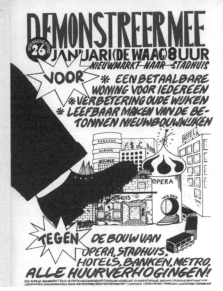

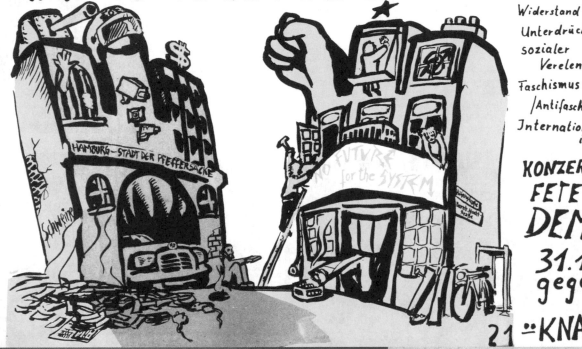

AUTONOMEN [1970s–1990s, Germany]

In the 1970s, radical German youth developed a powerful dual strategy of mounting militant actions against the West German and United States governments and building large-scale infrastructure for a liberated existence in Germany—based in widespread squatting that included housing, social centers, cafés, bookshops, and community service projects. Their proximity to East Germany helped them to see the failures of both the capitalist West and Soviet-style Communism of the East, and led them to try to forge an alternative path to both.

225. Photographer unknown, **An Autonomen**, photographic documentation, c. 1980s, Germany.

226. Artist unknown, **Demo**, screen print, 1982, Germany.

This poster was produced for a demonstration at the Startbahn West [Runway West] airport extension in Frankfurt. This runway was a major battlefield for the radical left in the 1980s.

227. Artist unknown, **Haig Demo**, offset lithograph poster, 1981, Germany.

This poster was created for a demonstration in solidarity with the attack on Alexander Haig by the Red Army Faction (RAF). Haig served as the Commander of NATO forces in Europe from 1974–1979. The RAF unsuccessfully attempted to blow up his car in Belgium on June 25, 1979 with a land mine. In 1993, Rolf Clemens Wagner, a former RAF member, was sentenced to life imprisonment for the assassination attempt.

Translation: Demo—Sep 13, 1981/Olivaer Platz/1979 attack on Haig in Brussels/With 2.7 seconds he came away with his life/How to move forward.

228. Artist unknown, **Anti-Nato Demo**, offset lithograph poster, 1982, Germany.

Translation: Against the Demonstration of Power—a Powerful Demonstration!/June 9, 1982 in Giessen, West Germany

229. Artist unknown, **TUWAT [Do Something!]**, screen print, 1982, Germany.

TUWAT was a call by the Autonomen to the rest of the European extra-parliamentarian left to descend on Berlin for a massive protest and celebration of the autonomous movement. Photos of naked activists were used as promotion.

230. Photographer unknown, **TUWAT**, photographic documentation, 1982, Germany.

231. Holger Meins, **Freiheit Für Alle Gefangenen [Freedom for all prisoners]**, screen print, 1970, Germany.

Holger Meins was a West German film student who joined the guerrilla organization the Red Army Faction and died in prison in 1974 from a hunger strike. This poster was created while he was still in school.

232. Photographer unknown, **Protest and Squat Puppet**, photographic documentation, c. 1980s, Germany.

233. Artist unknown, **Frauen/Lesben [Women/Lesbians]**, offset lithograph poster, c. 1990s, Germany.

Translation: Out to the revolutionary First of May. Come to the Demonstration! 1pm Oranienplatz [the banner states: Women Fight Back]

234. Photographer unknown, **Protest**, photographic documentation, c. 1980s, Germany.

Translation: Better out on the street, not in the clubhouse of the rich

225
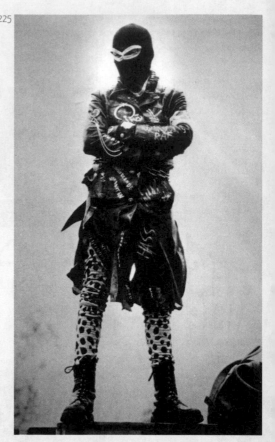

226

227

228
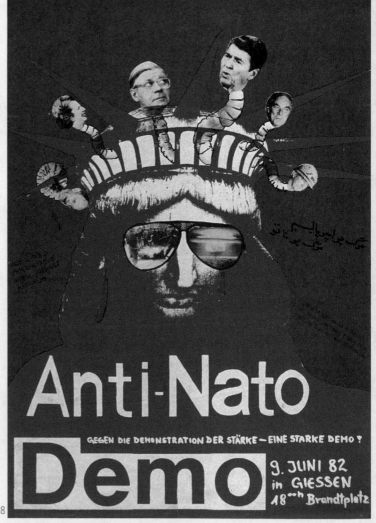

229

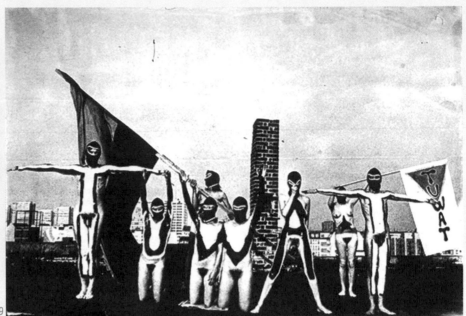

230

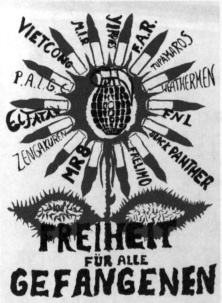

231

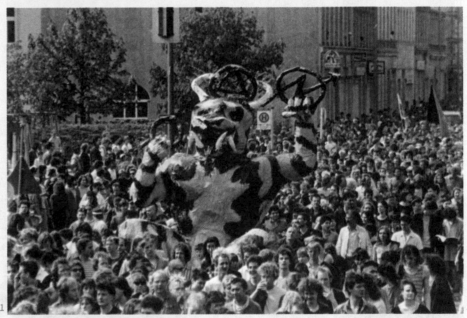

232

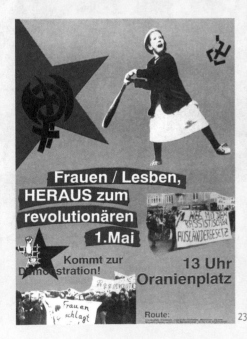

233

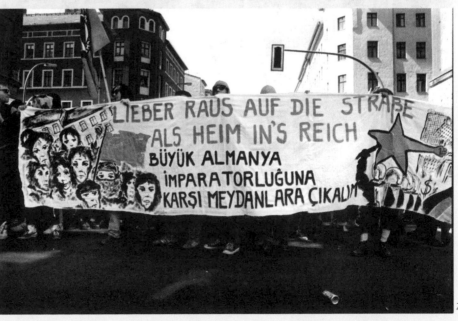

234

CHRISTIANIA [1971–present, Denmark]

In 1971, community residents and squatting activists broke into the abandoned military barracks on the edge of Copenhagen and founded Christiania. Christiania is a squatted "free town" of thousands of people that makes decisions through a community council run by direct democracy. The town has its own rules (including no cars, no zoning laws, and no housing codes) and has resisted integration with mainstream Copenhagen for almost forty years.

Solvognen (Chariot of the Sun) was a Danish theater group, which operated between 1972 and 1983. Soon after founding the group, many members moved to Christiania. Solvognen had a core of about ten to twenty-five people, which expanded when actions or theater pieces demanded it. Many people took part in their performances, a motley mixture of known and unknown actors, singers, musicians, dancers, and painters. They carried out a number of large-scale, spectacular, street theater political actions, which would often involve several hundred participants.

235. Slumstormerne [The Squatters] (artist unknown), **Kraev et Miljø [Demand an Environment]**, screen print, 1970, Denmark.

Slumstormerne was a Danish political group that grew out of Copenhagen's counterculture. They turned to the direct action of occupying empty buildings in order to find homes for people, and to have physical space from which to organize further political actions.

236. Slumstormerne (artist unknown), **Tomme Huse—Fulde Fængsler [Empty Houses—Packed Prisons]**, screen print, 1970, Denmark.

237. Nils Vest, **Slumstormerne Break into the Bådsmandsstræde military barracks to help start Christiania**, photographic documentation, 1971, Denmark.

238. Artist unknown, **Christiania, A legal decision**, offset lithograph poster, 1976, Denmark.

239. Solvognen (artist unknown), **Dejlig er den Himmel Blå**, screen print, 1975, Denmark.

The Santa Claus Army (see pages 92–93) was a street theater action in which an army of seventy Santa Clauses committed a series of "good deeds," including giving away gifts directly off the shelves of a Copenhagen department store and pulling down the fence around an automobile factory that workers were locked out of.

240. Artist unknown, **Christiania**, screen print, 1975, Denmark.

241. Rode Mør, **Støt Christiania**, relief print, 1976, Denmark.

Rode Mør [Red Mother] was a Danish anti-imperialist art collective that developed out of the radical politics of the late 1960s. Membership included Ole Finding, Thomas Kruse, Dea Trier Mørch, Yukari Ochiai, and Troels Trier. In addition to producing block printed posters, the collective also created banners, made puppets and street theater, and had a popular rock band.

235

236

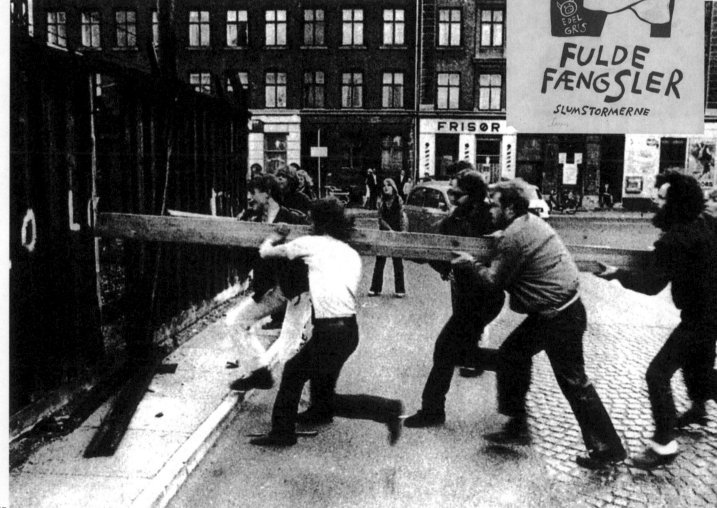

237

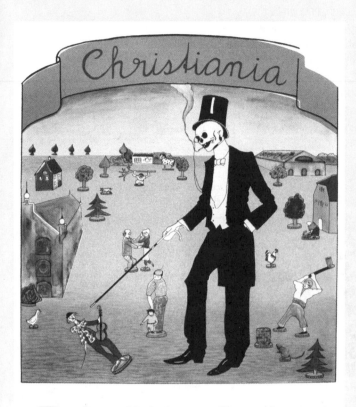

En lovlig beslutning.

238

239

240

241

UNGDOMSHUSET [1980s–2007, Denmark]

Ungdomshuset (The Youth House) was a squatted anarchist space in Copenhagen, which housed many young people and had a large public kitchen and a music venue. The city of Copenhagen officially owned the building and put it up for sale in 1999. The squatters refused to leave, and barricaded themselves in the building. In December 2006, over 2,000 squatters, punks, and sympathizers protested the coming eviction, and when the police attempted to shut down the demonstration, a large-scale riot broke out. In March 2007, police evicted residents, but this led to further riots, blockades, and street fighting with authorities. In part because of the mobilizations around Ungdomshuset, the squatting movement in Copenhagen has gained widespread support from Danish youth.

242. Ungdomshuset (artist unknown/photograph: Josh MacPhee), **Demonstration for Ungdomshuset**, photographic documentation, 2006, Denmark.
243. Ungdomshuset (artist: Mads Westrup), **Festen Ungern [Ungern Festival]**, offset lithograph poster, 2006, Denmark.
244. Ungdomshuset (artist: Esben Frederiksen), **Aktion G13**, offset lithograph poster, 2007, Denmark.
245. Ungdomshuset (artist: Toke Flyvholm), **Ungern**, offset lithograph poster, 2006, Denmark.

Translation: They say they want to demolish Ungdomshuset on the 14th, but we say fuck them

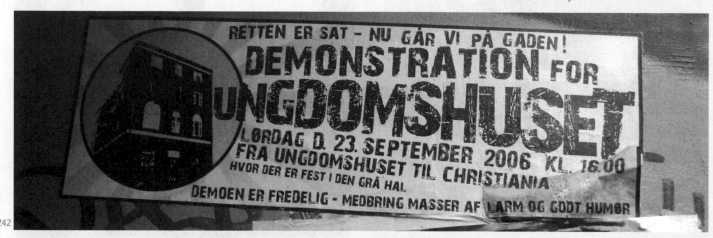

242

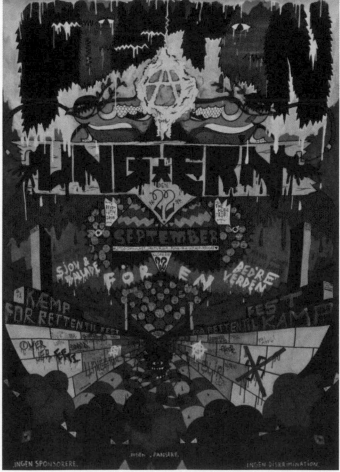

243

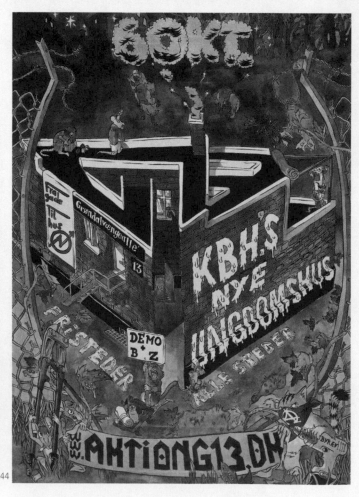

244

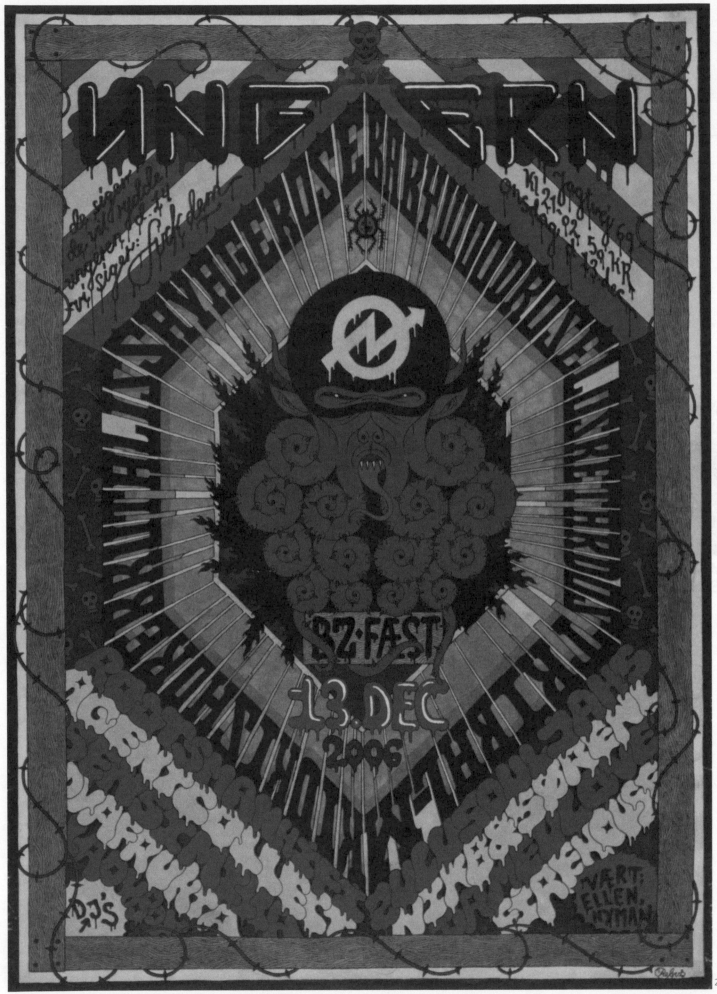

ANARCHISM AND ANARCHO-PUNK

[late 1970s–present, International]

Although the punk cultural movement has been stereotyped as simply a nihilistic lifestyle with accompanying loud music, politically engaged punk culture informed by anarchist ideas has become a world-wide phenomena. 1970s bands such as the British group Crass influenced a generation with their explicitly anarchist and pacifist politics, as well as their counter-cultural lifestyles. These anarchist values include mutual aid, non-hierarchical social organization, direct action, and critiques of both capitalism and the state. Today, anarchists have set up social centers and infoshops, and self-organize soccer leagues, reading groups, free schools, publishing houses, small-scale farms, and worker-run collectives. These initiatives aim to create a culture that provides for community needs, while at the same time transforming social relations.

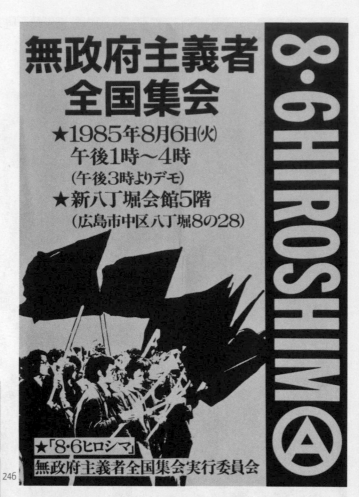

246

WE HAVE FOUND NEW HOMES FOR THE RICH

247

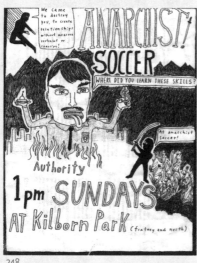

248

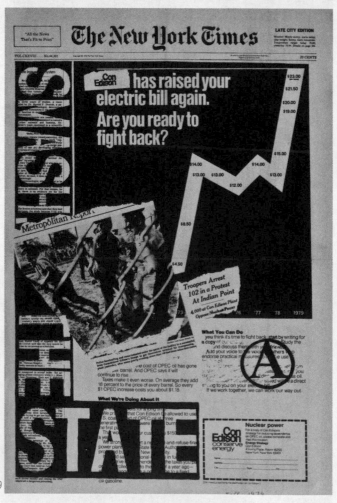

249

246. National Assembly of Anarchists Organizing Committee (artist unknown), **Nationwide Anarchist Meeting**, offset lithograph poster, 1985, Japan.
 Translation: Hiroshima, August 6th. Demonstration.
247. Class War, **We Have Found New Homes for the Rich**, photocopied poster, 1986, UK.
248. Artist unknown, **Anarchist Soccer**, photocopied flyer, 2007, USA.
249. Artist unknown, **Smash the State**, offset lithograph poster (spoof newspaper cover), 1979, USA.
250. Anarchist Unconvention (artist: Rocky Tobey), **Survival Gathering**, screen print, 1988, Canada.
 In the late 1980s, North American anarchists began gathering to rebuild the anarchist movement. These meetings took the form of weekend encampments, book fairs, and counter-conventions opposed to US and Canadian elections. Much of the organizing that happened at these meetings would lay the groundwork for North American wing of the future counter-globalization movement.
251. A-Zone (artist: Tony Doyle), **Active Resistance**, offset lithograph poster, 1996, USA.
252. Active Resistance (artist: Stefan Pilipa), **Active Resistance '98**, screen print, 1998, Canada.
253. Crass (artist: Gee Vaucher), **Feeding of the 5000**, music LP (back cover), 1978, UK.

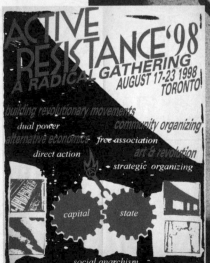

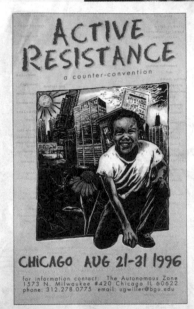

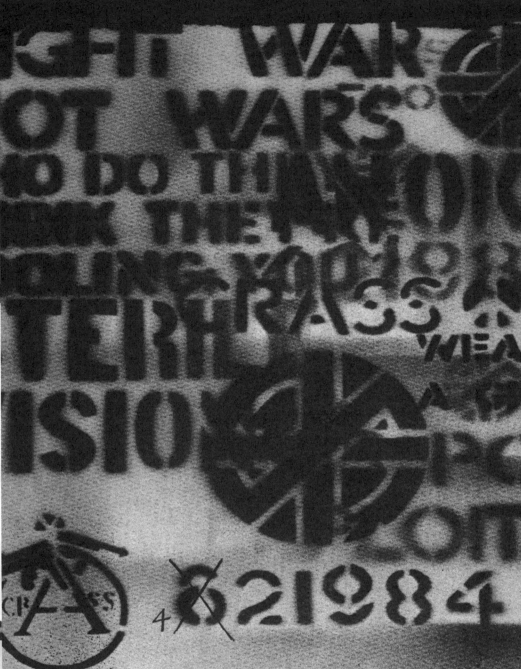

SURVIVAL GATHERING

AN ANARCHIST UNCONVENTION

TORONTO 1988

250

ACTIVE RESISTANCE

a counter-convention

CHICAGO AUG 21-31 1996

for information contact: The Autonomous Zone
1573 N. Milwaukee #420 Chicago IL 60622
phone: 312.278.0775 email: ugwiller@bgu.edu

251

ACTIVE RESISTANCE '98
A RADICAL GATHERING
AUGUST 17-23 1998
TORONTO!

building revolutionary movements

dual power community organizing

alternative economics free association

direct action art & revolution

strategic organizing

capital state

social anarchism

252
253

the feeding of the five thou

TARING PADI

[1998–present, Indonesia]

Taring Padi (which translates as "Fang of Rice") is an art collective based out of Yogyakarta, Indonesia. They formed in 1998 through the resistance movement to Suharto. When the reform party failed to fulfill its promises, Taring Padi felt they had to fight back through political art and culture. The group has made posters, murals, street performances, puppets, poetry, music, and publications. At one time, they ran a social center and art space out of a squatted art school. They are also involved in the punk music scene: one of their mottos is "art, activism, and rock and roll." They are committed to contributing to autonomous culture, democracy, and social justice in Indonesia. Some of the campaigns they have worked on through their art include wage hikes for workers, land rights for indigenous peoples, and autonomy for farmers.

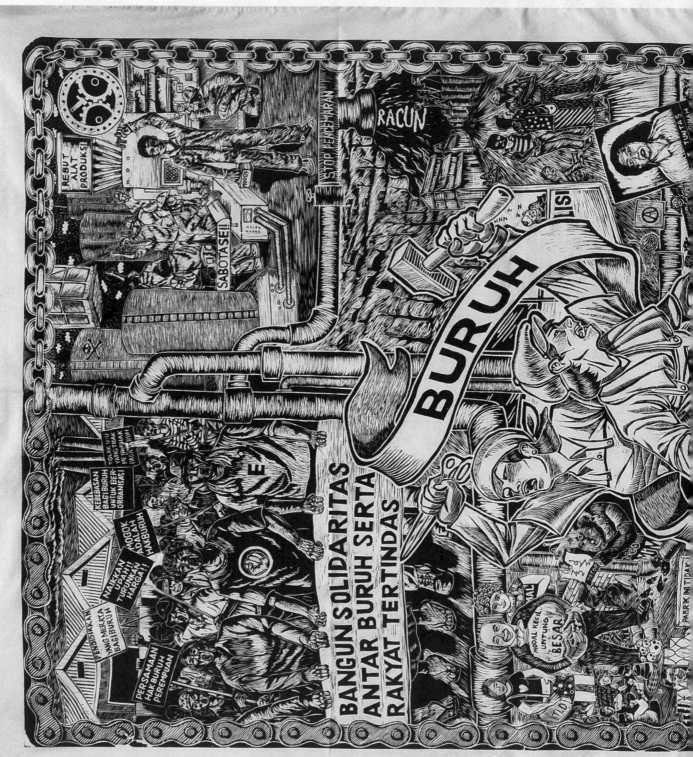

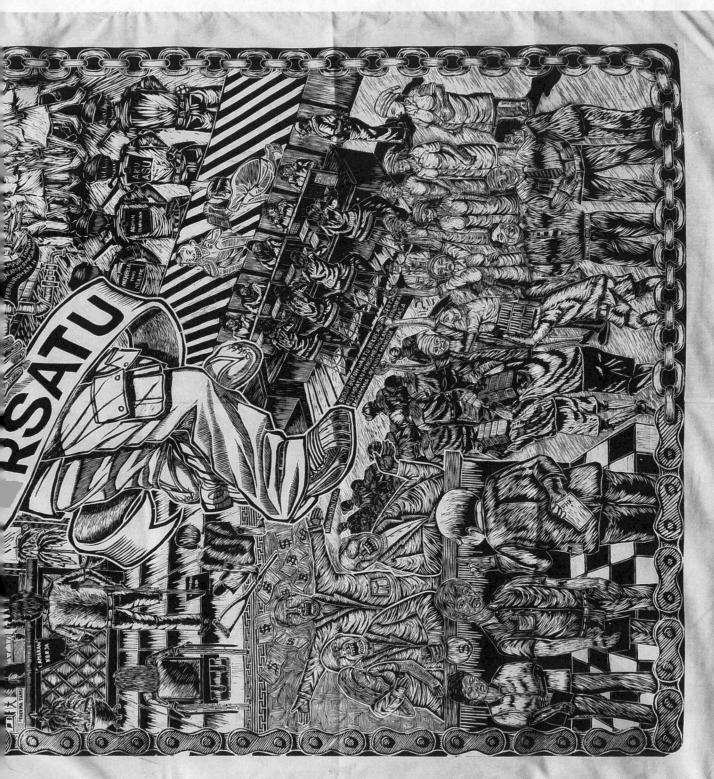

254. Taring Padi, **Buruh Bersatu** [United **Workers**], relief print, c. 2008, Indonesia. Translation: Build solidarity between the workers and oppressed people

254

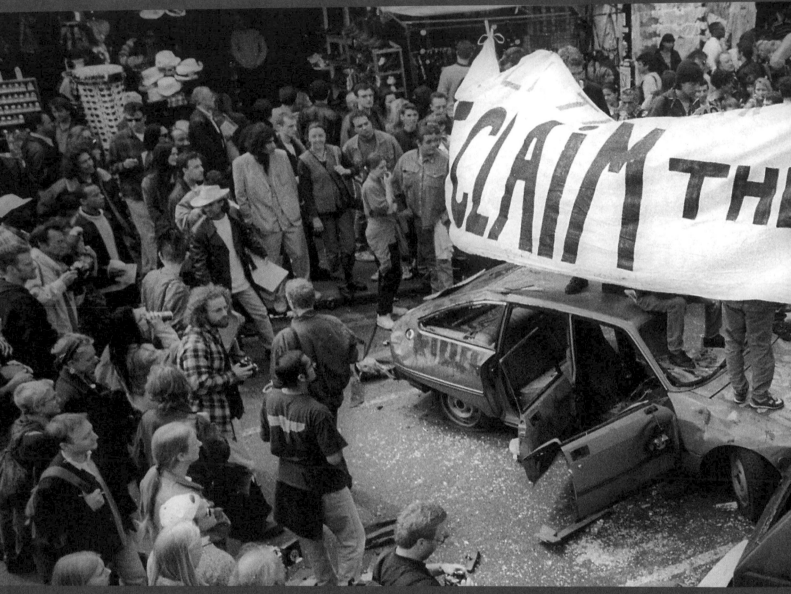

RECLAIM TH

All people deserve a right to clean air and water, healthy food, housing, transportation, green space, and culture. These are the commons—the common wealth that a society should share, with equal access to all. The 1960s and 1970s saw an increase in concern internationally about the planet we live on and the sustainability of our existence. Rather than simply calling for protection of the earth, environmental social movements made connections among all aspects of the commons. With this perspective, resistance to the proliferation of advertising and the growth of suburban sprawl and corporate architecture became part of the cause. Since the 1970s, millions have mobilized against both nuclear power and the stockpiling of nuclear weapons, not only for issues of peace and safety, but to preserve the health and quality of our ecosystems. This spirit continues in current housing, food, and climate justice struggles.

255. Nick Cobbing. **Reclaim the Streets/Carnival Against Capitalism**, photographic documentation, c. 1990s, UK.

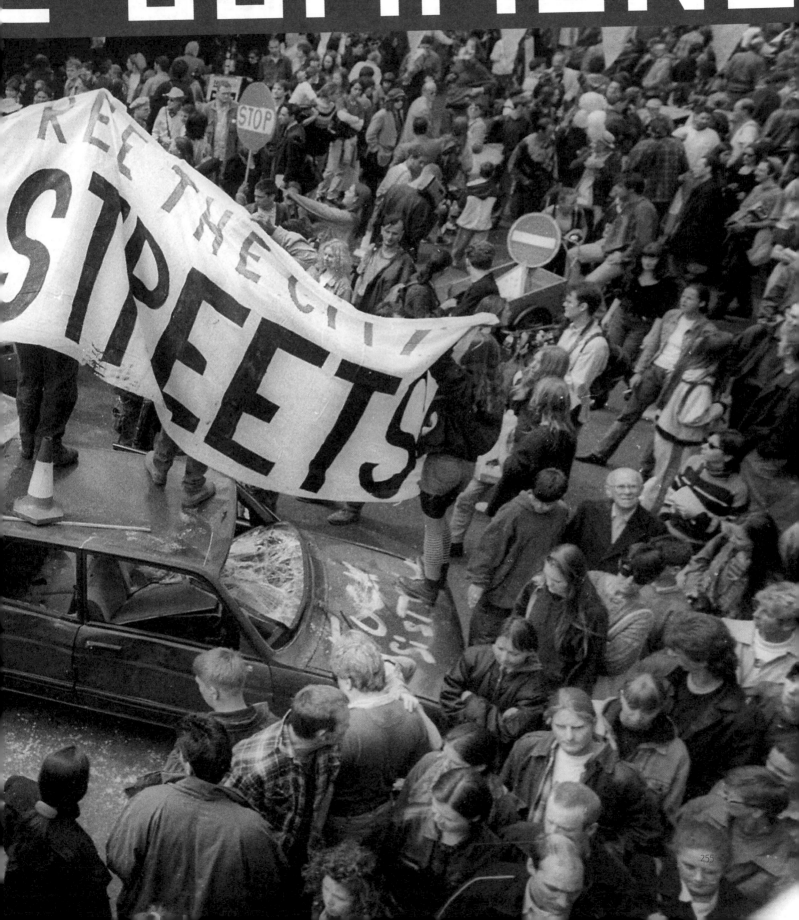

REET THE CITY
STREETS
STOP

255

ANTI-GENTRIFICATION STRUGGLES [1970s–present, International]

Gentrification is a complex economic, political, and social process in which real estate prices rise in certain neighborhoods or cities and the demographic and cultural characters of the location are altered. These changes make it difficult for working class and poor residents to maintain their homes and way of life. In the 1970s, one of the effects of gentrification was an explosion of homelessness in the US, and housing has become one of the main points of struggle for community and neighborhood activists and organizations. Community and tenant organizing has been a powerful force in the anti-gentrification and anti-displacement fight for rent control and affordable housing across the globe.

256. Aktiegroep Nieuwmarkt (artist: Bert Griepink), **The Nieuwmarkt: Make or Break**, screen print, 1974, the Netherlands.

The struggle for the Nieuwmarkt area was one of the most successful political campaigns in post-1960s Netherlands. The city of Amsterdam had planned to demolish a large part of a historical segment of the inner city, but this was blocked. A mass movement was organized which combined squatters with popular opposition to development intended to displace people and destroy historic architecture for short-term profits.

257. Docklands Community Poster Project (artist unknown), **The future's up for grabs. Make sure it's yours with the People's Plan**, offset lithograph poster, 1981, UK.

258. Aktiegroep Nieuwmarkt (artist unknown), **Saneren—Deporteren—Speculeren [Redevelop—Deport—Speculate]**, screen print, 1971, the Netherlands.

This poster, created by Dutch housing activists, uses a Situationist-inspired map graphic to illustrate the forces affecting the Nieuwmarkt neighborhood in Amsterdam, where construction of a public transit line was displacing residents from the city.

259. San Francisco Print Collective (photography: Eric Triantafillou), **Stop the Monster!**, photographic documentation of screen print, 2001, USA.

The San Francisco Print Collective (SFPC) began in February 2000 when a group of artists and designers met at Mission Grafica, a community-based screen print shop. This happened at the height of the dot-com boom in San Francisco, when there was an immense amount of development and displacement of long-term residents and poorer communities. SFPC came together to collectively produce political posters in response. Their first graphic campaign dealt with the impact of gentrification in the Mission District, where many of the members lived. SFPC joined the Mission Anti-Displacement Coalition and became the graphic wing of a large network of low-income and immigrant housing activists and organizations.

260. San Francisco Print Collective, **Gentrify Me!**, screen print, 2000, USA.

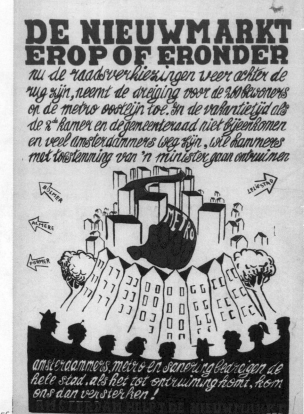

256

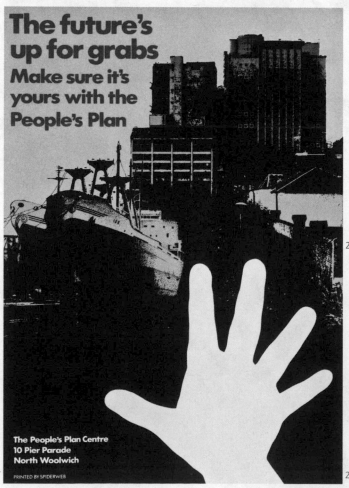

257 PRINTED BY SPIDERWEB

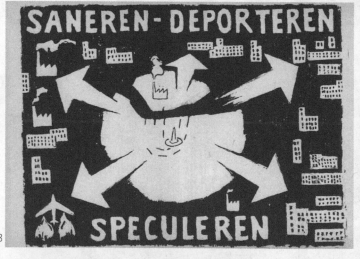

258

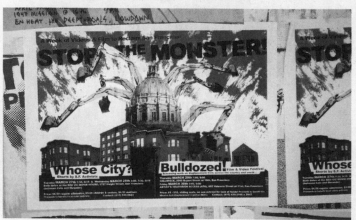

259

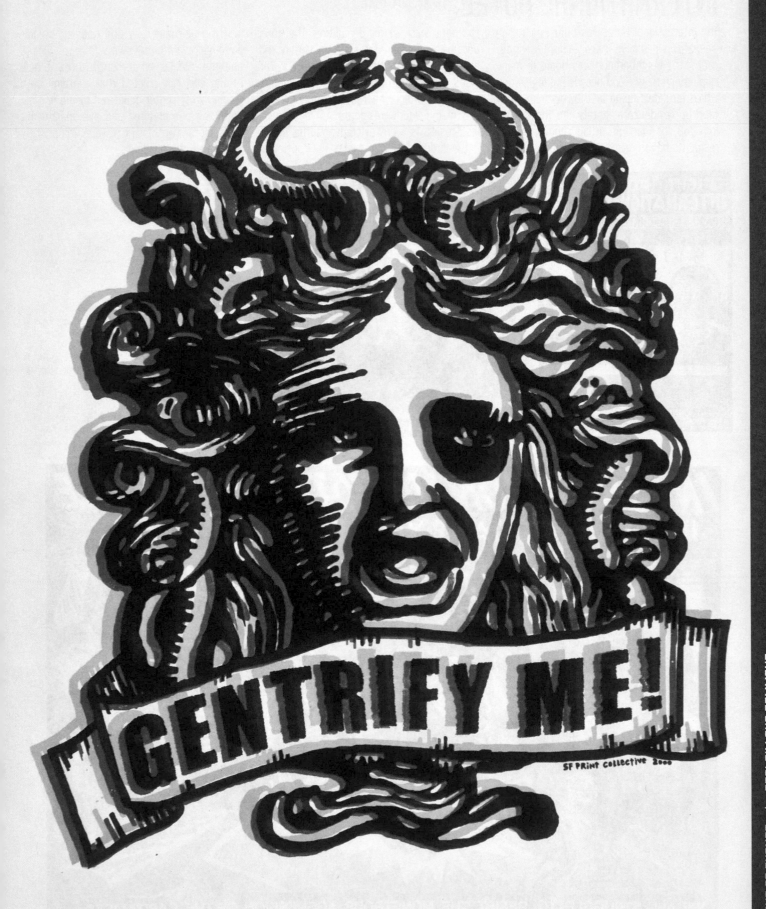

GENTRIFY ME!

SF Print Collective 2000

INTERNATIONAL HOTEL [1968–2003, USA]

The International Hotel was built in 1907 in Manilatown in San Francisco, California. For decades, the neighborhood was home to many Filipino Americans, and because of legislation which forbade Filipino land ownership, many took up residence at hotels like the I-Hotel. In 1968, as part of urban renewal plans, residents began receiving eviction notices as the hotel was set for demolition. The hotel became a hot spot for activism within and outside the Asian American community. For years there were protests and legal actions taken to protect the rights and homes of the many elderly residents. In 1977, the last residents were evicted and the building was demolished in 1981. The continued activism of community and housing organizations prevented the owner from rebuilding, and the site lay empty until 2003. A new I-Hotel was constructed that contains both a community center dedicated to the original hotel and one hundred and five apartments for seniors, two of which were occupied by original I-Hotel residents.

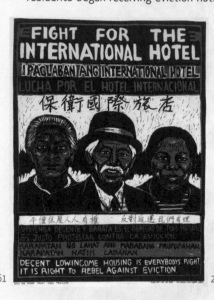

261

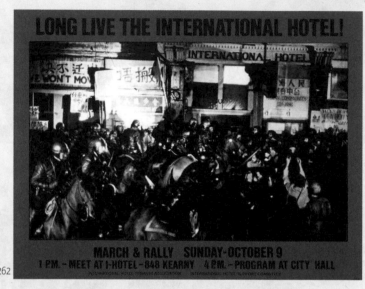

262

261. San Francisco Poster Brigade (artist: Rachael Romero), **Fight for the International Hotel**, offset lithograph poster, 1976, USA.
262. Artist unknown, **Long Live the International Hotel!**, offset lithograph poster, 1977, USA.
263. San Francisco Poster Brigade (artist: Rachael Romero), **International Hotel Struggle**, offset lithograph poster, 1979, USA.

263

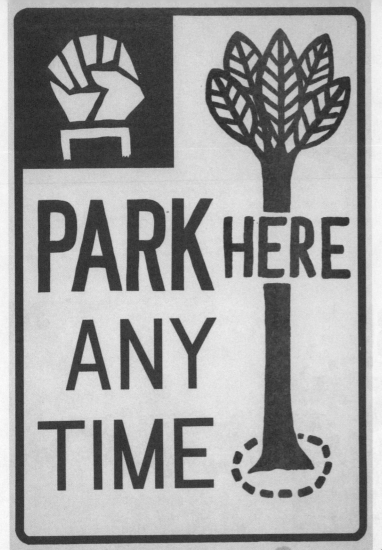

PEOPLE'S PARK [1969–present, USA]

The struggle over People's Park in Berkeley, California was, in many ways, an extension of the Berkeley Free Speech Movement. In 1969, a vacant tract of University of California-owned land was occupied by community residents, who began to convert it into a "people's park" and a place for political organizing. Hundreds helped to clear the land and plant flowers and trees. Some even set up tents and started living there. Within a month, the University set the site for demolition and police surrounded the area with an eight-foot-tall fence. Approximately 3,000 protestors tried to reclaim the park, and police shot at the crowds. Hundreds were wounded by police brutality and one student was killed. Ronald Reagan (then Governor of California) called in the National Guard, who occupied the city for seventeen days.

264. Artist unknown, **Park Here Any Time**, screen print, 1971, USA.
265. Artist unknown, **Today Pigs Tomorrows Bacon**, screen print, c. 1969, USA.
266. Artist unknown, **3rd Anniversary of People's Park**, screen print, 1972, USA.

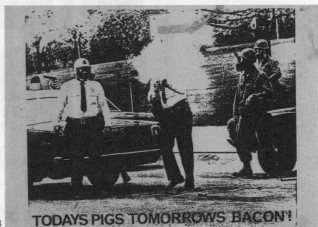

TODAYS PIGS TOMORROWS BACON!

264

265

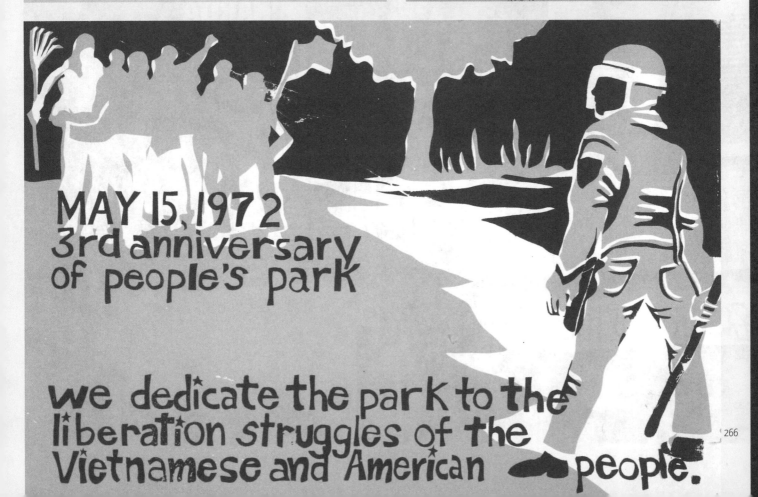

MAY 15, 1972
3rd anniversary
of people's park

we dedicate the park to the
liberation struggles of the
Vietnamese and American people.

266

NARITA AIRPORT STRUGGLE [1966–present, Japan]

In 1966 the Japanese government publicized plans to seize the property of the villages Sanrizuka and Shibayama in order to build a new Tokyo International Airport. Community residents and farmers refused to give up their land, and political groups from the Japanese Student Movement joined with them to oppose the airport (in part because of plans to allow the US to keep military aircraft there for the war in Vietnam). These groups formed the Sanrizuka-Shibayama Union to Oppose the Airport and used a diversity of tactics, including lawsuits, mass media campaigns, and guerilla attacks on the physical structures of the airport as they were being constructed. Originally set to open in 1971, the airport was not fully operational until the 1980s. In the 1970s and 1980s, anti-airport demonstrations and riots continued, and in the late 1980s, the Union to Oppose the Airport constructed two steel towers (102' and 206' tall) to block the approach to the main runway.

267. Keisuke Narita, **People's Noise Against the Airport Noise**, digital poster, 2008, Japan.
268. Camerawork (artist unknown), **Narita: 12 Years of Opposition**, offset lithograph poster, 1981, UK.
269. Film still from *Narita: Peasants of the Second Fortress/ Sanrizuka: Dainitoride No Hitobito* (1971, 02:23:00 minutes, Shinsuke Ogawa/Ogawa Productions), Japan.
270. Ricardo Levins-Morales, **Farmers United Against the Airport**, offset lithograph poster, 1978, USA.

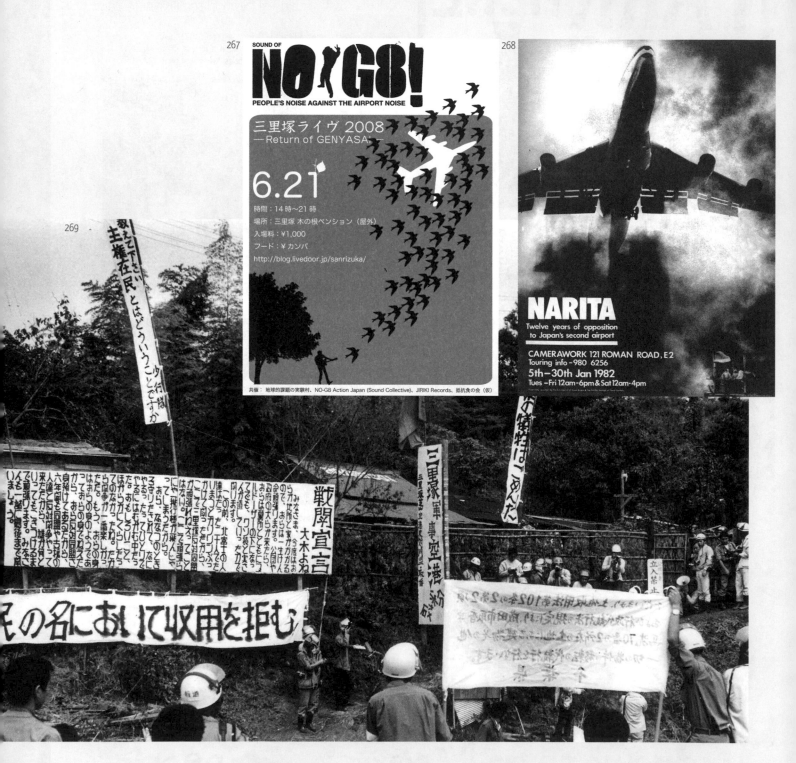

SANRIZUKA FARMERS UNITED AGAINST THE AIRPORT FOR THE LAND JAPAN

FARMERS, YOU ARE THE PLANTS LIVING ONE WITH THE SOIL AND YOUR ROOTS CLING TO ITS DEPTHS. FARMERS, LET YOUR HOLD ON THE SOIL PLUNGE EVER-DEEPER AND THOUGH IT SWALLOW YOU UP, NEVER LET GO. SAYAMA TADASHI

HUNT A CAR

de mensheid wordt bedreigd
door een toenemend aantal
gevaarlijke monsters.

JOIN THE BIG CITY SAFARI !

THE KABOUTERS

[1970s, the Netherlands]

The Kabouters (or Gnomes) were a Dutch political group that formed after the demise of Provo in the late 1960s. They expanded on Provo's concerns about the environment, making it the central pillar of their version of utopia, which they called the Orange Freestate (a state free of Orange, the Dutch royal color). They ran for office and were elected to the Amsterdam City Council, but unlike traditional political parties, they used the office to push for utopian proposals which would never be voted into law. They did not let their representation in government get in the way of many unorthodox stunts, which included printing counterfeit money, calling for the citizens of Amsterdam to shoot cars, and putting a proposal before the City Council that required the streets be deepened so that only car roofs were visible, and that the roofs must have gardens on them, so the people of Amsterdam would never have to look at automobiles, but only see moving green spaces.

271. Kabouters (artist: Gerard Goosen), **Hunt a Car**, offset lithograph poster, 1970, the Netherlands.
 Translation: Humanity is under threat of a growing number of dangerous monsters.

272. Kabouters (artist unknown), **Rode Stip [Red Dot Plan]**, screen print, 1970, the Netherlands.
 The Oranje Vrijstaat [Orange Free State, a state of being free, and free of "Orange," which is the color of the Dutch royal house] was the utopia aimed for by Provo and the Kabouters, who developed out of their collapse. The Red Dot Plan, following in the footsteps of Provo White Plans, is one of the many examples of how the Kabouters tried to change everyday life.
 Translation: Orange Freestate. Red Dot Red Dot Red Dot Red Dot Red Dot Red Dot.../In Rotterdam Gnome City, public transportation isn't all that it should be. Of course, this should be changed, but as a temporary solution, the Orange Free State comes with the Red Dot Plan. Car driver, stick a red dot on the right side of your front window. Everyone without transportation can raise his or her hand and drive with you, as long as there's room and directions are compatible. Call 010-231242 or 010-157827 or 018073082 to ask how to get Red Dots./Put a fellow human in your car./Hang this poster everywhere you want.

273. Kabouters (artist unknown), **Ruimtenood en Woningnood**, offset lithograph poster, c. 1970s, the Netherlands.
 Translation: A lack of air and a lack of space. Free the Leidse Square. You do not park your car at Dam Square either, right?/Occupation (arrow points at cars on Leidse Square)./Freedom (arrow points to the alternative): Person, tree, child, freedom of opinion, the street, theater./Gnome City, Orange Freestate.

274. Kabouters (artist unknown), **Stem Mar Kabouter**, offset lithograph poster, 1971, the Netherlands.

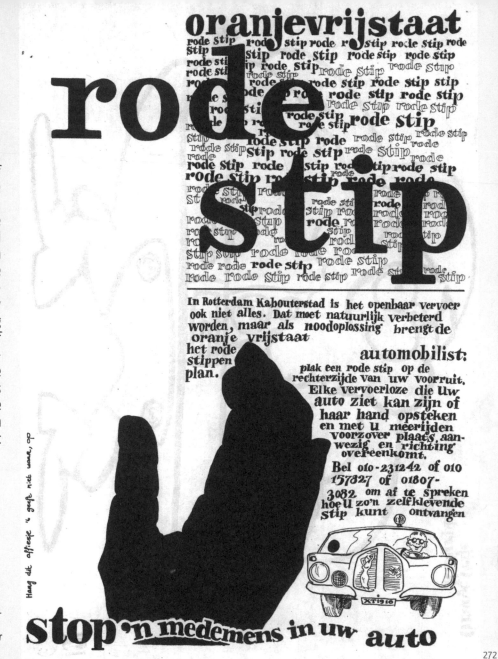

272

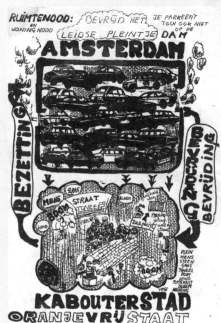

273

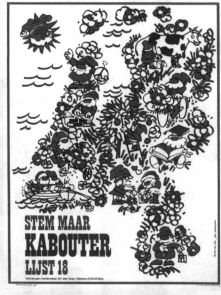

274

LARZAC [1970–1981, France]

Larzac is a plateau in south central France most well known for Roquefort cheese, made from the milk of local sheep. In 1970, the French military decided to build a base on the plateau, but faced continued resistance from farmers and their supporters until the plan was cancelled in 1981. The farmers used a creative mix of land occupations, protest encampments, non-violent resistance, and publicity stunts to fight off the military. Larzac is still an important location of French protest culture.

275. Organization Communiste des Travailleurs (artist unknown), **Larzac 13–14 Aout [August 13–14]**, offset lithographic poster, c. 1980s, France.

276. Paysans du Larzac (artist: F. Montes), **Pour le Gel Nucleaire**, offset lithograph poster, 1983, France.

277. Association de Sauvegarde du Larzac et de son Environnement (artist unknown), **Larzac**, offset lithograph poster, c. 1975, France.

Translation: Larzac/Third Harvest/Global Celebration on August 17/18

278. Association de Sauvegarde du Larzac et de son Environnement (artist unknown), **Larzac**, offset lithograph poster, c. 1975, France.

279. Artist unknown, **Larzac**, screen print, c. 1980s, France.

Translation: Discard plans to evict farmers from their land!/ National Day of Resistance!/Stop the plan to expand the military base!

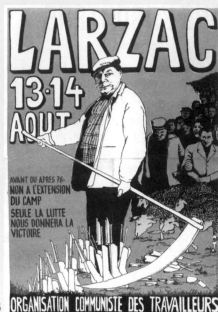

275

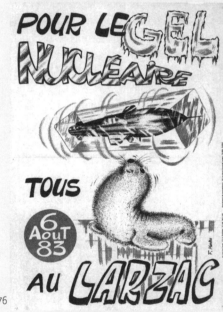

276

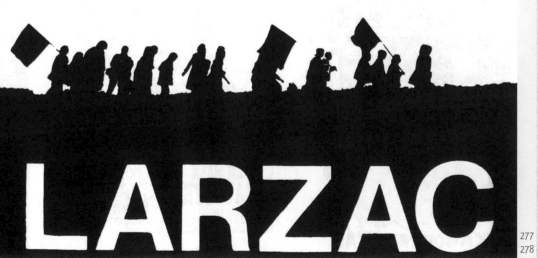

LARZAC

277
278

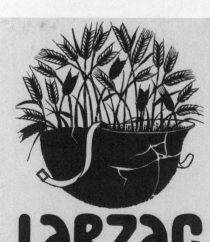

LARZAC

GISCARD DECLENCHE

L'EXPROPRIATION DES PAYSANS

JOURNEE NATIONALE
RESISTANCE !

POUR L'ABANDON DU PROJET D'EXTENSION DU CAMP MILITAIRE !

LE 28 OCT

ANTI-NUCLEAR MOVEMENT [1960s–present, International]

The anti-nuclear movement is international and multifaceted. It has focused on environmentalism, sustainable energy, feminism, peace, anti-militarism, and anti-imperialism, to name just some of the issues it has raised. Although nuclear power has been promoted by corporations and governments as "necessary" or even "cleaner" than other alternatives, the anti-nuclear movement has successfully reframed this option as dangerous and potentially threatening to all life on the planet. Anti-nuclear activists have developed multiple and memorable graphics to represent the "No Nukes" position.

280. Red Scare Products, **Nuclear War?**, offset lithograph poster, c. 1980s, USA.
281. Taring Padi, **Nuklir Merusak Alam, Nuklir Merusak Nafas**, relief print, 2000, Indonesia.
 Translation: Nuclear energy damages nature, nuclear energy damages breathing.
282. Artist unknown, **Fight the Power**, offset lithograph poster, c. 1990s, Germany.
 The red atom with its fist in the air has become an international symbol of the militant anti-nuclear movement.
 Translation: Immediate shutdown of all atomic installations world-wide.

283. The Coalition for Direct Action (artist: Peg Averill), **No Nukes**, screen print, 1980, USA.
284. Artist unknown, **Gorleben: Atommüll Fabrik Nie [Nuclear Plant Never]**, screen print, c. 1980s, Germany.
285. Leonard Rifas, **Atom Komix**, printed publication, 1976, the Netherlands.
286. Coalition for Direct Action at Seabrook (artist unknown), **Direct Action Seabrook**, screen print, c. 1970s, USA.

In 1976, plans were announced for the building of a nuclear power plant in Seabrook, New Hampshire. From the late 1970s through the late 1980s, Seabrook was at the center of a large anti-nuclear civil disobedience movement, with thousands of members of the Clamshell Alliance regularly being arrested for occupying the plant site. Two reactors were planned, but only one was built, and went online in 1990.

287. Artist unknown, **Lad 100 møller bloomstre...[Let 100 windmills bloom...]**, offset lithograph poster, c. 1980s, Denmark.
288. Artist unknown, **Danmark Uden Atomkraft [Denmark Against Nuclear Power]**, relief print, 1980, Denmark.
289. Anti-Atom Plenum Berlin (artist unknown), **Tag X [Day of Action]**, offset lithograph poster, 2000, Germany.

This poster is a call to protest the transport of Castor casks of nuclear waste to Gorleben, Germany. The X has become a visual representation of the anti-nuclear movement in Germany, and can be found in graffiti, signs, on clothing and bumper stickers.
 Translation: Castor Alert!/Day of Action, Autumn 2000/We Shall Be in the Way.
290. E. Kahlgah, **Arrêtez la Folie du Neutron![Stop the Nuclear Madness!]**, offset lithograph poster, 1978, France.

280

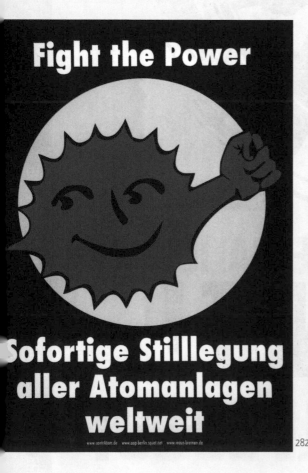

282

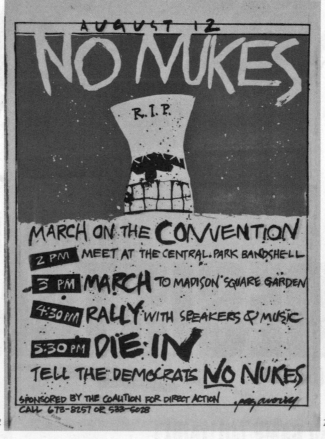

283

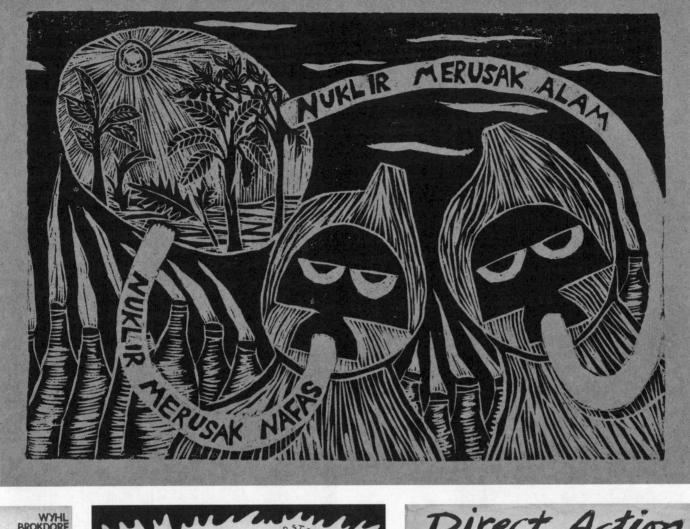

281

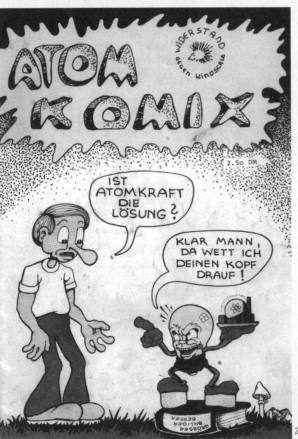

284

285

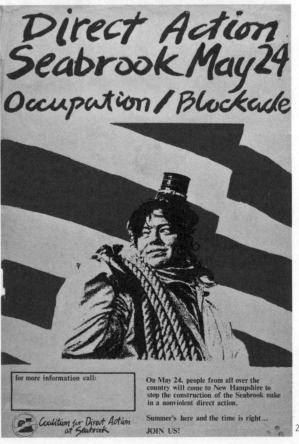

286

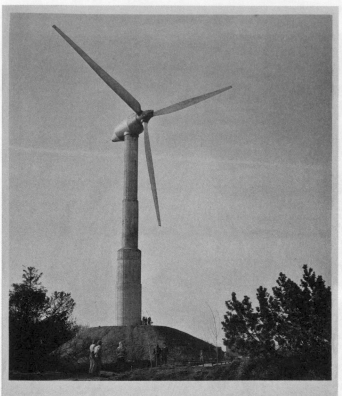

Lad 100 møller blomstre...

287

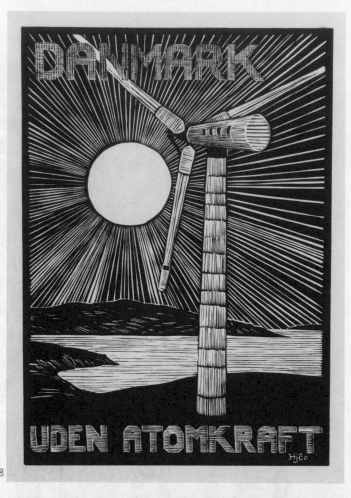

DANMARK

UDEN ATOMKRAFT

288

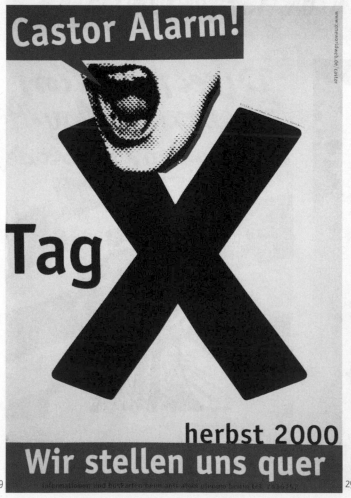

Castor Alarm!

Tag X

www.oneworldweb.de/castor

herbst 2000

Wir stellen uns quer

289

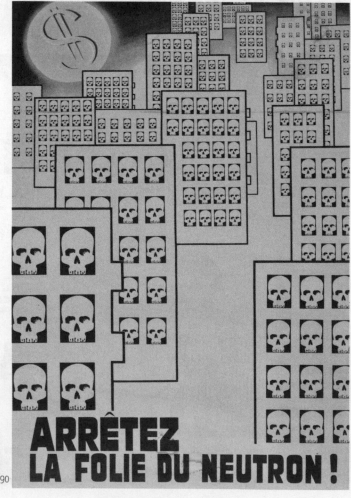

**ARRÊTEZ
LA FOLIE DU NEUTRON !**

290

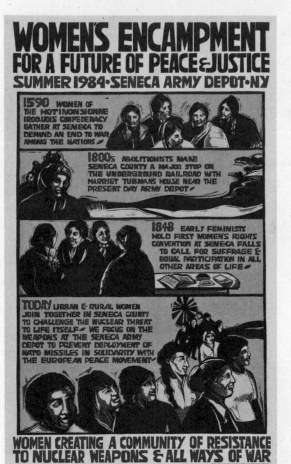

WOMEN'S ANTI-NUCLEAR ENCAMPMENTS [1981–1990s, International]

Greenham Common Women's Peace Camp was an all-women's anti-nuclear encampment surrounding the British Air Force base RAF Greenham Common. The camp was established in 1981 by a Welsh group, Women for Life on Earth, who had been organizing against the government for having allowed US cruise missiles to be placed there. The most well-known of multiple anti-nuclear peace camps in the UK (others were not women-only), it was occupied until 2000. Greenham Common inspired other peace encampments elsewhere, including the Seneca Women's Encampment for a Future of Peace and

Justice, set up in 1983 at Seneca Army Depot in Seneca, NY. Organized by consensus and direct democracy, Greenham and other encampments were sites for social experimentation in living, consciousness raising, and political organizing. At Greenham, as well as at the other women's peace encampments, feminist creativity and direct action were combined to produce a large outpouring of artwork, banners, performances, and self-published newsletters and publications. They also wove protest webs into the fences of the military bases.

291. Women's Encampment (artist: Bonnie Acker), **Women's Encampment for a Future of Peace and Justice**, offset lithograph poster, 1984, USA.
292. Artists unknown, **Green and Common**, pages from the photocopied Greenham Common encampment newsletter, 1980s, UK.

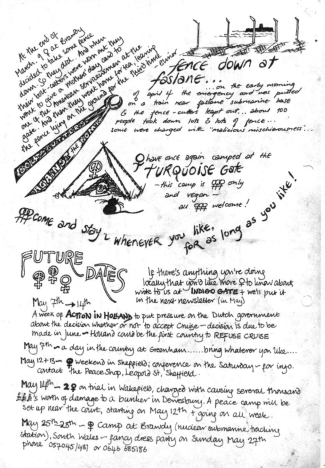

292

RECLAIM THE STREETS [mid-1990s–1999, International]

Reclaim the Streets (RTS) is a non-violent direct-action tactic that takes the form of large-scale illegal street parties. Developing from the British Earth First! and anti-road protest movements in 1991, RTS actions first targeted the dangers of car culture and the misuse of public space. As RTS events became more popular, they were held in support of specific campaigns and as critiques of capitalism. The creative costumes, mobile sound systems, use of radio, and their party-as-protest tactics spread around the world.

RTS was known for its ostentatious public stunts. In 1996 at one of the largest RTS actions in the UK, 6,000 protestors occupied the M41 Motorway in London with a giant dance party. Dancers on stilts wearing giant ball gowns with wire frames provided cover for other activists, who tore up the street with jackhammers underneath the fabric. At other events a children's inflatable bouncy castle was erected in a major intersection and a subway line was shutdown when activists climbed onto a train during rush hour.

294

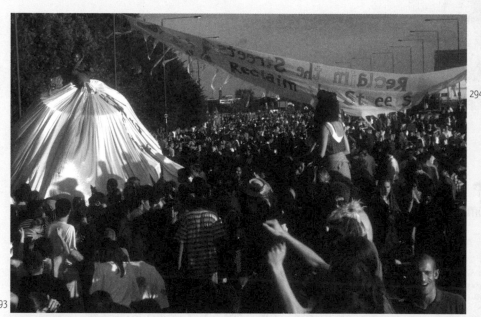

293

296

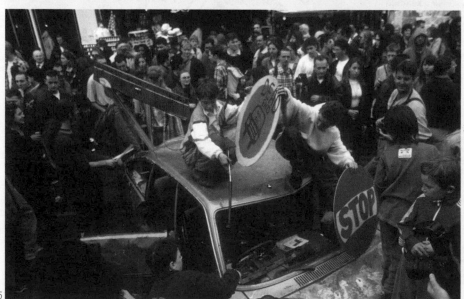

295

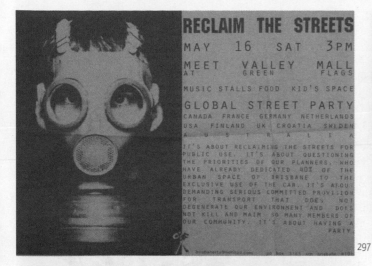

RECLAIM THE STREETS
MAY 16 SAT 3PM
MEET VALLEY MALL
AT GREEN FLAGS
MUSIC STALLS FOOD KID'S SPACE
GLOBAL STREET PARTY
CANADA FRANCE GERMANY NETHERLANDS
USA FINLAND UK CROATIA SWEDEN
A U S T R A L I A
IT'S ABOUT RECLAIMING THE STREETS FOR
PUBLIC USE. IT'S ABOUT QUESTIONING
THE PRIORITIES OF OUR PLANNERS, WHO
HAVE ALREADY DEDICATED 40% OF THE
URBAN SPACE OF BRISBANE TO THE
EXCLUSIVE USE OF THE CAR. IT'S ABOUT
DEMANDING SERIOUS COMMITTED PROVISION
FOR TRANSPORT THAT DOES NOT
DEGENERATE OUR ENVIRONMENT AND DOES
NOT KILL AND MAIM SO MANY MEMBERS OF
OUR COMMUNITY. IT'S ABOUT HAVING A
PARTY.

297

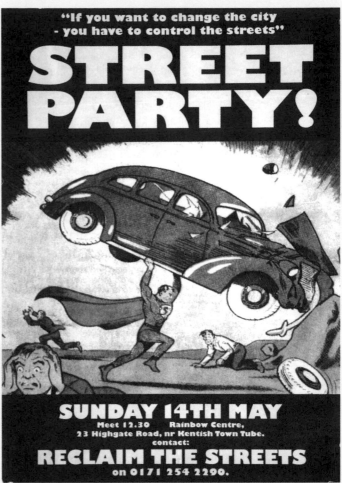

"If you want to change the city
- you have to control the streets"

STREET PARTY!

SUNDAY 14TH MAY
Meet 12.30 Rainbow Centre,
23 Highgate Road, nr Kentish Town Tube.
contact:
RECLAIM THE STREETS
on 0171 254 2290.

298

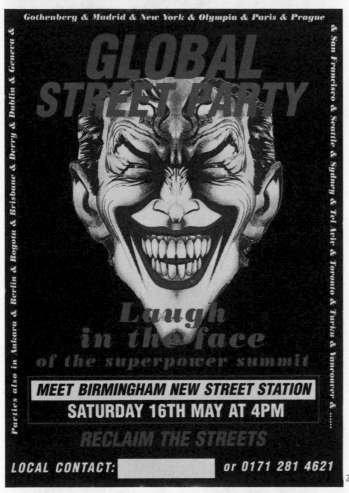

Gothenberg & Madrid & New York & Olympia & Paris & Prague

GLOBAL STREET PARTY

Laugh in the face of the superpower summit

MEET BIRMINGHAM NEW STREET STATION
SATURDAY 16TH MAY AT 4PM

RECLAIM THE STREETS

LOCAL CONTACT: _____ or 0171 281 4621

299

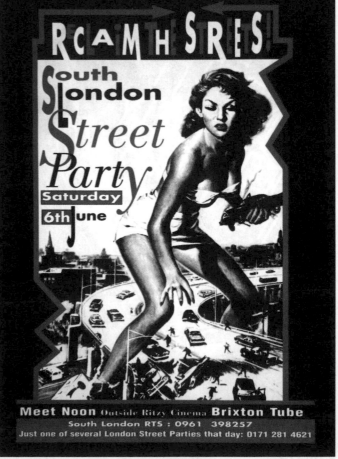

RCAMH SRES
South London Street Party
Saturday 6th June

Meet Noon Outside Ritzy Cinema Brixton Tube
South London RTS : 0961 398257
Just one of several London Street Parties that day: 0171 281 4621

300

293. Nick Cobbing, **Reclaim the Streets on the M41 Motorway**, photographic documentation, 1996, UK.

294. Peoples' Global Action (artist unknown), **Global Street Party '98**, offset lithograph poster, 1998, Czech Republic.

 May 16, 1998 was the first Global Day of Action Against Capitalism, organized by Peoples' Global Action (PGA). PGA, inspired by the Zapatistas in Mexico, is an international network of social movements and grassroots organizations struggling for social justice. May 16 was chosen as the date for the actions because it was the day the G8 met in the UK, but was also the anniversary of the destruction of the Vendôme Column during the 1871 Paris Commune.

295. Nick Cobbing, **Camden Street Party**, photographic documentation, c. 1995, UK.

296. Peoples' Global Action (artist unknown), **Reclaim the Streets/GSP**, offset lithograph poster, 1998, Canada.

297. Peoples' Global Action (artist unknown), **Reclaim the Streets/GSP**, offset lithograph poster, 1998, Australia.

298. Reclaim the Streets (artist unknown), **Street Party!**, offset lithograph poster, 1995, UK.

299. Peoples' Global Action (artist unknown), **Global Street Party**, offset lithograph poster, 1998, UK.

300. Reclaim the Streets (artist unknown), **Reclaim the Streets!**, offset lithograph poster, 1999, UK.

ROAD PROTESTS AND FOREST DEFENSE [1980s–present, International]

Protests aimed at stopping the creation of new roads have taken many forms including squatted encampments and street parties. The protesters' critiques include the negative environmental impact of building new roads, the displacement of residents, and the designing of society in the service of cars at the expense of all other human needs. In urban areas, protestors have often occupied entire blocks of buildings set for demolition and in rural areas, protestors create interconnected networks of tree houses and other experimental architectural forms to stop tree removal for road construction.

In Australia and the US, forest defense camps developed in the 1980s and 90s in order to protect old growth trees and forests from clear-cutting by multi-national logging and paper companies. These encampments often involved tree-sits, where activists would live on platforms or in small tree houses at the tops of trees in order to stop them from being cut down.

301. Vote Environment (artist: Tom Civil), **Tassie Forests: Lets Protect the Ancient Forests of the South**, offset lithograph poster, 2005, Australia.

302. Street Art Workers (artist: Alec Icky Dunn), **Stop the NAFTA Superhighway**, offset lithograph poster, 2006, USA.

303. Earth First!, **Earth First!**, printed publication, 1990s, USA.

304. Tony Hastings, **Goolengook Forest Blockade**, photographic documentation, c. 1997–2002, Australia.

Goolengook was Australia's longest running forest blockade. For five years activists lived in the trees to oppose old growth logging and the encroachment onto the traditional lands of the Bidaval Aboriginal people. In 2006, the Goolengook Forest was set aside as a national park and protected.

305. Tony Hastings, **Goolengook Forest Blockade**, photographic documentation, c. 1997–2002, Australia.

306. Kate Evans, **Copse**, printed publication, 1998, UK.

Copse is a popular comic book which visually tells the story of the UK road protest movement, as well as illustrating techniques for building tree houses and other protest encampment tactics.

307. Stacey Wakefield, **No M11**, photographic documentation, 1995, UK.

308. Stacey Wakefield, **Pollok Free State**, photographic documentation, 1995, UK (following page).

Built on the edge of Glasgow, Scotland, the Pollok Free State was an interlocking network of tree houses, constructed to block the path of the proposed M77 motorway.

301

NOTICE:
WOODCHIPPING BERSERK IN ENDANGERED
GIANT FRESHWATER CRAYFISH HABITAT

TASSIE FORESTS
LETS PROTECT THE ANCIENT WILD FORESTS OF THE SOUTH

THIS FEDERAL ELECTION TARGET:
THE WOODCHIPPING OF RAINFORESTS AND OLD GROWTH FORESTS
THE POISONING AND EXTINCTION OF NATIVE ANIMALS
THE CORPORATE/GOVERNMENT CULTURE OF BULLYING, CRONYISM, SECRECY AND LIES

ENSURE THE CONSERVATION OF UNIQUE NATIVE ANIMALS FOR FUTURE GENERATIONS.

EXTINCTION IS FOREVER, YOUR VOTE COULD MAKE THE DIFFERENCE
WWW.VOTEENVIRONMENT.COM.AU

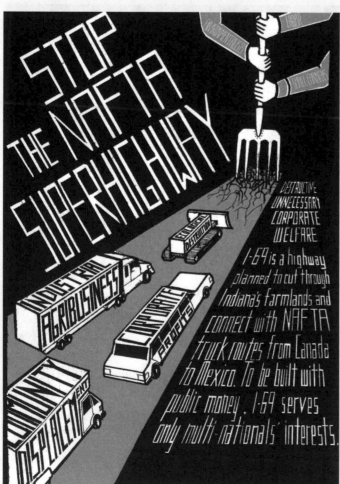

302

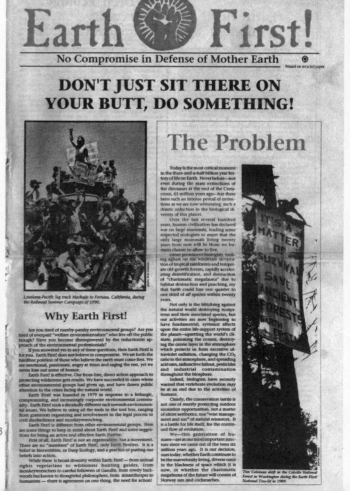

303

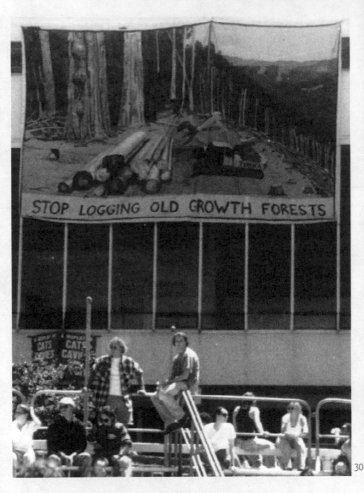

304

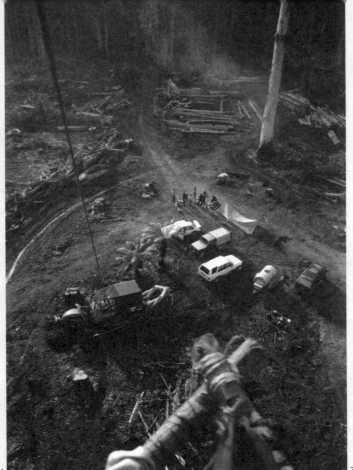

305

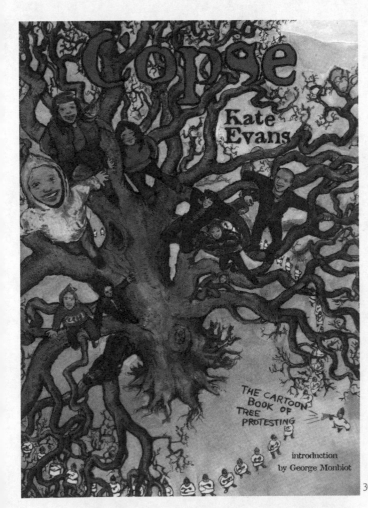

306

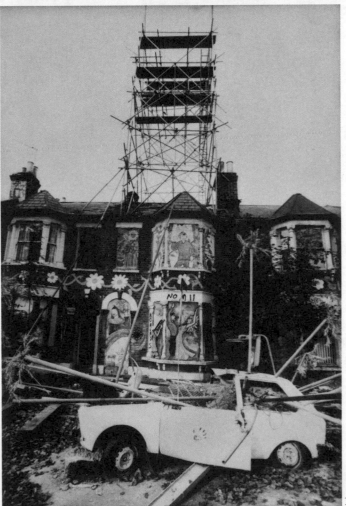

307

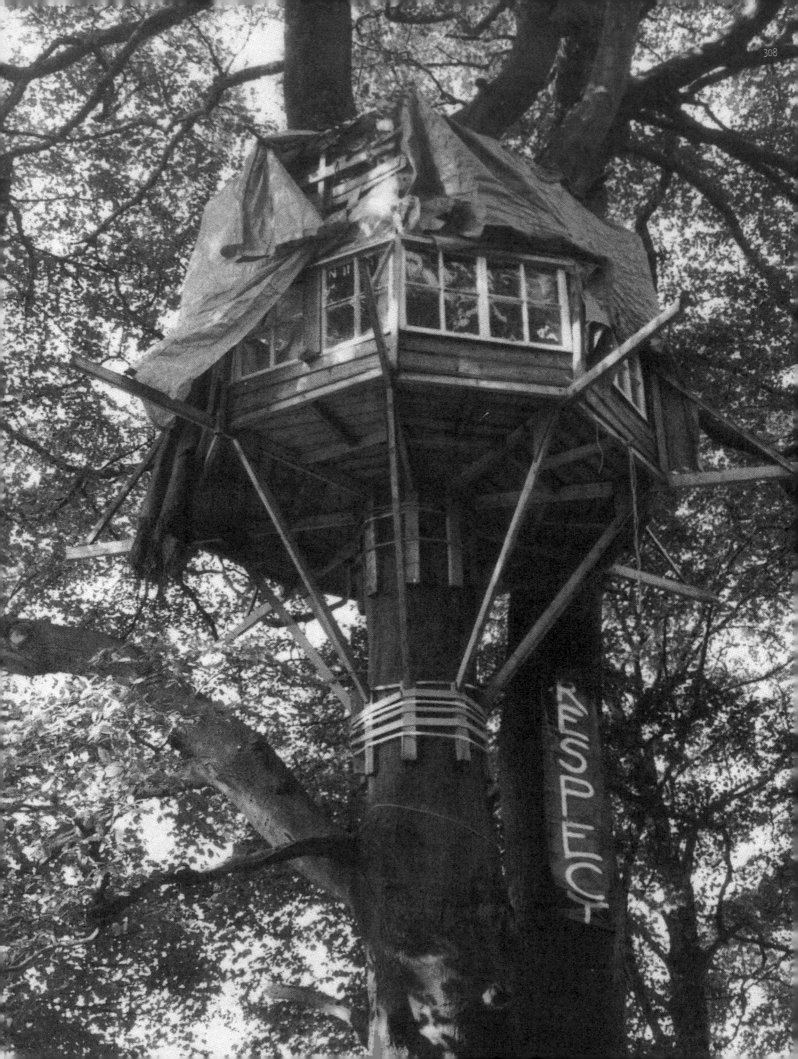

LIBERATING THE MENTAL ENVIRONMENT [1980s–present, International]

As part of a critique of the impacts of advertising, activists have made analogies between "ad-creep" and environmental pollution. Our minds, they argue, are environments being polluted by advertising, which is creeping into all aspects of our lives, from unavoidable outdoor billboards to adverts in bathroom stalls. In the United States, on average, people are exposed to between 400 and 4,000 advertisements per day. Activists committed to liberating the mental environment from advertising, with its top down directives to shop or follow rules, are sometimes referred to as culture jammers. Creating a balanced and healthy media ecosystem is connected to the work of balancing natural ecosystems.

The first documented examples of people fighting back against the spread of billboards and advertising begins in the 1970s. This took the form of individual and group attacks on advertisements. In the US, the Billboard Liberation Front, which formed out of the group the Suicide Club, transformed messages on billboards into critiques of consumerism or into political slogans. In Australia, a similar group was formed in the early 1980s called BUGA UP, who focused almost exclusively on destroying billboards promoting cigarettes. The last five years has seen a tremendous increase in attacks on advertising around the world. One of the centers of creative intervention is the UK, where billboards have been altered, splashed, and cut down in large numbers.

Another recent example is Stop Pub, a network of French activists who have been organizing against the encroachment of advertising into daily life. On October 17, 2003, seven groups of some twenty to twenty-five people descended on the Paris Metro system with paint, glue, rollers, brushes, spray paint, and markers. In one night they covered up, defaced, or simply ripped to shreds almost all of the system's advertisements. This was only one of many actions that year.

309. Tim Cole, **No War**, photographic documentation, 2004, Australia (previous page).
 Two activists, Will Saunders and David Burgess, painted "No War" in fifteen-foot letters on the Sydney Opera House in March 2003, just before the start of the current Iraq War.
310. I.R.L./Informations et Reflexions Libertaires (artist unknown), **Les Murs Garderont la Parole [The Walls Will Not be Muzzled]**, offset lithograph poster, 1988, France.
 Translation: They want to ban independent posters!/The walls will not be muzzled.
311. Boyd, **Destroyed Billboards**, photographic documentation, 2003, UK.
312. Stop Pub, **Paris Metro Action**, photographic documentation, 2003, France.

310

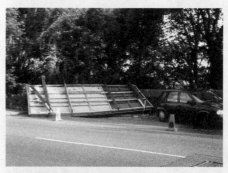

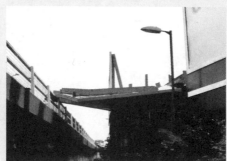

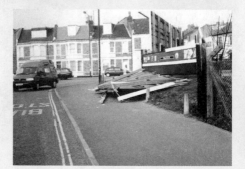

311

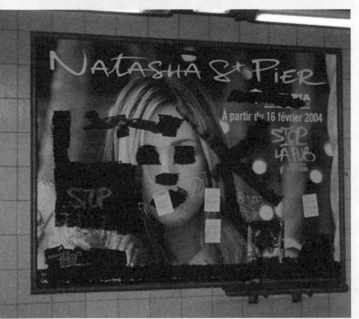

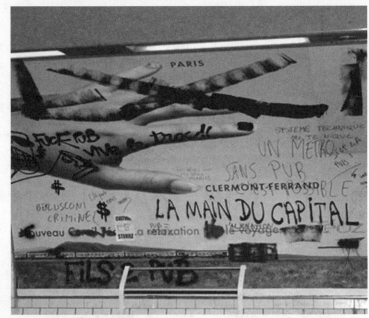

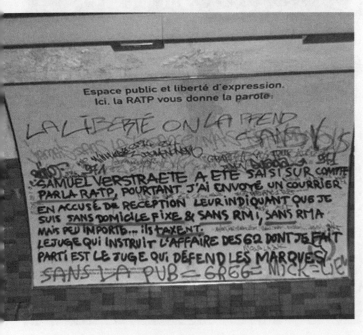

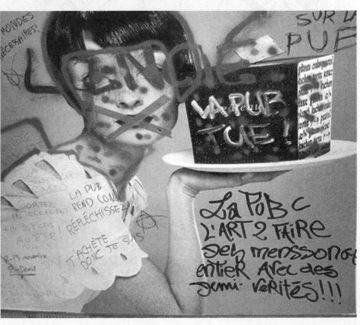

BIKE ACTIVISM AND ALTERNATIVE TRANSPORTATION [early 1990s–present, International]

Car culture, with its links to corporate profit, environmental degradation, and unsustainable urban and suburban redesign, has been the target of transportation activists for decades. Bike activists have made some gains in advocating biking as an environmentally and socially friendly alternative to automobiles. Our roads are an important part of the commons and should not exclusively serve the interests of car manufacturers and drivers. Transportation activists also advocate for other forms of more sustainable mass transit in addition to making cities more bike friendly.

One of the most popular forms of bicycle activism has been monthly Critical Mass bike rides in cities across the globe. These rides started in San Francisco in 1992. Although Critical Mass is a decentralized phenomenon and its values vary depending on local organizers, it is a direct action tactic that makes bike culture more visible and encourages the use of ecologically sustainable transportation as well as more human-scale city planning. One of the slogans coming out of Critical Mass

is, "We are traffic!" which is a call for us to rethink our relationship to cars.

Although visually reminiscent of the Provo White Bicycles, the Ghost Bike Project offers a different kind of intervention into the urban landscape. Without official permission, the Ghost Bike Project installs white bikes to mark the locations where bicyclists have been struck and killed by motor vehicles. Both a solemn memorial to the dead and a direct action call for the transformation of the streets, the Ghost Bikes are an extremely powerful reminder and call for a change in the domination of city streets by motor vehicles.

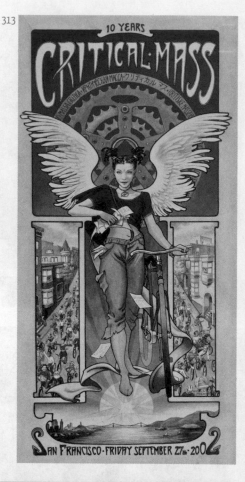

313. Mona Caron, **Critical Mass**, offset lithograph poster, 2002, USA.
314. Halfdan Mouritzen, **Kritiske Masser [Critical Mass]**, digital printed poster, 2007, Denmark.
 Translation: Meet at Blågårds Plads/Every Last Friday of the Month/We bicycle for more collective transport and for many, many more bikes in the streets.
315. Tom Civil, **The Revolution will Not be Motorised**, photographic documentation of street stencil, 2003, Australia.
316. Kevin Caplicki, **Ghost Bikes**, photographic documentation, 2000s, USA.

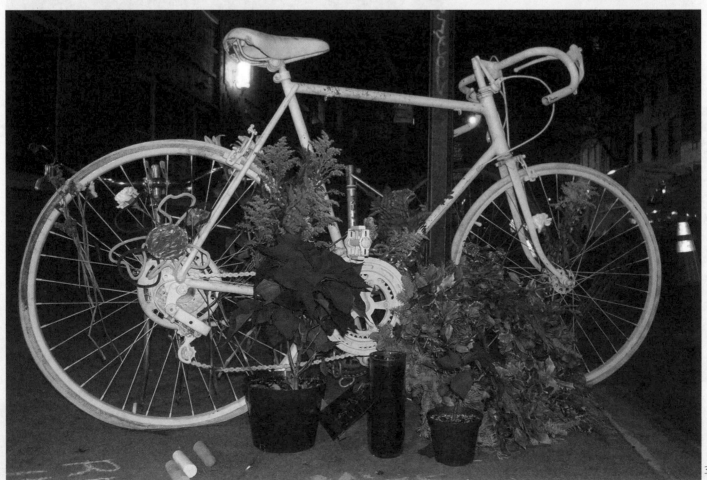

CLIMATE CAMPS

[2006–present, International]

Influenced by tactics of the anti-nuclear and anti-road movements, Camps for Climate Action are activist encampments, begun in the UK, that aim to both raise awareness about global climate change, while at the same time contesting unsustainable development plans slated for, or near, the site of the encampment. Each camp is planned over the previous year through a series of public meetings. The camps themselves are largely built from re-used and recycled materials, try to maximize use of renewable energy sources like solar power, and are organized through direct democracy. The Camp for Climate Action website states, "Every Camp for Climate Action event weaves four key themes: education, direct action, sustainable living, and building a movement to effectively tackle climate change both resisting climate crimes and developing sustainable solutions."

317. Climate Camp (artist: Rachel Bull), **The Camp for Climate Action,** *offset lithograph poster, 2007, UK.*
318. Climate Camp (artist unknown), **Climate Camp Heathrow,** *printed ephemera, 2007, UK.*
319. Climate Camp (artist unknown), **The Camp for Climate Action,** *printed ephemera, 2007, UK.*
320. Climate Camp (artist unknown), **The Camp for Climate Action,** *offset lithograph poster, 2006, UK.*
321. Climate Camp (artist unknown), **Be Prepared,** *offset lithograph poster, 2008, UK.*

317

THE CAMP FOR CLIMATE ACTION

MEET STAINES STATION FROM 10AM TUES 14TH
MASS ACTION 12NOON SUNDAY 20TH

14-21 AUGUST 2007 - NEAR HEATHROW - WWW.CLIMATECAMP.ORG.UK

No one can hide

The Camp for Climate Action

Head down to Megawatt Valley (near Leeds) for 10 days of direct action, information and discussion to stop climate chaos.

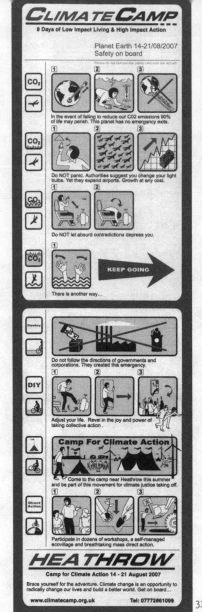

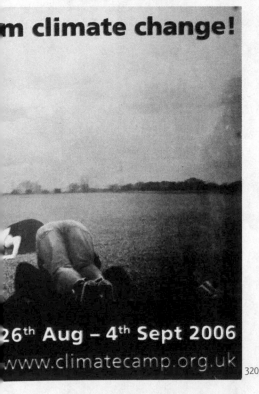

The collapse in the late 1980s of the Soviet Union was a catalyst for what would become an enhanced global capitalism of "open markets" and "free trade." This global marketplace has exponentially served the interests of transnational corporations, but has had dire consequences for workers and local economies. Simultaneously, access to the Internet and new media technologies has enabled grass-roots communities around the world to be more connected than ever before. Globalization from below has risen to challenge unfettered globalization from above. When the North American Free Trade Agreement (NAFTA) went into effect on January 1, 1994, an army of Indigenous people in Chiapas, Mexico descended from the mountains and took political control of several towns. The counter-globalization movement touched ground in the United States on November 30, 1999, when tens of thousands of students, union members, environmental activists, anarchists, and human rights organizations descended on downtown Seattle to protest a meeting of the World Trade Organization (WTO).

322. Radio Zapatista, Protest at the **Calexico/Mexicali No Borders Camp**, photographic documention, 2007, Mexico/USA.
 In 2007, activists on both sides of the US/Mexico border organized the first North American No Borders Camp in Calexico/Mexicali. The camp was a staging ground for protests against the building of a wall between the US and Mexico, which will split apart families and communities, and make it even more dangerous for Mexican immigrants to cross into the US for work.

ZAPATISTAS [1994–present, Mexico]

When the North American Free Trade Agreement (NAFTA) went into effect on January 1, 1994, an indigenous army descended from the mountains in Chiapas, Mexico and took political, economic, and military control over their own communities. This army, the Ejército Zapatista de Liberación Nacional (EZLN), commonly called the Zapatistas, captured the attention of the world by using both simple theatrics (many of the soldiers carried wooden guns) and high technology (the rebellion was announced to millions across the globe over the Internet). The Zapatistas have a powerful dual approach, both fighting for more democratic and communal existence locally, and being a catalyst for a highly visible network of international activists critiquing of neoliberalism. The term "neoliberalism," commonly used in Latin America and Europe, describes economic policies that support corporate globalization, privatization, the imposition of "free markets" and "free trade," and the destruction of social programs, such as those for education and healthcare. Neoliberalism has drastically increased the inequalities between the very rich corporate and government elites and everyone else.

323. Margarita Sada, **Las Mujeres con la Dignidad Rebelde [Women with Rebellious Dignity]**, offset lithograph poster, 2001, Mexico.

324. Artist unknown, **Fiesta Zapatista**, offset lithograph poster, 2004, Germany.

325. Rafael Baca, **Nuestro Mas Hermoso Sueño es su Peor Pesadilla [Our Most Beautiful Dream is Your Worst Nightmare]**, screen print, 2006, Mexico.

Translation: Our Most Beautiful Dream Is Your Worst Nightmare./Your Time is Over, we are Coming for You.

326. Refugio Solis, **La Otra Campaña [The Other Campaign]**, screen print, 2006, Mexico.

The Other Campaign is a large-scale project of the Zapatistas. In 2006, the Zapatista leadership decided to have their "public face," Subcomandante Marcos, travel around Mexico for six months.

Marcos held discussions with activists and community organizers, adherents and sympathizers for the Zapatista cause, and began building a national infrastructure for organized dissent against the political and economic elite of Mexico. This tour took place during the lead-up to a national presidential election and was intended to illustrate to those who participated that their needs and desires could only be attained through self-organization, not participation in the electoral process.

The figure in this poster is Mafalda, an anti-authoritarian character in a popular Argentine comic strip.

Translation: The Other Campaign/...Because the Exploited People Will Not Settle, but they will Rebel./Sixth Declaration of the Lacandon Jungle.

327. Rafel Seguí i Serres (photographer; artist unknown), photographic documentation of a mural in Zapatista communities, 1994–2004, Mexico.

328. La Corriente Eléctrica, **Zapaptopa**, photographic documentation, 2001, Mexico.

327

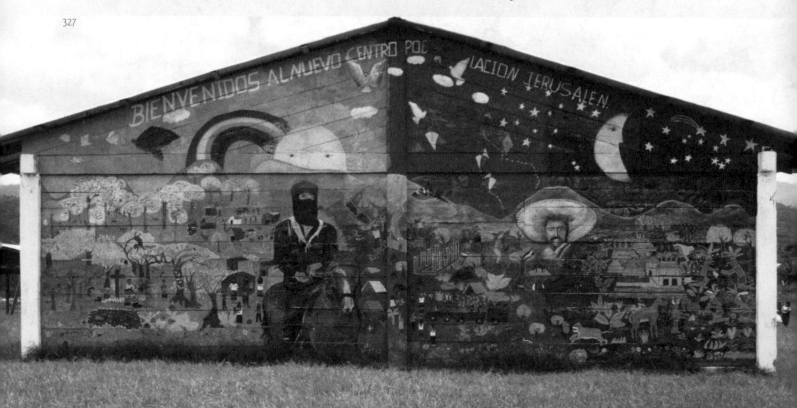

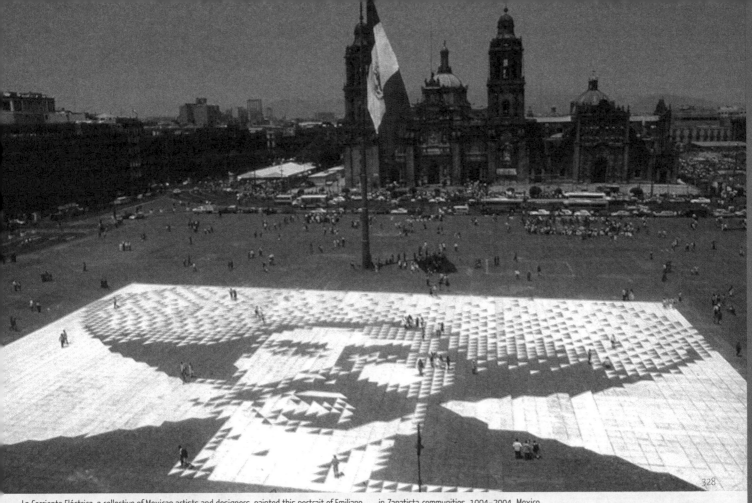

328

La Corriente Eléctrica, a collective of Mexican artists and designers, painted this portrait of Emiliano Zapata, Mexican revolutionary hero and namesake of the Zapatistas, in the zocalo in Mexico City in honor of Zapata's death and a Zapatista convoy to the city.

329. Rafel Seguí i Serres (photographer; artists unknown), photographic documentation of murals

in Zapatista communities, 1994–2004, Mexico.

330. Rafel Seguí i Serres (photographer; artist unknown), photographic documentation of murals in Zapatista communities, photographic documentation, 1994–2004, Mexico (following page spread).

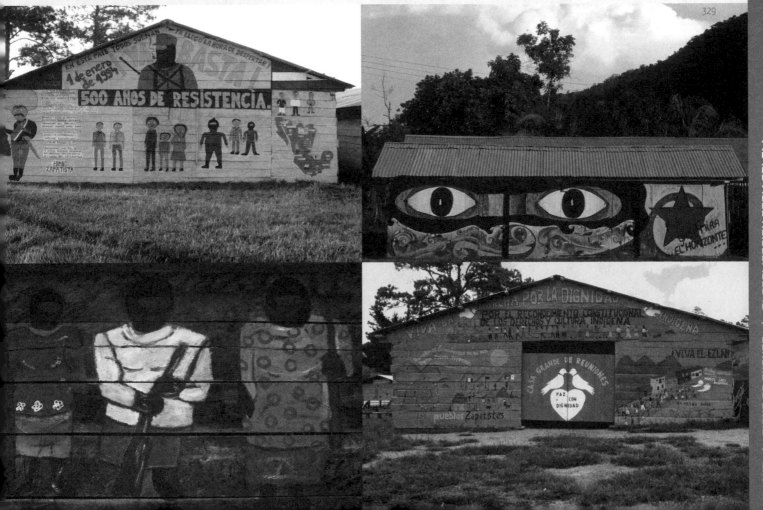

329

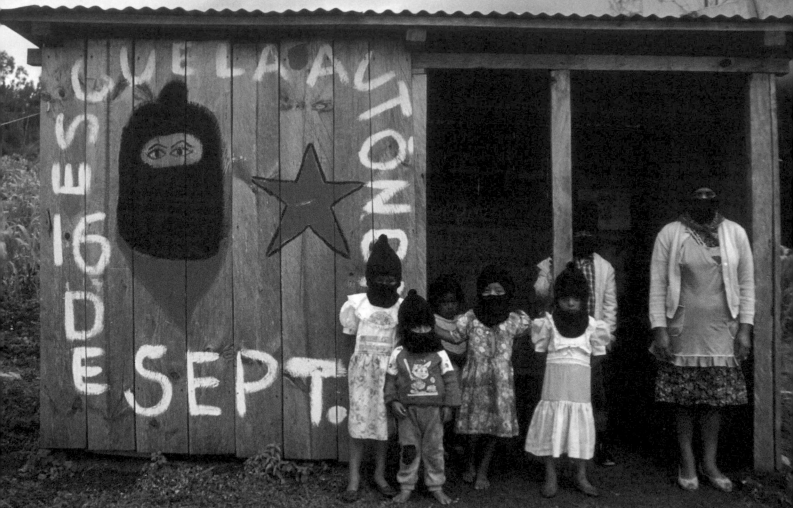
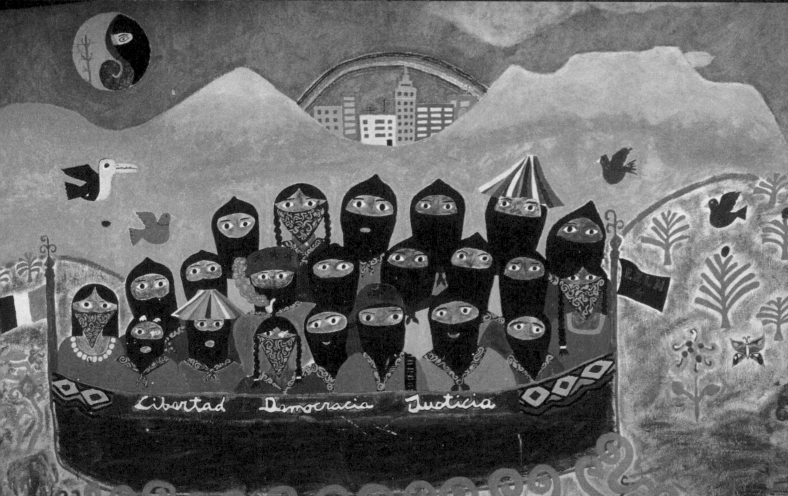

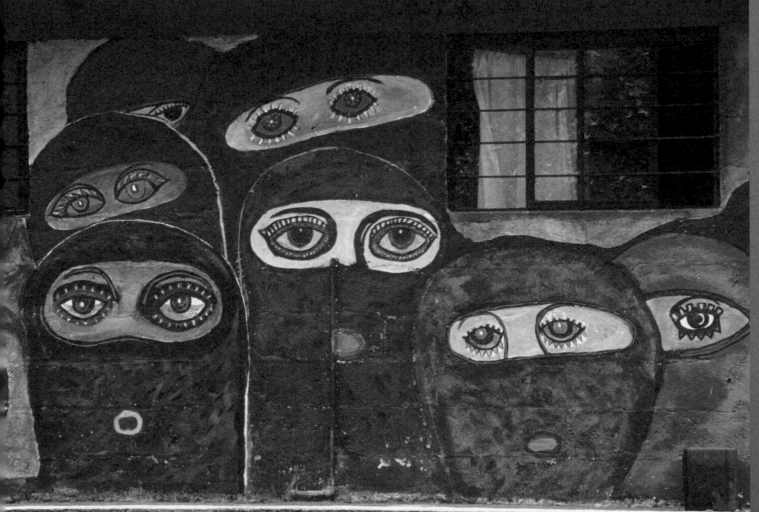

COUNTER-GLOBALIZATION MOVEMENT [late 1990s–2003, International]

Although it is hard to say exactly when the counter-globalization movement in the global North began, it has its origins in organizing against the World Bank and International Monetary Fund—institutions run by wealthy nations who determine how poorer nations can use their development loans. Many of the restrictions dictated by these organizations have led to privatization, decreased local community control of resources, and an increase in multi-national corporate profits with little benefit to the general populations in the affected countries. The movement has been referred to as the alter-globalization movement, the global justice movement, and the media misnomer, the anti-globalization movement. The movement is against *corporate* globalization, which has increased the exploitation of workers and the environment and has facilitated the unfettered movement of money and goods across borders, while restricting people's ability to cross these same boundaries. The movement first gained widespread recognition in the United States when activists targeted another organization implicated in corporate globalization, the World Trade Organization (WTO). The WTO meeting 331

in Seattle in November 1999 was met with massive resistance when activists and protestors converged and effectively shut down the meeting. In more recent years, the movement has focused its attention on the current organizational forms of the most economically powerful nations: the G8 and the G20, as well as on environmental issues.

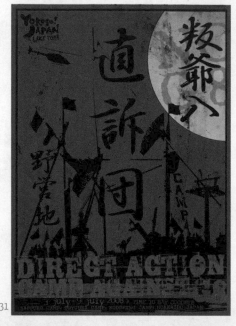

331. illcommonz, **Direct Action Camp Against the G8**, offset lithograph poster, 2008, Japan.

The Group of 8 (commonly called the G8) is an international forum of some of the most powerful governments in the world (Canada, France, Germany, Italy, Japan, Russia, the UK, the US, and the European Union). At annual gatherings, government leaders deal with economic policy decisions that have enormous effect on billions of people, none of whom are represented in these meetings. For this reason, the G8 is a continuous target of protest by a wide range of activists, including anti-capitalists, workers, and farmers from the Global South.

332. Artist unknown, **Global Sale**, offset lithograph poster, 1999, UK.

333. La Convergence de Luttes Anti-Capitalistes/CLAC (artist: Rocky Tobey), **Carnival Against Capitalism**, offset lithograph poster, 2001, Canada.

334. Indymedia/Peoples' Global Action/Reclaim the Streets (artist unknown), **Financial Crimes**, mock newspaper, 2000, UK.

335. Yo Mango, **New Kids on the Black Block**, offset lithograph poster, 2003, Spain.

336. Melbourne Indymedia (artist: Tom Civil), **Melbourne Indymedia**, offset lithograph poster, 2004, Australia.

Indymedia is a network of collectively run media organizations. It was first established in 1999 by counter-globalization movement activists to allow for citizen journalists and on-the-ground participants to cover events during the WTO protests in Seattle. Indymedia pioneered web technologies that allow users to directly contribute to media content. Since then, Indymedia has spread all around the world. It has transformed the ways movements have been able to distribute information and has served as an entry point for many people to get involved in news production.

337. Artist unknown, **Queer Against G8**, offset lithograph poster, 2008, the Netherlands.

338. Artist unknown, **Queer Barrio**, offset lithograph poster, 2008, the Netherlands.

339. Antifaschistische Aktion (artist unknown), **Fight Fortress Europe**, offset lithograph poster, 2002, Germany.

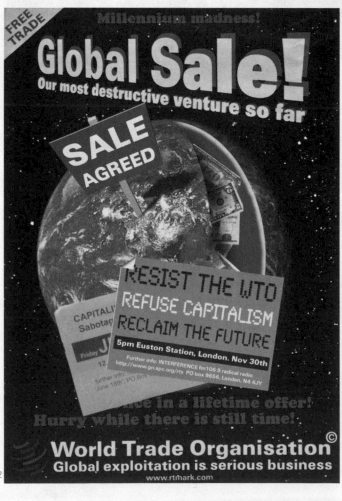

332

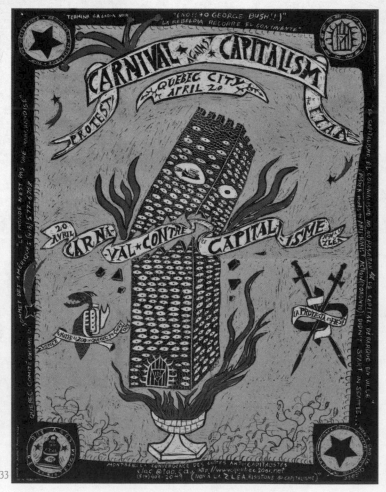

333

FINANCIAL CRIMES

www.reclaimthestreets.net Tuesday September 26 2000 free

Stop free trade rolling
Understand the IMF, World Bank
page 4

Head in the clouds
Corporate control of weather
and more free trade to solve
climate chaos
Dream on: turn to page 3

Dismantling Capitalism
Your guide to creating a free
and ecological society based on
co-operation and community
More information pages 1-18

BUSINESS AS USUAL

World Bank debt to multinationals
A World Bank problem: "We did things for the clients out there in the developing world, but it was more driven by an internally cloned system of thinking rather than a more open, market-oriented approach." says Human Resources manager Pauline Ramprasad. Solution: borrow 57 corporate employees under a new program enabling sharing between multinational corporations and the World Bank.

Weatherman sacked for prediction
A Californian weather forecaster was sacked from a radio station for predicting rain on the day of the corporation's annual picnic. The company sacked their employee after ten years of service for 'failing to predict a sunny day'. It rained.

Covert employment for SAS
The SAS are being used to train the Benefits Agency fraud squad. Now the Northern Ireland ceasefire is in place, the search for new terrorists seems to be on. Will the benefits fraud squad also be trained to 'shoot to kill'?

Children on death row
Kids in the US apparently bored of dolls that just wet their nappy and cry now have a new option: Death Row Marv, a 6 inch doll that can be strapped to an electric chair and then the realistically convulses as he is electrocuted to death.

Unpleasant endings
A Company in San Francisco have discovered a gap in the market – the clean-up of homicide, suicide and accidental death. Crime Scene Cleaner's owner Neal Smithers: 33, said: "Look, if you come home and find the grandma's been rotting on the floor for a month, you've got a problem. But for us, it's straight manual labour."

PRAGUE MEETING OF THE WORLD BANK AND IMF

World Bank terrorism – more evidence

By Horst Wollenzon and James Kehler

This week 20,000 economists and their followers converge in the Czech capital of Prague, for the 55th annual meeting of the World Bank and International Monetary Fund (IMF). The meetings are taking place behind closed doors, amid thousands of riot-ready police and army battalions. Outside tens of thousands take to the streets incensed at the effects of World Bank and IMF policies on the environment and those outside the global elite.

The World Bank acts along side NATO to pursue Western powers' interests – the former through loans, the latter through bombs. For example, in 1990, the IMF and World Bank used "shock therapy" to introduce Western-style capitalism to Yugoslavia which led to massive job losses and a rise in ethnic nationalism. The institutions lost control and an alternative was required.

Economists had failed so a military option was chosen. Of the institutions on offer NATO was selected. The Serb leaders were offered a deal called the 'Rambouillet terms', which according to Lord Gilbert, defence minister during the Kosovo war, speaking in the House of Commons last month was "absolutely intolerable" and designed to provoke war.

The truth behind many of the recent events id the Balkans remains obscure. What is clear is that the media was heavily used to manufacture sympathy for the Kosovan Albanians. This was then used to justify the NATO bombings and legitimise the military action necessary to restore business as usual.

Now the institutional baton has been passed back by NATO to the IMF and World Bank to rebuild Kosovo and create "a thriving, open and transparent market economy", as one of their brochures states.

Disastrous 'unforeseen' effects of IMF and World Bank policies are the norm. Almost all so-called Third World and former Eastern Bloc countries have loans from the IMF. In return, countries agree to let the IMF decide their major economic policies. These 'structural adjustment policies' (SAPs) are designed to promote economic growth by cutting government spending in areas such as health and education, privatising state utilities such as water, increasing exports like tropical timber, coffee, and out-of-season mange tout.

The 'unforeseen' results are, almost without exception, increased unemployment, inequality and ecological destruction. As in terms of real peoples lives, not enough to eat, ill health and nowhere safe to sleep at night. When people react, it is often in one of two ways; resistance through collective action such as Brazil's landless workers movement and Mexico's Zapatista indigenous peoples, or the scapegoating of marginalised groups who are considered 'different' as was the case in Rwanda and Kosovo.

Stating that the World Bank and IMF are involved in 'terrorism' seems more like an eye-catching headline than a serious accusation. However, compare their behaviour to this year's new Terrorism Act definition: "terrorism" means the use or threat of action designed to influence the government or intimidate the public for advancing a political, religious or ideological cause. As long as it also involves serious violence against the person or damage to property; endangers a persons life; creates serious risk to the health and safety of the public; or is designed to seriously disrupt an electronic system." Still only an eye-catching headline?

Is it any wonder that tens of thousands of ordinary people have travelled to Prague to 'intervene on humanitarian grounds,' to paraphrase NATO. This is despite knowing that the media will at best dismiss them as eccentric 'inchoate herbivores' as *The Guardian's* leader writer Hugo Young called the UK's anti-capitalists or 'evil scum' in the front-page words of *The Sun*.

Many people are looking beyond single issues and calls for reform. Reform assumes institutions, such the IMF or World Bank are fundamentally beneficial, needing only slight tinkering to iron out a few injustices. Yet if the institutions are designed to protect an inherently socially and ecologically flawed system then it is the system itself that needs to be dismantled. Groups and individuals are linking up with exactly this aim. As the Canadian Security Intelligence Service concludes, "the philosophy of capitalism also is under attack, facing charges that it is ignoring the social welfare of individuals, and destroying cultures and the ecology in the quest for growth and profit."

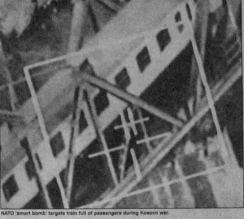

NATO 'smart bomb' targets train full of passengers during Kosovo war.

GENERAL UPRISING

Global action on September 26
Action sparked by this week's IMF/World Bank meeting reaches far beyond Prague. All over the world people are answering a call to action from Peoples' Global Action, an international network of grassroots social movements.

Siege in Bangladesh
The Garment Workers Unity Forum have "decided to lay siege to the premises of the World Bank in Dhaka on 26 September, ...organising students, youths, women, peasants (and) workers."

Action in Aotorea/New Zealand
Maoris from the Foundation for an Independent Aotorea call on "all organisations and people of the Pacific to unite ... in order to send a powerful message of resistance to global colonisation."

Ecuador peasants rise-up
The Ecuadorian farmers movement plans mass actions "born of dignity and of the long history of rebellion of our peoples..."

Mobilisation in Russia
The Moscow S26 Collective is planning events across the country, with the 'Citizens Network for the Abolition of External Debt' using Prague as a focus for their campaigning.

Zimbabwe coalition tackle debt
The Zimbabwe Coalition on Debt and Development have declared, "We will not relent in our demands for the creation of a socially, economically and ecologically just world order."

Indian groups converge over IMF
The National Alliance of People's Movements will act "for the people's rule, resources in the hands of communities, equality and freedom from exploitation".

Brazilians target McDonald's
'Local action for global justice' will "distribute good local food at a McDonald's restaurant" with "direct action during the morning and a mass demo at the stock market at noon."

Scottish solidarity actions
Global Action Scotland, a Glasgow-based umbrella group of anarchists, environmentalists and peace campaigners are planning an action in solidarity with the events in Prague.

Reclaim the Streets editorial

Don't be fooled by the 'spoof' format of this newspaper. Despite the humour running through most pages the articles and quotes are all factual.

But why went to such trouble and why? A small group of people from Reclaim the Streets in London formed an editorial collective to produce this newspaper. Reclaim the Streets, London, is an open non-hierarchical group that takes direct action to tackle the root causes of social and ecological ills. The editors are from a diversity of backgrounds and all contributed freely with none possessing 'professional' skills for the tasks we undertook (so bear with us on grammar).

Our reasons for producing a newspaper are myriad. We want to contribute to the growth of alternatives non-corporate media. We want to present other sides of debates, demonstrate the links between issues and disseminate the information that for many reasons never makes the pages of daily newspapers or television news bulletins.

Another major reason is to show you - the reader - the acts of resistance, the strikes, the blockades and the personal stories from around the world that inspired us to become involved in the continuing development of a diverse global movement against capitalism. We hope that this inspiration motivates others to become actively involved in moving towards new societies in hundreds of different ways.

We do not, and make no claim to, have all the answers to our social and ecological problems. Indeed, we do not even all agree on all the contents of this newspaper. Developing alternatives must be a collective endeavour. Publishing this newspaper is only part of that process.

Further fuel blockades in the pipeline

By Johnathon Manbul and George Perritt

Oil refineries shut-down, petrol stations empty, motorways blockaded; ordinary people taking 'direct action' to effect change. No, not 'eco-protesters' highlighting the damaging impact of a car and oil-based economy again but road hauliers and farmers taking radical action seemingly for cheaper petrol.

These two groups of activists, while sharing some working methods, would seem to have mutually exclusive objectives. Arguably though, the ultimate aims are not so far apart.

As it stands the petrol protesters, understandably enough, blame government tax increases, the government blames the oil cartels, and the oil cartels blame the need to get the most profit out of the oil. The answer from governments - oblivious to environmental commitments - is to pressure the oil countries to increase cheap oil production.

The ecological effects of such growth logic are increasingly clear. Many environmentalists have been keen to distance themselves from the blockades. Their calls for eco-taxes are precisely what the petrol protesters' are fighting against. This green analysis does not question the institutional structures of the system itself, which lead to the conclusion that the only way to cut pollution is through higher prices and state enforcement. Of course, it isn't the ministers or oil barons (or most environmental 'experts' for that matter) who then suffer the effects of price-hikes and job losses.

However, the petrol protests are less about supporting cars and oil-use than about defending the livelihoods of people threatened by the workings of the present economic system.

This is the same economic system that is presently being targeted by radical environmental activists in Prague and elsewhere this week as the dominant cause of a many-sided social and ecological crisis. The road hauliers, farmers and Prague protesters are all ultimately concerned with survival: of human livelihoods and of life itself.

Placed in the context of the looming ecological crisis the demand for cheaper petrol and the continuation of present practices is an inadequate response to the scale of our current problems.

While the blockades and shut-downs are an inspiring expression of the power of self-organisation and leaderless collective action they remain essentially indirect action by virtue of simply calling for the government to do something about high fuel costs.

The fuel protesters' demand is to return to the world of a few weeks ago. This is firstly not possible, given the new global economic conditions requiring job flexibility and lower wages continue. Secondly, it is suicidal given climate change and other environmental crises.

If the fuel protesters achieve their demand of lower fuel taxes, the intertwined social and environmental crisis will continue to deteriorate anyway. They will be blockading again. However, if collectively with many groups in society we target the root causes we may avert environmental crises and come up with more fulfilling and creative things than work for others' profits all day.

At best, this paper - and the related protests against the WTO, IMF and World Bank - point ultimately to the only answer able to transcend the presented logics vs environment trade-off: the replacing of the underlying institutional structures and related values of capitalism and the state, with alternatives securing a free and ecological society. Overall, the action of the fuel protesters is exemplary - but next time they must demand more.

Coca Cola-sponsored school suspends boy over Pepsi t-shirt

By Theresa Blunkett and David May

When Greenbriar High School decided to call an official Coke Day they didn't count on one thing: the disruptive influence of Pepsi. The school participated in a competition to win US$500 on offer to the school that could come up with the best strategy for distributing Coca Cola coupons to students.

The school certainly took the competition seriously. For Coke Day, all pupils were to come to school in Coca Cola t-shirts. They posed for a photograph arranging themselves to form the word 'coke'. All lessons were Coke related. One student, Mike Cameron defiantly but quietly was spotted in a Pepsi t-shirt. He was promptly suspended.

The School principal Gloria Hamilton was unrepentant: "I know it sounds bad - 'Child suspended for wearing Pepsi shirt on Coke Day" she conceded. "It really would have been acceptable ... if it had just been in-house, but we had the regional president ... flying in from Atlanta to do us the honour of being resource speaker."

Couldn't happen in Britain? Yes, given current trends. New Labour's 'Education Action Zones' have allowed businesses further into schools. The idea is that business helps poorly performing schools. Companies involved so far include Shell, Yorkshire Water and McDonalds.

What's in it for the company? 'Caring' publicity and, of course, profit. Take this extract from McDonalds' secret Operations Manual: "Schools offer excellent opportunities. Not only are they a high traffic [sales] generator, but students are some of the best customers you could have." Meanwhile a judge ruled that McDonalds' marketing strategy 'exploits children,' following Britain's longest running libel trial, dubbed 'McLibel'.

Of course, people are not happy about these developments. Recently 500 children from Kingsland's school, London, walked out in disgust at their school being turned into an Education Action Zone. Some children took control of the tannoy system in the headteachers office: that's what you call a proper action zone!

agp.org visit the PGA website at www.agp.org

WORLD MARKETS

FINANCIAL MARKET
Long-term outlook: Gains from speculation on financial markets rather than goods and services continues. More people take larger bets. Inherent...

LABOUR MARKET
Long-term outlook: Relocation to pay lower wages continues but the world runs out of new people to be brought into the global economy.

ENVIRONMENTAL MARKET
Impact of environment...

DISCONTENTS
Indigenous people
Peasants
Unemployed
Workers
Environmentalists
Women

SchNEWS

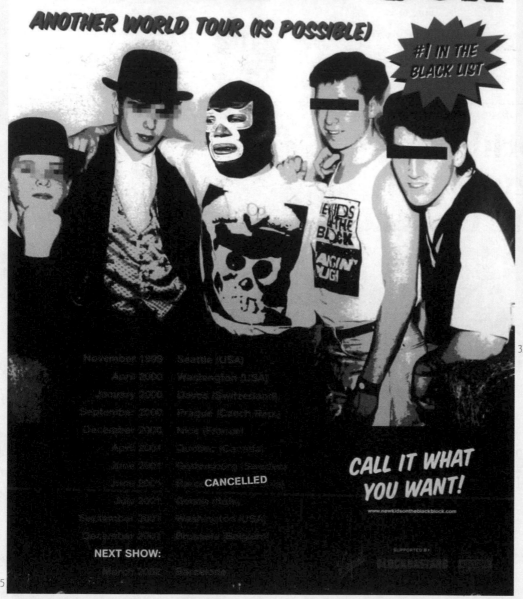

NEW KIDS ON THE BLACK BLOCK

ANOTHER WORLD TOUR (IS POSSIBLE)

#1 IN THE BLACK LIST

CALL IT WHAT YOU WANT!

www.newkidsontheblackblock.com

2.-8. Juni 2007
HEILIGENDAMM
QUEER BARRIO

QUEER AGAINST G8

337

QUEER BARRIO

2.-8. Juni 2007 HEILIGENDAMM

QUEER AGAINST G8

www.dissentnetzwerk.org
www.queeragainstg8.blogspot.com

338

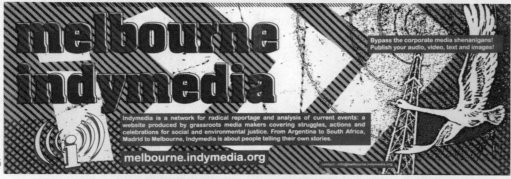

melbourne indymedia

Bypass the corporate media shenanigans!
Publish your audio, video, text and images!

Indymedia is a network for radical reportage and analysis of current events: a website produced by grassroots media makers covering struggles, actions and celebrations for social and environmental justice. From Argentina to South Africa, Madrid to Melbourne, Indymedia is about people telling their own stories.

melbourne.indymedia.org

contact: info@melbourne.indymedia.org

336

335

340. Gelöbnix (artist unknown), **Deutschland abschwören!** [Germany, abjure!], offset lithograph poster, 2004, Germany

341. *Bristle Magazine*, **Shut Down the G8**, photographic documentation of altered billboard, 2005, UK.

342. *Bristle Magazine*, **Sabotage**, photographic documentation of altered billboard, 2000, UK.

343. Artist unknown, ZΘRO: La Europe du Capital c'est du zéro social [The Europe of Capital is nothing social], stickers, c. 2000s, France.

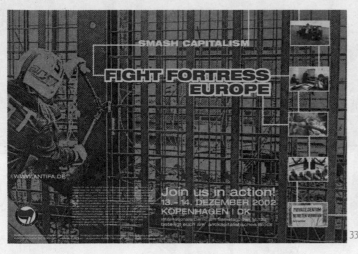

SMASH CAPITALISM

FIGHT FORTRESS EUROPE

Join us in action!
13. - 14. DEZEMBER 2002
KOPENHAGEN | DK

339

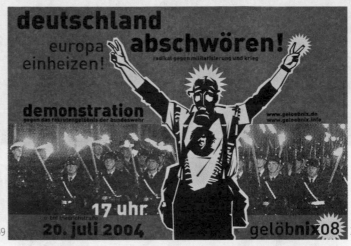

deutschland **abschwören!**
europa einheizen!

radikal gegen militarisierung und krieg

demonstration
gegen das rekrutengelöbnis der bundeswehr

www.geloebnix.de
www.geloebnix.info

17 uhr.
20. juli 2004

gelöbnix08

340

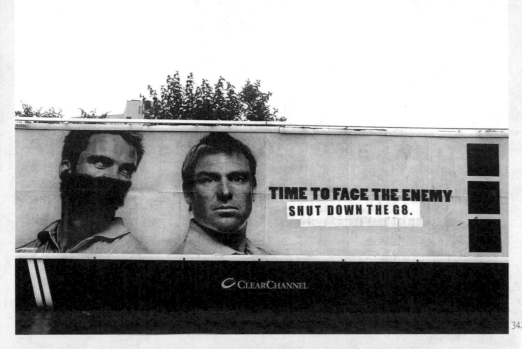

TIME TO FACE THE ENEMY
SHUT DOWN THE G8.

CLEARCHANNEL

341

L'EUROPE DU CAPITAL
Z€RO
C'EST DU ZÉRO SOCIAL

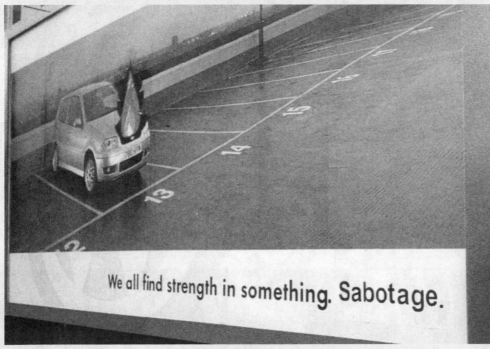

We all find strength in something. Sabotage.

342

343

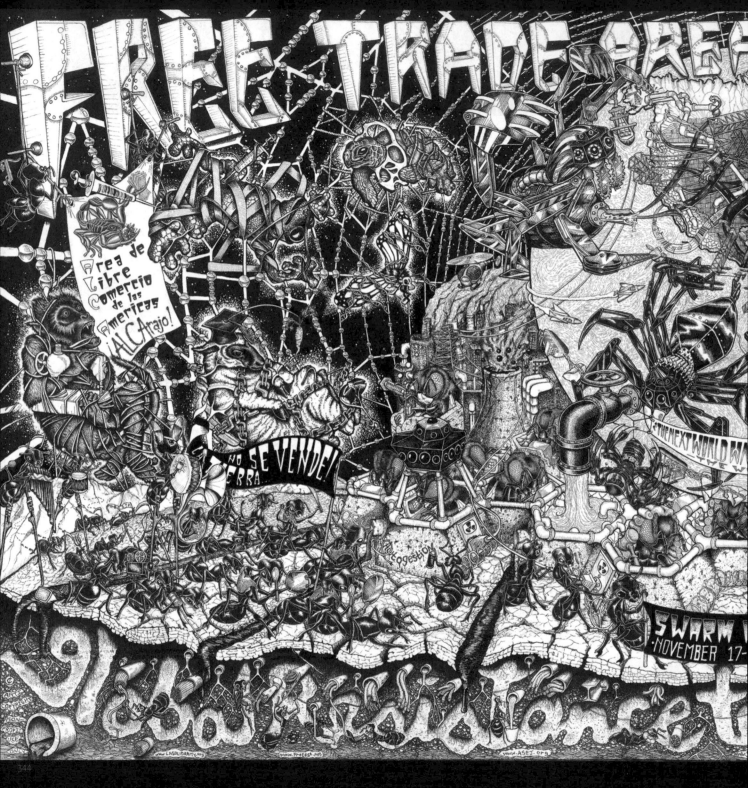

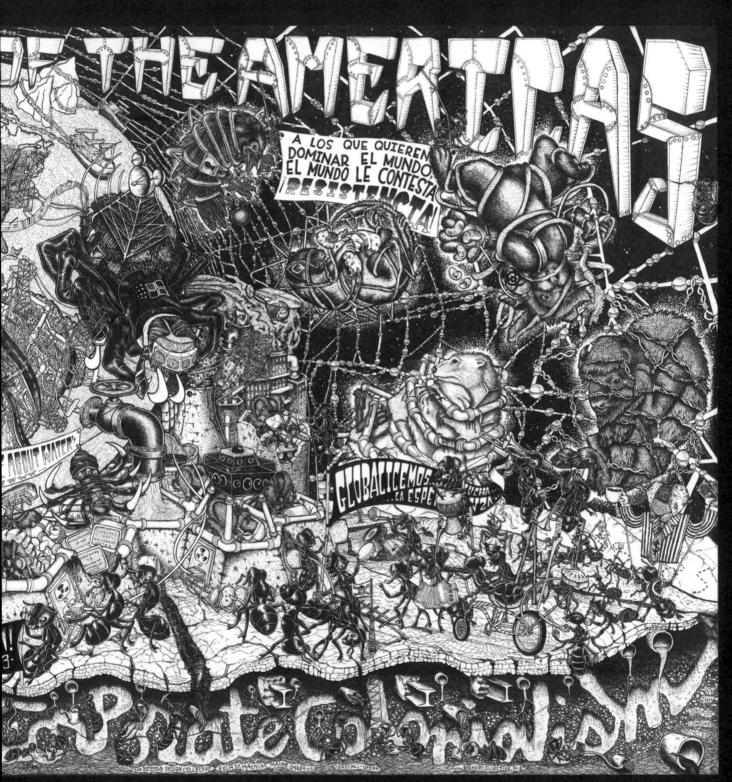

344. Beehive Collective, **Free Trade Area of the Americas**, fabric banner, 2003, USA.

ARGENTINE CRISIS [2001–present, Argentina]

After years of economic and political crisis (in October 2001, millions of Argentine voters cast blank or voided ballots), the entire economy collapsed on December 19 and 20, 2001. A massive grassroots protest engulfed the nation, with the middle-class taking to the streets for *cacerolazos*, the public banging of pots and pans. President Fernando de la Rúa, and much of the government and ruling class, fled the country. Community and workplace assemblies became the functional form of social organization, and they took up the anti-government chant of *Que se Vayan Todos* (They All Must Go). As many factory owners fled the country, workers occupied their factories and began running them, often by popular assembly and direct democracy.

Street art, in particular stencils, became a popular form of public communication in the days after the collapse. Thousands of witty, poetic, and political slogans were painted on the streets. Soon, collectives of street artists formed, including BSAS Stencil and Vomito Attack, and they continue this tradition of public communication.

El Taller Popular de Serigrafía (The People's Silkscreen Workshop, TPS) was formed in February 2002 in Buenos Aires, and developed out of the popular rebellion that had begun two months earlier. The ten artists who formed TPS were participants in the Popular Assembly of San Telmo, a directly democratic organization of the residents of the San Telmo neighborhood. The TPS held public screenprinting classes in plazas and created posters to support demonstrations, worker-occupied factories, and the unemployed workers movement (*piqueteros*). Their work can been seen on pages 154–155.

345. El Fantasma de Heredia, **Ein Schrei Für BSAS [A Cry for BSAS]**, offset lithograph poster/map (front & back shown), 2003, Argentina.
El Fantasma de Heredia is a Buenos Aires-based experimental design group. More like communications experts for civil society than a traditional design firm, they define their work as "visual activism."
346. Still from **"i" the Film** (2006, 84:00 minutes, Andres Ingoglia and Raphael Lyon, Spanish and English), Argentina/USA.
347. Ryan Hollon (photographer; stencil artist unknown), **Ahora o Nunca [Now or Never]**, photographic documentation, 2002, Argentina.
348. Jenny Schochenmohl (photographer; stencil artist unknown), **Despertate [Wake Up]**, photographic documentation, 2003, Argentina.
349. El Taller Popular de Serigrafía (TPS), **The TPS at work**, photographic documentation, 2002–2004, Argentina.
350. TPS, **Fabricas Recuperados de Pie, Trabajadores en Lucha [Occupied Factories, Workers in Struggle]**, screen print, 2003, Argentina.
351. TPS, **somos nosotros [we are us]**, screen print, 2002, Argentina.
352. TPS, **¡No al Alca! [No to the FTAA!]**, screen print, 2003, Argentina.
"Alca" is Spanish acronym for the Free Trade Area of the Americas (FTAA).
353. TPS, **Hecho por las obreras de Brukman [Made by the women workers of Brukman]**, screen print, 2003, Argentina.
354. TPS, **Manifiesta, 19 y 20 de diciembre 2002 [demonstration/party]**, screen print, 2002, Argentina.
355. TPS, **El tiempo es el espacio en donde se desarrola el hombre [Time is the space where man flourishes]**, screen print, 2004, Argentina.

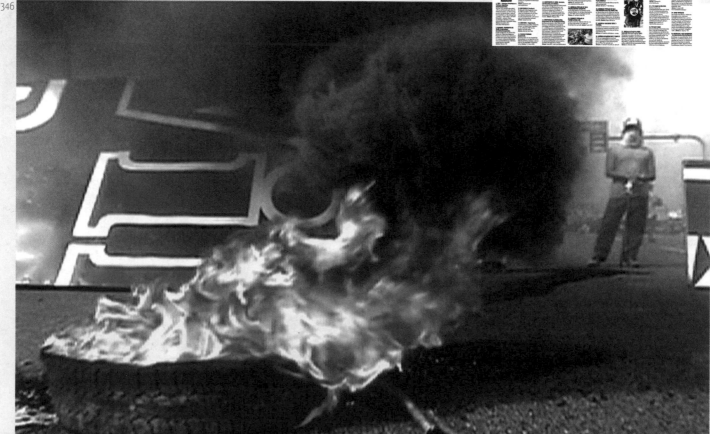

349

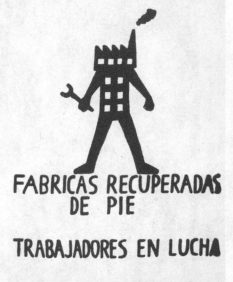

FABRICAS RECUPERADAS
DE PIE

TRABAJADORES EN LUCHA

350

DICIEMBRE 19 Y 20

351

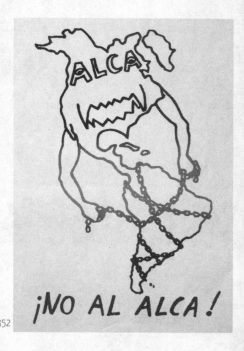

ALCA

¡NO AL ALCA!

352

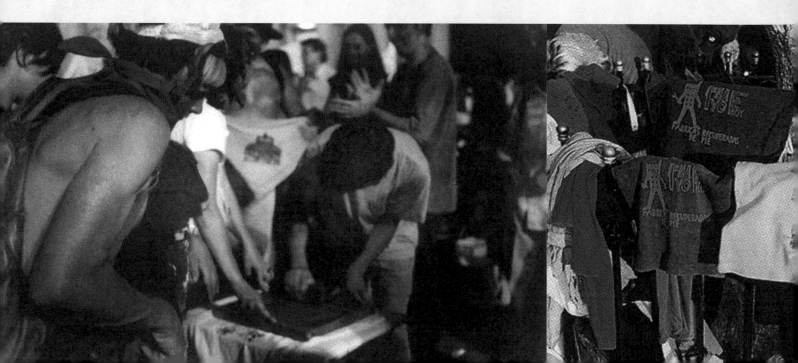

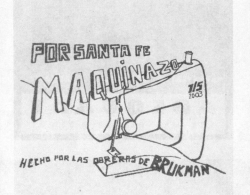

POR SANTA FE
MAQUINAZO
1/5 2003
HECHO POR LAS OBRERAS DE BRUKMAN

MANIFIESTA

19 Y 20 de DICIEMBRE 2002

353

354

EL TIEMPO ES EL ESPACIO EN DONDE SE DESARROLLA EL HOMBRE

MOVIMIENTO NACIONAL POR LA JORNADA LEGAL
DE 6 HORAS Y AUMENTO DE SALARIOS

355

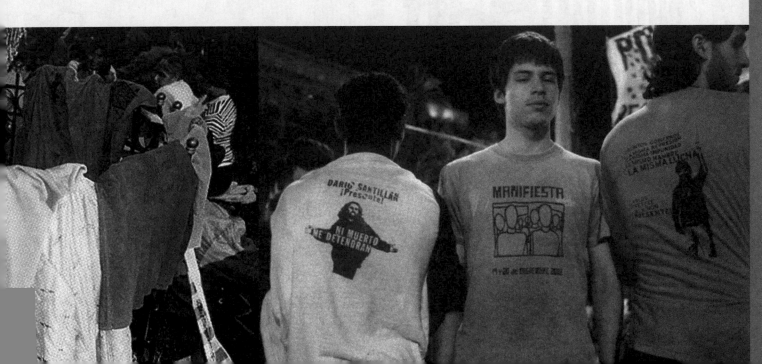

NO BORDERS MOVEMENT [1990s–present, International]

A movement, developing as part of the counter-globalization movement, has been organizing around borders and immigration. Although diverse in composition, these activists share a critique of how corporate global capitalism facilitates the free flow of capital and goods, but restricts and heavily polices the free movement of people. In the US, immigrant rights groups organized the "Day Without Immigrants" general strike on May Day 2006. In Europe, a series of No Borders Camps have been set up at, or near, national borders. The first No Borders Camp took place at the German-Polish-Czech border in 1998 and more recently one took place in 2007 in Calexico-Mexicali on the US-Mexican border, the first in North America. The No Borders Camps are places to strategize and work against global capitalism, border militarization, and migration controls. One of the slogans of the movement is "No One is Illegal." On the 2007 No Borders Camp website, they state, "We intend to create a world without repression, without exploitation, and without borders."

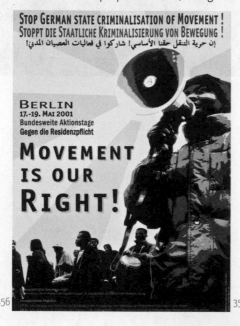

356

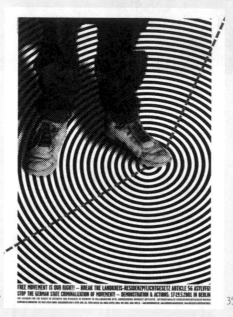

357

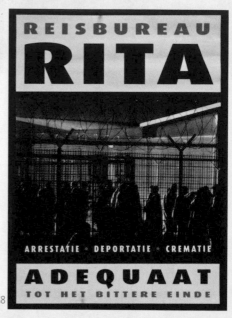

358

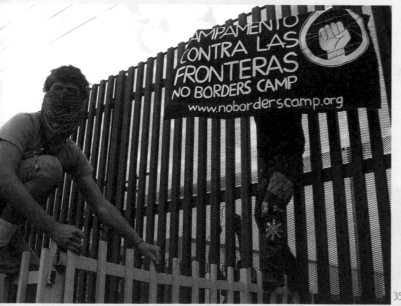

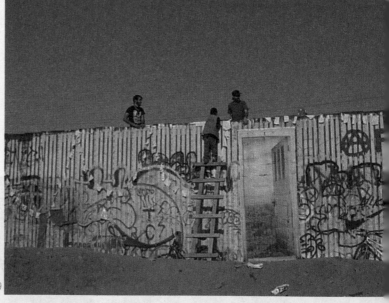

359

356. Artist unknown, **Movement is Our Right**, offset lithograph poster, 2001, Germany.

357. No Borders (artist: Sandy K.), **Free Movement is Our Right**, offset lithograph poster, 2001, Germany.

According to No Borders: "This poster was produced for the campaign against the Residential Law, or Residenzpflicht. Residenzpflicht against refugees is a system of residential restriction like the apartheid Pass Laws in the former South Africa. This law, existing since 1982, forbids refugees to move freely in Germany. They are not allowed to leave the local districts where they are confined to habitation in isolated buildings, often in the woods and isolated city areas under permanent surveillance. They must apply for traveling permission from the Foreign office or Federal office, which forbid the movement of refugees. They have to pay administration fees for an application for traveling permission. They have to pay these fees out of their meager social allowances of 80 DM. The fees are not refunded, even in the case of a denial of permission. This situation pushes them to cross their district borders 'illegally,' forcing upon them to police control, criminalization and illegality. Illegality finally leads to the deportation of refugees through isolated confinement in deportation prisons."

358. Artist unknown, **Reisbureau Rita**, offset lithograph poster, 2005, the Netherlands.

On October 16, 2005, eleven detainees of the Schiphol Airport Immigration Detention Center burned or suffocated to death in their cells as a fire destroyed part of the prison. Then Dutch Minister of Immigration, Rita Verdonk, who was responsible for the increasingly repressive regime against "illegal immigrants" and for lowering the standards for their detention regime, responded within a day by stating that the people working under her responsibility were not to blame and that they had acted "adequately."

This poster was created in response, and an activist was arrested for displaying it. In the court case against him, the immigration office said it was especially appalled by the fact that the poster shows a picture of "a concentration camp." The picture on the poster however, was actually taken on the night of the fire; it shows Verdonk's own detention center. In the ensuing "Banner War," several houses were raided for hanging up banners against politicians held responsible for the repression against immigrants.

Translation: Rita's Travel Agency/Arrest. Deport. Cremate./ Adequate to the bitter end

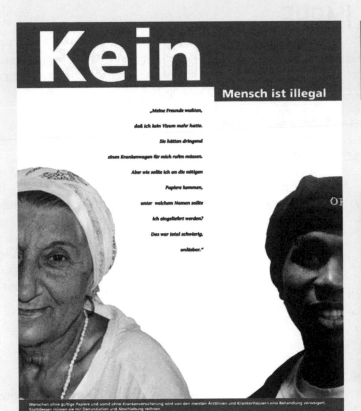

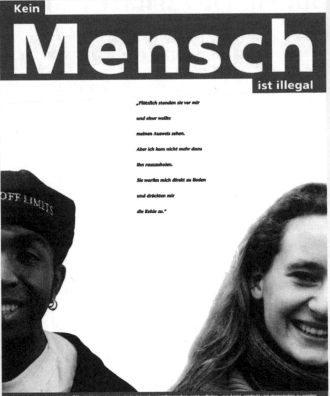

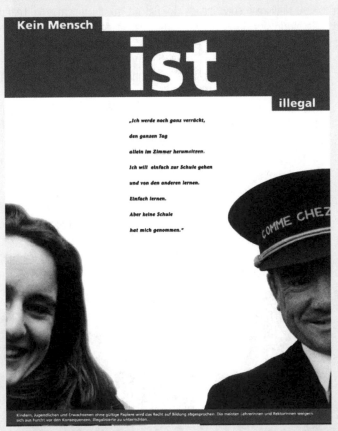

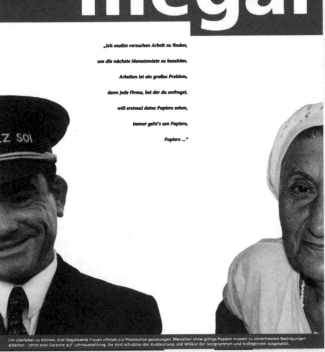

359. Radio Zapatista, **Calexico-Mexicali No Borders Camp**, photographic documentation, 2007, Mexico/USA.

Their website states that "Radio Zapatista is a Bay Area-based alternative media collective. It broadcasts reports and testimonies about the war that the Mexican government, the military, police, large enterprises, and paramilitary groups are waging against Zapatista communities, and indigenous communities in general." Radio Zapatista "sees the Zapatista movement as linked to other, global struggles for autonomy, democracy, and justice. By spreading the voices of resistance in not only Chiapas but across Mexico, the US, and the rest of the world, we hope to make these connections explicit and demonstrate the power of the Zapatista experience as a potential example for anti-capitalist social movements beginning to imagine another way of doing politics, as they say, *desde abajo y a la izquierda (from below and to the left)*."

360. Kein Mensch ist Illegal (artist: Sandy K.), **Kein Mensch ist Illegal [No Person is Illegal]**, offset lithograph posters, 1998, Germany.

According to the designer: "These posters were produced for Kein Mensch ist Illegal [No Person is Illegal], an anti-rascist campaign founded by activists, radio practitioners, photographers, artists, filmmakers, and others in 1997 at Documenta X in Kassel, Germany. In the mainstream media, illegal immigrants are often portrayed as having no personal identity; these posters are intended to counter that dominant perception. The four posters deal with different situations of daily life (difficulties with work, health, education, and being in public space)."

SOCIAL MOVEMENT MOVING IMAGE

In the *Signs of Change* exhibition, film and video was presented in multiple ways: installed on monitors in the different sections; a longer program, which rotated weekly, was projected in a screening room or set up as a library; and events were planned for one-time screenings of feature films, which were followed by discussion. The list below represents films and videos that were shown as part of the exhibit. These are just a small sampling of the moving images produced by and about social movements.

STRUGGLE FOR THE LAND

Kanehsatake: 270 Years of Resistance
(1993, 01:59:00 minutes, Alanis Obomsawin, Canada, courtesy of Bullfrog Films)

This documentary covers the two-and-a-half month armed stand-off between members of the Mohawk Nation, the Québec police, and the Canadian army. The Mohawks are fighting to keep their land as a commons against the development interests of a private golf course.

The Land Belongs to Those Who Work It/La tierra es de quien la trabaja
(2005, 15:00 minutes, Chiapas Media Project, in Spanish and Tzeltal with English subtitles, Mexico, courtesy of Chiapas Media Project/ Promedios)

For over a decade, the Chiapas Media Project has partnered with indigenous and *campesino* (farm worker) communities in Chiapas and Guerrero, Mexico, to provide video production and computer equipment and training. This film from the Chiapas Media Project documents a meeting between Zapatista authorities and Mexican government officials to discuss the sale of land to a private eco-tourism company without permission from the local community.

Newe Segobia is Not for Sale: The Struggle for Western Shoshone Land
(1993, 29:00 minutes, Jesse Drew, USA, courtesy of the artist and Video Data Bank)

This video documents a confrontation between Western Shoshone ranchers, sisters Carrie and Mary Dann, and the US Federal Bureau of Land Management (BLM) over disputed grazing lands. The Dann sisters purchased a video camera to document the BLM's misconduct. Filmmaker Jesse Drew was given the unedited footage and created a documentary that was distributed by Native American activists and public access

stations to gain support for the Western Shoshone struggle. Though this incident involved only a few people, it is part of the ongoing battle for Native North American land rights.

Standing with Palestine
(2004, 12:00 minutes, Paper Tiger Television, USA, courtesy of Paper Tiger Television Collective)

Standing with Palestine documents the grassroots movement in the United States in support of the Palestinian people and against the Israeli occupation of the West Bank and Gaza Strip. The video includes interviews with groups, such as the International Solidarity Movement (ISM) and campus activists who are working on a campaign (based on the successful student divestment campaigns against apartheid South Africa in the 1980s) to force universities to withdraw their ties to companies that support the Israeli occupation. Paper Tiger Televison is a collectively-run, alternative media producer in New York City.

AGITATE, EDUCATE, ORGANIZE

Finally Got the News
(1970, 55:00 minutes, League of Revolutionary Black Workers, Stewart Bird, Rene Lichtman and Peter Gessner, USA, courtesy of the American Friends Service Committee)

A Newsreel crew heads to Detroit to document the League of Revolutionary Black Workers. The League decides to take the means of production into their own hands to represent themselves and their struggle. The League of Revolutionary Black Workers developed from the autonomous organizing of Black unions in Detroit-based automotive plants, which included DRUM (Dodge Revolutionary Union Movement) and CRUM (Chrysler Revolutionary Union Movement). The League critiqued the racist practices of the United Auto Workers and called for an analysis of the role of the Black working class in revolutionary struggles in the United States.

Gimme an Occupation with that McStrike
(2005, 04:05 minutes, Victor Muh, France, Precarity DVD–Magazine, made in collaboration with: P2Pfightsharing Crew; Greenpepper Project, Amsterdam; and Candida TV, Rome, courtesy of Greenpepper Project)

McDonald's workers go on strike in Paris, occupying their workplace (a McDonald's restaurant) for six months.

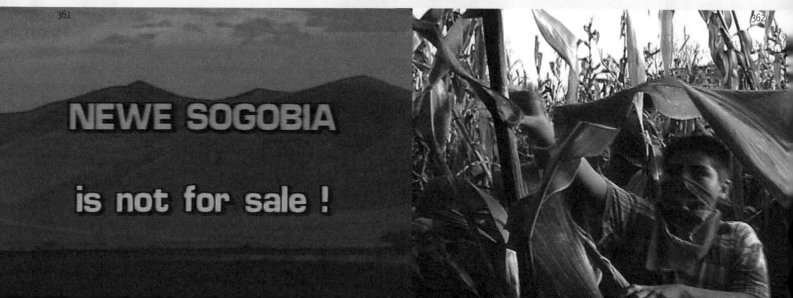

361

362

NEWE SOGOBIA

is not for sale !

Iraq Veterans Against the War: Operation First Casualty

(2008, 05:00 minutes, Elizabeth Press for Democracy Now, USA, courtesy of the artist)

Iraq Veterans Against the War (IVAW) is a national organization formed in 2004 by veterans of the Iraq War. Operation First Casualty (OFC) is a street theater project that members of the organization perform dressed in military uniforms. OFC stages performances that are reenactments of combat patrols on the streets of US cities, as they would happen in Iraq, to bring the realities of war home. In this document they perform OFC outside the Democratic National Convention in Denver 2008.

Korea: Until Daybreak

(a segment of ...will be televised, 1990, 58:00 minutes, Deep Dish TV, Hye Jung Park and the Han-Kyoreh One Korea, One People Video Collective, S. Korea, courtesy of the Deep Dish TV Archives)

This compilation includes grassroots footage from multiple protests in South Korea in the 1980s, including the massive Gwangju uprising, militant workers and farmers, and fights for Korean unification. *Korea: Until Daybreak* is just one segment from the series ... *will be televised: Video Documents From Asia* that was coordinated and produced by Shu Lea Cheang for Deep Dish TV. The first public access satellite network, Deep Dish TV was launched in 1986 by Paper Tiger TV as a way to link independent producers, activists, and viewers who support movements for social change.

Richmond Strike

(1969, 15:30 minutes, Newsreel, USA, courtesy of Roz Payne Archives)

In January 1969, local police in Northern California attacked striking oil workers and their families, killing one person and injuring many others. Student protestors from San Francisco State University were asked to join the struggle, uniting workers and students against a common foe. This film includes interviews with employees on strike against Shell Oil in Martinez and Richmond, California. Newsreel Films, founded in the late 1960s, was composed of decentralized film collectives. These groups produced 16mm films that would counter the way events and issues were being presented in the mainstream media. Today three Newsreel organizations remain: Third World Newsreel in New York, California Newsreel in San Francisco, and Roz Payne's Vermont Newsreel Archives.

Standing with the Students

(2007, 23:00 minutes, Sphinx in cooperation with Sin Fronteras Media Collective and Indymedia Ambazonia, Ambazonia, courtesy of the artist)

In 2005, students at the University of Buea in Cameroon organized to demand more educational resources and basic human rights. The Cameroon government violently attacked them, killing five. This video was shot with a cell phone and the footage was snuck out of the country.

Un Poquito de Tanta Verdad/A Little Bit of So Much Truth

(2007, 93:00 minutes, produced by Corrugated Films in collaboration with Mal de Ojo, Mexico/USA, courtesy of Corrugated Films)

In the summer of 2006, a teachers' strike exploded into a popular uprising in the southern Mexican state of Oaxaca. This film captures the unique media story that emerged when tens of thousands of school-teachers, housewives, indigenous communities, health workers, farmers, and students took 14 radio stations and one TV station into their own hands and used them for the needs of the people. Mal de Ojo TV is a coalition of independent, indigenous, and community media workers, including Indymedia-Oaxaca and Ojo de Agua Comunicación. Mal de Ojo produces and distributes media related to the movement. Corrugated Films, with Jill Freidburg, collaborated with them on this project.

What the Fuck are These Red Squares?

(1970, 15:00 minutes, Kartemquin Film Collective, USA, courtesy of Kartemquin Films)

Documentary of students during a "revolutionary seminar" at the Art Institute of Chicago during the 1970 national student strike that was called in response to the invasion of Cambodia and the killing of students at Kent and Jackson State Universities. The students raised questions related to artists' roles in a capitalist economic system, such as: "Is it possible not to be co-opted, as 'radical' as one's art may be? What are the connections between money and art in America? Between the 'New York Scene' and the rest of the country?" Kartemquin Films, best known for its award-winning documentary *Hoop Dreams* (1994), was once known as Kartemquin Film Collective. The collective made social and politically charged films about various issues in Chicago, including labor, gentrification, and student protests. They also collaborated with members of Newsreel.

Winter Soldier: Iraq and Afghanistan

(2008, 30:00 minutes, Big Noise Films, USA, courtesy of Big Noise Films)

In 2008, Iraq Veterans Against the War (IVAW) restaged the Winter Soldier hearings to testify to the world about the injustices of the war.

363

364

The original Winter Soldier was organized by Vietnam Veterans Against the War (VVAW). The Winter Film Collective came together to document the event and created the 1972 film *Winter Soldier*. This 2008 action was influenced by this history.

FORWARD TO PEOPLE'S POWER

Be a DIVA
(1990, 28:00 minutes, DIVA TV, USA, courtesy of Deep Dish TV)

This tape includes clips from a variety of DIVA (Damn Interfering Video Activists) TV programs. DIVA TV was one of several video groups that emerged from ACT UP (AIDS Coalition To Unleash Power).

Mayday (Black Panther)
(1969, 13:30 minutes, Newsreel, USA, courtesy of Roz Payne Archives)

On May 1, 1969, International Workers Day, the Black Panther Party held a massive rally in San Francisco to help free Huey P. Newton. This piece is on the DVD compilation: *What We Want, What We Believe: The Black Panther Party Library* (AK Press, 2006).

It Can Be Done
(1974, 32:00 minutes, Shirley Jensen and Barbara Bejna with the Chicago Women's Graphic Collective, USA, courtesy of Kartemquin Films and Barbara Bejna and Shirley Jensen)

This documentary follows the Chicago Women's Graphics Collective as it makes a poster for the United Farm Workers. These artists, women, and activists talk about their collective process and the political relevance of this project for the women's movement and other political campaigns. The Chicago Women's Graphics Collective was a group that formed out of the Chicago Women's Liberation Union.

Purple Dinosaur Action
(1973, 10:00 minutes, Barbara Jabaily, Tracy Fitz, and Lesbians Organized for Video Experience (L.O.V.E) USA, courtesy of the Lesbian Herstory Educational Foundation, Inc. and Tracy Fitz)

In this video members of the Lesbian Feminist Liberation (LFL) create a large, purple, papier-mâché dinosaur and wheel it to the Museum of Natural History in New York to protest the patriarchal values and histories presented by the museum. They are accompanied by the Victoria Woodhall Marching Band, a women's marching band that performed at protests and senior centers. L.O.V.E. documented many of the activities organized by LFL, including the New York City Lesbian Olympics and this action at the Museum of Natural History.

Queen Mother Moore Speech at Green Haven Prison
(1973, 17:00 minutes, People's Communication Network, USA, courtesy of Chris Hill and Bob Devine)

Think Tank, a self-organized group of prisoners at Green Haven Prison, coordinated a community day with outside activists. This tape captures a powerful speech by one of the guest speakers: Queen Mother Moore, a follower of Marcus Garvey, founder of the Universal Negro Improvement Association and African Communities League (UNIA-ACL). People's Communication Network, a community video group founded by Elaine Baly and Bill Stevens, documented the event for cablecast in New York City.

Repression
(1969, 13:33 minutes, Newsreel, USA, courtesy of Roz Payne Archives)

A documentary about the Los Angeles Black Panther Party with music by Elaine Brown. This piece is also on the DVD compilation: *What We Want, What We Believe: The Black Panther Party Library* (AK Press, 2006)

Up Against the Wall Ms. America
(1968, 08:00 minutes, Newsreel, USA, courtesy of Roz Payne Archives)

This film documents a creative women's liberation protest outside the 1968 Miss America Pageant in Atlantic City, New Jersey.

Women's Lib Demonstration I
(1970, 23:00 minutes, Videofreex, USA, courtesy of Video Data Bank and the Videofreex Partnership)

Documentation of the 1970 women's liberation march in New York City, part of the "national women's strike for equality" called to commemorate the fiftieth anniversary of women's suffrage. Demonstrators include members of Women's Strike for Peace. Videofreex was an early video collective, which existed from 1969–1977. During that time, the collective documented the counterculture and social movements, experimented with new video technology, ran a pirate television station, and produced over 1,500 tapes.

The Young Lords Film/El Pueblo Se Levanta
(1971, 50:00 minutes, Newsreel, USA, courtesy of Roz Payne Archives)

For over a year and a half, a Newsreel crew worked closely with the Young Lords Party, a chapter of the Puerto Rican nationalist and civil rights group. The film documents their many programs and plans for Puerto Rican communities.

365 366

FREEDOM AND INDEPENDENCE NOW

The Columbia University Divestment Struggle: Paper Tiger at Mandela Hall,
(1985, 28:00 minutes, Paper Tiger Television, USA, courtesy of Paper Tiger Television Collective)

In 1985, there was a nationwide campaign calling for corporations and institutions to divest from South Africa as part of the anti-apartheid movement. In solidarity with this campaign, student protestors at Columbia University occupied a hall to demand that the university sever its ties to businesses with investments in South Africa.

South Africa: Freedom Rising
(1978, 20:00 minutes, audio slideshow, ITT Boycott and the Dayton Community Media Workshop, USA, courtesy of the American Friends' Service Committee)

This slideshow was produced to educate Americans on the injustice of the apartheid system in South Africa and the presence of US corporations in that country. It serves to illustrate one of the many ways grassroots movements used technology that was accessible to them to get the message out. The Dayton Community Media Workshop described itself as "a collective of artists working within the New American Movement."

LET IT ALL HANG OUT

Five Days for Peace
(1973, 37:00 minutes, Nils Vest, Denmark, courtesy of Christiania's Cultural Association)

In *Five Days for Peace*, the members of Slovegnen—the theater collective from the squatted free town of Christiania, Copenhagen, Denmark—dress as North American Treaty Organization (NATO) troops and perform "military" operations in Copenhagen during the NATO Summit.

Indonesia: Art, Activism, and Rock 'n' Roll
(2002, 26:00 minutes, Charlie Hill Smith and Jamie Nicolal, in Indonesian and English with English subtitles, Australia/Indonesia courtesy of Marcom Projects)

This documentary film features Taring Padi, an art collective based in Yogyakarta, Indonesia. Since 1998, the group has produced posters, murals, street performances, puppets, poetry, music, and published a newsletter. They describe themselves as an "independent non-profit cultural community, which is based on the concept of people's culture." They are committed to contributing to autonomous culture, democracy, and social justice in Indonesia.

Lanesville Overview 1
(1972, 32:00 minutes, Videofreex, USA, courtesy of the Video Data Bank and the Videofreex Partnership)

A behind the scenes look at America's first pirate television station, Lanesville TV. Between 1972 and 1977, the Videofreex aired over 250 television broadcasts from their hand-built studio.

RECLAIM THE COMMONS

Break and Enter
(1970, 42:00 minutes, Newsreel, USA, courtesy of Third World Newsreel)

Break and Enter captures the efforts of several hundred Puerto Rican and Dominican families to take over and live in abandoned buildings in New York City.

Carry Greenham Home
(1984, 66:00 minutes, Beeban Kidron and Amanda Richardson, UK, courtesy of Women Make Movies)

Carry Greenham Home is an on-the-ground look at the activities of the Greenham Common Women's Encampment. The film focuses not just on the women's anti-nuclear and anti-military actions, but also on the feminist practices on which their lives were based.

Indymedia Brazil Inside an MST Camp
(2002, 10:00 minutes, Indymedia Brazil, Brazil, courtesy of Indymedia Brazil)

Brazil's Landless Workers Movement, Movimento dos Trabalhadores Rurais Sem Terra (MST), is the largest social movement in Latin America with an estimated one and a half million members. This short documentary represents an MST camp from the inside. Some 12,000 families, who work together to oversee security and governance, occupy this territory. The documentary features the workers' abilities to self-govern, provide food, child care, and housing for all, and to deal with unwanted visits from government officials and mainstream media. Indymedia is a global network of grassroots reporters and citizens who cover issues and events important to diverse social movements.

Narita: Peasants of the Second Fortress/Sanrizuka: Dainitoride No Hitobito
(1971, 02:23:00 minutes, Shinsuke Ogawa/Ogawa Productions, Japanese with English subtitles, Japan, courtesy of the Athénée Français Cultural Center)

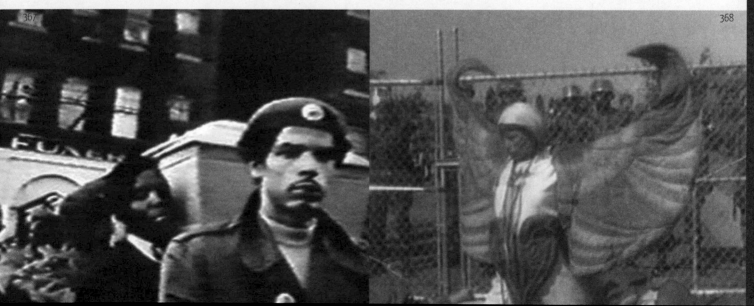

367

368

"In Japan, guerrilla film activity reached high intensity during the war (Vietnam). The use made of Japan as a conduit for Vietnam war supplies generated strong anti-government feelings and many 'protest films...' It now saw such powerful films as the Sanrizuka series—three feature length films. The heavy air traffic through Japan—swollen by the war prompted a 1966 decision to build a new international airport for Tokyo. The area chosen, Sanrizuka, was occupied by farmers who were determined to block seizures of their lands. For four years, the filmmaker Ogawa Shinsuke documented their struggle, which reached its climax in the third film, *The Peasants of the Second Fortress*. Here we see resistance turning into a pitched battle with riot police as farm women chain themselves to impoverished stockades, and students join the struggle for anti-government, anti-war motives. Ogawa, patiently recording the growth of resistance . . . achieved an extraordinary social document, and one of the most potent of protest films."—Erik Barnouw, *Documentary: A History of the Non-Fiction Film*, (Oxford: Oxford University Press, 1974).

Ogawa Productions was a Japanese filmmaking collective that was founded in the 1960s, and directed by Ogawa Shinsuke. After making films about the student movement, the collective moved to Sanrizuka to cover the struggle against the building of the Narita Airport. While there, they made eight films covering the struggle.

People's Park
(1969, 25:00 minutes, Newsreel, USA, courtesy of Roz Payne Archives)
This film documents the battle over People's Park in Berkeley, California. In 1969, a vacant tract of university-owned land was occupied by community residents, who converted it into a "people's park" and a place for political organizing. Hundreds helped clear the land, planting flowers and trees. Some set up tents and started living there. Within a month, the university set the site for demolition. Police surrounded it with an eight-foot fence. Approximately 3,000 protestors tried to reclaim the park, and in the chaos police shot at the crowds. Hundreds were wounded by rioting or gunfire, one student was killed.

Reclaim the Streets
(1996, 07:00 minutes, Undercurrents, UK, courtesy of Undercurrents)
Undercurrents is an alternative news organization that has documented social movements in the United Kingdom since 1994. This film documents a Reclaim the Streets Party/Protest.

Sound Demo
(2003, 03:11 minutes, *Japanese Activism* DVD, Japan, courtesy of illcommonz)
A sound-based protest from Reclaim the Streets, Japan.

Stronger Than Before
(1983, 27:00 minutes, the Boston Women's Video Collective, USA, courtesy of the Boston Women's Video Collective)
This film documents the militant actions and creative activities of the Women's Encampment for a Future of Peace and Justice in Seneca, New York in 1983. Although the Boston Women's Video Collective was formed specifically to document this encampment, they continued producing video projects after it closed.

Transistor Connected Drum Collective
(2003, 06:49 minutes, illcommonz, Japan, courtesy the artist)
Japanese experimental musicians reclaim the streets of Tokyo to protest the war in Iraq.

Uku Hamba 'Ze/To Walk Naked
(1995, 12:00 minutes, Jaqueline Maingard, Sheila Meintjes, and Heather Thompson, South Africa, courtesy of Third World Newsreel)
After an exhausting fight to procure housing, a group of women in Soweto, South Africa built a settlement of makeshift shacks. When police tried to evict them with bulldozers and dogs, the women defiantly stripped naked in a peaceful protest against the destruction of their homes. This unconventional action gained massive media attention and caught the attention of filmmakers who documented the struggle in *Uku Hamba 'Ze/To Walk Naked*.

GLOBALIZATION FROM BELOW

Crowd Bites Wolf
(2001, 22:00 minutes, Guerillavision, UK, NonCommercial-ShareAlike 2.0)
Part fictive-narrative, part protest-documentary, *Crowd Bites Wolf* tells the story of the protest against the 2001 meeting of the International Monetary Fund in Prague, Czech Republic.

Fourth World War
(2003, 76:00 minutes, Big Noise Films, USA, courtesy of Big Noise Films)
This documentary takes viewers around the world—Mexico, Argentina,

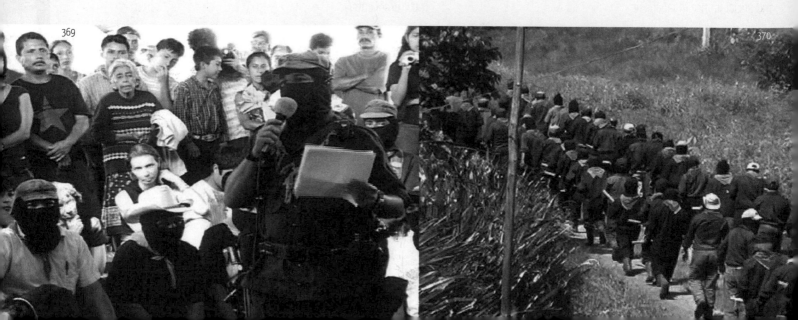

South Africa, Palestine, Korea, Italy, Afghanistan, and Iraq—to reveal people fighting against war and corporate domination. Big Noise Films is a volunteer media collective that was first established to document the Zapatista uprising in Chiapas, Mexico, and has continued making social movement media ever since.

"i" the film
(2006, 84:00 minutes, Andres Ingoglia and Raphael Lyon, Spanish and English, Argentina/USA, courtesy of the artists)

This film is about Indymedia, a grassroots, independent media network, and specifically focuses on Indymedia Argentina. The film documents demonstrations after the collapse of the Argentine economy—independent media played a major role in helping to organize the protesters. The film also reveals the growth of social movements transforming Argentine society, and functioning outside of government political structures.

The Piqueteros Method—Los Metodos
(2002, 03:44 minutes, Cine Insurgente, Argentina, courtesy of the artist)

A music video with images of protests during the economic collapse in Argentina in 2001.

TXTmob–Nw Mor Thn Evr
(2004, 02:31 minutes, the Institute for Applied Autonomy, USA, courtesy of the artist)

Documentation of creative uses of a text messaging service devised to assist protest communications. The Institute for Applied Autonomy (IAA) is an arts and engineering collective founded in 1998 devoted to developing "technologies which extend the autonomy of human activists."

A Very Big Train Called the Other Campaign/Un tren muy grande que se llama: La Otra Campaña
(2006, 39:00 minutes, Chiapas Media Project, Spanish with English subtitles, Mexico, courtesy of Chiapas Media Project/Promedios)

This video was produced by indigenous video makers· from four of the five Zapatista Caracoles in Chiapas, Mexico. It documents the 2006 planning and organizing of the Other Campaign. This was a campaign by the Zapatista Army of National Liberation to build a self-governing national infrastructure. For over a decade, the Chiapas Media Project has partnered with indigenous and campesino (farm worker) communities in Chiapas and Guerrero, Mexico to provide video production and computer equipment and training.

What Would It Mean to Win?
(2008, 40:00 minutes, German and English, Zanny Begg and Oliver Ressler, Austria, courtesy of the artists)

This film—shot at the G8 Summit protests in Heiligendamm, Germany in June 2007—asks activists in the counter-globalization movement to answer the question: "What would it mean to win?" The film features interviews with protestors and with John Holloway, whose 2002 book, *Change the World without Taking Power*, was influential to the movement.

Yomango Tango
(2002, 06:11 minutes, Yo Mango, Spain, Precarity DVD-Magazine, made in collaboration with: P2Pfightsharing Crew; Greenpepper Project, Amsterdam, courtesy of Greenpepper Project)

Barcelona activists, on the occasion of the one-year anniversary of the 2001 uprising in Argentina, dance in supermarkets and banks against corporate global capitalism. *Yo mango*, translated as "I steal," is a play on a Spanish corporate chain store called Mango, which supports precarity, a commonly used term in Europe, meaning the lack of job security, social safety net, and/or predictability in contemporary labor conditions.

361. Video still from **Newe Segobia is Not for Sale: The Struggle for Western Shoshone Land** (1993, 29:00 minutes, Jesse Drew), USA.
362. Video still from **The Land Belongs to Those Who Work It/La tierra es de quien la trabaja** (2005, 15:00 minutes, Chiapas Media Project), Mexico.
363. Video still from **Standing with the Students** (2007, 23:00 minutes, Sphinx in cooperation with Sin Fronteras Media Collective and Indymedia Ambazonia), Ambazonia.
364. Film still from **What the Fuck are These Red Squares?** (1970, 15:00 minutes, Kartemquin Film Collective), USA.
365. Video still from **It Can Be Done** (1974, 32:00 minutes, Shirley Jensen and Barbara Bejna), USA.
366. Video still from **Purple Dinosaur Action** (1973, 10:00 minutes, Barbara Jabaily, Tracy Fitz, and Lesbians Organized for Video Experience), USA.
367. Film still from **The Young Lords Film/El Pueblo Se Levanta** (1971, 50:00 minutes, Newsreel), USA.
368. Video still from **Stronger Than Before** (1983, 27:00 minutes, the Boston Women's Video Collective), USA.
369. Video still from **A Very Big Train Called The Other Campaign/Un tren muy grande que se llama: La Otra Campaña** (2006, 39:00 minutes, Chiapas Media Project), Mexico.
370. Video still from **A Very Big Train Called The Other Campaign/Un tren muy grande que se llama: La Otra Campaña** (2006, 39:00 minutes, Chiapas Media Project), Mexico.
371. Video still from **What Would It Mean to Win?** (2008, 40:00 minutes, German and English, Zanny Begg and Oliver Ressler), Austria.
372. Video still from **"i" the film** (2006, 84:00 minutes, Andres Ingoglia and Raphael Lyon), Argentina/USA.

371
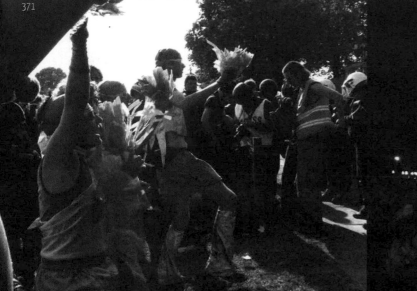

372

BIBLIOGRAPHY

STRUGGLE FOR THE LAND

Attwood, Brian, and Andrew Markus. *The Struggle for Aboriginal Rights: A Documentary History.* Crows Nest, Australia: Allen and Unwin, 1999.

Arthur, Paul. *People's Democracy, 1968–1973.* Belfast: Blackstaff Press, 1974.

Bartelt, Dana, curated by, et al. *Both Sides of Peace: Israeli and Palestinian Political Poster Art.* Raleigh, NC: Contemporary Art Museum, 1996.

Drew, Jesse. "Newe Sogobia is Not for Sale!" *FELIX Journal of Media Arts and Communication: Landscapes,* 2, Kathy High, ed. (1996): 123–129.

Johnson, Troy R., ed. *Alcatraz: Indian Land Forever.* Los Angeles: American Indian Studies Center, University of California, 1994.

Kulchyski, Peter. *The Red Indians: An Episodic, Informal Collection of Tales From the History of Aboriginal People's Struggles in Canada.* Winnipeg: Arbeiter Ring Publishing, 2007.

Massey, David, ed. *It's All Lies: Leaflets, Underground Press and Posters, The Fusion of Resistance and Creativity in Israel.* Tel Aviv: The Agency for an Independent Critical Culture, 2002.

Murphy, Yvonne, Allan Leonard, Gordon Gillespie, and Kris Brown, eds. *Troubled Images: Posters and Images of the Northern Ireland Conflict from the Linen Hall Library, Belfast.* Belfast: The Linen Hall Library, 2001.

Rolston, Bill. *Politics and Painting: Murals and Conflict in Northern Ireland.* Cranbury, NJ: Fairleigh Dickinson University Press, 1991.

_____. *Drawing Support Vol. 2: Murals of War and Peace.* Belfast: Beyond the Pale Publications, 1995.

_____. *Drawing Support Vol. 3: Murals and Transition in The North of Ireland.* Belfast: Beyond the Pale Publications, 2003.

Rudin, Marc. *Marc Rudin/Jihad Mansour: Katalog zur Ausstellung.* Zurich: Kasama, 1993.

Smith, Paul Chaat, and Robert Allen Warrior. *Like a Hurricane: The Indian Movement from Alcatraz to Wounded Knee.* New York: New Press, 1996.

AGITATE! EDUCATE! ORGANIZE!

Aquino, Arnulfo, and Jorge Pérezvega. *Imagenes y simbolos del 68: Fotografia y grafica del movimiento estudiantil.* Mexico City: Universidad Nacional Autónoma de México, 2004.

Atelier Populaire. *Posters from the Revolution Paris May 1968.* London: Dobson Books Ltd., 1969.

Beaubourg, Galerie, and Bruno Barbey. *Mai 68 ou l'imagination au Pouvoir.* Paris: La Différence, 1998.

Besançon, Julien. *Les Murs Ont La Parole, Journal Mural Mai 68: Sorbonne Odéon Nanterre etc.* Paris: Tchou, 1968.

Cuninghame, Patrick. "Autonomia: A Movement of Refusal—Social Movements and Social Conflict in Italy in the 1970s." PhD diss: Middlesex University, 2002.

_____. "A Laughter That Will Bury You All: Irony as Protest and Language as Struggle in the Italian 1977 Movement." *International Review of Social History* 52 (2007): 153–68.

Dalla Costa, Mariarosa, and Selma James. *Power of Women and the Subversion of the Community.* New York: Falling Wall Press, Limited, 1975.

D'Amico, Tano. *Volevamo solo cambiare il mondo: Romanzo fotografico degli anni '70 di Tano D'Amico.* Napoli: Edizioni Intra Moenia, 2008.

_____. *Gli anni ribelli 1968–1980.* Roma: Editori Riuniti, 1998.

D'Amico, Tano, and Collettivo Resa dei Conti. *é il '77.* Roma: Il Manifesto, 2007 (reprint).

Davidson, Steef. *Images de la Revolte 1965–1975.* Paris: Editions Henri Veyrier, 1985.

Debord, Guy. *Society of the Spectacle.* Detroit: Black and Red, 1983, first English trans., 1970.

Debroise, Olivier, ed. *The Age of Discrepancies: Art and Visual Culture in Mexico, 1968–1997.* Mexico City: Turner/UNAM, 2007.

Echaurren, Pablo. *Parole Ribelli: '68 e dintorni.* Roma: Stampa Alternativa, 1998.

_____. *Parole Ribelli: I Fogli Del Movimento Del 77.* Roma: Stampa Alternativa, 1977.

Exposición: Arte, luchas populares en México. México City: Museo Universitario de Ciencias y Artes, 1979.

Feest, Christian F., trans. *Indians and Europe: An Interdisciplinary Collection of Essays.* New York: Bison Books, 1999.

Gasquet, Vasco. *500 Affiches de Mai 68.* Bruselles: Editions Aden, 2007 (originally published 1978).

Greenpepper Magazine, Precarity issue, 2004.

Grupo Mira. *La Grafica del '68: Homenaje al Movimiento Estudiantil.* Mexico City: Revista Zurda, 1988.

Hobsbawm, Eric J., and Marc Weitzmann. *1968 Magnum throughout the World: A Year in the World.* New York: Penguin, 1998.

Hulse, Benjamin. *Billy Clubs and Culture Wars: The Art of Remembering the 1968 Democratic Convention.* Boston: Harvard University Press, 1999.

Katz, Donald. "Tribes: Italy's Metropolitan Indians." *Rolling Stone* (Nov. 17, 1977): 60–65.

Katsiaficas, George. *The Imagination of the New Left: A Global Analysis of 1968.* Boston: South End Press, 1987.

Knabb, Ken, ed. *Situationist International Anthology*. Berkeley: Bureau of Public Secrets, 1981.

Kurlansky, Mark. *1968: The Year That Rocked the World*. New York: Random House Trade Paperbacks, 2005.

Lee Jae-Eui. *Kwangju Diary: Beyond Death, Beyond the Darkness of the Age*. trans. Kap Su Seol and Nick Mamatas. Los Angeles: University of California, 1999.

López, Elizabeth Christine. "The Mexican Front: Artist Collectives in México City 1968–1985. " PhD diss: UCLA, 2002.

Lumley, Robert. *States of Emergency: Cultures of Revolt in Italy from 1968 to 1878*. London: Verso Press, 1990.

Mabry, Donald J. *The Mexican University and the State: Student Conflicts, 1910–1971*. College Station, TX: Texas A&M University Press, 1982.

Nevaer, Louis E.V. *Protest Graffiti Mexico: Oaxaca*. New York: Mark Batty Publisher, 2009.

Novelli, Italo. *Per la Rivoluzione, Per la Patria, Per la Famiglia, e Per le Donne: 100 Anni di Manifesti Politici nel Mondo*. Venice: Marsilio, 1978.

Poniatowska, Elena, and Octavio Paz. *Massacre in Mexico*. Trans. Helen R. Lane. Columbia, MO: University of Missouri Press, 1991.

Quattrochi, Angelo, and Tom Nairn. *The Beginning of the End: France, May, 1968*. London: Verso, 1998 (originally published 1968).

Rohan, Marc. *Paris '68: Graffiti, Posters, Newspapers & Poems of the Events of May 1968*. London: Impact Books, 1988.

Ross, Kristin. *May '68 and Its Afterlives*. Chicago: The University of Chicago Press, 2002.

Spini, Valdo. "The New Left in Italy." *Journal of Contemporary History* (1972): 65–66.

Sunada, Ichiro. "The Thought and Behavior of Zengakuren: Trends in the Japanese Student Movement." *Asian Survey* 9.6 (1969): 457–74.

Taibo II, Paco Ignacio. *68*. New York: Seven Stories Press, 2004.

Tempest, Gene M., "Anti-Nazism and the *Ateliers Populaires*: The Memory of Nazi Ccollaboration in the posters of Mai '68." Thesis: UC Berkeley, 2006 (published online at http://www.docspopuli.org/articles/Paris1968_Tempest/AfficheParis1968_Tempest.html).

Tsurumi, Kazuko. "Some Comments of the Japanese Student Movement in the Sixties." *Journal of Contemporary History* 5.1 (1970): 104–12.

Willener, Alfred. *The Action-Image of Society: On Cultural Politicization*. New York: Routledge, 2001.

Wright, Steve. *Storming Heaven: Class Composition and Struggle in Italian Autonomist Marxism*. New York: Pluto Press, 2002.

FORWARD TO PEOPLE'S POWER

Bin Wahad, Dhoruba, Assata Shakur, and Mumia Abu-Jamal. *Still Black, Still Strong: Survivors of the War Against Black Revolutionaries*. New York: Semiotexte, 1993.

Chicano Communications Center. *450 Years of Chicano History in Pictures*. Albuquerque, NM: Chicano Communications Center, 1976.

Cleaver, Kathleen, and George Katsiaficas, eds. "Special Issue: Liberation, Imagination, and the Black Panther Party." *New Political Science: A Journal of Politics and Culture*. Vol 21, Number 2, 1999.

Crimp, Douglas, and Adam Rolston. *AIDS Demo Graphics*. Seattle: Bay Press, 1990.

Durant, Sam, ed. *Black Panther: The Revolutionary Art of Emory Douglas*. New York: Rizzoli, 2007.

Echols, Alice. *Daring to Be Bad: Radical Feminism in America, 1967–1975*. Minneapolis: University of Minnesota Press, 1989.

Ecole du Magasin. *Aids Riot, New York, 1987–1994: Collectif D'artistes Face Au Sida = Artist Collectives against AIDS*. Grenoble, France: Magasin, 2003.

Freeman, Jo, and Cathy Levin. *Untying the Knot: Feminism, Anarchism, and Organization*. London: Dark Star/Rebel Press, 1984.

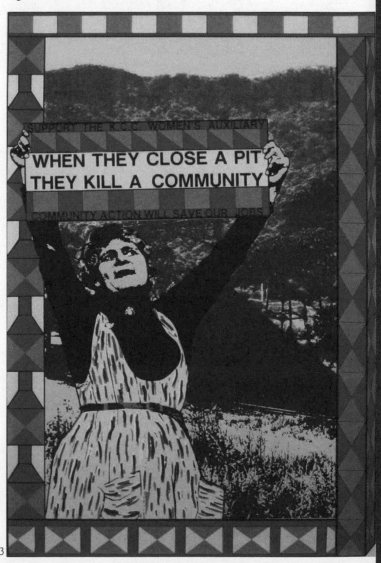

La Gaffiche. *Les Femmes S'Affichent*. Paris: Syros, 1984.

Goldman, Shifra M. *Dimensions of the Americas: Art and Social Change in Latin America and the United States*. Chicago: University of Chicago Press, 1994.

Ho, Fred W., ed. *Legacy to Liberation: Politics and Culture of Revolutionary Asian/Pacific*. Oakland: AK Press, 2000.

INCITE! Women of Color Against Violence, ed. *The Color of Violence: The INCITE! Anthology*. Cambridge, MA: South End Press, 2006.

_____. *The Revolution Will Not Be Funded: Beyond the Non-profit Industrial Complex*. Cambridge, MA: South End Press, 2007.

Lipsitz, George, Tere Romo, and Raphael Perez-Torres. *Just Another Poster? Chicano Graphic Arts in California*. Berkeley: University of California, 2002.

Manifesto Group of GLF. "Gay Liberation Front: Manifesto." London: Gay Liberation Information Service, 1971, revised 1978. (published online at http://www.fordham.edu/halsall/pwh/glf-london.html).

Moraga, Cherrie and Gloria Anzaldúa, eds. *This Bridge Called My Back: Writings by Radical Women of Color*. New York: Kitchen Table, Women of Color Press, 1983.

McQuiston, Liz. *Suffragettes to She Devils*. New York: Phaidon Press, 2000.

Ochoa, María. *Creative Collectives: Chicana Painters Working in Community*. Albuquerque: University of New Mexico Press, 2004.

Posener, Jill. *Louder Than Words*. London: Pandora Press, 1986.

_____. *Spray It Loud*. New York: Routledge & Kegan Paul, 1982.

Robert and Sallie Brown Gallery and Museum. *Radicals in Black & Brown: Palante, People's Power, and Common Cause in the Black Panthers and the Young Lords Organization*. Chapel Hill: University of North Carolina Press, 2007.

Shakur, Assata. *Assata: An Autobiography*. Westport, CT: Lawrence Hill, 2001.

Sibalis, Michael. "Gay Liberation Comes to France: The Front Homosexual d'Action Revolutionanaire (FHAR)." *The French History and Civilization: Papers from the George Rudé Seminar* 1 (2005): 265-76.

Van Deburg, William L. *New Day in Babylon: The Black Power Movement and American Culture, 1965-1975*. Chicago: University of Chicago Press, 1993.

Young, Cynthia. *Soul Power: Culture, Radicalism, and the Making of A U.S. Third World Left*. Durham, NC: Duke University Press, 2006.

FREEDOM AND INDEPENDENCE NOW

Adams, Jacqueline. "Art in Social Movements: Shantytown Women's Protest in Pinochet's Chile." *Sociological Forum* 17.1 (2002): 21-56.

Aulich, James, and Tim Wilcox. *Europe Without Walls: Art, Posters and Revolution 1989-1993*. Manchester: Manchester City Art Galleries, 1993.

Brett, Guy. *Through Our Own Eyes: Popular Art and Modern History*. Philadelphia: New Society Publishers, 1987.

Cabezas, Omar, and Dora Maria Tellez. *La insurreccion de las paredes: Pintas y graffiti de Nicaragua*. Managua: Editorial Nueva Nicaragua, 1984.

Castillo, Eduardo. *Cartel Chileno 1963-1973*. Santiago de Chile: Ediciones B Chile, 2006.

_____. *Puno Y Letra: Movimiento social y comunicacion grafica en Chile*. Chile: Ocho Libros Editores, 2006.

Coombes, Annie E. *History After Apartheid: Visual Culture and Public Memory in a Democratic South Africa*. Durham: Duke University Press, 2003.

Davidson, Russ, ed. *Latin American Posters: Public Aesthetics and Mass Politics*. Santa Fe: Museum of New Mexico Press, 2006.

Enwezor, Okwui, and Museum Villa Stuck. *The Short Century: Independence and Liberation Movements in Africa, 1945-1994*. New York: Prestel, 2001.

Felgueiras, Fernando, and Amelia Afonso. *As Paredes em Liberdade*. Lisbon: Editorial Teorema, 1974.

Frick, Richard, ed. *The Tricontinental Solidarity Poster*. Bern, Switzerland: Commedia-Verlag, 2003.

Guimãras, Sérgio, ed. *As Paredes Val Revolução*, Lisbon: Mil Dias Editora, 1978.

Goodman, David S. *Beijing Street Voices: The Poetry and Politics of China's Democracy Movement*. New York: Marion Boyars, Ltd., 1981.

Mailer, Phil. *Portugal: The Impossible Revolution?* Quebec: Black Rose Books, 1977.

Mattelart, Armand, ed. *Communicating in Popular Nicaragua*. New York: International General, 1986.

Nizza, Enzo, and Paolo Zappaterra. *La Grecia Deei Colonnelli e Documenti Della Resistenza Greca*. Milan: La Pietra, 1969.

Oliphant, Andries W., and Ivan Vladislavic, eds. *Ten Years of Staffrider 1978-1988*. Vol. 7. Johannesburg: Raven Press, 1988.

O'Toole, Sean. "Bring Me the Head of Nelson Mandela." *Eye: The International Review of Graphic Design* 12/48 (Summer 2003) 18-27.

Raboy, Marc. *Movement and Messages: Media and Radical Politics in Quebec*. Toronto: Between the Lines, 1984.

Sachs, Alby. *Images of a Revolution*. Harare, Zimbabwe: Zimbabwe Publishing House, 1983.

Sahlstrom, Berit. *Political Posters in Ethiopia and Mozambique: Visual Imagery in a Revolutionary Context*. Stockholm: Almqvist & Wiksell International, 1990.

Sarhandi, Daoud, and Alina Boboc. *Evil Doesn't Live Here: Posters of the Bosnian War*. New York: Princeton Architectural Press, 2002.

Seidman, Judy. *Red on Black: The Story of the South African Poster Movement*. Johannesburg: STE Publishers, 2007.

The Posterbook Collective of The South African History Archive. *Images of Defiance: South African Resistance Posters of the 1980s*. Johannesburg: STE Publishers, 2004 (originally published 1991).

Templeton, Rini. *The Art of Rini Templeton: Where There Is Life and Struggle.* Seattle: Real Comet Press, 1989.

Tió, Teresa. *El Cartel en Puerto Rico.* Mexico City: Pearson Educación Mexico, 2003.

Williamson, Sue. *Resistance Art in South Africa.* New York: St Martin's Press, 1990.

Wylie, Diana. *Art and Revolution: The Life and Death of Thami Mnyele, South African Artist.* Charlottesville: University of Virginia Press, 2008.

Younge, Gavin, and Desmond Tutu. *Art of the South African Township.* New York: Rizzoli, 1988.

LET IT ALL HANG OUT

Azagra, Carlos. *Antologia del Panfletismo Ilustrado.* Barcelona: Virus Editorial, 1993.

Bey, Hakim. *T.A.Z.: The Temporary Autonomous Zone, Ontological Anarchy, Poetic Terrorism.* Brooklyn: Autonomedia, 1991.

Bogad, Larry M. *Electoral Guerilla Theatre: Radical Ridicule and Social Movements.* New York: Routledge, 2005.

Boyle, Deidre. *Subject to Change: Guerrilla Television Revisited.* New York: Oxford University Press, 1997.

Boyle, Jeffrey, and Peter Harper, eds. *Radical Technology.* London: Undercurrents, 1977.

Carlsson, Chris. *Nowtopia: How Pirate Programmers, Outlaw Bicyclists, and Vacant-Lot Gardeners Are Inventing the Future Today.* Oakland: AK Press, 2008.

Centre Wallonie-Bruxelles and Namur. *Cobra Singulier Pluriel: Les Oeuvres Collectives, 1948–1995.* Tournai: La Renaissance du livre, 1998.

Christianitter. *Christiania Plakater 1971–78.* Copenhagen: Informations Forlag, 1978.

Davidson, Steef. *The Penguin Book of Political Comics.* Harmondsworth: Penguin Books, 1982.

Delta: A Review of Arts Life and Thought in the Netherlands. Provo Issue 10.3 (1967).

Dessauce, Marc, ed. *The Inflatable Moment: Pneumatics and Protest in '68.* New York: Princeton Architectural Press, 1999.

The Diggers. "The Digger Papers." *The Realist* No 81 (August 1968).

Duivenvoorden, Eric. *Met Emmer en Kwast: Veertig jaar Nederlandse actieaffiches 1965–2005.* Amsterdam: Uitgeverij Het Fort van Sjakoo, 2005.

Fuller, Matthew. *Flyposter Frenzy: Posters from the Anticopyright Network.* London: Working Press, 1992.

Grauwacke, A.G. *Autonome in Bewegung.* Berlin: Assoziation A, 2008.

Grogan, Emmett. *Ringolevio: A Life Played for Keeps.* Boston: Little, Brown & Company, 1972.

Heins, Wil, Amersfoort (Netherlands), and Culturele Raad. *Cobra: Aventures Collectives.* Amersfoort: De Raad, 1984.

Hofland, H.J.A., Marius Van Leeuwen, and Nel Punt. *Een Teken Aan De Wand Album Van de Nederlandse Samenleving 1963–1983.* Amsterdam: Uitgeverij Bert Bakker, 1983

Jorgensen, Aage. "Touring the 1970s with the Solvognen in Denmark." *The Drama Review,* 26 (1982): 15–28.

Katsiaficas, George. "The Extra-Parliamentary Left in Europe." *Monthly Review* 34.4 (1982): 31–45.

Kempton, Richard. *Provo: Amsterdam's Anarchist Revolt.* Brooklyn: Autonomedia, 2007.

Langer, Bernd. *Art as Resistance: Placats, Paintings, Actions, Texts from the Initiative Kunst und Kampf (Art and Struggle)/Kunst als Widerstand: Plakate, Olbilder, Aktionen, Texte der Initiative Kunst und Kampf.* Gottingen: Kunst und Kampf, 1998.

McKay, George. *DIY Culture: Party and Protest in Nineties' Britain.* London: Verso 1998.

_____. *Senseless Acts of Beauty: Cultures of Resistance Since the Sixties.* London: Verso, 1996.

Meijer, Henk J., and Cor Jaring. *Dit Hap-Hap-Happens in Amsterdam.* Amsterdam: De Arbeiderspers, 1966.

Poppe, Ine, and Sandra Rottenbrg. *De KRAAKgeneratie.* Amsterdam: Uitgeverij De Balie, 2000.

Reid, Jamie, and Jon Savage. *Up They Rise: The Incomplete Works of Jamie Reid.* London: Faber & Faber, 1987.

Shamberg, Michael, and Raindance Corporation. *Guerrilla Television.* New York: Holt, Rinehart, and Winston, 1971.

Silvestro, Carlo, ed. *The Living Book of the Living Theater.* Köln: M. Dumont Schauberg, 1971.

Stansill, Peter, and David Z. Mairowitz, eds. *BAMN: By Any Means Necessary: Outlaw Manifestos & Ephemera 1965–70.* Brooklyn: Autonomedia, 2003.

Teasdale, Parry D. *Videofreex: America's First Pirate TV Station & the Catskills Collective That Turned It On.* Hensonville, NY: Black Dome, 1999.

Van Duyn, Roel. *Message of a Wise Kabouter.* London: Gerald Duckworth & Co. Ltd, 1969.

Vaneigem, Raoul. *The Revolution of Everyday Life.* London: Rebel Press, 1994 (originally published 1967).

Vaucher, Gee. *Gee Vaucher: Crass Art and Other Pre Post-Modernist Monsters.* Oakland: AK Press, 1997.

Wakefield, Stacy, and Grrrt. *Not for Rent: Conversations with Creative Activists in the U.K.* Amsterdam: Evil Twin Publications, 1995.

Worthington, Andy. *Stonehenge: Celebration and Subversion.* Leicestershire, UK: Alternative Albion, 2004.

RECLAIM THE COMMONS

Alland, Alexander, and Sonia Alland. *Crisis and Commitment: Life History of the French Social Movement*. Amsterdam: Harwood Academic, 2001.

Apter, David Ernest, and Nagayo Sawa. *Against the State: Politics and Social Protest in Japan*. Cambridge, MA: Harvard University Press, 1984.

Bristle Magazine. "Bristle: Political Street Expression in Bristol and the South West, Vol. 1." UK: Bristle Magazine, 2005.

Costello, Cynthia, and Amy Dru Stanley. "Report from Seneca." *Frontiers: A Journal of Women Studies* 8.2 (1985): 32–39.

Carlsson, Chris, ed. *Critical Mass: Bicycling's Defiant Celebration*. Oakland: AK Press, 2002.

Compost, Terri, ed. *People's Park: Still Blooming*. Berkeley, CA: Slingshot, 2009.

Cook, Alice, and Gwyn Kirk. *Greenham Women Everywhere: Dreams, Ideas and Actions from the Women's Peace Movement*. Boston: South End Press, 1983.

Corr, Anders. *No Trespassing! Squatting, Rent Strikes, and Land Struggles Worldwide*. Boston: South End Press, 1999.

Epstein, Barbara. *Political Protest and Cultural Revolution: Nonviolent Direct Action in the 1970s and 1980s*. Berkeley: University of California Press, 1991.

Fairhall, David. *Common Ground: The Story of Greenham*. London: I. B. Tauris, 2006.

Felshin, Nina. *Disarming Images: Art for Nuclear Disarmament*. New York: Adama Books, 1984.

Harford, Barbara, and Sarah Hopkins. *Greenham Common: Women at the Wire*. London: Women's Press Ltd, 1984.

Lefebvre, Henri. *The Production of Space*. Malden, MA: Blackwell, 1974, English translation, 1991.

Nornes, Abe M. *Forest of Pressure: Ogawa Shinsuke and Postwar Japanese Documentary*. Minneapolis: University of Minnesota Press, 2007.

Pershing, Linda. "The Ribbon Around the Pentagon: Women's Traditional Fabric Arts as a Vehicle for Social Critique." PhD diss., University of Texas at Austin, 1990.

Schirmer, Jennifer. "The Claiming of Space and the Body Politic within National-Security States: The Plaze de Mayo Madres and the Greenham Common Women." In *Remapping Memory: Space, Time, and the Politics of Memory*. Ed. Jonathan Boyarin. Minneapolis: University of Minnesota Press, 1994.

Sakolsky, Ron, and Stephen Dunifer. *Seizing the Airwaves: A Free Radio Handbook*. Oakland: AK Press, 1998.

Staeck, Klaus. *Die Gedanken sind frei: Plakate*. Berlin: Eulenspiegel, 1981.

Welsh, Ian. *Mobilising Modernity: The Nuclear Moment*. New York: Routledge, 2000.

Women's Encampment for a Future of Peace & Justice Resource Handbook. Seneca Army Depot, NY, 1983.

GLOBALIZATION FROM BELOW

Big Noise, "A Storm From the Mountain," *FELIX Journal of Media Arts and Communication: Risk/Riesgo*. Kathy High, ed. (2004): 246–251.

Cockburn, Alexander, Jeffrey St. Clair, and Allan Sekula, eds. *5 Days That Shook The World: Seattle and Beyond*. London: Verso, 2000.

Crimethinc. ex-Workers' Collective. *Days Of War, Nights of Love*. Atlanta: Crimethinc. Free Press, 2001.

Critical Art Ensemble. *Digital Resistance: Explorations in Tactical Media*. Brooklyn: Autonomedia, 2000.

_____. *Electronic Civil Disobedience and Other Unpopular Ideas*. Brooklyn: Autonomedia, 1996.

_____. *The Electronic Disturbance*. Brooklyn: Autonomedia, 1994.

Froehling, Oliver. "The Cyberspace 'War of Ink and Internet' in Chiapas, Mexico," *Geographical Review* 87.2, (1997): 291–307.

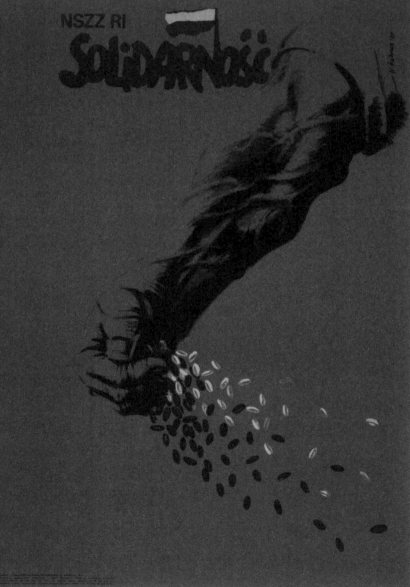

Garcia, David, and Geert Lovink. "The ABC of Tactical Media." 3 Oct. 2006 (1997). (publiished online at http://subsol.c3.hu/subsol_2/contributors2/garcia-lovinktext.html).

Hardt, Michael, and Antonio Negri. *Empire*. Cambridge, MA: Harvard University Press, 2000.

Hartman, Chester. "San Francisco's International Hotel: Case Study of a Turf Struggle," *Radical America* 12.3 (1978).

Harvie, David, Keir Milburn, Ben Trott, and David Watts, eds. *Shut Them Down! The G8, Gleneagles 2005 and the Movement of Movements*. Leeds, UK: Dissent!, 2005.

Indij, Guido, ed. *Hasta la Victoria Stencil*. Buenos Aires: La Marca, 2004.

Klein, Naomi. *No Logo*. New York: Picador, 2002.

Langlois, Andrea, and Frederic Dubois, eds. *Autonomous Media: Activating Resistance and Dissent*. Montreal: Cumulus, 2005.

Lane, Jill. "Digital Zapatistas." *The Drama Review* 47.2 (2003): 129–44.

Marcos, Subcomandante, and the Zapatistas. *The Other Campaign*. San Francisco: City Lights, 2006.

Mertes, Tom. *A Movement of Movements: Is Another World Really Possible?* London: Verso, 2004.

Midnight Notes Collective, eds. *Auroras of the Zapatistas: Local and Global Struggles of The Fourth World War*. Brooklyn: Autonomedia, 2001.

Notes From Nowhere, eds. *We Are Everywhere: The Irresistible Rise of Global Anticapitalism*. London: Verso, 2003.

On Fire: The Battle of Genoa and the Anti-Capitalist Movement. London: One Off Press, 2001.

Palladino, Luca, and David Widgington, eds. *Counter Productive: Quebec City Convergence Surrounding The Summit of The Americas*. Montreal: Cumulus Press, 2002.

Pickard, Victor W. "Assessing the Radical Democracy of Indymedia: Discursive, Technical, and Institutional Constructions," *Critical Studies in Media Communication* 23.1 (2006): 19–38.

Sassen, Saskia. *Globalization and Its Discontents: Essays on the New Mobility of People and Money*. New York: The New Press, 1999.

Solnit, Rebecca. *Hollow City: Gentrification and the Eviction of Urban Culture*. London: Verso Press, 2001.

Van Aelst, Peter, and Stefann Walgrave. "New Media, New Movements? The Role of the Internet in Shaping the 'Anti-Globalization' Movement." In *Cyberprotest: New Media, Citizens and Social Movements*. Ed. Wim Van De Donk, Brian D. Loader, and Dieter Rucht. New York: Routledge, 2003.

Yuen, Eddie, George Katsiaficas, and Daniel Burton-Rose, eds. *The Battle of Seattle: The New Challenge to Capitalist Globalization*. New York: Soft Skull Press, 2002.

GENERAL BIBLIOGRAPHY

Antliff, Allan. *Anarchy and Art: From the Paris Commune to the Fall of the Berlin Wall*. Vancouver: Arsenal Pulp Press, 2007.

Baines, Jess. "The Freedom of the Press Belongs to Those Who Control the Press: The Emergence of Radical and Community Printshops in 1970s London." 28 Jan. 2010 (2009). (publiished online at http://www.afterall.org/online/radical.printmaking).

Barnouw, Erik. *Documentary: A History of Non-Fiction Film*. New York: Oxford University Press, 1974.

Benjamin, Walter. *Illuminations*. New York: Schocken, 1986 (originally published 1934).

Boyer, Jean-Pierre, Jean Desjardins, and David Widgington, eds. *Picture This! Posters of Social Movements in Quebec 1966–2007*. Montréal: Cumulus Press, 2007.

Chaffee, L. G. *Political Protest and Street Art: Popular Tools for Democratization in Hispanic Countries*. Westport, CT: Greenwood Press, 1993.

Cohen-Cruz, Jan, ed. *Radical Street Performance*. London: Routledge, 1998.

Cushing, Lincoln, ed. *Visions of Peace and Justice: San Francisco Bay Area: 1974–2007*. Berkeley: Inkworks Press, 2007.

Dackerman, Susan, and Fogg Art Museum. *Dissent!* Cambridge, MA: Harvard University Art Museums, 2006.

Downing, John D.H. *Radical Media: Rebellious Communication and Social Movements*. Thousand Oaks, CA: Sage Publications, 2001.

Duncombe, Stephen, ed. *Cultural Resistance Reader*. London: Verso, 2002.

Einwohner, Rachel L., Jocelyn A. Hollander, and Toska Olson. "Engendering Social Movements: Cultural Images and Movement Dynamics." *Gender and Society* 14.5 (2000): 679–99.

Esche, Charles, Mark Lewis, and Will Bradley, eds. *Art and Social Change: A Critical Reader*. London: Tate Gallery, Limited, 2008.

Eyerman, John, and Andrew Jamison. *Music and Social Movements*. Cambridge: Cambridge University Press, 1998.

Felshin, Nina, ed. *But Is It Art? The Spirit of Art and Activism*. Seattle: Bay Press, 1995.

Fox, Richard G. and Orin Star. *Between Resistance and Revolution: Cultural Politics and Social Protest*. New Brunswick, NJ: Rutgers University Press, 1997.

Yves Fremion. *Orgasms of History: 3000 Years of Spontaneous Insurrection*. Oakland: AK Press, 2002.

Graeber, David. *Fragments of an Anarchist Anthropology*. Chicago: Prickly Paradigm Press, 2004.

Hall, Doug, and Sally Jo Fifer. *Illuminating Video: An Essential Guide to Video Art*. New York: Aperture, 1990.

Halleck, DeeDee. *Hand-Held Visions: Uses of Community Media*. New York: Fordham University Press, 2002.

Harding, Thomas. *Video Activist Handbook*. London: Pluto Press, 2001.

Hill, Chris, ed. *Rewind: Video Art and Alternative Media in the United States 1968–1980*. Chicago: Video Data Bank, 1995.

Jacobs, Karrie, and Steven Heller. *Angry Graphics: Protest Posters of the Reagan/Bush Era*. Salt Lake City: Peregrine Smith Books, 1992.

Jasper, James M. *The Art of Moral Protest: Culture, Biography, and Creativity in Social Movements*. Chicago: University of Chicago Press, 1999.

Katsiaficas, George. "The Necessity of Autonomy." *New Political Science* 23.4 (2001): 547–55.

_____. *The Subversion of Politics: European Autonomous Social Movements and the Decolonization of Everyday Life*. Oakland: AK Press, 2006 (originally published 1997).

Kazymerchyk, Amey. *Riseup: Where Art Intersects with Activism*. Vancouver: A. Kazymerchyk, 2001.

Kester, Grant, ed. *Art, Activism, and Oppositionality: Essays from Afterimage*. Durham: Duke University Press, 1998.

Kidron, Michael, and Ronald Segal. *The State of the World Atlas: A Unique Visual Survey of Global Political, Economic, and Social Trends*. New York: Penguin, 1995.

Lippard, Lucy. *Get the Message? A Decade of Art for Social Change*. New York: E.P. Dutton, Inc, 1984.

MacPhee, Josh. *Paper Politics: Socially Engaged Printmaking Today*. Oakland: PM Press, 2009 (originally published 2005).

_____. *Stencil Pirates*. New York: Soft Skull Press, 2003.

MacPhee, Josh, and Erik Reuland, eds. *Realizing the Impossible: Art Against Authority*. Oakland: AK Press, 2007.

MacPhee, Josh, and Favianna Rodriguez, eds. *Reproduce and Revolt*. New York: Soft Skull Press, 2008.

Martin, Susan, ed. *Decade of Protest: Political Posters from the United States Vietnam Cuba 1965–1975*. Santa Monica: Smart Art Press, 1996.

McMillan, John C., and Timothy P. McCarthy, eds. *The Radical Reader: A Documentary History of the American Radical Tradition*. New York: The New Press, 2003.

McQuiston, Liz. *Graphic Agitation*. New York: Phaidon Press, 1995.

_____. *Graphic Agitation 2: Social and Political Graphics in the Digital Age*. New York: Phaidon Press, 2004.

Melucci, Alberto. *Challenging Codes*. Cambridge: Cambridge University Press, 1996.

Morris, William. *Signs of Change: Seven Lectures Delivered on Various Occasions*. New York: Longmans, Green, and Co., 1903.

National Collection of Fine Arts 1975. *Images of an Era: The American Poster 1945–75*. Washington, DC: Smithsonian Institution, 1975.

Ostertag, Bob. *People's Movements, People's Press: The Journalism of Social Justice Movements*. New York: Beacon Press, 2007.

Philippe, Robert. *Political Graphics: Art as a Weapon*. Oxford: Phaidon Press Limited, 1980.

Reed, T. V. *The Art of Protest: Culture and Activism from the Civil Rights Movement to the Streets of Seattle*. Minneapolis: University of Minnesota Press, 2005.

Raunig, Gerald. *Art and Revolution: Transversal Activism in the Long Twentieth Century*. Trans. Aileen Derieg. Los Angeles: Semiotexte, 2007.

Rickards, Maurice. *Posters of Protest and Revolution*. New York: Walker and Company, 1970.

Sanders, Hubb, and Els Hiemstra-Kuperus. *Images of Aspiration*. Amsterdam: International Institute of Social History/Aksant, 2005.

Shepard, Benjamin, and Ronald Hayduk eds. *From ACT UP to the WTO: Urban Protest and Community Building in the Era of Globalization*. London: Verso, 2002.

Sholette, Gregory. "Dark Matter: Activist Art and the Counter-Public Sphere" (2003) (published online at http://www.journalofaestheticsandprotest.org/3/sholette.htm).

Solomon, Alisa, ed. "Theater and Social Change." *Theater* 31.33. Yale Repertory Theater/Yale School of Drama. Durham: Duke University Press, 2001.

Sontag, Susan. "1970 Posters: Advertisement, Art, Political Artifact, Commodity." In *Looking Closer 3: Classic Writings on Graphic Design*. Ed. Michael Bierut, Jessica Helfand and Steven Heller. New York: Allworth Press, 1999.

Stimson, Blake, and Gregory Sholette, eds. *Collectivism After Modernism: The Art of Social Imagination After 1945*. Minneapolis: University of Minnesota, 2007.

Tarrow, Sidney. *Power in Movement*, 2nd edition. Cambridge: Cambridge University Press, 1998.

Thompson, Nato, and Gregory Sholette, ed. *The Interventionists: Users' Manual for the Creative Disruption of Everyday Life*. Cambridge, MA: The M.I.T. Press, 2004.

Tschabrum, Susan. "Off the Wall and into a Drawer: Managing a Research Collection of Political Posters." *The American Archivist* 66 (2003): 303–24.

Vogel, Amos. *Film As a Subversive Art*. New York: Random House, 1974.

Yanker, Gary. *Prop Art: Over 1000 Contemporary Political Posters*. New York: Darien House, 1972.

373. Redback Graphix, **Support the K.C.C. Women's Auxiliary**, screen print, c. 1980s, Australia.
374. Solidarność [Solidarity] (artist: Karol Sliwka), **Independent Self-Governing Trade Union of Individual Farmers/Solidarity**, offset lithograph poster, 1981, Poland.

CREDITS

All images (marked below by their catalog number) are courtesy of the following lenders. All other material is courtesy of the artists, anonymous, or public domain. Audio clips courtesy of the Freedom Archives, San Francisco.

All of Us or None Archive, Berkeley, CA
65, 266, 270

Archivo Arnulfo Aquino, Mexico City
70–77

Athénée Français Cultural Center, Tokyo
269

Benton Gallery at University of Connecticut
178–180

Breakdown Press, Melbourne
60, 61, 301, 309, 315, 336

Kevin Caplicki
108–110, 316, 323

The Center for the Study of Political Graphics, Los Angeles
11, 18, 19, 78–80, 88, 125, 134, 138, 152, 190, 217, 265, 279, 290, 291

Centro Studi Movimenti, Parma, Italy
82–85, 87

Chiapas Media Project, Chicago
362, 369, 370

Chicago Women's Liberation Union Herstory Project, Chicago
5, 146, 154

Christiania's Cultural Association, Copenhagen
237–241

CIRA Japan, Tokyo
246

Tony Credland
320, 321, 334, 343

Mariarosa Dalla Costa
88, 90–94

Grrrt
141, 205, 216, 218

Sérgio Guimãras
(taken from As Paredes Val Revolução, Lisbon: Mil Dias Editora, 1978)
181

HKS 13, Berlin
22, 161, 176, 208, 209, 210, 214, 212, 226–233, 275, 284

Hoover Institution Archives, Stanford, CA
374

R. Howze
204

Inkworks (c/o Lincoln Cushing), Berkeley, CA
37, 158, 262–263

Interference Archive, Brooklyn
2, 12, 15, 21, 32, 38, 40, 41, 42, 43, 49, 51, 115, 122, 130, 132, 140, 147, 149, 156, 157, 165, 166, 174, 177, 201, 225, 232, 234, 242–245, 247, 248, 251–253, 277, 280, 282, 285, 289, 302–303, 306, 313–314, 324–326, 333, 335, 339–340, 356, 373

The International Institute of Social History, Amsterdam
3, 20, 36, 39, 54, 62, 64–69, 124, 126, 144, 159, 161, 194–196, 198, 212–213, 215, 220, 222, 224, 235, 236, 250, 256, 258, 268, 271–274, 276, 278, 310

It's All Lies, Tel Aviv
202

John Jordan
255, 293–300, 317–319, 332

Jura Books, Sydney
56–59

Kartemquin Films, Chicago
364–365

Jessica Lawless
145

Lesbian Herstory Educational Foundation, Inc., Brooklyn
160, 366

The Linen Hall Library, Belfast
45, 46

Matt Meyer
32, 34, 139

The Middle East Division of Harvard's Weiner Library, Cambridge
52, 53

Political Art Documentation/Distribution (PAD/D) Archives at The Museum of Modern Art, New York (original pieces lent to exhibition by MoMA, reproductions copyright the artists)
33, 97, 98, 100, 121, 127, 133, 142, 150, 151, 163, 164, 167, 175, 206, 249, 257, 283, 286–288

Panopticon Gallery of Photography, Boston
123

Mary Patten
128, 129, 131, 153, 183–185

Roz Payne Archive
367

Rachael Romero
35, 99, 261

Sasha Roseneil
292

Rutger van Ree
207, 223, 337, 338, 358

South African History Archive, Johannesburg
187–189, 191–192

Video Data Bank, Chicago
14, 361

Every effort has been made to identify the producers. Any omissions are inadvertent and will be amended in future additions if notification is given.

INDEX

In 2009, Exit Art initiated Chupacabra Publications, an experimental "catalogue" model that diverges from the traditional exhibition catalogue by offering a hand-finished publication in an exclusive edition of 100. All catalogues are packaged in a stamped and sealed cardboard box, creating an art object as well as a publication. Chupacabra Publications are available at Exit Art's online store. When each edition is sold out, the catalogue will be available for download from Exit Art's website. Please visit www.exitart.org to purchase a publication or to browse our dozens of other catalogues and posters from our twenty-eight-year history.

AVAILABLE CATALOGS:

BRAINWAVE: Common Senses
ISBN 0-913263-53-2 / $30

Includes 41-page saddle-bound catalogue with exhibition texts; essay by Joseph Ledoux and curatorial statement by Exit Art Co-founder/Artistic Director Papo Colo; DVD with video documentation of the exhibition and *Somehow*, a performance by Trickster Theater; exhibition poster; and full color images of each of the artists' works

CHARLES JUHASZ-ALVARADO: Complicated Stories
ISBN 0-913263-54-0 / $30

Includes 38-page saddle-bound catalogue with exhibition texts; excerpt of interview with the artist and curatorial statement by Exit Art Co-founder/ Artistic Director Papo Colo; DVD with video documentation of the exhibition and *Still Life*, a performance by Trickster Theater; exhibition poster; full color images of each of the artist's works; and a small artwork produced by Charles Juhasz-Alvarado

ELECTRIC LAB
ISBN 0-913263-51-6 / $30

Includes 38-page saddle-bound catalogue with exhibition texts and curatorial statement by Exit Art Co-founder/Artistic Director Papo Colo; DVD with video documentation of the exhibition; exhibition poster; and full color images of each of the artists' works

LOVE / WAR / SEX
ISBN 0-913263-52-4 / $30

Includes 38-page saddle-bound catalogue with exhibition texts and curatorial statement by Exit Art Co-founder/Artistic Director Papo Colo; DVD with video documentation of the exhibition and *Cannon Dialogues*, a performance by Trickster Theater; exhibition poster; and full color images of each of the artists' works

EPA (Environmental Performance Actions)
ISBN 0-913263-48-6 / $30

Includes 52-page loose-sheet catalogue with exhibition texts; black and white images of each of the artists' works; full color catalogue frontispiece; and an exhibition poster

SUMMER MIXTAPE VOLUME 1: the Get Smart edition
ISBN 0-913263-55-9 / $30

Includes 30-page saddle-bound catalogue with exhibition texts and curatorial statement by Exit Art Assistant Curator Lauren Rosati; exhibition postcard; and full color images of each of the artists' works

VERTICAL GARDENS
ISBN 0-913263-49-4 / $30

Includes 37-page loose-sheet catalogue with exhibition texts; black and white images of each of the artists' works; and a full color catalogue frontispiece

Support AK Press!

AK Press is one of the world's largest and most productive anarchist publishing houses. We're entirely worker-run and demo-cratically managed. We operate without a corporate structure—no boss, no managers, no bullshit. We publish close to twenty books every year, and distribute thousands of other titles published by other like-minded independent presses from around the globe.

The Friends of AK program is a way that you can directly contribute to the continued existence of AK Press, and ensure that we're able to keep publishing great books just like this one! Friends pay a minimum of $25 per month, for a minimum three month period, into our publishing account. In return, Friends automatically receive (for the duration of their membership), as they appear, one free copy of every new AK Press title. They're also entitled to a 20% discount on everything featured in the AK Press Distribution catalog and on the web-site, on any and every order. You or your organization can even sponsor an entire book if you should so choose!

There's great stuff in the works—so sign up now to become a Friend of AK Press, and let the presses roll!

Won't you be our friend? Email friendsofak@akpress.org for more info, or visit the Friends of AK Press website: http://www.akpress.org/programs/friendsofak